THE
ANATOMY
OF THE
HORSE

By GEORGE STUBBS

Original Text and Modern Paraphrase by

J. C. McCUNN and C. W. OTTAWAY

With a New Introduction by

ELEANOR M. GARVEY

Curator of Printing and Graphic Arts,
Harvard College Library

DOVER PUBLICATIONS, INC.

NEW YORK

Introduction to the Dover Edition

Two hundred ten years after its publication in 1766, George Stubbs's book *The Anatomy of the Horse* has generated new interest in this remarkable artist. In his own time the book was recognized as an important publication, and the artist was well known as a painter, but his reputation, based on his numerous pictures of horses, became restricted to that of a sporting artist or animal painter. In the last quarter-century this view has been corrected, thanks in great part to the scholarship of Basil Taylor, who wrote on "The Graphic Work of George Stubbs" in *Image* in 1949–1950 and has since published many articles and a book, *Stubbs* (1971), in which he refers to the larger study with which he is still occupied. In 1947 Geoffrey Grigson had discussed Stubbs in a perceptive essay in *The Harp of Aeolus*. Terence Doherty's recent publication, *The Anatomical Work of George Stubbs* (1975), is a thorough study of this important phase of Stubbs's work, including the original of the present facsimile.

George Stubbs (1724–1806) was born in Liverpool, where his father was a currier, and at an early age he was introduced to the harsh practices of animal slaughter in preparation for the dressing of hides. As a child he began to draw animal bones and organs from his father's tannery, and even to dissect. When he was sixteen he was briefly an assistant to the painter Hamlet Winstanley, a copyist working with Lord Derby's painting collection at nearby Knowsley Hall.

By the age of twenty, Stubbs had settled in York, at that time a medical center, and his interest in anatomy was widened to include the human body, which he was able to dissect. In 1751 he illustrated Dr. John Burton's *An Essay Towards a Complete New System of Midwifery* with eighteen etchings, a technique in which he was almost wholly self-taught. He was shown a primitive method that he developed by his own experimentation; as with all his work, his formal training was slight.

Like most young artists of the eighteenth century, Stubbs made an Italian journey and was in Rome in 1754–1755. At the end of the decade he settled in London and became a successful painter of animals, and particularly horses. Hunting, racing and breeding were primary concerns of many of the aristocracy, and they patronized artists who would record this interest. Stubbs painted such famous horses as Gimcrack, Mambrino and Hambletonian. In all these pictures, as well as in his equestrian portraits and animal groups, Stubbs's work shows not only his understanding of anatomy, but a sense of picture construction and monumentality that gives them a timeless, classical quality. His painting could also be dramatic and expressive, as the pictures of fighting horses and lions demonstrate. He began to experiment with enamel, first on copper and then on ceramic, with which he was associated with Josiah Wedgwood. Although Stubbs was received into the Royal Academy, because of a dispute he refused to supply the Diploma work. Through the years his reputation declined somewhat, and at his death in 1806 he had been in financial difficulties, but he was still, at the age of eighty-two, vigorously and independently pursuing his anatomical studies and working on his etchings for *A Comparative Anatomical Exposition of the Human Body with that of a Tiger and a Common Fowl.*

The Anatomy of the Horse is fully titled *The/ Anatomy/ Of The/ Horse./ Including/ A particular Description of the Bones, Cartilages, Muscles, Fascias, Ligaments,/ Nerves, Arteries, Veins and Glands./ In Eighteen Tables, all done from Nature.* The title page identifies the artist-author as "George Stubbs, Painter" and bears the imprint "London, Printed by J. Purser, for the Author, 1766." The oblong portfolio consists of twenty-six leaves of letterpress-printed text measuring 17⅞ x 21½ in. (43.5 x 55 cm.) and eighteen illustrated tables on twenty-four plates, the plate mark measuring 15 x 18¾ in. (38 x 48 cm.). In 1765 Stubbs had issued a prospectus announcing the publication price at £5/5, with a special rate to subscribers of £4/4, to be paid in two installments. Since the published book contains no list of subscribers as announced, which was the usual eighteenth-century practice, we may assume that the desired quota of one hundred fifty supporters was not filled.

This Dover edition, first published in 1976, reproduces Stubbs's original text and the modern paraphrase by J. C. McCunn and C. W. Ottaway from the edition published in 1938 by G. Heywood Hill, Ltd., London. The illustrations are reproduced directly from the original edition of 1766, printed by J. Purser for the author, London. The 1765 prospectus (page vi) is reproduced from an original copy. Eleanor M. Garvey has written a new Introduction specially for the present edition.

International Standard Book Number: 0-486-23402-9
Library of Congress Catalog Card Number: 76-17945

Manufactured in the United States of America
Dover Publications, Inc.
180 Varick Street
New York, N.Y. 10014

In his systematic anatomical study, Stubbs depicts the horse in three positions—side, front and back. He first presents the skeleton alone in each of these three positions, then devotes to each position five studies of "Muscles, Fascias, Ligaments, Nerves, Arteries, Veins, Glands, and Cartilages." Accompanying each of these eighteen etchings is a schematic etched outline with lettered parts serving as a key to be read with the accompanying letterpress text. In the case of the front and back views—actually three-quarter front and three-quarter back—the outline key figure was etched on the same copperplate with the anatomical study. Since the side views are too large to accommodate this arrangement, the outline figures were etched on separate copperplates, thus adding six plates to the eighteen tables.°

To study Stubbs's engravings is to follow his dissection, as he presents, step by step, the successive layers of the animal's structure. After the three preliminary skeleton tables, he first depicts for each position (side, front, back) the superficial muscles with the skin removed. This is followed by studies of deeper layers of muscles in the next two plates of each position. In the fourth and fifth plates of each position, the deepest muscles, the vascular system, the blood vessels and the nerves are revealed. The clarity of the artist's presentation and his transformation of the toil of dissection into etchings of aesthetic significance are so strong as to make us forget the task he mastered. His dissection had been done many years earlier, in 1758, in an isolated farmhouse at Horkstow in Lincolnshire. The meagre contemporary accounts of his life record the brutal task of killing by bleeding from the jugular vein to avoid damaging the carcass, and the injection of warm tallow as a preservative. The animal was then suspended by an iron tackle. The work was slow, arduous and unpleasant, and only a man of Stubbs's natural strength and tenacity and early exposure to animal slaughter could have achieved it.

He made preparatory drawings, and forty-one of them, which formerly belonged to the animal painter Sir Edwin Landseer, are now in the collection of the Library of the Royal Academy at Burlington House, London. Eighteen of them, in pencil, are finished studies from which the etchings were made; the remaining twenty-three, in various mixtures of pencil, chalk and ink, are working drawings, which enable us to follow the artist's method, beginning with measured skeletal and silhouette drawings used as an outline basis. These master drawings were transferred by tracing or pouncing to other sheets to form identical figures on which Stubbs depicted each phase of the dissection, as recorded in the working drawings.

A careful examination of the published plates shows them to be entirely etched, with only a very rare strengthening of tone by the engraver's burin. In the key plates, the outlines are etched and the numbers engraved, as demonstrated by the blunt ends of the contour lines and the tapering ends of the number lines when seen under high magnification.

Stubbs's introduction to *The Anatomy of the Horse* states that his purpose was "that it might prove particularly useful to those of my own profession; and those to whose care and

°In the present edition, each view is on a separate page, making a total of 36.

skill the horse is usually entrusted, whenever medicine or surgery becomes necessary to him; I thought it might be a desirable addition to what is usually collected for the study of comparative anatomy, and by no means unacceptable to those gentlemen who delight in horses, and who either breed or keep any considerable number of them. The Painter, Sculptor, and Designer know what assistance is to be gained from the books hitherto published on this subject; and . . . they must be supposed best able to judge, how fitly the present work is accommodated to their purpose" That it was well received is indicated by the enthusiasm of the Dutch anatomist Petrus Camper, who wrote to Stubbs of his amazement "to meet in the same person so great an anatomist, so accurate a painter, and so excellent an engraver."

There had been numerous previous books dealing with the anatomy of the horse, the most important being Carlo Ruini's *Dell'anotomia, et dell'infirmità del cavallo* of 1598, illustrated with woodcuts notable for their boldness and decorative quality. Stubbs's etchings, on the other hand, are not dramatic, stylized or embellished with any decorative accessories. They are simple, silhouetted but fully modeled shapes, lightly and finely etched with parallel and cross-hatching designed to impart information. Their impact comes from these very qualities, for the precision and detail with which the dissected horse is pictured invest the figures with an unexpected vitality. The skull, for instance, is finely modeled with light strokes of the etching needle, while emerging from the dark cavern of the body are exposed veins and muscles highlighted as carefully as any more familiar surface. Pinpoints of light are reflected from the eyes of these skeletal creatures, whose vigorous stance belies their lifelessness. Their solid presence is timeless.

Cambridge, Mass. ELEANOR M. GARVEY
1976

Bibliographic Note

The Anatomy of the Horse appeared in a second edition in 1853 (London, Henry G. Bohn), with the etchings probably printed from the original copperplates. Two twentieth-century facsimiles reproduce the plates: the first, published by G. Heywood Hill, Ltd. in 1938, contains a modern veterinary paraphrase by James C. McCunn and C. W. Ottaway; the second, published by J. A. Allen & Co., London, in 1965, contains the same paraphrase and additional notes by James C. McCunn and Constance-Anne Parker. Modern studies of Stubbs that discuss *The Anatomy of the Horse* and contain illustrations and references to earlier studies of the artist include:

1971: Basil Taylor, *Stubbs*, London, Phaidon (New York, Harper & Row).

1971: Constance-Anne Parker, *Mr. Stubbs: The Horse Painter*, London, J. A. Allen & Co. (New York, British Book Center).

1975: Terence Doherty, *The Anatomical Works of George Stubbs*, Boston, David R. Godine (fully illustrated with the complete text, etchings and preliminary drawings).

On the following page is a reproduction of the rare original prospectus (1765) advertising the first edition. Pages 1 through 34 of the present volume contain J. C. McCunn and C. W. Ottaway's modern paraphrase of Stubbs's text, which originally appeared in the 1938 edition published by G. Heywood Hill, Ltd., London. Pages 35 through 83 contain (in modern type) Stubbs's original text, including the first-edition errata. This is followed by the plates, reproduced directly from the first edition (1766).

PROPOSALS for Publishing by SUBSCRIPTION,

THE

ANATOMY

OF THE

HORSE.

INCLUDING

A particular Defcription of the Bones, Cartilages, Mufcles, Fafcias, Ligaments, Nerves, Arteries, Veins, and Glands.

Reprefented in Eighteen Tables, all done from Nature.

By GEORGE STUBBS, Painter.

CONDITIONS.

The Tables engraved on Plates 19 Inches by 15.

The Explanation of the Tables will be printed on a Royal Paper anfwerable to the Plates; each of which will be printed upon an half Sheet of Double Elephant.

The Price of the Book to Subfcribers will be 4*l.* 4*s.* one Half to be paid at the Time of Subfcribing, the other Half when the Book is delivered.

The Price to Nonfubfcribers will be 5*l.* 5*s.*

The Names of the Subfcribers will be printed at the Beginning of the Work.

N. B. The Plates being all finifhed and the whole Work in the Prefs, it will be publifhed as foon as 150 Subfcribers have given in their Names; which will, together with their Subfcriptions, be received by the following Bookfellers, *viz.* Mr. DODSLEY, in *Pall-Mall*; Mr. NOURSE, in the *Strand*; Mr. OWEN, at *Temple-Bar*; Mr. NEWBERRY, in *St. Paul's Church-Yard*; and by all other Bookfellers in *Great-Britain* and *Ireland.* Subfcriptions are likewife received by Mr. STUBBS, at his Houfe in *Somerfet-Street*, oppofite to *North-Audley-Street*, *Oxford-Road.*

This Work being the Refult of many Years actual Difections, in which the utmoft Accuracy has been obferved, the Author hopes, that the more expert Anatomifts will find it a very ufeful Book as a Guide in comparative Anatomy; and all Gentlemen who keep Horfes, will, by it, be enabled not only to judge of the Structure of the Horfe more fcientifically, but alfo to point out the Seat of Difeafes, or Blemifhes, in that noble Animal, fo as frequently to facilitate their Removal, by giving proper Inftructions to the more illiterate Practitioners of the veterinarian art into whofe Hands they may accidentally fall.

The ANATOMY of the HORSE

The First Anatomical TABLE of the Skeleton of the HORSE

Bones of the Head

aaaabcdefg THE frontal bone or bone of the forehead.

b The supra-orbital foramen which transmits the supra-orbital artery and nerve. These vessels are distributed to the skin and connective tissue of the upper eyelid and the region adjacent thereto.

c The suture between the supra-orbital process of the frontal bone and the zygomatic process of the squamous temporal bone.

de The coronal suture.

d The squamous or scale-like portion of the coronal suture.

e The serrated portion of the coronal suture which is between the frontal and parietal bones.

f A suture between the frontal and nasal bones.

g The suture between the frontal and lachrymal bones. (This suture is on the inner wall of the orbital cavity.)

hik The parietal bone.

i The squamous suture between the parietal bone and the squamous temporal bone.

k The lambdoid suture between the parietal bone and the occipital bone.

lmnoppq The occipital bone.

l The occipital crest, which is very strong in the horse. Behind and below this crest is the nuchal crest to which the ligamentum nuchæ is attached.

The suture between *m* and *n* is situated between the supra-occipital bone and the ex-occipital bone, which are portions of the complete occipital bone. In young horses this suture is not firm and the bones are easily separated. In adult life the union becomes firm and strong, and the four parts of the occipital bone are firmly united into one complete structure.

o The styloid or paramastoid process of the occipital bone.

p The occipital condyle which in life is covered by articular cartilage and articulates with the atlas.

rsstuwx The temporal bone.

r The zygomatic process of the squamous temporal bone.

t The part of the squamous temporal bone which articulates with the condyle of the mandible or lower jaw bone. This part comprises three areas: the emenentia articularis, the post glenoid cavity, the post glenoid process, from before backwards.

uw The petrous portion of the temporal bone. It is called the petrous temporal bone. In the horse the squamous and petrous portions of the temporal bone are not firmly united.

u The mastoid crest of the petrous temporal bone.

w The external auditory meatus, i.e., the entrance to the middle ear.

x The suture between the zygomatic process of the squamous temporal bone and the zygomatic process of the malar bone.

yz The orbital portion of the palatine bone.

y The suture between the palatine bone and the frontal bone.

z The suture between the palatine bone and the superior maxilla bone.

1 2 3 4 5 6 The lachrymal bone.

1 A small tubercle (the lachrymal tubercle) to which is attached the orbicular muscle of the eyelids.

2 The lachrymal fossa leading to the naso-lachrymal canal.

3 The suture between the lachrymal bone and the malar bone.

4 The suture between the nasal bone and the lachrymal bone.

5 The suture between the lachrymal bone and the frontal bone.

6 The suture between the lachrymal bone and the superior maxilla bone.

7 8 9 10 The malar bone.

8 9 The suture between the malar bone and the superior maxilla bone.

10 The suture between the lachrymal bone and the malar bone.

11 11 12 13 14 The superior maxilla or upper jawbone.

12 The infra-orbital foramen. The lower opening of the superior dental canal which extends from under the region marked *axy*, i.e., the superior dental foramen. (One of the foramina of the maxillary hiatus.)

13 The suture between the nasal bone and the superior maxilla bone.

14 The suture between superior maxilla bone and the nasal process of the premaxilla bone.

15 The premaxilla bone (nasal process).

16 The nasal bone.

17 17 17 17 18 19 19 20 The mandible, lower jawbone, or inferior maxilla.

17 17 17 17 Roughened areas for the insertion of the masseter muscle.

18 The mental foramen which transmits the mental nerves and blood vessels to the chin. The mental nerve is the termination of the inferior dental nerve, and the vessels are the terminal branches of the inferior dental artery and vein.

19 19 The coronoid process of the mandible.

20 The condyle of the mandible which articulates with the emenentia articularis, the glenoid cavity, and the post-glenoid process of the squamous temporal bone.

21 A fibro-cartilaginous disc called the meniscus which is interposed between the condyle of the mandible and the glenoid area of the squamous temporal bone.

The Vertebræ of the Neck

A Æ E abbcde The atlas or 1st cervical vertebra.

A The anterior part which articulates with the occipital condyles.

a The tubercle of the atlas.

bb The wings of the atlas.

c Slightly anterior and medial to this letter is a raised roughened area which corresponds to the spine of a typical vertebra.

d The posterior part which articulates with the axis or 2nd cervical vertebra.

e The posterior foramen of the atlas, which is situated in the wing and through which passes the retrograde branch of the occipital artery.

N.B. This vertebra like all other vertebræ is arranged in series. Posteriorly it articulates with the axis on the odontoid process of which it is pivoted. Anteriorly it articulates with the occipital bone, which bone, bearing some resemblance in form to a vertebra, is called a cranial vertebra.

E The antero-internal foramen of the atlas.

Æ The antero-external foramen of the atlas.

fghiklmn 1 2 The axis or 2nd vertebra of the neck.

f The posterior part of the body or centrum which articulates with the body of the 3rd cervical vertebra.

g The odontoid process which projects into the ring of the atlas and articulates with the floor of that bone.

h The ventral spine or inferior spinous process of the axis.

i The transverse process.

k The dorsal spine or superior spinous process.

l The posterior oblique or articular process, this process bears an articular facet within the dotted lines.

m The intervertebral foramen which gives exit to the 3rd cervical spinal nerve.

l Entrance to the vertebral foramen which pierces the root of the transverse process. The anterior aperture of this foramen is shown at 2. It gives passage to the vertebral artery.

opqrstuwxy. The 3rd cervical vertebra.

o The ventral spine, or inferior spinous process.

p The anterior end of the body or centrum, which articulates with the posterior end of the body of the 2nd cervical vertebra.

q The posterior end of the body.

r The transverse process.

s The right anterior oblique process.

t The right posterior oblique process.

u The dorsal spine or superior spinous process.

w The vertebral foramen.

x The left anterior oblique process. (Shaded area.)

y The left posterior oblique process (shaded area) seen through the intervertebral foramen. This foramen gives access to the bony spinal canal which contains the spinal cord and its membranes. Figures before mentioned with reference to the 3rd cervical vertebra may be applied likewise to the 4th, 5th, 6th, and 7th bones. It will be noted that the vertebral foramen is absent in the 7th bone, the transverse process marked *r* is a single structure and that the superior spinous process or dorsal spine is well developed and pointed. Another striking feature of the 7th cervical vertebra is its shortness in the antero-posterior direction when it is compared with the other cervical bones. In the 6th vertebra the ventral spine is small and not visible, but there is a 3rd or ventral portion of the transverse process marked *z*.

The bones of the spine from the neck onwards

1 *abcdefG* The 1st dorsal vertebra.

a The body.

b The transverse process.

c The anterior oblique process.

d The posterior oblique process.

e The superior spinous process.

f The posterior oblique process of the left side (shaded area) seen through the intervertebral foramen.

G The intervertebral disc.

2 5 6 7 8 9 10 11 12 13 14 15 16 17 18 The dorsal vertebræ behind No. 1, and to which the letters of explanation applied to No. 1, refer.

ABCDEF The six lumbar vertebræ. The explanatory letters also apply to these bones.

ggghiiiiikklllmmmm The sacrum, or great bone of the spine. It is composed of five vertebræ which in adult life are firmly united.

ggg The ventral surface of the sacrum. This surface still shows indication of the five segments.

h The transverse processes of the sacrum, which are joined together forming its lateral edge.

iiiii The five dorsal spines.

kkk The ventral sacral foramina which transmit the ventral roots of the sacral nerves.

lll The superior or dorsal sacral foramina which transmit the dorsal root of the sacral nerves.

The ventral and superior sacral foramina correspond to the intervertebral foramina of other parts of the spine.

mmmm Indicate roughened areas which represent the fused oblique processes of the five sacral vertebræ.

nopq The 1st coccygeal or tail vertebra.

n The body.

o The transverse process.

p The anterior oblique process.

q The superior spinous process.

r The intervertebral disc.

The above letters may be applied to such of those bones of the tail which retain the characteristics of what might be called a typical vertebra. It will be noted that the first few bones of the tail, i.e., up to about the 6th, retain the typical characters of the vertebræ. From this point these characters gradually disappear the terminal caudal vertebræ being simply elongated rods of bone which are somewhat constricted in their middles. These bones gradually diminish in size as they pass backwards. On an average there are 18 bones in the tail.

Bones in the Thorax and Shoulder Region

aaaaab The sternum or breast-bone.

aaaaa Represent the bony segments of this bone. The part marked *b* remains for a considerable time cartilaginous.

1 *cde* The 1st rib.

c The tubercle of the rib which articulates with the transverse process of the 1st dorsal vertebra.

d The head of the rib which articulates with facets on the bodies of the last cervical vertebra and the first dorsal vertebra. The lower end of this rib articulates with the sternum at the point *e*. These markings will serve for the description of the rest of the ribs. It will be observed that the eight anterior ribs are directly connected with the sternum. The other ribs are called the asternal ribs and their connection with the sternum is not direct. All the ribs with the exception of No. 1 possess well developed costal cartilages marked *e* on the posterior series of ribs. In the first anatomical plate the ribs of both sides of the chest are illustrated.

fg A portion of the inner side of the left scapula.

hikllmmnnopq The right scapula or shoulder blade.

h The neck.

i The spine. The letter being in the position of the tubercle of the spine.

k The corocoid process.

ll The posterior or costal edge.

mm The anterior or cervical edge.

nn The vertebral or dorsal edge, which is sometimes called the base.

o The infra-spinous fossa.

p The supra-spinous fossa.

q The cartilage of prolongation.

Bones in the Right Fore Limb

abcdefghik, Klm The humerus or bone of the arm.

b The deltoid tubercle into which is inserted the deltoid muscle. At a point a little above *b* the teres minor muscle is inserted.

cdefgh The upper extremity or head of the humerus.

cde *c* and *e* are the inner and outer tuberosities of the

upper extremity of the humerus. Between *c* and *e* is a smooth groove, this groove is divided by a central ridge marked *d*. The groove is covered in life by a smooth cartilage and gives passage to the tendon of origin of the biceps muscle. The latter tendon shows a groove on its deep face which is opposed to the ridge *d*.

h The articular head of the humerus. It is covered by articular cartilage and articulates with the glenoid fossa of the scapula.

i The external condyle of the humerus.

k The internal condyle of the humerus.

K The articular surface of its lower extremity.

l The coronoid fossa. This fossa receives the coronoid process of the radius when the cubit or elbow joint is completely flexed.

m The olecranon fossa. This fossa receives part of the olecranon process of the ulna when the elbow is extended.

nopqr The radius.

no The upper extremity.

o The bicipital tuberosity into which is inserted the tendon of the biceps muscle.

pqr The lower extremity of the bone.

p A groove which gives passage to the tendon of the extensor metacarpi magnus muscle.

q A groove which gives passage to the tendon of the extensor pedis muscle.

r A groove which gives passage to the tendon of the lateral extensor or extensor suffraginis muscle.

sttuu The ulna.

s The olecranon process.

tt The articulation for the humerus—the sigmoid cavity.

uu The attenuated lower extremity of the ulna which in aged horses becomes fused to the shaft of the radius.

wxyz 2 3 The bones of the carpus.

w The scaphoid.

x The semilunar.

y The cuneiform.

z The pisiform.

2 The os magnum.

3 The unciform.

The inner bone of the lower row, the trapezoid, is shown marked 1 on the carpus of the left fore limb.

4 5 6 7 The metacarpal bones. The large metacarpal bone marked 4 5 is often called the shank bone. This bone corresponds to the 3rd metacarpal bone of the human hand. Of the small metacarpal bones sometimes called the splint bones, that marked 6 and 7 corresponds to the 4th metacarpal of the human hand. That marked 8 and 9 corresponds to the 2nd metacarpal bone. The points marked 7 and 9 can be felt in the living animal. The numbers mark the lower extremities of the splint bones which are sometimes called the buttons.

4 The upper extremity of the large metacarpal bone, which articulates with the lower row of carpal bones.

5 The lower extremity, which articulates with the sesamoid bones and with the 1st phalanx.

10 11 Indicates two bones which are placed behind the lower extremity of the large metacarpal bone and are called the sesamoid bones. They provide posteriorly a smooth groove for the passage of the deep flexor tendon. They function as a fulcrum for this tendon.

12 13 The 1st phalanx or os suffraginis or great pastern bone.

14 15 The 2nd phalanx or os coronæ.

16 The 3rd phalanx or os pedis or the so called coffin bone.

17 A transverse elongated sesamoid bone articulating with the 2nd and 3rd phalanges which because of its likeness to a boat is called the navicular bone.

In the Left Fore Limb

cde The three protuberances of the humerus which correspond to those marked *cde* in the right limb.

op The radius.

o The bicipital tuberosity.

Below this point the numbers and markings are similar to those of the right limb, except that the trapezoid bone, i.e., the inner bone of the lower row of carpal bones is shown and indicated by the mark 1.

In the Pelvis

abcdefgghiiklll The pelvis viewed from the right side. The pelvis is sometimes called the basin bone. It is made up of two parts each of which is called the os innominatum. These two parts are joined in the ventral mid-line. Each innominate bone is made up of three bones which from before backwards are called the ilium, the pubis, and the ischium. At the point of union of these bones there is a deep cup shaped fossa—the acetabulum—with which the head of the femur articulates.

abcd The ilium.

bc The crest of the ilium.

b The antero-external angle of the ilium or tubercoxæ (the angle of the haunch).

c The internal angle of the ilium or tuber-sacrale (the angle of the croup).

d Behind this point is the site of origin of the rectus femoris muscle.

efgg The ischium, sometimes called The "H" or hich bone.

e The superior ischiatic spine.

f The tuber ischii.

gg The lower border of the small sacro-sciatic foramen is formed by this portion of the ischium. The obturator internus muscle passes over the bone at this site.

hii The os pubis.

ii The anterior edge of the pubis which forms part of the brim of the pelvis and is in direct continuity with the pubic edge of the ilium otherwise called the ilio-pectineal line.

k The obturator foramen in the floor of the pelvis.

lll Indicates the external margin of the acetabulum or cotyloid cavity.

aabccdfghiikll The left os innominatum.

The explanatory letters apply also to this part.

In the Hind Limbs

abccddefghi The right femur or thigh bone.

a The shaft or diaphysis of this bone.

bccdde The upper extremity.

b The neck.

cc The articular head which is covered by articular cartilage, and articulates with the acetabulum of the pelvis.

dd The great trochanter.

e The internal or small trochanter.

f The external or 3rd trochanter into which is inserted the superficial gluteus muscle. This tuberosity is peculiar to the equine species.

g The supra-condyloid fossa from which arises the outer head of the gastrocnemius and the superficial flexor of the digit muscles.

hi The lower extremity.

h Indicates the external condyle.

i Indicates the trochlea, a smooth pulley-like surface which is covered with articular cartilage and on which the patella glides.

klmnopppp The left femur.

l The internal or small trochanter.

m The supra-condyloid crest from which arises the internal head of the gastrocnemius muscle.

n The inner condyle.

o A portion of the outer condyle.

pppp The lower articular surface. This area is covered with smooth articular cartilage, and articulates with the tibia and the patella.

qqqrr The patellæ or knee-cap bones.

rr The posterior surface which is covered with articular

cartilage and articulates with the trochlea of the femur.

ss The inner semilunar cartilages of the stifle joint.

tt The outer semilunar cartilages of the stifle joint.

uvwxy, uvwxy The tibiæ.

u The upper extremity.

v Part of the external tuberosity which is covered with articular cartilage.

w The tibial crest which is continuous above with the anterior tuberosity. The straight ligaments of the patella are attached to the anterior tuberosity.

y The lower extremity of the right tibia.

z The lower extremity of the left tibia.

1 2 1 The fibula.

1 The upper extremity or head.

2 The lower extremity which is pointed.

3 4 5 4 5 6 The astragalus.

4 5 Its pulley-like articular surface.

7 7 8 9 The os calcis.

8 A projecting portion of the os calcis which supports the astragalus.

9 The tuber calcis into which is inserted the tendon of the gastrocnemius and over which the tendon of the superficial flexor (flexor perforatus) passes. The latter tendon is attached to this tuber by two lateral slips.

10 The cuboid bone.

11 11 The scaphoid bone.

12 12 The cuneiform magnum.

13 The cuneiform parvum. N.B. In some animals including man, three cuneiform bones are present. Occasionally three are present in the horse.

14 15 16 17 14 15 16 18 19 The metatarsal bones.

14 15 The large metatarsal bone.

16 17 18 19 The small metatarsal bones. These are imperfect bones as are the small metacarpal bones of the fore limb.

14 The upper extremity of the large metatarsal bone.

15 The lower extremity.

17 19 The buttons or lower extremities of the small metatarsal bones.

16 18 The upper extremities or heads.

Below the numbers 17 and 19 the bones of this part of the skeleton resemble in almost every way those of the fore limbs.

The Second Anatomical TABLE of the Skeleton of the HORSE

In the Head

Aaabbccddeeffgg The frontal bones.

The line of demarcation between the two is indicated by the letter *A* which sits upon the longitudinal or saggital suture of the head (frontal portion).

bb The supra-orbital foramina which each transmit a small artery and nerve of the same name.

cc The suture between the supra-orbital process of the frontal bone and the zygomatic process of the squamous temporal bone.

dd Sutures between the frontal and squamous temporal bones forming part of the coronal suture.

ee A part of the coronal suture which is formed between the frontal and parietal bones.

ff Transverse sutures between the frontal and nasal bones.

gg The suture between the frontal bone and the lachrymal bone.

hhiikkl The parietal bones.

ii The suture between the parietal and the squamous temporal bones.

kk The suture between the parietal and occipital bones, forming part of the lambdoid suture.

l That portion of the longitudinal, i.e., saggital suture, which is between the parietal bones.

mnn The occipital bone.

m The occipital crest which is marked by the letter *l* in the first table, and which is sometimes, in the horse, called the poll bone.

nn Outer portions of the lambdoid suture formed by the union of the occipital bone and temporal bones.

oooppqrr The temporal bones.

oooo The zygomatic process.

r The suture between the zygomatic process of the squamous temporal and the malar bones.

ssttuu The nasal bones.

Between *ss* is the nasal part of the longitudinal or saggital suture.

tt The sutures between the nasal and lachrymal bones.

uu The sutures between the nasal and superior maxilla bones.

wwxxyyzz The lachrymal bones.

xx The sutures between the lachrymal and malar bones.

yy The sutures between the lachrymal and superior maxilla bones.

zz A small tubercle called the lachrymal tubercle, to which is attached the orbicularis muscle of the eyelids.

1 1 2 2 3 3 The malar bones.

3 3 The sutures between the malar and the superior maxilla bones.

5 5 6 6 The superior maxilla bones.

5 5 The infra-orbital foramina which gives passage to the infra-orbital nerves. This foramen is the lower end of the superior dental canal.

6 6 That portion of the superior surface of the hard palate formed by the superior maxilla bones.

7 7 8 8 9 The premaxilla bones.

7 7 That portion of the hard palate formed by the palatine process of the premaxilla bones.

8 8 The point of junction of the nasal process and the body of the premaxilla bone.

9 The junction of the two premaxillary bones at the incisor foramen.

10 11 12 13 14 15 The upper incisor teeth.

16 16 18 18 The lower jaw or mandible.

16 16 The rami.

18 18 The coronoid process.

In the Spine

aa The wing of the atlas, or 1st cervical vertebra.

1d The transverse process of the 5th cervical vertebra.

2 *bcddefg* The 6th cervical vertebra.

b The posterior end of the body.

c The anterior end of the body.

dd The 3rd or ventral portion of the transverse process of the 6th cervical vertebra, marked *z* in the 1st table.

f The anterior articular or oblique process.

g The posterior articular or oblique process.

3 *bcdfg* The 7th cervical vertebra.

3 The body.

b The ventral spine.

c The anterior end of the body, which articulates with the posterior end of the body of the 6th cervical vertebra.

d The single transverse process.

f The anterior oblique process.

g The posterior oblique process.

hhhhikk,etc., *ll*,etc. The dorsal vertebræ.

hhhh Their bodies showing the ventral ridge or spine.

i The anterior oblique or articular process of the 1st dorsal vertebra. Those of the rest are not seen in this plate.

kk,etc. The transverse processes.

ll,etc. The superior spinous processes or dorsal spines.

lmnop The 1st lumbar vertebra.

m The anterior oblique process.

n The posterior oblique process.

o The superior spinous process.

p The transverse process.

These indicating marks apply to all the lumbar vertebræ.

qrrrr The sacrum.

q The anterior oblique process of the 1st sacral vertebra which articulates with the posterior oblique process of the last lumbar vertebra.

rrrr The superior spinous processes.

ssss The coccygeal bones.

In the Thorax and Shoulder Blades

aaaaab The sternum or breast bone.

aaaaa The body which is of bone.

b The lower end or keel which is cartilaginous.

c The ensiform or xiphoid cartilage.

1 *cde* The 1st rib.

c The tubercle which articulates with the transverse process of the 1st dorsal vertebra.

d The head of the rib which articulates with the bodies of 1st dorsal and the last cervical vertebræ.

e The lower end which articulates with the sternum by means of a small cartilage.

These indicating marks will serve for the other ribs which are serially numbered.

fghiikllmno The scapula.

f The neck, and glenoid area.

g The spine.

h The coracoid process.

ii The posterior or costal edge.

kk The anterior or cervical edge.

ll The vertebral or dorsal edge which is sometimes called the base.

m The infra-spinous fossa.

n The supra-spinous fossa.

o The cartilage of prolongation.

p The subscapular fossa of the left scapula.

In the Pelvis

abcddddeeeeff The innominate or basin bones, which are each made up of three bones, viz:

abc The ilium or flank bone.

b The external angle of the ilium (the angle of the haunch).

c The internal angle of the ilium (the angle of the croup).

dddd The ischium or "H" bone seen through the intercostal spaces.

eeee The os pubis seen through the intercostal spaces.
ff The obturator foramina seen through the intercostal spaces.

In the Fore Limbs

abcdefghiklmn, abcdehiklmn The os humeri or arm bones.
b The deltoid tubercle.
cdefgh The upper extremity or head.
ce The internal and external tuberosities.
d The central ridge of the bicipital groove. This groove is covered by articular cartilage and accommodates the tendon of origin of the biceps muscle.
h The articular head, which articulates with the glenoid fossa of the scapula.
i The external epicondyle, of the lower extremity.
kl The articular part of the lower extremity. This articulates with the upper end of the radius.
m The coronoid fossa which receives the coronoid process of the radius when the elbow is flexed.
n The internal epicondyle.
opq, opqrr The radii.
o The bicipital tuberosity for the insertion of the biceps muscle.
p A groove which gives passage to the tendon of the extensor metacarpi magnus muscle.
q A similar groove for the tendon of the extensor pedis muscle.
rr The articular surface of the lower extremity. This articulates with the upper row of carpal bones.
ss The olecranon processes of the ulnæ.
wxy, 1 2 3, 1 u, 2 u, 3 u, wt, xty The bones of the carpus or knee.
wt The scaphoid, *t* being the smooth surface for articulation with the radius.
xt The semilunar, *t* being the smooth surface for articulation with the radius.
y The cuneiform.
1 u The trapezoid, *u* being the area which articulates with the scaphoid.
2 u The os magnum, *u* being the area which articulates with the scaphoid and semilunar. This is the largest bone of the carpus.
3 u The unciform, *u* being the part which articulates with the cuneiform and semilunar bones.
The articular areas do not appear in the right carpus for that joint is shown in the extended position.
4 5 6 7 8, 4 5 6 8 9 The metacarpal, shank or cannon bones.
4 5 The large metacarpal bone. This represents the 3rd metacarpal bone of the human hand.
4 The upper extremity.
5 The lower extremity.
The upper extremity articulates with the lower row of carpal bones, and the lower extremity with the 1st phalanx and sesamoid bones.
6 7 The external small metacarpal bone. This represents the 4th metacarpal bone of the human hand.
6 The upper extremity of this bone which articulates with the unciform of the carpus.
7 The lower extremity often called the button.
8 9 The internal small metacarpal bone. This represents

the 2nd metacarpal bone of the human hand.
8 The upper extremity which articulates with the trapezoid bone of the carpus.
9 The lower extremity or button.
10 11 The sesamoid bones.
12 13 12 13 The os suffraginæ or 1st phalanges sometimes called the great pastern bones.
14 15 14 15 The os coronæ or 2nd phalanges.
16 16 The os pedis, or coffin bones, or 3rd phalanges.
17 The inner or medial extremity of the left navicular bone. It articulates with the os pedis and the os coronæ.

In the Hind Limb

abcde, aff The ossa femorum or thigh bones.
a The great trochanter.
b The internal or small trochanter.
c The external or 3rd trochanter. A process which is well marked in the horse. It gives insertion to the superficial gluteus muscle.
d The external condyle.
e The internal condyle.
ff The trochlea of the left femur. This is a smooth pulley-like surface for articulation with the patella or knee-cap.
gg The left patella.
g The right patella.
h Position of the external semilunar cartilage of the stifle joint.
iklm, im The tibiæ.
kl The upper extremity.
k The anterior tuberosity into which are inserted the three straight patellar ligaments.
l The upper part of the external tuberosity.
m The lower extremity of the tibia which articulates with the astragalus bone of the hock.
M The fibula.
nopp, nop The astragalus bones.
no The pulley-like surface which articulates with the tibia.
qr The os calcis.
r The part with which the astragalus articulates.
s The cuboid bone.
tt The scaphoid bones.
uu The cuneiform magnum bones.
w The cuneiform parvum bones.
xyz&, xyz& The metatarsal bones.
xy The large metatarsal bone, or cannon bone which is equivalent to the 3rd metatarsal bone in the human foot. It articulates at *x* with the lower row of tarsal bones.
x The upper extremity.
y The lower extremity, which articulates with the upper extremity of the 1st phalanx.
z&, z& The small metatarsal or splint bones.
These correspond to the 2nd and 4th metatarsal bones in the human subject.
1 1 The os suffraginæ or great pastern bones also called the 1st phalanges.
2 2 The os coronæ or little pastern bones or 2nd phalanges.
3 3 The os pedis or coffin bones or 3rd phalanges.
4 4 The navicular bones.

The Third Anatomical TABLE of the Skeleton of the HORSE

In the Head

AA The supra-orbital process of the frontal bone.

abbc The occipital bone.

abb That portion which is sometimes called the bone of the poll.

c The suture between the occipital and the sphenoid bones.

de The squamous temporal bone.

d The zygomatic process.

e The suture between the squamous temporal bone and the sphenoid bones.

f The external auditory meatus of the petrous temporal bone.

ghhG, G The palatine bone.

g The orbital portion. Between *g* and *A* is the fronto-palatine suture.

hh The palatine portion of the palatine bone. This portion bounds the posterior nares and forms part of the hard palate. Between *h* and *h* is the palatine portion of the median suture of the hard palate.

iikllmmnn The sphenoid bone.

ii Denotes a roughened area at the junction of the basi-occipital and the basi-sphenoid bones to which the ventral straight muscles of the head are attached.

mm The pterygoid processes.

lnln The wings of the sphenoid bone.

pq The malar bone.

Between *p* and *d* is the suture between the zygomatic processes of the malar and the squamous temporal bones.

q The facial portion of the malar bone and the malar-superior maxilla suture.

rrst, t The superior maxilla bone.

rrst The ventral aspect of the superior maxilla bone.

s The zygomatic process.

tt The hard palate. Between *t* and *t* is the superior maxillary portion of the median suture of the hard palate.

uww The premaxilla bone.

u The portion of the nasal process of the premaxilla where it joins the body of the bone.

Between *r* and *u* is a suture between the premaxilla and the superior maxilla bones at the point marked 4.

ww The palatine process of the premaxilla which helps to form the hard palate.

xy The vomer bone.

y This part bisects the posterior nares and is in direct line with the nasal septum.

1 2 2 *zz* The site of the ethmoid bone.

1 The orbital portion (cribriform plate).

2 The nasal portion (lateral masses).

z The superior or nasal turbinate bone.

&& The inferior or maxillary turbinate bone.

These structures of the ethmoid and turbinate bones are not visible but the numbers indicate their positions.

3 3 3 The upper molar teeth sometimes called grinding teeth.

4 An upper canine tooth or tusk.

5 An upper incisor tooth.

6 6 7 8 The mandible (the inferior maxilla or jaw bone).

8 The articular condyle. This part articulates with the glenoid cavity of the squamous temporal.

9 The lower row of incisor teeth.

In the Spine

abbcde The atlas or 1st cervical vertebra.

a The dorsal spine. (The spine of the atlas is very poorly developed.)

bb The transverse process or wing.

c The groove between the antero-internal and the antero-external foramina.

d The posterior foramen.

e The tubercle of the atlas.

fgghhiikl The axis or 2nd cervical vertebra.

f The superior spinous process.

gg At *gg* the superior spinous process is bifid and is continued backwards on to the posterior oblique processes which are marked *hh*.

ii The transverse processes.

k The anterior end of the body of the axis. The atlas is pivoted on this part.

l The vertebral foramen.

kllmmnnp The 3rd cervical vertebra.

k The superior spinous process.

ll The anterior oblique processes.

mm The posterior oblique processes.

nn The transverse processes.

p Indicates the position of the neural canal.

The above explanatory letters may be applied to the cervical vertebræ which are posterior to number 3, with the following additions:

o Indicates the anterior end of the body of the 5th cervical vertebra.

r Denotes the 3rd or ventral portion of the transverse process of the 6th cervical vertebra.

qq The articular facets of the anterior and posterior oblique or articular processes.

rr, etc., *ss*, etc., *tt*, etc. The dorsal vertebræ.

rr, etc. The superior spinous processes or dorsal spines.

ss, etc. The bodies.

tt, etc. The position of the intervertebral discs.

uu, etc., *wwxx*, etc., *yyzz*, etc. The lumbar vertebræ.

uu, etc. The spinous processes.

ww, etc. The bodies.

xx, etc. The transverse processes.

yy, etc. The position of the intervertebral discs.

zz, etc. The intervertebral foramina which give passage to the spinal nerves.

1 1 1 1 1, 2 2 2 2 2, 3 3 3 3 3, 4 4 4 4 4, 5 5 5 5 5 The sacrum

1 1 1 1 1 The wings which are composed of the fused transverse processes.

2 2 2 2 2 The spinous processes.

3 3 3 3 3 The ventral aspect. This aspect also shows 4 4 4 4 4 which are the ventral sacral foramina.

At the points marked 5 5 5 5 5 there are transverse lines or marks which pass between opposite foramina. These marks indicate the line of fusion of the individual segments or vertebræ which together comprise the sacrum.

6 6, etc., 7 7, etc., 8 8, etc., 9 9, etc. The coccygeal or tail vertebræ.

6 6, etc. The transverse processes.

7 7, etc. The spinous processes.

8 8, etc. The bodies.

9 9, etc. The intervertebral discs.

In the Thorax and Shoulder Blades

aa The sternum.

b The ensiform or xiphoid cartilage.

cc, etc., *dd*, etc., *ee*, etc., *ff*, etc., *gg*, etc. The ribs.

cc, etc. The heads of the ribs by which they articulate with the vertebræ.

dd, etc. The costal cartilages. The first eight of these articulate with the sternum.

ee, etc. The external surface of the ribs.

ff, etc. The internal surface of the ribs.

gg, etc. The asternal cartilages. There are ten of these on each side.

hiikl The right scapula.

h The spine.

ii The vertebral edge.

k The cartilage of prolongation.

l The infra-spinous fossa.
mmno The inner aspect of the left scapula.
n The coracoid process of the left scapula.
o A portion of the neck of the left scapula.

In the Pelvis

abcdefgghhhhii, abcfghh The pelvis or innominate bone of the right side.
abcd The ilium.
bc The crest.
d A rough pit from which the outer tendon of origin of the rectus femoris muscle arises.
ef The ischium or "H" bone.
e The superior ischiatic spine.
f The tuber ischii.
gg The os pubis.
hhhh The obturator foramen.
ii The rim of the acetabulum (outer part).

In the Fore Limbs

abcd, A The os humeri.
a The external tuberosity.
b The articular head.
c The deltoid tuberosity. Just above this is the point of insertion of the teres minor muscle.
d The external condyle.
A The internal tuberosity of the left humerus.
efggg The ulnæ.
e The olecranon process.
f The part of the olecranon process which articulates with the humerus.
gg The lower narrow part which fuses to the radius in old horses.
hiklmnop, klmnop The radii.
hi The upper extremity.
klmno The lower extremity.
k A groove for the passage of the tendon of the lateral extensor, i.e., extensor suffraginis muscle.
m Area for articulation with the scaphoid bone of the carpus.
n Area for articulation with the pisiform bone of the carpus.
o A depression and a ridge to which is attached the posterior carpal ligament.
Ppqrstuwxyz, Ppqrstuwxyz The bones of the carpus.
P The pisiform.
pq The scaphoid, *p* being the area for articulation with the radius.
r The semilunar.
s The cuneiform.
tu The trapezoid, *t* being the area for articulation with the scaphoid.
yz The unciform, *y* being the area for articulation with the cuneiform.
1 2 3 4 5 6 7, 1 2 3 4 5 6 7 The metacarpal bones.
1 2 2 3 The large metacarpal, which represents the 3rd metacarpal of the human hand.
1 The upper extremity which articulates with the lower row of carpal bones.
2 2 3 The lower extremity which articulates with the sesamoids and the 1st phalanx.
4 5 The inner small metacarpal or splint bone.
4 The head which articulates with the trapezoid.

5 The lower extremity or button.
6 7 Refer to similar parts of the external small metacarpal bone. Its head 6 articulates with the unciform.
8 9, 8 9 The sesamoid bones; two in number they provide a groove for the passage of the perforans or deep flexor tendon, and act as a fulcrum for that tendon.
10 10 The 1st phalanges or great pastern bones.
11 11 The 2nd phalanges or lesser pastern bones.
12 12 The 3rd phalanges or coffin bones.
13 13 The navicular bones which are situated at the back of the coffin joint.

In the Hind Limbs

abcddefghik, acddefghik The thigh bones or ossa femorum.
b The articular head which articulates with the acetabulum.
c The internal or small trochanter.
dd The great trochanter.
e The 3rd trochanter into which the superficial gluteus muscle is inserted.
f The supra-condyloid fossa from which arises the tendon of origin of the superficial flexor or perforatus and the outer head of the gastrocnemius muscle.
g The supra-condyloid crest from which arises the inner head of the gastrocnemius muscle.
h The external condyle.
i The internal condyle.
Both of these are covered by articular cartilage.
ll The patellæ.
mm The external semilunar cartilages of the stifle joint.
nn The internal semilunar cartilages of the stifle joint.
opqr, opqr The tibiæ.
op The upper extremity.
r The lower extremity.
st, st The fibulæ.
s The upper extremity or head.
t The pointed lower extremity.
uwxxys& 1, uwxxyz& 1 The bones of the tarsus.
uw, uw The os calcanei.
xx, xx The astragali.
yy The cuboids.
zz The scaphoids.
&& The large or external cuneiforms.
1 1 The cuneiform parvums.
2 3 4 5 6 7, 2 3 4 5 6 7 The metatarsal bones.
2 3 The large metatarsal.
2 The upper extremity which articulates with the lower row of tarsal bones.
3 The lower extremity which articulates with the 1st phalanx.
4 5 The internal small metatarsal bone.
4 The upper extremity or head, which articulates with the cuneiform parvum bone.
5 The lower extremity or button.
6 7 The external small metatarsal bone.
6 The upper extremity or head which articulates with the cuboid bone.
7 The lower extremity or button.
8 9, 8 9 The sesamoid bones.
10 10 11 11 12 12 The phalanges.
13 13 The navicular bones.
These have similar alternative names to those of the fore limb.

The ANATOMY of the HORSE

The First Anatomical TABLE of the Muscles, Fascias, Ligaments, Nerves, Arteries, Veins, Glands and Cartilages of the HORSE

In the Head

AAa The frontalis; a portion of the panniculus carnosus muscle.

AA The tendinous sheath of same which goes to the levator labii superioris et alaeque nasi muscle.

a The muscular part which is related to the orbicular muscle of the eyelid and is attached to the skin.

bcde The orbicularis occuli muscle.

e The origin of the muscle from the lachrymal tubercle near the inner canthus.

fg The corugator muscle of the upper eyelid. It is inserted into the skin.

hikllmno The levator labii superioris et alaeque nasi muscle.

ik The origin.

ll The part which passes under the dilator naris lateralis muscle.

m The part which passes over the dilator naris lateralis muscle and is inserted into the upper lip.

n The point where it divides to give passage to the dilator naris lateralis muscle.

o The origin near the inner canthus of the eye.

pq The dilator naris lateralis muscle.

rstuwx The zygomaticus muscle.

t The insertion into the orbicularis muscle of the mouth near to the commissure of the lips.

wx The origin from the surface of the masseter muscle near to the zygomatic ridge. By means of the deep fascia it is attached to the orbicularis occuli muscle at its origin. Its action is to raise the commissure of the mouth. It is a relatively thin muscle.

zz and *BC* The orbicular muscle of the mouth, i.e., orbicularis oris.

B Where its fibres intermingle with the other muscles of the upper lip.

C Fibres which pass to the lower lip and mingle with those of the levator menti.

1 2 The depressor labii inferioris muscle.

3 4 Part of the panniculus muscle which is attached by fascia to the mandible at the point marked 4.

5 The levator menti muscle. The fibres of this muscle intermingle with those of the orbicularis oris muscle. In this region there is also some adipose tissue.

6 The dilator naris superioris muscle.

7 The tendon of insertion of the levator labii superioris muscle.

8 The nasal septum.

9 The facial or submaxillary vein. This is a tributary of the jugular vein near the figure 9. It has one branch from the eye region, i.e., the angular vein of the eye, and others from the nasal, facial and labial regions.

10 The transverse facial vein.

11 The facial or submaxillary artery.

12 Branches of the facial or 7th cranial nerve. They are divided into superior and inferior labial groups. The superior group is accompanied by a branch of the mandibular division of the 5th cranial nerve.

Muscles of the Outer Ear

abb The cervico-auricularis muscle. Also called retrahentes aurem.

cdee The parieto-auricularis muscle.

k The scutiform cartilage.

gi The scuto-auricularis externus muscle.

l the zygomatico-auricularis muscle.

m The mastoido-auricularis muscle.

no The parotido-auricularis muscle.

p The conchal cartilage of the external ear.

In the Neck

3 4 *aabcdd* The panniculus or cutaneous muscle of the neck.

b The origin from the sternum.

4 The attachment to the mandible.

c The sheet-like part which covers the jugular vein.

dd Where it is attached to the fascia of the cervical portion of the trapezius.

fghiiklmn The mastoido-humeralis muscle.

g The mastoid origin.

h The origin from the trapezius or cervical fascia and from the occipital bone.

l The deep portion which arises from the transverse processes of the first four cervical vertebræ and is partly covered by the part *fghiik*.

m The lower end which is inserted into the humerus, between the biceps and the brachialis anticus muscles (at the lip of the musculo-spiral groove).

6 A branch of the 6th cervical nerve, seen emerging between the two divisions of the mastoido-humeralis muscle.

opqqrrstuwxxx The cervical part of the trapezius muscle.

op The origin of the muscular part.

p The thickest part of the muscle.

qq Here the muscle is thin but still fleshy. The fascia covering this part forms part of the cervical fascia and it is adherent to the fascia of the mastoido-humeralis muscle. There are two layers of fascia in this site, one superficial, and one deep to the mastoido-humeralis muscle.

rr At this site the muscle has a thin covering of the panniculus muscle.

s This is the lower part of the tendon of origin.

t The levator anguli scapulæ is under this part.

u A tendon of origin in common with the mastoido-humeralis muscle.

xxx The origin of the trapezius muscle from the funicular part of the ligamentum nuchæ.

The muscle fibres of the cervical trapezius run in the same direction as do those of the mastoido-humeralis. They are inserted into the fascia covering the outer aspect of the scapula, the mastoido-humeralis, the infraspinatus, and the triceps muscles.

yyz& The dorsal part of the trapezius muscle.
yy The origin.
& The insertion.

Between *z* and *y* it is attached to the latissimus dorsi muscle by loose connective tissue. These fibres are fairly adherent to both muscles and pass downwards and backwards.
cddv The jugular furrow and jugular vein.

Ramifying in the lateral aspect of the neck are branches of the cervical nerves, arteries and veins.

In the Shoulder and Trunk

abcddeefgghiiiikllmnooooooooppqrs The panniculus carnosus.
a The thickest, fleshy part.
b The part running on to the extensors of the elbow, i.e., triceps extensor cubiti. It becomes tendinous at *c* and this tendon is inserted on to the internal tubercle of the humerus with the tendons of the teres major and latissimus dorsi muscles.
dd Some of the panniculus which passes over the triceps muscles and is directed towards the elbow. It becomes membranous at *q* under which may be seen some branches of the nerves and vessels which are distributed in the muscular panniculus.
ee The posterior origin of the panniculus. It is thin at its origin but it gradually increases in thickness as it passes towards *a*.
f A muscular part which passes towards the thigh. At *gg* it is muscular but thin.
h Where it is reflected on to the prepuce.
iiii The tendinous part which merges into the lumbo-dorsal fascia.
k The part which helps to form the fold of the flank.
ll Indicates the lower border of the latissimus dorsi muscle.
m The panniculus at this part is as thick as the latissimus dorsi and its covering of panniculus.
ooooooo The thin aponeurotic, tendinous, or membranous origin of the panniculus. The fibres all converge towards the elbow at *q* and *pp*. The muscle takes the form of a fascial sheet spreading over the shoulder muscles and over the elbow. The sheet is attached to the deeper muscles and the deeper fascia.
ttuwxyy The pectoral muscles.
ttuw The posterior deep pectoral muscle.
tt The origin from the aponeurosis of the external oblique muscle of the abdomen. This muscle is inserted into the internal tuberosity of the humerus.
x The part which arises from the ventral part of the sternum. (The author evidently means this to indicate the posterior superficial pectoral muscle.)
yy The anterior superficial pectoral muscle. It is inserted into the ridge below the deltoid tubercle of the humerus. It is related to the mastoido-humeralis muscle and in the groove between these two muscles may be seen the cephalic vein. The insertion of the anterior superficial pectoral is situated between the biceps brachii and the origin of the brachialis anticus muscles.
z The spur vein (the subcutaneous thoracic vein).

The blood vessels and nerves marked in the thorax arise from the intercostal and lumbar vessels and nerves.
& The tail.

Muscles, etc., in the Fore Limb as they Appear under the Panniculus carnosus muscle

abb Extensor carpi radialis muscle (extensor metacarpi magnus).
a The belly of the muscle.
b The tendon, the lower part of which runs under the muscle *cc*, i.e., the extensor metacarpi obliquus and under the fibrous sheath of the extensors at the carpus.
deefgh The extensor pedis muscle (extensor communis digitorum).

d The muscular belly.
fg The tendon after passing over the carpus.
f A slip to the lateral extensor (Phillip's muscle).
h The insertion at the pyramidal process of the os pedis.
m A slip from the suspensory ligament which joins the extensor pedis tendon.
iii The lateral extensor (extensor suffraginis muscle).

This muscle has a small fleshy belly which lies to the external side of that of the extensor pedis in the forearm. Its tendon passes through a vertical groove on the outer aspect of the lower extremity of the radius. It is inserted into the 1st phalanx.

At the point *f* can be seen two tendinous bands which it receives as follows: The anterior from the tendon of the extensor pedis, and the posterior from the fascia over the outer aspect of the carpus.
n The lower extremity of the external small metacarpal or external splint bone. This part is called the button and it is easily felt in the live animal.
o The fibro fatty pad behind the fetlock which supports the ergot.
pq The flexor carpi ulnaris muscle (flexor metacarpi externus).
p The fleshy belly.
q The tendon expands here and is inserted into the pisiform bone and the head of the external small metacarpal bone.
Rr The deep flexor (perforans) of the digit.
R A portion of the fleshy belly.
r The tendon.
S The tendon of the superficial flexor (perforatus) of the digit.
T, tt The fascial sheath covering the carpus.
u Marks a band of fascia which arises from the pisiform and runs obliquely downwards and forwards to the metacarpus.
WW Ligamentous fibres, part of the deep fascia which helps to form the fibrous sheaths of the flexor tendons.
xx The external plantar or metatarsal vein.
y The external plantar nerve.
z A branch of the internal plantar nerve, which joins the external plantar nerve.

The aponeurotic tendons of the panniculus and the posterior superficial muscles (pectoral) are joined with or inserted into the deep fascia of the forearm. This deep fascia covers the muscles of the forearm and sends septa between the muscles. The latter is attached to the radius and ulna. This fascia confines the muscles to their proper place.
& The hoof.

In the Hind Limb

abcdefghikKlmnopqrstuwxyz& The fascia of the hind limb which consists of the gluteal fascia, the tensor fascia lata, and the tensor vaginæ femoris. Over part of it there is a portion of the panniculus.
a The gluteal fascia which is continuous with the lumbo-dorsal fascia.
b The origin of the tensor vaginæ femoris muscle from the external angle of the ilium.
cd The fleshy part of the tensor vaginæ femoris muscle.
e The tendinous part of the tensor vaginæ femoris muscle.
f The superficial gluteus muscle lies under this part of the gluteal fascia.
ghi The biceps femoris muscle. This muscle arises in part from the fascia lata and is here completely covered by this fascia.
k The semitendinosus muscle, which is covered by the fascia lata.
K The patella. It is covered by a fascial sheath and its ligaments can be identified through this fascia.
l The belly of the extensor pedis muscle.
m The peroneus longus muscle or lateral extensor.
n The deep flexor (perforans) of the digit.

o The outer head of the gastrocnemius muscle.
p The tendo achillis. This is covered by a sheath of fascia.
q Branches of the external saphena nerve.
r The fascial covering of the hock.
s The tendon of the extensor pedis muscle.
t The flexor tendons.
u The suspensory ligament.
ww The digital veins.
x The external plantar nerve.
y The anterior slip of the suspensory ligament which passes to the tendon of the extensor pedis.
z The lateral aspect of the fetlock joint.
& The fibro fatty pad behind the fetlock which supports the ergot.

The fascia of the hind limb forms a kind of sheath to the muscles, nerves, etc.

A The hoof.
I The pedal venous plexus.

Muscles which are Prominent in the Left Fore Limb

ab The extensor metacarpi magnus.
c The extensor metacarpi obliquus.
d The biceps brachii.
e The posterior superficial pectoral.
f The deep flexor (perforans) of the digit.
g The internal flexor of the metacarpus (flexor metacarpi internus).
h The tendon of the superficial flexor (perforatus) of the digit.
j The tendon of the deep flexor (perforans) of the digit.
k The tendon of the extensor pedis.

l The fibro fatty pad behind the fetlock which supports the ergot.
m The internal subcutaneous vein of the forearm.
n The internal digital vein.
o The internal plantar nerve.
p The suspensory ligament.
q The slip of the suspensory ligament to the tendon of the extensor pedis.
r The hoof.

Prominent Muscles, etc., of the Left Hind Limb

a The belly of the flexor metatarsi.
b The sartorius.
c The tendon of the extensor pedis.
d The slip of the suspensory ligament to the tendon of the extensor pedis.
e The suspensory ligament.
ff The tendon of the superficial flexor (perforatus) of the digit.
fgh A fascial expansion which goes to the os calcis. A portion of this fascia goes to the front of the hock at k.
l The fibro fatty pad behind the fetlock which supports the ergot.
m The internal saphena vein.
n Tributaries of the internal saphena vein.
o The internal digital vein.
p The internal plantar nerve.
q The internal saphena nerve. A branch of the anterior crural nerve.
r The hoof.

The Second Anatomical TABLE of the Muscles, Fascias, Ligaments, Nerves, Arteries, Veins, Glands and Cartilages of the HORSE

In the Head

abcd The dilator naris lateralis muscle.
bc The insertion into the upper lip and wing of nostril.
d The origin.
f The dilator naris transversalis muscle.
ghik The orbicularis oris muscle.
g The part belonging to the lower lip.
h The commissure or angle of the mouth.
i The part belonging to the upper lip.
k Fibres which are directed towards the nostril.
lmno Levator labii superioris proprius muscle.
m The origin.
lmn The fleshy belly.
o The insertion.
o–n The tendon.
ppq The masseter muscle.
r 8 8 The buccinator muscle.
St The palpebral ligaments which are attached to the periosteum of the orbital rim.
uu Site of origin of the occular muscles.
w Site of the inner canthus of the eye.
xy The upper part of the levator labii superioris et alæque nasi muscle.
y The origin.
x Near its insertion into the cartilage of the nostril.
z Part of the nasal cartilage, i.e., alæ naris.
& The nasal septum.
2 2 3 The temporal muscle.
3 The insertion into the coronoid process of the mandible.
4 4 Part of the dilator naris superioris muscle.
5 The nasal mucous membrane; i.e., that which lies in the nasal septum and is called the pituitary or schneiderian membrane.
6 7 7 The superficial fibres of the buccinator muscle.
9 10 The depressor labii inferioris muscle. It arises near the posterior end of the buccinator.
12 The levator menti muscle.
13 A nasal branch of the superior maxillary division of the 5th cranial nerve.
14 The facial or submaxillary vein. A branch of the jugular vein.
15 The facial or submaxillary artery.
16 The transverse facial vein.
17 17 Two valves in the maxillo-muscular vein.
18 The facial nerve; i.e., 7th cranial, with which is incorporated a branch of the 5th cranial nerve.
19 The duct of the parotid gland; i.e., Stenson's duct.
20 The scutiform cartilage of the ear.
22 23 The scuto-auricularis externus muscle.
24 A portion of the scuto-auricularis internus muscle.
25 A portion of the cervico-auricularis muscle.
26 26 26 *c* The parotid gland.

In the Neck

abc The sterno-maxillaris muscle. It arises from the sternum at *b* and is inserted into the mandible by means of a flat tendon at *c* under cover of the parotid gland.
d The fibro fatty tissue over the ligamentum nuchæ (the integument of the mane).
e Part of the ligamentum nuchæ.
ff The Omo or subscapulo-hyoideus muscle. It arises from the subscapular fascia and is inserted into the hyoid bone.
g The hyoid portion of the sterno-thyro-hyoid muscle.
hi The semispinalis colli muscles.
kl The tendon of insertion of the trachelo-mastoideus muscle.
mn Rectus capitis ventralis major (anticus) muscle.

m The lowest point of origin; i.e., the 4th cervical vertebra.
p Part of the longus colli muscle which extends from the level of the 6th dorsal vertebra to the tubercle of the atlas.
oooo Part of the intertransversalis colli muscles.
pq The longus colli muscle.
rstuw The splenius muscle.
u The insertion into the occiput.
stw The fleshy part.
r The posterior part.
 It is inserted into the transverse processes of the 2nd to 5th cervical vertebræ, the occiput, and the wing of the atlas, and arises partly from the ligamentum nuchæ and the 2nd, 3rd and 4th dorsal spines.
x The thyroid part of the sterno-thyro-hyoid muscle.
y The thyro-hyoid muscle.
z The crico-thyroid muscle.
& One of the constrictor muscles of the pharynx.
1 1 The jugular vein.
2 The facial or submaxillary vein.
3 The internal maxillary vein.
4 The cervical carotid artery.
5 The pre-scapular lymphatic gland.
6 6 6 6 Branches of the ventral divisions of the cervical nerves and cutaneous arteries.
7 7 Branches of the superior cervical and the dorsal arteries passing to the trapezius, the skin, and subcutaneous tissues.

Muscles in the Neck and Trunk which are Inserted into the Scapula

aab The rhomboideus muscle.
aa The origin of the cervical portion from the ligamentum nuchæ. The dorsal portion arises from the dorsal supraspinous ligament.
b The insertion into the dorsal border of the scapula.
cdef The anterior deep pectoral muscle. This muscle is situated in front of the scapula and extends from the cervical angle to the sternum. It is related to the prescapular glands. It partly overlaps the supra spinatus muscle.
ghiklop The levator anguli scapulæ or the anterior part of the serratus magnus muscle. It extends between the inner or deep surface of the scapula near the cervical angle, and the transverse processes of the last four cervical vertebræ. The posterior part of the serratus magnus muscle originates from the outer aspect of the first 8–9 ribs.

Muscles Inserted into the Humerus and Elbow

1 1 2 3 4 5 5 6 The pectoral muscles.
1 1 2 The posterior deep pectoral muscle.
3 4 The anterior superficial pectoral muscle.
5 5 6 The posterior superficial pectoral muscle.
abcdef The supraspinatus muscle. The origin from the scapula is between *abde,* and at *c* it is inserted into the external tuberosity of the humerus. It is covered by a strong fascial sheath which is continued on to the infra spinatus and deltoid muscles. At *f* it is joined to the anterior deep pectoral muscle.
hiklmn The infraspinatus muscle. Between *h* and *i* are marks which indicate the position of the dorsal portion of the trapezius.
ikm Roughly marks the posterior border of the muscle and where it is in contact with the teres major. Near *n* it is inserted into the external tuberosity of the humerus.
opqq The deltoid muscle.
o The origin from the dorsal angle of the scapula.
qq The insertion into the humerus at the deltoid tubercle. It is partly covered by the fascia of this region.

rrsttuw The latissimus dorsi muscle. It extends from the region of the loin, i.e., *rrs* and its fleshy part forms a somewhat fan-shaped flattened sheet. It is inserted into the internal tuberosity of the humerus along with the teres major.

tt Shows the direction of its fibres.

rru Area of the dorsal portion of the trapezius muscle which is connected with the fascia of the latissimus dorsi muscle.

In the Trunk

IIIIIKKLM The external oblique muscle of the abdomen.

IIIII This is the thickest part of its fleshy sheet.

KK Here its tendon begins.

L Is the site of the linea alba, a strong tendon which extends from the chest to the os pubis.

Between *KKK* and *L* the tendon of this muscle helps to form what is called the abdominal tunic, i.e., a strong yellow elastic aponeurosis for the support of the abdominal viscera. The muscle arises from the last fourteen ribs. At its origin it interdigitates with the serratus magnus. It is inserted into the linea alba, the external angle of the ilium and into the prepubic tendon. Penetrating this muscle in regular series are branches of the intercostal and lumbar nerves and vessels.

In the Right Fore Limb

NOP The triceps brachii muscle.

PN The long head.

O The middle or external head.

The long head arises from the scapula.

QRS The biceps brachii muscle, sometimes called the coraco radialis.

aAbcdeegh The fascia of the forearm.

This fascia encloses the muscles of the forearm as in a sheath and it sends in septa which passing between the muscles are attached to the bones, i.e. radius and ulna.

d The muscular belly of the extensor metacarpi magnus muscle.

ee Its tendon.

bc The extensor pedis muscle.

g The extensor metacarpi obliquus muscle.

f The tendon of the extensor metacarpi magnus muscle which is inserted into the metacarpal tuberosity at the upper extremity of the large metacarpal bone.

i The tendon of the extensor pedis at its insertion into the pyramidal process of the os pedis.

mnooPpqrst The deep fascia of the posterior part of the forearm. This is continuous with that on the anterior aspect. It forms sheaths for the flexor muscles, and is attached to the bones by fibrous septa.

m The extensor suffraginis muscle or the extensor lateralis. The deep fascia is attached to the underlying muscles and to the deep fascial coverings of the carpus. It is also attached to part of the pisiform bone which is indicated by the prominence at *z*.

r The external flexor of the metacarpus (flexor metacarpi externus).

ss Its tendon of insertion.

From *z* a band of fascia passes forwards and downwards to join the tendon of the extensor suffraginis at *m*.

LLP, puwxyyz The common fascial covering of the carpus. It serves to bind the flexor and extensor tendons into place. At 16 this is adherent to the anterior common ligament.

xw Position of the upper and lower limits of the anterior common ligament.

ch The tendon of the extensor pedis muscle. At this place it is in a groove on the radius and is retained in position by a strong fascial covering which is attached to the lips of the groove.

Pzw Part of the external lateral ligament of the carpus.

1 2 The lateral ligament of the pisiform bone which helps to control the action of the flexor metacarpi externus muscle.

3 A part of the flexor tendon aponeurosis.

4 The tendon of the deep flexor (perforans) of the digit.

5 The tendon of the superficial flexor (perforatus) of the digit.

6 The external digital vein.

7 The external plantar nerve.

9 Site of the external lateral ligament of the fetlock.

10 The anterior division of the suspensory ligament.

11 12 The hoof.

11 The wall of the hoof at the toe.

12 The junction of the wall and the sole of the foot.

13 The sensitive laminæ. These are dovetailed into the horny laminæ. The sensitive laminæ are attached to the periosteum of the coffin bone or os pedis. The horny laminæ are in the inner aspect of the wall of the hoof.

In the Right Hind Limb

abccdddDefgghikl The tensor vaginæ femoris muscle and its attached fibrous aponeurosis.

a The origin from the external angle of the ilium.

b The fleshy belly.

D The posterior portion.

The fascia of the muscle is continuous with the gluteal fascia above. This muscle is thickest in its anterior part, it thins towards the origin and in the lower part as it passes on to the patella.

de Marks the line where the fascia lata meets the gluteal fascia.

ef Marks the posterior limit of the fascia lata where it meets the biceps femoris muscle.

h At *h* the rectus femoris muscle appears from under the tensor fascia lata (vaginæ femoris portion).

ik The external straight patellar ligament. This passes between the patella and the anterior tuberosity of the tibia.

l The point of the attachment of the external lateral patellar ligament which passes between the patella and the external condyle of the femur.

mnoop The superficial gluteus muscle.

m The origin from the gluteal fascia.

Qa The origin from the external angle of the ilium.

p The insertion into the 3rd or external trochanter of the femur. This is a relatively thin muscle. It is V-shaped and covered by gluteal fascia to which it is adherent.

qQrst The middle gluteus muscle.

qrs The origin from the crest of the ilium and the lumbo-dorsal fascia. It is covered by part of the gluteal fascia.

t At *t* it passes under the superficial gluteus muscle to be inserted into the great trochanter of the femur.

ikluuwwxyz The biceps femoris muscle.

uuww The anterior part of its muscular belly.

Its origin is from the sacral spines, the sacro-sciatic ligament, the gluteal and coccygeal fascia, and the tuber ischii. It is inserted into the posterior surface of the femur, the patella and its external straight ligament, the crest of the tibia, the fascia lata, and the os calcis. Its insertions are marked: 5 4 *k i* 7 7 3. In its upper part it can be divided into two parts which are named the anterior and posterior heads.

15 The tendon of the superficial flexor (perforatus) of the digit.

16 17 17 18 19 The semitendinosus muscle.

16 Marks its origin from the sacral spine and adjacent part of the sacro-sciatic ligament.

16 17 17 This part is covered by fascia which is continuous with the gluteal fascia.

17 18 At this point it has an origin from the tuber ischii.

19 It is inserted here into the fascia of the gastrocnemius muscle, but its principal insertion is on the medial side of tibial crest.

22 A portion of the semimembranosus muscle showing at the region of the tuber ischii.

24 25 25 26 27 30 31 33 34 The fascial covering of the hock joint, which also serves to keep the tendons of the leg muscles in position.

24 25 25 This portion is called the anterior annular ligament. This fascia is continuous with the deep fascia of the tibial and metatarsal regions.

26 At this point the tendons of the flexor metatarsi and the extensor pedis can be seen through the deep fascia.

30 At this point the fascial fibres are directed downwards towards the metatarsal bones.

34 Marks the prominence of the cuboid bone.

35 The fascial sheath of the flexor tendons.

36 36 The tendon of the extensor pedis muscle.

37 37 The tendon of the peroneus longus muscle which joins that of the extensor pedis just below the hock near the figure 36.

38 Position of the flexor perforans tendon, or deep flexor of the digit.

39 The great metatarsal artery.

40 The superficial flexor (perforatus) of the digit.

41 The deep flexor (perforans) of the digit.

42 The external metatarsal vein.

43 The external plantar nerve.

44 The suspensory ligament.

45 The anterior slip or division of the suspensory ligament.

46 The external digital vein.

47 48 The wall of the hoof.

49 The sensitive laminæ which are attached to the periosteum of the os pedis.

y The fascial sheath of the flexor tendons.

z The tendinous part of the flexor metatarsi muscle, i.e., the peroneus tertius.

2 3 3 The superior anterior annular ligament.

4 The inferior anterior annular ligament.

6 6 7 Part of the ligamentous covering of the hock. It provides a passage for the small tendon of the flexor accessorius which is part of the deep flexor tendon.

8 9 9 Site of the internal lateral ligament of the hock joint.

10 11 Site of the ligament binding the flexor tendons at the hock.

12 12 12 Site of the fascia between the divisions of the flexor metatarsi.

13 The middle anterior annular ligament of the hock.

14 15 16 17 The tendon of the extensor pedis muscle.

14 The insertion into the pyramidal process of the os pedis.

16 Here it receives the antero-internal slip of the suspensory ligament.

18 The suspensory ligament.

19 The anterior slip or division of the suspensory ligament.

20 Site of the antero-lateral ligament of the coffin joint.

21 The internal metatarsal vein which becomes the internal saphena vein above the hock.

22 The posterior tibial nerve.

23 The internal plantar nerve.

24 The internal digital vein.

25 26 The horny wall of the hoof.

27 The sensitive laminæ.

The Internal Side of the Left Hind Limb

a The tendon of the rectus femoris muscle.

b The vastus internus muscle.

cd The sartorius muscle.

eef The gracilis muscle.

ghkl The semitendinosus muscle.

g The fleshy part.

kl The tendon which is inserted into the crest of the tibia at "k".

mmm The inner head of the gastrocnemius muscle.

n The fascial sheath of the tendo-achillis.

opqrs The tendo achillis is formed by the tendons of the superficial flexor and the gastrocnemii muscles and by the fascial extensions of the neighbouring muscles.

tuuwx The tendon of the superficial flexor which twists over the gastrocnemius tendon. At *uw* it is expanded where it passes over the tuber calcis, to which it is attached by means of a slip on either side.

In the Left Fore Limb

c The lower end of the biceps muscle.

defgg The deep fascia of the forearm.

h The tendon of the extensor metacarpi obliquus muscle.

iiklm The fascia in the front of the carpus which covers the anterior common ligament of the carpus.

no A sheet of fascia which passes from the pisiform to the metacarpus internally.

p The fascial sheath of the flexor tendons.

q The deep flexor tendon (perforans) of the digit.

r The superficial flexor tendon (perforatus) of the digit.

s The internal digital vein.

t The internal plantar nerve.

wx The tendon of the extensor pedis.

z The suspensory ligament.

y The anterior slip of the suspensory ligament.

1 2 The horny part of the hoof at the toe region.

3 The sensitive laminæ.

The Third Anatomical TABLE of the Muscles, Fascias, Ligaments, Nerves, Arteries, Veins, Glands, and Cartilages of the HORSE

In the Head

ab The levator palpebral superioris muscle.
c The lachrymal gland.
d The ventral eyelid.
ee The palpebral ligament.
f The anterior nares.
ghii The dilator naris lateralis muscle.
k The nasal septum.
mmn The superficial part of the buccinator muscle.
oo The orbicularis oris muscle.
pqr The depressor labii inferioris muscle.
ss The deep part of the buccinator muscle.
t The dilator naris superioris muscle.
u The levator menti muscle.
w The masseter muscle.
1 The jugular vein.
3 The transverse facial vein.
4 The facial or submaxillary vein.
5 The facial or submaxillary artery.
6 7 8 The infra-orbital nerve.
9 The facial nerve, with which are incorporated branches of the fifth cranial nerve.
10 The glandular part of the upper lip near the nostril.
11 The parotid duct, i.e., Stenson's duct.
12 The scutiform cartilage of the ear.
13 The conchal cartilage of the external ear.

In the Neck

abcde The subscapulo-hyoideus muscle.
fg The sterno-thyro-hyoideus muscle, sterno-hyoideus part.
hik Sterno-thyroideus muscle. This is the outer part of the sterno-thyro-hyoideus muscle.
l Part of the cervical carotid artery.
m Upper part of the cervical carotid artery.
n The thyroid gland.
oooo The superior cervical lymphatic glands.
q Part of the muscular wall of the pharynx.
r The thyro-hyoid muscle.
s The crico-thyroid muscle.
t The crico-arytenoideus-posticus muscle.
u The posterior end of the submaxillary gland.
wxy The rectus capitis ventralis (anticus) major muscle, which extends from the 5th cervical vertebra to the body of the post-sphenoid bone.
ABCDEFGH The semispinalis colli and intertransversalis group of muscles.
IKL The trachelo-mastoideus muscle.
I The tendon which is inserted into the wing of the atlas and the mastoid crest. This muscle arises near *L* from the transverse processes of the 1st and 2nd dorsal vertebræ. In the neck it arises from the articular processes of the last six vertebræ.
MOOPPQST The complexus muscle. At the region *Q* it arises from the 2nd, 3rd and 4th dorsal spines and the first six dorsal transverse processes. In the neck it is attached to the last six articular processes. It is inserted at *s* into the occipital bone.
UU The inferior oblique muscle of the head. Origin: the spine of the axis. Insertion: wing of the atlas.
WW The superior oblique muscle of the head. Origin: the wing of the atlas. Insertion: the occipital bone, styloid process, and mastoid crest.
XY The longus colli muscle. Origin: bodies of the first six dorsal vertebræ, the bodies and transverse processes of the last six cervical vertebræ. Insertion: the tubercle of the atlas.

1 2, 1 2, 1 2 Branches of the superior cervical, vertebral, and occipital arteries and veins.
3 The cut lower end of the jugular vein.

Muscles on the Shoulder

ab A small portion of the subscapularis muscle showing from the inner aspect of the scapula.
cdeefgh The triceps extensor cubiti, i.e., the triceps muscle.
cdee The long head arising at *ede* from the dorsal border of the scapula.
fh The external head.
iiklmn The biceps brachii muscle.
ik The tendon of origin.
l The belly.
n The insertion into the bicipital tuberosity of the radius.
o The suprascapular nerve.
p The musculo-spiral or radial nerve.
q The musculo-cutaneous nerve.
r The median nerve.
s Branches of the subscapular (or deep humeral) artery, and vein.
t A branch of the suprascapular artery.

In the Trunk

aabbcd The serratus anticus muscle.
eefghh The serratus posticus muscle.
 These are two thin muscles which sit upon the upper portion of the ribs. The fibres of the anterior one are directed downwards and backwards. Those of the posterior downwards and forwards and they partly overlap.
l Part of the serratus magnus muscle.
mnmn, etc. *nnnoo*, etc. *pp*, etc. *qq*, etc. *rr*, etc. The intercostal muscles.
km The site of origin of the external oblique muscle of the abdomen.
pp The cutaneous branches of the intercostal arteries and nerves.
qqq Part of the internal intercostal muscles.
sstuuwxy The internal oblique muscle of the abdomen. The fibres of this muscle are directed downwards and forwards. It arises from the external angle of the ilium and from Poupart's ligament and is inserted into the prepubic tendon, the linea alba and the last four or five costal cartilages.
z The rectus abdominis muscle. The fibres of this muscle run parallel to the long axis of the body. It arises from the costal cartilages 5 to 9 and from the adjacent part of the sternum. It is inserted into the prepubic tendon. It is intersected by transverse bands of fibrous tissue called tendinal inscriptions.
 The vessels and nerves which are exhibited on the trunk are branches of the intercostal and lumbar vessels and nerves.

In the Cubit and Right Fore Limb

abcdd The extensor metacarpi magnus muscle.
a The origin at the lower extremity of the humerus, from the lip of the musculo spiral groove.
 Just below *d* it is inserted into the metacarpal tuberosity on the large metacarpal bone.
d The tendon which is bound in place by *fg* which is the extensor metacarpi obliquus muscle.
abc The fleshy belly. It has a sheath derived from the deep fascia of the forearm.
fg The extensor metacarpi obliquus muscle.
 This muscle arises from the outer aspect of the lower half of the shaft of the radius and crossing over the tendon of the extensor metacarpi magnus it is inserted into the head of the inner small metacarpal bone.

hiklmn The extensor pedis muscle.
i The origin from the deep fascia.
h The origin from the external condyle of the humerus.
k The fleshy belly.
mn The tendon which is inserted at *n* into the pyramidal process of the coffin bone.

The principal origin of this muscle is from the pit at the lower extremity of the humerus, external to the coronoid fossa and internal to the origin of the extensor metacarpi magnus.

ooo Part of the carpal fascia.
pqrs The extensor suffraginis muscle.

At *p* it arises from the external lateral ligament of the elbow joint. It also arises from the radius and from the ulna. It is covered by a sheath of deep fascia and it is inserted into the anterior aspect of the os suffraginis.

tuwxyz The external flexor of the metacarpus (flexor metacarpi externus).
t The origin from the external condyle of the humerus. It is inserted into the pisiform at *x* and into the external small metacarpal bone just below *w*.
z The fleshy belly.
y The origin of its tendon.
1 2 3 The deep flexor (perforans) of the digit. It arises by three heads from the inner condyle of the humerus, from the olecranon process of the ulna, and from the posterior aspect of the shaft of the radius.
3 The tendon. The tendon passes through the carpal canal and in the metacarpal region it lies between the suspensory ligament and the tendon of the superficial flexor. A little below the carpus the tendon receives a strong band called the check ligament which originates from the posterior common ligament of the carpus. The tendon of the perforans is inserted into the roughened semilunar area on the ventral aspect of the os pedis.
5 10 The superficial flexor (perforatus) of the digit.
6 The anterior slip of the suspensory ligament.
8 The anterior common ligament of the carpus.
9 The external lateral ligament of the carpus.
11 The external plantar nerve.
12 The external digital vein.
13 A section of the hoof at the toe to show its thickness.

In the Right Hind Limb

aaabbbcdd The middle gluteus muscle.
aaa The origin from the lumbo-sacral fascia and the crest of the ilium.
bbb Here it is covered by the gluteal fascia to which it is attached.
b Below *b* it is covered by the superficial gluteus muscle and posteriorly it is in contact with the biceps femoris muscle.
dd The insertion into the great trochanter.
e A portion of the iliacus muscle, protruding from under the ilium. This muscle arises from the ventral surface of the ilium and is inserted by a common tendon with the psoas magnus into the internal trochanter of the femur.
f Branches of the iliaco-femoral artery and vein.
ghik The rectus femoris muscle. This muscle arises by two tendons from two pits in the shaft of the ilium near to the hip joint.
h The fleshy belly.
k The tendon of insertion into the patella.
nopqrrs The vastus externus muscle.
o Its highest point of origin from near the great trochanter.
rr The tendon of insertion into the patella.
rs The tendon of insertion into the lateral ligament of the patella.
n The fleshy part.
q A part which is related to the biceps femoris muscle.
uu Insertion of the biceps femoris muscle into the external straight patellar ligament.

w The insertion into the crest of the tibia.
yz Site of the external straight patellar ligament.
1 2 Site of the external lateral patellar ligament which is attached at 2 into the external condyle of the femur.
3 4 Part of the capsular ligament of the stifle joint.
5 The cut end of the superficial gluteus muscle, near its insertion into the third trochanter.
6 Site of the posterior branch of the superficial gluteus muscle.
8 8 8 8 The lateral sacral ligament which gives origin to the biceps femoris muscle.
8 8 9 10 The great sciatic ligament. The biceps femoris has an origin from this also. It extends between the sacrum and the innominate bone and forms a considerable part of the lateral wall of the pelvis.
8 9 Indicates the position of the intramuscular septum between the biceps femoris and the semitendinosus muscles.
9 9 11 The site of the tuberischii.
12 13 14 15 16 Branches of the gluteal and ischiatic arteries and veins.
18 Muscular branches of the deep femoral artery and vein going to the semitendinosus muscle.
19 20 21 22 23 24 25 30 The extensor pedis muscle.
19 The tibial origin.
20 The femoral origin.
25 22 The tendon which runs under the annular ligament marked 26.
22 Where it is joined by the tendon of the peroneus longus.
23 Where it receives the slip from the suspensory ligament.
24 The insertion into the pyramidal process of the os pedis.
27 The peroneus brevis muscle. (The extensor brevis digitorum.)
28 29 The flexor metatarsi. This muscle has a muscular part, the tibialis anticus, which arises from the tibia; and a tendinous part, the peroneus tertius, which has a common origin from the femur with the extensor pedis. The muscular portion is inserted into the metatarsal tuberosity and the cuneiform parvum. The tendinous portion is inserted into the large metatarsal bone and into the cuboid bone.
31 31 32 33 The semimembranosus muscle.

This muscle arises from the tuber ischii at 31 31, and also from the coccygeal fascia. It is inserted into the inner condyle of the femur.
34 35 The cut lower part of the semitendinosus muscle cut at 34. It passes over the inner aspect of the biceps femoris and is inserted into the crest of the tibia.
36 36 37 38 39 39 40 15 The semimembranosus muscle.
36 36 The origin from the coccygeal fascia. (The upper part of the semitendinosus has been removed from over the area 36 36 37 37 38 15.)
40 The thick fleshy part of the muscle. Intermuscular septa extend between this muscle, the biceps femoris, and the semitendinosus muscles.
50 51 52 53 The peroneus longus muscle.
51 The fleshy belly.
52 53 The tendon which runs in a groove over the outer aspect of the hock. This tendon joins the extensor pedis tendon at 22.
58 59 The deep flexor (perforans) of the digit.
58 The fleshy belly.
59 The beginning of the tendon.
60 60 61 62 62 63 64 The heads of the gastrocnemius muscle.
60 The beginning of the tendon. Below this point the tendons of the two heads fuse.
62 62 Part of the fleshy belly.
64 The tendo achillis which is composed of the tendon of the gastrocnemii and that of the superficial flexor of the digit. The tendo achillis is formed by the twist of the perforatus over the gastrocnemius at the point of the hock.

68 69 The tendon of the perforatus. This muscle arises from the supra-condyloid fossa of the femur, deep to that of the outer head of the gastrocnemius muscle.

68 Here the tendon forms a flattened expansion and sits on the summit of the tuber calcis. This expansion is bound to the bone by two lateral slips.

69 The tendon divides here and is inserted into the 2nd phalanx, i.e., the os coronæ.

70 Part of the external lateral ligament of the hock joint.

71 71 The calcaneo-metatarsal ligaments (the seat of curb).

72 Part of the anterior common ligament of the hock joint.

74 75 The suspensory ligament which arises from the posterior aspect of the lower row of tarsal bones and from the posterior aspect of the upper end of the great metatarsal bone.

74 The point of attachment to the sesamoid bones.

75 The anterior slip which joins the tendon of the extensor pedis.

76 The great metatarsal artery which is the continuation of the anterior tibial artery.

77 A muscular vein, a tributary of the obturator vein.

81 A vein which connects the obturator vein with the femero-popliteal vein.

82 The external saphena nerve of the thigh, a branch of the great sciatic nerve.

The external popliteal nerve which is the continuation of the lesser sciatic nerve.

84 The external plantar nerve.

85 The external digital vein.

86 A section of the wall of the hoof at the toe.

The Internal Side of the Left Hind Limb

Aa The tendon of insertion of the rectus femoris muscle which is inserted into the patella at *A*.

bbc 12 The vastus internus muscle which is inserted into the patella and its inner straight ligament.

dd The semimembranosus muscle.

e The tendon of insertion of the semitendinosus muscle.

fg The inner head of the gastrocnemius muscle.

ln The tendo achillis.

h The thin tendon of the soleus muscle.

mnnpr The tendon of the superficial flexor (perforatus) of the digit.

uwxyz 30 The extensor pedis muscle.

u The fleshy belly.

y Where it receives slips from the suspensory ligament.

x The insertion.

1 2 3 The flexor metatarsi muscle.

6 The popliteus muscle.

7 The flexor accessorius muscle.

8 8 The deep flexor (perforans) of the digit.

9 10 Part of the capsular ligament of the hock joint.

15 15 Part of the capsular ligament of the stifle joint.

16 The internal lateral ligament of the stifle joint.

18 18 The internal lateral ligament of the hock joint.

22 23 23 Part of the posterior ligament of the hock joint.

25 The posterior tibial nerve.

26 The anterior slip of the suspensory ligament.

27 The suspensory ligament.

28 The internal plantar nerve.

29 The internal plantar vein.

36 The hoof in section: at the toe.

The inner aspect of the Left Fore Limb

abc The extensor metacarpi magnus muscle.

e The tendon of the deep flexor (perforans) of the digit.

fg The extensor metacarpi obliquus muscle.

h The tendon of the extensor pedis muscle.

i The median nerve.

k The brachial artery.

llmm The inner aspect of the carpal joint.

n The flexor metacarpi internus muscle.

o The tendon of the superficial flexor (perforatus) of the digit.

p Part of the flexor metacarpi medius muscle.

q The suspensory ligament.

s The cephalic vein.

t The internal digital vein.

u The internal plantar nerve.

w The hoof: a section at the toe.

The Fourth Anatomical TABLE of the Muscles, Fascias, Ligaments, Nerves, Arteries, Veins, Glands and Cartilages of the HORSE

In the Head

ab The eyeball.

a The pupil.

b The sclerotic coat, or white part of the eyeball. The muscles of the eyeball are attached to this part.

c The carancula lachrymalis, a structure which is situated at the inner canthus or commissure of the eye.

d The membrana nictitans or third eyelid.

efgh The superior, inferior, internal, and external recti muscles of the eye.

i The superior oblique muscle of the eye.

k The inferior oblique muscle of the eye.

l The small loop or pulley for the superior oblique muscle.

mmno The superficial part of the buccinator muscle.

pp The orbicularis oris muscle.

qr The mucous membrane of the lips.

s The levator menti muscle.

tu A part of the dilator naris transversus muscle.

ww The buccinator or cheek muscle (deep part), this muscle extends between the alveolar borders of the upper and lower jaws.

x The dilator naris superior muscle.

y The nasal mucous membrane.

z The parotid duct. (Stenson's duct.)

1 The jugular vein.

2 The transverse facial vein.

3 The facial or submaxillary artery.

4 The facial or submaxillary vein.

5 The supra-orbital nerve. A branch of the ophthalmic division of the 5th cranial nerve. It is a sensory nerve to this region.

6 7 8 9 The infra-orbital nerve; this nerve emerges from the infra orbital foramen and it breaks up into branches which supply sensation to the region of the lips and the nose.

10 The scutiform cartilage of the ear.

11 The puma or conchal cartilage of the external ear.

In the Neck

a The thyroid gland.

bbccddeff The cervical carotid artery. It gives off branches which supply all regions of the lower part of the neck.

g A branch to the œsophagus.

kk The trachea.

imn The thyroid portion of the sterno-thyro-hyoideus muscle.

n The insertion into the thyroid cartilage.
m The sternal origin.
op The crico-thyroid muscle.
o The origin from the cricoid cartilage.
p The insertion into the thyroid cartilage.
qq The posterior constrictor muscle of the pharynx.
r The thyro-hyoid muscle.
s The body of the thyroid cartilage of the larynx.
tu The rectus capitis posticus (dorsalis) major.
wx The rectus capitis posticus (dorsalis) minor.
These two muscles are antagonistic to the ventral straight muscles of the head.
yz The obliquus capitis superior muscle.
y The origin from the wing of the atlas.
z The insertion into the mastoid crest and styloid process of the occipital bone.
AB The obliquus capitis inferior.
A The origin from the spine of the axis.
B The insertion into the wing of the atlas.
CDEFGHIKL The longus colli muscle. This muscle originates from the bodies of the first six dorsal vertebræ and from the transverse processes of the last six cervical vertebræ, and is inserted into the bodies of the cervical vertebræ as far as the tubercle of the atlas.
LL, etc. *MM*, etc. The intertransversalis colli muscles; these muscles arise from the articular processes of the last five cervical vertebræ and the first dorsal, and are inserted into the transverse processes of the last six cervical vertebræ.
NNN Extra portions of the intertransversalis colli muscles.
OOOOPQ The semispinalis colli muscles. These muscles lie on the inner side of the articular processes and they are inserted into the spines of the cervical vertebrae.
RTU The dorsal division of the longissimus dorsi muscle in the neck.
1 1 1 1 Branches of the dorsal divisions of the cervical nerves.
2 2 Branches of the superior cervical artery.
3 3 Tributaries of the superior cervical vein.
4 The jugular vein.
5 The funicular portion of the ligamentum nuchæ.

In the Shoulder

ab The subscapularis muscle projecting from under the scapula.
def The teres major muscle.
d The origin from the dorsal angle of the scapula.
e The tendon of insertion which is passing to the internal tubercle of the humerus.
f The part which lies adjacent to the long head of the triceps extensor cubiti.
ghiikklm The long head of the triceps.
dg The origin from the dorsal angle of the scapula.
h The beginning of its fleshy belly.
m The tendon of insertion into the olecranon process of the ulna.
k This line shows the outline of the lower portion of the latissimus dorsi muscle. The latissimus dorsi is inserted into the internal tubercle of the humerus along with the teres major muscle.
no A portion of the external head of the triceps muscle. It arises from the line above the deltoid tubercle of the humerus and is inserted into the olecranon process of the ulna.
ppq The insertion of the serratus magnus muscle into the ribs. This interdigitates with the origin of the external oblique muscle of the abdomen.
r The ulnar nerve.
s The musculo-spiral or radial nerve.
t The musculo-cutaneous nerve, i.e., the anterior root of the median nerve.
u The median nerve.
w Branches of the subscapular artery and vein.

Muscles of the Trunk

1 1 &, 2 2 & The external intercostal muscles. These fibres pass downwards and backwards.
3 3 &, 4 4 & The lower portion of the internal intercostal muscles exposed. Their fibres pass downwards and forwards between adjacent ribs. The internal intercostals are continued into the spaces between the costal cartilages. The external have origin from all ribs except the last. The internal from all ribs except the first. The external are inserted into all the ribs except the first and the internal into all ribs and cartilages except the last.
5 5 5 5 5 Ventral branches of the intercostal nerves. These arise in series and are distributed to the thoracic and abdominal muscles, subcutaneous tissue, and skin.
aabccdeeffghhiikkl The longissimus dorsi muscle is a large muscle in the back and loins. This muscle extends from the ilium near *hi* to the 4th cervical vertebra. Its origin is from the ilium and from the lumbar and dorsal spinous processes. It is inserted into the lumbar transverse and articular processes, into the dorsal articular processes and into the transverse processes and spines of the last four cervical vertebræ. It is also inserted into the upper third of the outer aspect of the ribs. It is strongest in the lumbar region. In the neck it splits, one part going to the spines and the other going to the transverse processes of the last four cervical vertebræ. The trachelo-mastoideus muscle originates between these two parts, from the 1st and 2nd dorsal transverse processes and from the cervical articular processes.
lmnn, etc. *o* The transversalis costarum muscle. This muscle is made up of many small parts, and it lies just ventral to the lower edge of the latissimus dorsi. It arises from the lumbar transverse processes, i.e., the first two or three. It also arises from the anterior border of the ribs. Its tendons are inserted into the posterior edges of the first fourteen ribs near the angle and into the single transverse process of the last cervical vertebra.
Ppqrstu The transversalis abdominis muscle. The tendinous portion in aponeurosis. It arises from the last ten or eleven ribs near their lower extremities and from their cartilages. It also arises from the lumbar transverse processes. It is inserted into the linea alba which extends in the ventral mid line from the ensiform cartilage of the sternum to the prepubic tendon. The peritoneum is attached to its deep face.
W Branches of the posterior abdominal artery.
xxx Ventral branches of the lumbar nerves which supply the abdominal muscles and integuments.
yy Branches of the circumflex iliac artery and vein.
z Site of the linea alba.

In the Right Hind Limb

effg The iliacus muscle.
ff The origin from the ventral surface of the ilium.
g Over this area it is somewhat tendinous.
eg A septum of the fascia lata from which it has an origin. The iliacus is inserted into the internal trochanter of the femur by a tendon which is common with that of the psoas magnus.
hikkll The deep gluteus muscle.
i The fleshy part.
kk The tendon of insertion. It is inserted into the great trochanter of the femur.
pqqrst The semimembranosus muscle.
p The origin from the sacral and coccygeal fascia.
qqr The fleshy belly.
It is inserted into the inner condyle of the femur.
uw A portion of the gracilis muscle.
w The tendinous part.
xy The rectus parvus muscle. This muscle arises from the ilium just above the point *x* and is inserted into the anterior surface of the shaft of the femur at *y*.
1 1 1 2 2 3 4 5 6 The rectus femoris muscle. This muscle

arises from the ilium by two tendons just in front of the point *x*, it is inserted into the patella near 3.

7 8 9 A portion of the vastus internus muscle. This muscle arises from the inner and anterior surfaces of the shaft of the femur. It is inserted into the patella at 9. These muscles: the vastus internus and externus and the rectus femoris possess a common tendon of insertion. They are thickest about the middle of the femur.

10 The external lateral patellar ligament, which is attached to the external condyle of the femur.

11 The external straight patellar ligament which is inserted into the anterior tuberosity of the tibia.

12 The middle straight patellar ligament which is also inserted into the anterior tuberosity of the tibia.

13 A part of the capsular ligament of the stifle joint showing between these two ligaments.

14 14 15 15 16 17 18 19 20 The flexor metatarsi muscle which consists of two divisions: the tibialis anticus and the peroneus tertius.

14 14 The origin of the tibialis anticus (deep portion) from the tibia.

15 The origin of the peroneus tertius (superficial part) from the digital fossa of the femur.

16 17 The peroneus tertius.

18 19 20 The insertions of the two divisions in the region of the hock. The peroneus tertius is inserted into the metatarsal tuberosity at the head of the large metatarsal bone, and also in the cuboid bone. The tibialis anticus is inserted into the metatarsal tuberosity and also into the cuneiform parvum bone.

23 24 25 25 26 26 27 27 The deep flexor (perforans) of the digit. The origin is from the external tuberosity of the tibia and the head of the fibula. It contains numerous tendinous strands. Its fleshy belly ends just above the hock. The tendon passes through the tarsal canal and is seen in the lower part of the limb. It is inserted into the semilunar crest of the os pedis.

The flexor accessorius may be considered to be a part of this muscle.

27 27 A portion of fascia which covers the muscle at this site.

28 The popliteus muscle, here seen passing out from its origin under the external lateral ligament of the stifle joint.

30 Site of the external lateral ligament of the stifle joint.

31 The external lateral ligament of the hock joint.

32 The calcaneo-metatarsal ligament.

33 The external lateral ligament of the fetlock joint.

34 A posterior branch of the gluteal artery.

35 35 Branches of the iliaco-femoral and ilio-lumbar vessels.

36 A branch of the anterior femoral artery and vein.

37 A branch of the obturator artery which connects with the deep femoral artery.

38 A tributary of the femoral vein.

39 The femoro-popliteal artery.

51 The femoro-popliteal vein.

52 The popliteal artery.

53 The popliteal vein.

54 The external popliteal nerve just before its division into the anterior tibial and musculo cutaneous branches.

55 The anterior tibial artery.

56 The anterior tibial vein.

57 The popliteal lymphatic gland sometimes called the pope's eye.

58 A radicle of the internal saphena vein.

59 The external lateral cartilage of the foot.

60 A portion of the internal lateral cartilage of the foot.

40 41 42 43 44 45 49 The superficial flexor (perforatus) of the digit.

40 The origin from the supra-condyloid fossa of the femur.

41 Where it is joined to the gastrocnemius muscle.

42 42 The tendon which is inserted at 43 into the os coronæ or second phalanx.

45 The posterior annular ligament of the fetlock joint. At 45 the tendon of the perforatus forms a ring or tube for the passage of the tendon of the perforans.

46 The capsular ligament of the fetlock joint.

47 The lateral ligament of the pastern joint.

48 The capsular ligament of the coffin joint.

49 The external slip which binds the tendon of the superficial flexor to the point of the os calcis.

50 The anterior lateral ligament of the coffin joint.

In the Left Hind Limb

ab The anterior femoral artery and vein.

hhi The popliteus muscle.

kllmnop The superficial flexor (perforatus) of the digit.

o The internal slip which binds it to the os calcis.

n The insertion.

q The posterior annular ligament of the fetlock joint.

1 2 3 The flexor accessorius. At 3 its tendon is inserted into that of the deep flexor.

4 The main part of the deep flexor (perforans) of the digit.

10 11 12 13 15 16 The divisions of the flexor metatarsi viewed from the inner aspect.

15 The insertion of the tibialis anticus into the cuneiform parvum, known as the cunean tendon.

16 The insertion into the metatarsal tuberosity.

17 17 18 The internal lateral patellar ligament which binds the patella to the internal condyle of the femur.

19 19 20 The internal straight patellar ligament.

21 22 The middle straight patellar ligament.

23 24 The internal lateral ligament of the stifle joint.

25 25 The capsular ligament of the stifle joint.

26 The suspensory ligament.

27 28 The internal lateral ligament of the hock joint.

34 The internal lateral ligament of the fetlock joint.

35 Part of the capsular ligament of the fetlock joint, at which point a bursa is interposed between it and the tendon of the extensor pedis.

36 The capsular ligament of the pastern joint.

37 The internal lateral ligament of the pastern joint.

38 Part of the capsular ligament of the coffin joint exposed.

39 Tributaries of the anterior tibial vein.

40 The posterior tibial nerve.

41 The internal lateral cartilage of the foot.

In the Right Fore Limb

abc The brachialis anticus muscle.

a The origin.

b The belly.

c The insertion into the radius.

deffghi The deep flexor (perforans) of the digit.

de The humeral head.

gh The ulnar head.

i The radial head.

ff The common tendon which is inserted into the semilunar crest of the coffin bone.

k The ligamentous cord connecting the ulna to the carpus.

lm The superficial flexor (perforatus) of the digit.

l The fleshy part.

m The tendon of insertion.

nnnn External lateral ligaments of the carpal, fetlock, pastern, and coffin joints.

ooo Portions of the capsular ligament of the carpal, fetlock, and pastern joints.

p The cephalic vein.

q The suspensory ligament.

r The external lateral cartilage of the foot.

In the Left Fore Limb

abc The lower end of the brachialis anticus muscle near its insertion into the radius.

d The median nerve.
e The brachial artery.
f The brachial vein.
g The cephalic vein.
i The internal flexor of the metacarpus. (Flexor metacarpi internus.)
lm The superficial flexor (perforatus) of the digit.
l The fleshy part.
m The tendon of insertion.

nopp The deep flexor (perforans) of the digit.
pp The tendon.
n The ulnar head.
qqqq The internal lateral ligaments of the carpal, fetlock, pastern, and coffin joints.
rrr Portions of the capsular ligament of the carpal, fetlock, and pastern joints.
s The suspensory ligament.
t The internal lateral cartilage of the foot.

The Fifth Anatomical TABLE of the Muscles, Fascias, Ligaments, Nerves, Arteries, Veins, Glands and Cartilages of the HORSE

In the Head

a The retractor muscle of the eye. This originates from around the optic foramen and it is inserted into the sclerotic coat of the eye near to the point of exit of the optic nerve.
b The superior oblique muscle of the eye.
c Its pulley or trochlea.
d The inferior oblique muscle of the eye.
e The superior rectus muscle.
f The inferior rectus muscle.
g The internal rectus muscle.
h The external rectus muscle.
i The third eyelid or membrana nictitans. This is of a cartilaginous nature and it is covered by conjunctiva. Its shape is adapted to the contour of the eyeball, anteriorly it possesses a free edge which is pigmented and can be seen at the inner canthus of the eye. Posteriorly it is related to the post-orbital fat.
k The cut end of the optic nerve.
llmnnooop The mucous membrane of the cheek and lips.
nn The buccal glands.
llmp The labial glands.
q The levator menti muscle.
1 The facial or submaxillary vein.
2 The facial or submaxillary artery.
3 The mental nerve which is the continuation of the inferior dental nerve, a branch of the mandibular nerve.
4 5 6 The infra-orbital nerve which is the continuation of the superior dental nerve, a branch of the superior maxillary division of the 5th cranial nerve. The infra-orbital nerve breaks up into branches which pass to the nostrils, muzzle and lips.
7 8 9 The supporting cartilages of the nostrils.
7 Part of the nasal septum. This divides the nasal chambers into right and left parts. Posteriorly it is attached to the ethmoid bone. Ventrally it sits in the groove of the vomer bone.
10 The scutiform cartilage of the ear.
11 The conchal cartilage of the external ear.

In the Neck

a The rectus capitis ventralis or anticus minor muscle. A muscle which passes between the atlas and the basi-occiput.
d The crico-arytenoideus lateralis muscle.
e The crico-arytenoideus posticus muscle.
f A portion of the arytenoideus muscle.
ghhhh The œsophagus.
g The upper end where it joins the pharynx.
ik The cornu of the thyroid cartilage of the larynx.
l The cricoid or annular cartilage of the larynx.
m The crico-thyroid ligament.
ooo The trachea or windpipe.
pp The cervical carotid or common carotid artery.
1 The external carotid artery.
2 The internal carotid artery.
qq The trunk of the 8th cervical nerve.

3 A branch of the 8th cervical nerve.
4 The superior cervical artery.
5 The superior cervical vein.
rs Rectus capitis dorsalis or posticus minor muscle.
r The origin from the atlas.
s The insertion into the occiput.
tu An intertransversalis colli muscle.
t The origin from the anterior oblique process of the 3rd cervical vertebra.
u The insertion into the transverse process of the 2nd cervical vertebra, i.e., the axis.
uw The other intertransversalis muscles.
xxxy The semispinalis colli muscles, which pass between the oblique and the spinous processes of the cervical vertebræ.
z The upper division of the scalenus muscle which arises from the transverse process of the 7th cervical vertebra and is inserted into the 1st rib.
1 2 2 3 4 5 6 6, etc. 7 8 8, etc. The ligamentum nuchæ.
1 2 The funicular or cord portion. This part extends from the summit of the 3rd dorsal spine to the nuchal crest of the occipital bone.
3 4 5 6 8 8 The lamellar or sheet-like portion. It is reticular and is attached to the funicular part and to the spines of the first three dorsal and the last six cervical vertebræ. The ligament is the largest in the body and it is composed of yellow elastic tissue. It occupies the midline of the neck and there are right and left parts which are identical. The shaded areas represent the reticular fibres of the lamellar part and 8 8, etc., indicates the series of arches which bridge the interspinous spaces.
13 13 14 15 The occipito-atlantal capsular ligament. At 14 it is thickened and this part is called the cruciform ligament.
16 The interannular ligament sometimes called the ligamentum subflavum between the atlas and the axis.
17 17 17 17 The capsular ligaments of the oblique or articular processes.
18 18 The vertebral artery and vein and their branches.
19 The cut lower end of the jugular vein.

In the Trunk

ab, etc. The levatores costarum muscles. These muscles elevate the ribs and are used in respiration. They arise on the transverse processes of the dorsal vertebræ and they are inserted into the anterior and outer aspects of the ribs in the region of the angle. Their fibres pass downwards and backwards.
cc, etc. *dd*, etc. The multifidus spinalis and semispinalis muscles of the back which pass between the articular and transverse processes and the spinous processes.
ef The lateral muscle of the tail or curvator coccygis muscle (sacro-coccygeus lateralis). This muscle corresponds to the semispinalis or multifidus muscle. It arises from the spines of the sacrum and is inserted into the lateral aspect of the coccygeal or tail bones.

gg The intertransversalis coccygis muscle. Fibres of this muscle pass from the transverse process of one vertebra to the transverse process of the next. It envelops the vertebræ after the manner of a sheath.

h The supraspinous ligament of the sacrum.

i The erector coccygis muscle or elevator muscle of the tail. It arises from the sacral spines and is inserted into the dorsal aspect of the coccygeal bones.

k The depressor coccygis muscle. This arises from the ventral surface of the sacrum as far forward as the 3rd segment. It is divided into two parts: an inner and an outer. The inner part is inserted into the ventral aspects of the first six coccygeal bones. The outer part extends to the end of the tail.

lll The lungs.

mmnnnn The diaphragm.

mmm The muscular part.

nnn The tendinous centre.

oo etc. The intercostal nerves.

pp etc. The intercostal arteries.

q Part of the large colon and cæcum.

In the Right Hind Limb

abc The rectus parvus muscle.

a The fleshy belly.

b The origin.

c The insertion.

def Site of origin of the rectus femoris muscle. It arises from the shaft of the ilium.

d The origin. There are two heads of origin.

f The cut end of the muscle.

iiklo The iliacus muscle, which lies under the blade of the ilium.

o The tendon of insertion into the internal trochanter of the femur.

mnnoo The retractor ani muscle. This muscle arises from the superior ischiatic spine and adjacent part of the great sciatic ligament and is inserted into the anus near the sphincter ani.

p The internal sphincter of the anus.

ss Site of the insertion of the pectineus muscle into the inner aspect of the femur.

tu The sartorius muscle. This muscle arises from the iliac fascia covering the iliacus muscle. It is inserted into the internal straight patellar ligament.

t The fleshy belly.

T The deep fascia of the femoral canal. The femoral vessels and nerves are shown as projecting through it.

wxx The gracilis muscle.

w The fleshy part.

xx The aponeurotic tendon of insertion.

z Part of the adductor magnus muscle.

1 2 3 The obturator internus and gemelli muscles.

1 3 The gemelli muscle which arises from the superior ischiatic spine.

2 The tendon of insertion of the obturator internus muscle. This muscle arises on the floor of the pelvis around the obturator foramen. The gemelli and obturator internus are inserted into the trochanteric fossa of the femur.

4 A part of the deep gluteal fascia.

10 11 11 The capsular ligament of the hip joint.

13 13 The line of attachment to the femur of the capsular ligament of the stifle joint.

14 The posterior binding slip of the external semilunar cartilage of the stifle joint.

15 The external semilunar cartilage of the stifle joint.

18 19 The external lateral ligament of the stifle joint.

20 The interrosseus ligament between the tibia and fibula.

21 The external lateral patellar ligament.

22 The middle straight patellar ligament.

23 The external straight patellar ligament.

24 The tendon of the gastrocnemius muscle cut off at its insertion into the os calcis.

25 The calcaneo-cuboid ligament.

26 26 26 The external lateral ligaments of the hock, fetlock, and pastern joints.

27 The astragalo-metatarsal ligament.

28 The suspensory ligament.

29 The internal iliac artery.

30 The gluteal artery.

31 The internal pudic artery.

32 32 The obturator artery.

33 The femoral artery.

34 The femoral vein.

35 The anterior crural nerve.

36 The popliteal artery.

37 The popliteal vein.

38 39 The lateral cartilages of the foot.

The Inner Side of the Left Hind Limb

1 The internal lateral patellar ligament.

2 The internal straight patellar ligament.

3 The middle straight patellar ligament.

4 The internal lateral ligament of the stifle joint.

5 The posterior common ligament of the hock joint.

6 6 6 6 The internal lateral ligaments of the hock, fetlock, pastern, and coffin joints.

7 The astragalo-metatarsal ligament.

8 The cut tendon of the gastrocnemius near its insertion.

9 The suspensory ligament.

10 The femoral artery.

11 The femoral vein.

12 13 The inner and outer semilunar cartilages of the stifle joint.

14 The internal lateral cartilage of the foot.

Muscles on the Right Fore Limb

aab The subscapularis muscle showing from underneath the scapula.

c The suspensory ligament.

ddd The ligaments which bind the pisiform to the radius, carpal, and metacarpal bones.

eeee Lateral ligaments of the elbow, carpal, fetlock, pastern, and coffin joints.

f The ulnar nerve.

g The axillary or circumflex nerve.

h The radial or musculo-spiral nerve.

i The musculo-cutaneous nerve (anterior root of the median).

kk The median nerve.

l The subscapular artery (behind the scapula).

l The axillary artery (in front of the scapula).

m The axillary vein.

n The cephalic vein.

op The lateral cartilages of the foot.

The Inner Aspect of the Left Fore Limb

aaaa The internal lateral ligaments of the carpal, fetlock, pastern, and coffin joints.

b The suspensory ligament.

c The median nerve.

d The brachial artery.

e The brachial vein.

f The cephalic vein.

g The internal lateral cartilage of the foot.

The Sixth Anatomical TABLE of the Muscles, Fascias, Ligaments, Nerves, Arteries, Veins, Glands and Cartilages of the HORSE

In the Head

aab, aab The temporo-auricularis muscles. They are inserted into the conchal cartilage at its base.

cc The zygomatico-auricularis muscles. These muscles arise from the zygomatic process and are inserted into the scutiform cartilage and also into the base of the conchal cartilage.

dd The parieto-auricularis muscles. These muscles arise from the region of the parietal crest or saggital suture and are inserted into the base and inner aspect of the conchal cartilage.

ff The scuto-auricularis muscles.

hh The parieto-auricularis internus muscles.

i The parotido-auricularis muscle. This muscle arises from the connective tissue over the parotid gland and is inserted into the outer aspect of the base of the ear.

kkk The thin epicranius or scalp muscle; a part of the panniculus carnosus. This muscle is best marked in the region of the masseter and near the orbit. Near the lips and in the intermaxillary space it is thin and mostly replaced by fascia.

1 1 2 m, 1 1 2 m The orbicularis occuli muscles of the eyelids.

2 2 The origins from the lachrymal tubercles.

LL The corrugator supercilii muscles of the upper eyelids.

nnNN 4 4, nnN The levator labii superioris et alæque nasi muscle.

4 4 The part which elevates the lips.

NN The part which passes under the dilator naris lateralis muscle.

o 3 5, o 3 The zygomaticus muscles.

3 5 The origin near the eye.

o The insertion with the buccinator into the commissure of the mouth.

p The dilator naris lateralis muscle.

qqqr The orbicularis oris muscle.

ss The insertion of the panniculus over the masseter muscle.

tuu The tendons of the levator labii superioris proprius muscles.

t The union of the tendons of the levator labii superioris proprius muscles.

ww The dilator naris superior muscle.

xx Part of the nasal mucous membrane which lines the nostrils.

In the Neck, Breast, Shoulders and Trunk

abcdefghss The panniculus or skin muscle of the neck.

a The origin from the sternum.

b The continuation of the pectoral fascia over this muscle.

c The site where the fleshy portions of this muscle diverge.

g At this point it covers the sterno-maxillaris muscle.

h Where it passes over the mastoido-humeralis muscle.

ss Where a portion passes onto the masseter muscle.

ikll The mastoido-humeralis muscle.

i The upper part which arises from the mastoid crest.

k The part which arises from the transverse processes of the cervical vertebræ.

ll The lower end which is inserted into the humerus between the biceps and the brachialis anticus muscles.

mm Cutaneous nerves.

nnoppqr The pectoral muscles.

nno The anterior superficial pectoral muscle. It extends from the sternum to the humerus.

ppqq Part of the posterior superficial pectoral muscle. This muscle arises from the sternum and is inserted into the humerus.

r Part of the posterior deep pectoral muscle. This muscle arises from the abdominal aponeurosis, the sternum, and the last four costal cartilages, and is inserted into the internal tuberosity of the humerus.

s Part of the cervical trapezius muscle.

ttuwwxxyyyzzz&& The panniculus which extends over the thorax, abdomen, and flank. It possesses a long thin tendon of insertion which passes into the axilla and is inserted onto the internal tubercle of the humerus. At *xx* it is thin, at *yyy* and *&&* it is thicker and at *w* it is quite thick. At *zz* it meets the gluteal fascia and the fascia lata.

In the Fore Limbs

abbcdefghiiikkk The panniculus muscle. In the upper part of the fore limb this muscle merges into the fascia of the limb.

def The extensor pedis muscles.

d The fleshy belly.

ef The tendon.

gh The internal flexors of the metacarpus (flexor metacarpi internus muscles).

kkk Cephalic vein.

l The hoof.

In the Hind Limbs

ABCDabcdeghhik The panniculus, now fused with the fascia of the hind limb.

ABC The anterior crural or quadriceps extensor cruris muscles.

D The patella and its covering of fascia lata.

bcd The extensor pedis muscle.

b The fleshy belly.

cd The tendon.

e Fascia covering the anterior aspect of the hock.

g The peroneus longus muscle.

hh The internal saphena vein and its radicle: the internal metatarsal vein.

iik The tendon of the superficial flexor (perforatus) of the digit.

l The hoof.

The Seventh Anatomical TABLE of the Muscles, Fascias, Ligaments, Nerves, Arteries, Veins, Glands and Cartilages of the HORSE

In the Head

a The dilator naris transversalis muscle.

bcdd The dilator naris lateralis muscle.

efgh The levator labii superioris proprius muscle.

gg The union of its tendons.

kk The cartilages of the nostril.

lmno An additional head of the levator labii superioris proprius muscle. This head may be considered as part of the panniculus muscle.

p Part of the nasal mucous membrane exposed inside the the nostril.

P The superficial part of the buccinator muscle.

QQQ The orbicularis oris muscle.

qrr The orbicularis occuli muscle.

st The tarsal or palpebral ligament.

uw The eyeball.

u The site of the pupil.

w The iris.

xxy The temporal muscle.
xx The origin.
y The insertion onto the coronoid process of the mandible.
z The masseter muscle.
1 The facial or submaxillary artery.
2 The facial or submaxillary vein.
3 The duct of the parotid gland—Stenson's duct.
4 Branches of the facial nerve, i.e., the 7th cranial nerve with which are incorporated branches of the mandibular division of the 5th cranial nerve.

In the Ear

ab The scuto-auricularis muscle.
c Part of the scuto-auricularis internus muscle.
d Part of the parieto-auricularis muscle.
f The scutiform cartilage.
g The conchal cartilage of the external ear.

In the Neck

abc The sterno-maxillaris muscle.
a The sternal origin.
dd The subscapulo-hyoideus muscle.
ee The longus colli muscle.
ff The scalenus muscle.
gh A portion of the intertransversalis muscle.
iklm The levator anguli scapulæ muscle.
nnoo The jugular vein.
oo Indicates the site of some of its valves.
The inferior cervical glands are situated on either side of the origin of the sterno-maxillaris muscles.

In the Shoulders and Trunk

abc The anterior deep pectoral muscle. This muscle arises from the lateral surface of the sternum and from the cartilages of the first four ribs. It is inserted into the deep fascia which covers the supraspinatus muscle near the cervical angle of the scapula.
ddeeffggh The pectoral muscles.
ddee The anterior superficial pectoral muscle.
ffgg The posterior superficial pectoral muscle.
h Part of the posterior deep pectoral muscle.
ikklmn The supraspinatus muscle. It occupies the supraspinous fossa of the scapula.
lm The site of its insertion into the inner and outer tuberosities of the humerus.
opq The infraspinatus muscle.
q The site of its insertion into the inner tuberosity of the humerus.
r The teres minor muscle.
ssttuw The latissimus dorsi muscle.
ss The aponeurotic origin, from the lumbo dorsal fascia.
tt The fleshy part.
x The coraco-radialis or biceps muscle.
yz The triceps brachii or extensor cubiti muscle.
y Part of the long head.
1 1 1 1 2 2 2, etc. 3 3 4 4 4 5 6 6 The external oblique muscle of the abdomen.
1 1 1, etc. Site of its origin from the ribs.
2 2 2, etc. Point where cutaneous nerves emerge.
5 4 4 The fleshy part in the flank.
6 The insertion into the external angle of the ilium.
7 7 Part of the longissimus dorsi muscle.

In the Fore Limbs

aabcdeffghi The deep fascia of the forearm. This encircles the limb as in a sheath. It sends in trabeculæ which are attached to the underlying bones.
abcdef The extensor metacarpi magnus muscle.
bcde The fleshy part.
f The insertion into the metacarpal tuberosity.
hik The extensor pedis muscle.
h Part of the fleshy belly.
i The tendon.
k The insertion into the pyramidal process of the os pedis.
nn The slips to the extensor pedis which are part of the suspensory ligament.
op The flexor metacarpi internus muscle, and its covering of fascia.
p *p* in the left fore limb is part of the flexor metacarpi medius muscle.
qr The cephalic vein which enters the jugular vein.
ss The internal and external digital veins.
t A cutaneous branch of the musculo cutaneous nerve.
u The tendon of the extensor pedis. It runs in a groove on the lower end of the radius and is held in position by an annular ligament.
wxyy The fascia covering the carpal joint. Its fibres are strong and cover the anterior common ligament of the joint.
zz The internal and the external lateral ligaments of the fetlock joint.
& The sensitive laminæ.

In the Hind Limbs

a A part of the superficial gluteus muscle.
bbbcd The middle gluteus muscle.
efghik The tensor fascia lata, or tensor vaginæ femoris muscle which is inserted into the patella at *i*.
lmnopqrssst The biceps femoris muscle.
lm The part which is inserted into the patella. The part below the stifle is tendinous and covers the other muscles of this region.
Puuxu The extensor pedis muscle.
qs The flexor metatarsi muscle.
rt The peroneus longus muscle.
2 2 The tendon of the peroneus longus.
u The insertion of the tendon of the extensor pedis.
3 The peroneus brevis which arises from the lower part of the front of the hock—the astragalus bone—and is inserted into the tendon of the extensor pedis.
4 Part of the superior annular ligament of the hock which binds the tendons of the flexor metatarsi and extensor pedis into place.
5 The tendon of the extensor pedis.
6 Part of the annular ligament of the peroneus longus.
7 The fascial sheath of the tendon of the peroneus longus.
8 8 Part of the fascial covering of the hock.
9 10 10 The suspensory ligament.
11 The deep flexor tendon (perforans) of the digit.
12 12 The superficial flexor tendon (perforatus) of the digit.
13 13 The internal saphena vein.
14 14 The external digital vein.
15 The internal digital vein.
16 The origin of the digital veins.
17 The tendo achillis.
18 Part of the flexor accessorius muscle.
19 The sensitive laminæ.

The Eighth Anatomical TABLE of the Muscles, Fascias, Ligaments, Nerves, Arteries, Veins, Glands and Cartilages of the HORSE

In the Head

a The dilator naris transversalis muscle. This is a quadrilateral muscle which extends from the cartilage of one nostril to that of the other. It lies under the common tendon of the levator labii superioris proprius.
bcD A portion of the levator labii superioris proprius

muscle. It terminates near the nostril and its principal function is to wrinkle the skin of the face. This portion may be considered as part of the panniculus muscle.

dd The orbicularis oris muscle.

e The superficial part of the buccinator muscle which blends with the orbicular muscle of the mouth.

f The masseter muscle.

ggh The temporal muscle.

h The insertion into the coronoid process of the mandible.

i Part of the nasal mucous membrane.

K Part of the alæ nasi or cartilage of the nostril.

kl The eyeball.

k The pupil.

l The iris.

mmn The orbicular muscle of the eye.

o The levator palpebræ superioris. This muscle arises from above the optic foramen and it is inserted into the upper eyelid.

1 1 2 The infra orbital nerve which is a branch of the superior maxillary division of the 5th cranial nerve. It breaks up into branches which are the sensory nerves to the region of the mouth and nostril.

3 Branches of the facial nerve, i.e., the motor nerve of the face, with which are incorporated branches of the mandibular division of the 5th cranial nerve.

4 The facial or submaxillary artery.

5 The facial or submaxillary vein.

6 The duct of the parotid gland—Stenson's duct.

7 The scutiform cartilage.

8 The conchal cartilage of the external ear.

In the Neck

ab The sterno-thyro-hyoideus muscle.

a The origin from the sternum.

cd The subscapulo-hyoideus muscle which originates from the subscapular fascia and is inserted into the body of the hyoid bone.

f The scalenus muscle. This muscle arises from the transverse processes of the last four cervical vertebræ and is inserted into the 1st rib.

ggh A portion of the longissimus dorsi muscle in the neck which is inserted into the transverse and the oblique processes of the cervical vertebræ.

l The trachelo-mastoideus muscle. This muscle arises from the transverse processes of the 1st and 2nd dorsal vertebræ and from the articular processes of the last six cervical vertebræ. It is inserted into the wing of the atlas and into the mastoid crest of the occiput.

k The cervical or common carotid artery.

l The cut end of the jugular vein.

In the Trunk

aabc The lateralis sterni muscle.

aa The origin from the first rib.

b The insertion into the sternum.

ffgghhiii The serratus anticus muscle. This is a thin muscle which arises from the spines of the 2nd to the 13th dorsal vertebræ and is inserted into the outer surface of the last eight or nine ribs.

Kkllmm The serratus posticus muscle. This muscle arises from the spines of the 11th dorsal to 2nd lumbar vertebræ and is inserted into the last eight ribs, marked *mmmm*.

FFG The anterior deep pectoral muscle arising from the sternum at *FF*.

H The supraspinatus muscle.

I The infraspinatus muscle.

no The posterior part of the longissimus dorsi muscle.

h A portion of the anterior part of the longissimus dorsi.

yy, etc., *zz*, etc., 1 1, etc., 2 2, etc. The external intercostals. From *zz* to 1 1 the external oblique muscle of the abdomen is attached to these muscles.

3 3 3 A portion of the fleshy part of the external oblique muscle of the abdomen.

4 4 Parts of the internal intercostal muscles.

5 5 6 6 7 The internal oblique muscle of the abdomen.

8 9 9 Part of the transversalis abdominis muscle of the abdomen near its origin.

10 10 Branches of the lumbar nerves.

11 12 Branches of the circumflex iliac vessels.

13 13 14 14 Branches of the intercostal vessels and nerves.

15 15 Branches of the ilio-lumbar artery and veins.

In the Shoulders and Fore Limbs

A The musculo-cutaneous nerve. (The anterior root of the median nerve.)

B The median nerve.

C The ulnar nerve.

D The radial or musculo-spiral nerve.

E The axillary or circumflex nerve.

F The axillary vein at its junction with the jugular.

abc A small portion of the subscapularis muscle.

de The posterior deep pectoral muscle.

c Its insertion into the inner tuberosity of the humerus.

fgh The triceps brachii or extensor cubiti muscle.

f The long head.

g The external head.

h The insertion into the olecranon process of the ulna.

iklmn The biceps brachii muscle.

i The origin from the corocoid process of the scapula.

k The part which occupies the bicipital groove of the humerus.

lm The fleshy belly.

n The insertion into the bicipital tuberosity of the radius.

o A part of the brachialis anticus muscle. This muscle arises from the shaft of the humerus and the lip of the musculo-spiral groove. It is inserted into the radius under the internal lateral ligament of the elbow joint.

pqrstuwxy The extensor metacarpi magnus muscle.

p The origin from the lower end of the humerus.

rstuy The fleshy belly.

x The tendon of insertion into the metacarpal tuberosity.

zz A band of fascia.

1 1 2 2 3 4 5 6 6 The extensor pedis muscle. It arises from the humerus just internal to the extensor metacarpi magnus.

2 2 The tendon.

6 6 Here it is joined by slips from the suspensory ligament. Below 3 it is inserted into the pyramidal process of the os pedis. Its tendon lies in a groove in the lower extremity of the radius.

7 7 8 The extensor metacarpi obliquus muscle.

7 7 The fleshy part.

8 The tendon.

14 is the region of its insertion into the external small metacarpal bone.

9 The flexor metacarpi internus muscle.

10 Part of the flexor metacarpi medius muscle.

12 The cephalic vein.

13 13 The capsular ligament of the carpal joint or anterior common ligament.

14 14 The internal and external lateral ligaments of the carpus.

15 15 The internal and external lateral ligaments of the fetlock joint.

16 The digital vein.

In the Hind Limbs

abbbcd The middle gluteus muscle.

abbb The origin from the superior surface of the ilium.

d The insertion into the great trochanter of the femur.

efg The vastus externus muscle.

ef The fleshy belly.

g The insertion into the patella.

ghik The flexor metatarsi muscle.

g The origin from the upper end of the tibia (tibialis anticus). The superficial tendinous part: the peroneus tertius, arises from the digital fossa of the femur.

h The insertion into the metatarsal tuberosity.

i The insertion into the cuneiform parvum.

k The insertion into the cuboid.

This muscle as previously described is made up of two parts a deep and a superficial. The deep part is often called the tibialis anticus. It has a thick muscular belly and it originates from the anterior and outer aspects of the tibia. It has a bifid tendon of insertion. The main tendon is inserted into the metatarsal tuberosity on the large metatarsal bone, the other passes to the inner aspect of the hock and is attached to the small cuneiform bone, this tendon is known as the cunean tendon. The superficial part is often called the peroneus tertius. It consists of a strong thin tendon and it originates from the lower end of the femur. Its tendon of insertion is also bifid. The main tendon is inserted into the metatarsal tuberosity, the other passes to the outer aspect of the hock and is attached to the cuboid bone.

lmnopqrstt The extensor pedis muscle.

l The origin from the digital fossa of the femur.

m The fleshy belly.

n The tendon.

oq Where its tendon is joined by that of the peroneus longus and peroneus brevis.

10 Slips of the suspensory ligament which joins the tendon over the first phalanx at *t*.

s The insertion into the pyramidal process of the os pedis.

uu Site of the extensor brevis or peroneus brevis muscle.

wxx The peroneus longus muscle or lateral extensor.

xx The tendon which joins that of the extensor pedis at *o*.

y The flexor accessorius muscle. This is really part of the deep flexor and its thin tendon joins that of the parent muscle just below the hock.

z The tendon of the gastrocnemius muscle.

& The tendon of the superficial flexor passing over the point of the hock to which it is attached.

1 The anterior tibial artery where it turns downwards, on the metatarsal bone and becomes the great metatarsal artery.

2 The internal saphena vein.

3 The external digital vein.

4 The internal digital vein.

5 A part of the tendon of the extensor pedis.

6 Part of the capsular ligament of the hock joint.

7 8 The internal and external lateral ligaments of the hock.

9 10 Part of the suspensory ligament. This ligament has attachments similar to that of the fore limb.

The Ninth Anatomical TABLE of the Muscles, Fascias, Ligaments, Nerves, Arteries Veins, Glands and Cartilages of the HORSE

In the Head

a The dilator naris transversalis muscle.

efgg The orbicularis oris muscle.

hhhiik The superficial part of the buccinator muscle which elevates the angle of the mouth.

elm The deep part of the buccinator muscle.

The buccinator may be divided into a superficial and a deep part, and it contains a median tendinous raphé. It extends between the lower and upper jaws as far forwards as the angle of the mouth. The superficial part is called the caninus by Stubbs. Internally it is lined by the mucous membrane of the cheek.

nop The eyeball.

n The pupil.

o The iris.

p The white or sclerotic coat.

q The caruncula lachrymalis.

r The membrana nictitans or third eyelid.

s The superior rectus muscle.

t The inferior rectus muscle.

u The internal rectus muscle.

All these muscles arise from near the optic foramen and they are inserted into the sclerotic coat of the eyeball.

w The inferior oblique muscle of the eye.

xyz The infra-orbital nerve, a part of the superior maxillary division of the 5th cranial nerve. This is a sensory nerve and it supplies the skin of the nostrils, muzzle, and lips.

1 The facial or submaxillary artery.

2 The facial or submaxillary vein.

3 The scutiform cartilage.

4 The conchal cartilage of the external ear.

In the Neck

ab The sterno-thyro-hyoideus muscle. It sits upon the trachea or wind-pipe. At its mid-point there is a tendinous part from which the two slips arise one for the hyoid bone and one for the thyroid cartilage.

c The trachea or wind-pipe.

defgh Part of the longus colli muscle. This muscle covers the ventral aspect of the vertebræ. It is divided into right and left halves and it extends from the 6th dorsal vertebra to the tubercle of the atlas.

iikk The intertransversalis and semispinalis colli muscles.

m Ventral branches of the cervical spinal nerves which help to form the brachial plexus.

n The common carotid artery (cervical).

o The lower part of the jugular vein.

p Where the cephalic vein joins the jugular vein.

In the Trunk

a The semispinalis dorsi muscles.

bbccdefgh The longissimus dorsi muscle, which arises at *bb* from the crest of the ilium, and at *cc* from the lumbar and dorsal spines and the supraspinous ligament. It also gains origin from the lumbo dorsal fascia. The thickest part of the muscle is at *d*. It is inserted into the upper extremity of the ribs the lumbar transverse and articular processes, the dorsal transverse processes, the last four cervical transverse processes, and the 3rd, 4th, 5th, and 6th cervical spines.

bbfh The origin of the middle gluteus muscle. This muscle arises in part from the aponeurosis of the longissimus dorsi.

ikkllllllL The transversalis costarum muscle. This muscle lies below the longissimus dorsi and it is made up of many small muscle bundles. Its origin is from the transverse processes of the first two lumbar vertebræ and from the anterior borders of the ribs. Its insertion is into the posterior borders of the first fourteen ribs and the transverse process of the last cervical vertebra.

noopp Some of the bundles of the levatores costarum muscles.

qqrr, etc. The external intercostal muscles.

sstt The internal intercostal muscles.

(These muscles have been described previously.)

uuwwxyy Part of the transversalis abdominis muscle. This is the innermost of the abdominal muscles. It arises from the inner surface of the last ten ribs and from the lumbar

E

transverse processes. Its tendon is a wide aponeurotic sheath to which the peritoneum is attached. It is inserted into the linea alba and the ensiform cartilage of the sternum.

z The erector coccygis muscle.

1 The lateral coccygis or curvator coccygis muscle.

2 2 The intertransversalis coccygis muscle.

3 The depressor coccygis muscle.

4 Branches of the anterior gluteal nerve.

5 5, 6 6 Ventral branches of the intercostal and lumbar nerves which are going to the abdominal muscles.

7 Branches of the gluteal arteries.

8 8 Branches of the intercostal arteries.

10 A branch of the circumflex iliac artery.

11 A branch of the circumflex iliac vein.

In the Shoulders and Fore Limbs

abcde Portions of the subscapularis muscle which can be seen projecting from under the scapula. This muscle arises from the subscapular fossa and is inserted into the internal tuberosity of the humerus at the point *e*.

fgh The teres major muscle. This muscle arises from the dorsal border of the scapula and is inserted into the humerus at its inner tubercle.

ikllmno The long head of the triceps brachii. It is inserted into the olecranon process at about *q*.

pq The coraco brachialis muscle.

p The origin from the inner side of the coracoid process of the scapula.

q The insertion into the inner aspect of the shaft of the humerus.

rs The brachialis anticus muscle. This muscle sits in the musculo-spiral groove of the humerus. It is inserted just below *s* into the radius under the internal lateral ligament of the elbow joint.

t The internal flexor muscle of the metacarpus (flexor metacarpi internus). This muscle arises from the inner condyle of the humerus and is inserted into the head of the internal small metacarpal bone.

u Part of the flexor metacarpi externus muscle.

w The musculo-cutaneous nerve.

x The median nerve.

y The ulnar nerve.

zz The radial or musculo-spiral nerve.

1 The circumflex nerve.

2 The axillary artery.

3 The axillary vein.

4 The brachial artery.

5 The cephalic vein.

6 6 The capsular ligaments of carpal, fetlock, pastern, and coffin joints.

7 7 The internal and external lateral ligaments of the carpal, fetlock, pastern, and coffin joints.

8 8 The internal and external lateral cartilages of the foot.

In the Hind Limbs

aab The iliacus muscle. This muscle lies on the ventral aspect of the ilium from which it gains origin. It is inserted into the internal trochanter of the femur along with the psoas magnus muscle.

ccdefghi The flexor metatarsi muscle.

cc The origin of the tibialis anticus.

d The origin of the superficial tendinous part, the peroneus tertius.

e The course of the peroneus tertius down the tibia.

f The insertion into the metatarsal tuberosity.

g The site of the division of the tendons.

h The insertion into the cuneiform parvum bone.

i The insertion into the cuboid bone.

kl A part of the extensor pedis muscle.

1 1 The anterior tibial artery. At the lower figure 1 it is the great metatarsal artery.

2 The anterior tibial vein.

3 The middle straight patellar ligament.

4 The external lateral patellar ligament.

5 The external lateral ligament of the stifle joint.

6 Part of the capsular ligament of the stifle joint.

7 The external lateral ligament of the hock joint.

8 The internal lateral ligament of the hock joint.

9 9 The internal and external lateral ligaments of the fetlock joint.

10 10 The internal and external lateral ligaments of the pastern joint.

11 11 The internal and external lateral ligaments of the coffin joint.

12 12 12 12 The anterior part of the capsular ligament of the hock joint.

13 13 The anterior part of the capsular ligament of the fetlock joint.

14 14 The anterior part of the capsular ligament of the pastern joint.

15 The anterior part of the capsular ligament of the coffin joint.

16 17 The suspensory ligament.

18 18 The lateral cartilages of the foot.

The Tenth Anatomical TABLE of the Muscles, Fascias, Ligaments, Nerves, Arteries, Veins, Glands and Cartilages of the HORSE

In the Head

ab The mucous membrane lining the lips.

a The labial glands.

b The buccal glands.

c The lateral boundary of the anterior nares.

defg The four recti or straight muscles of the eye.

h The inferior oblique muscle of the eye.

i The retractor occili muscle.

k The facial or submaxillary artery.

l The facial or submaxillary vein.

m The middle part of the nasal septum. This extends from the ethmoid bone to the anterior nares. It is vertical in position and sits in the groove of the vomer bone. It is covered by nasal mucous membrane.

no The alæ cartilages of the nostril.

pqr The infra-orbital nerves.

s The scutiform cartilage of the ear.

t The conchal cartilage of the external ear.

In the Neck and Trunk

ab An intertransversalis muscle of the neck.

cc, etc., *dd*, etc. The semispinalis muscles of the back and loins.

e The erector coccygis. This muscle arises from the sacral spines, sides and summits. Its tendons are inserted into the upper aspect of the coccygeal vertebræ in series.

fgh The sacro-coccygeus lateralis or curvator coccygis muscle. This muscle arises from the last two lumbar spines and from the sacral spines. It is inserted into the lateral aspect of the coccygeal vertebræ.

i Associated with the sacro-coccygeus lateralis muscle are some small bundles which correspond to the intertransversalis muscles of the rest of the spine—the intertransversalis coccygis muscles.

k The depressor coccygis muscle. This muscle arises from the ventral aspect of the sacrum. It is in two parts, the inner part is inserted into the first six coccygeal vertebræ,

and the outer part is inserted into the vertebræ as far as the end of the tail.

ll, etc. The levatores costarum muscles.
m The superior cervical artery.
n The vertebral artery and vein.
o The common carotid artery.
q The lower end of the jugular vein.
r The internal thoracic artery.

12 The brachial artery.
13 The cephalic vein.
14 The superficial venous plexus of the foot.
16 16 The anterior interosseous ligaments of the carpus.
17 17 The internal and external lateral ligaments of the carpal, fetlock, pastern, and coffin joints.
18 18 The lateral cartilages of the foot.

In the Shoulders and Fore Limbs

1 2 3 4 4 The subscapularis muscle. This muscle has been described previously. It sits in the subscapular fossa and its tendon of insertion is attached to the internal tuberosity of the humerus.
5 The musculo-cutaneous nerve.
6 The median nerve.
7 The ulnar nerve.
8 The radial or musculo-spiral nerve.
9 The axillary or circumflex nerve.
10 The axillary artery.
11 The axillary vein.

In the Hind Limbs

aa The iliacus muscle. Here it is seen under the ilium. It has been described in a previous table.
b The suspensory ligament.
c The anterior tibial vein.
d The internal saphena vein.
ee The internal and external digital veins.
f The astragalo-metatarsal ligament.
gg, etc. The internal and external lateral ligaments of the hock, fetlock, pastern, and coffin joints.
h The external semilunar cartilage of the stifle joint.
ii The lateral cartilages of the foot.

The Eleventh Anatomical TABLE of the Muscles, Fascias, Ligaments, Nerves, Arteries, Veins, Glands and Cartilages of the HORSE

In the Head

A The conchal cartilage of the external ear.
ab The scuto-auricularis muscle.
1 2 The cervico-auricularis muscles.
3 The parotido-auricularis muscle.
c Part of the temporo-auricularis muscle.
d Part of the zygomatico-auricularis muscle.
e The orbicularis occuli muscle.
4 (Upper) Approximate site of the insertion of the sterno-maxillaris muscle into the lower jaw.
4 (Lower) The masseter muscle.
f The cornea, i.e., anterior part of the eyeball.
gh The depressor labii inferioris muscle.
iii The orbicularis oris muscle.
k The levator menti muscle.
l The superficial part of the buccinator muscle.
m The zygomaticus muscle. This muscle originates near the eye and it is inserted into the buccinator near the angle of the mouth.
n The dilator naris lateralis muscle.
o The anterior belly of the digastricus muscle.
p Site of the submaxillary lymphatic gland.
q The facial or submaxillary vein.

In the Neck, Shoulders, and Trunk

abc The mastoido-humeralis muscle. This muscle has been described previously.
def The cervical part of the trapezius muscle, under which at *d* the splenius, at *e* the cervical part of the serratus magnus, and along *fd* the rhomboideus muscles can be seen.
g The crest of the neck or mane region.
hikllmmnnopq The panniculus carnosus. This muscle extends over the area bounded by these letters. It is thickest over the area *mplom* near the ventral mid-line and it thins towards the dorsal mid-line.
p The subcutaneous abdominal or spur vein which is partly embedded in this muscle.
r The tail.

In the Fore Limbs

abcdDefghiklmn This outlines the area covered by the panniculus muscle or its fascia.
E2

a Part of the extensor metacarpi magnus muscle.
b The extensor pedis muscle.
cdD The flexor metacarpi externus and part of the flexor metacarpi medius muscles.
D Site of the pisiform bone and insertion of the flexor metacarpi externus muscle.
g Part of the posterior superficial pectoral muscle.
i A fibro fatty pad behind the fetlock which supports the ergot.
k The internal metacarpal vein.
h The internal subcutaneous vein of the forearm.
mn Site of the superficial and deep flexor tendons.
op A fascial band on the outer side of the carpus.
qr The horny hoof.
q The wall.
r The sole.

In the Hind Limbs

ABabcdefghiklmnopqrstuwwxyz& Indicates the distribution of the panniculus and the deep fascia with which it is associated.
A The semimembranosus muscle.
B The gracilis muscle.
a The middle gluteus muscle.
b The external angle of the ilium which is the point of origin of the tensor fascia lata or tensor vaginæ femoris muscle.
cde The fleshy belly of the tensor vaginæ femoris muscle.
f A part of the posterior division of the superficial gluteus muscle.
ghi Parts of the biceps femoris muscle.
k The patella.
l The fleshy belly of the extensor pedis muscle.
m The fleshy belly of the peroneus longus muscle.
n The fleshy belly of the perforans muscle.
o Lower end of the fleshy belly of the gastrocnemius muscle.
p Part of the deep fascia.
pq Near this point some tributaries of the external saphena vein are to be seen, and some cutaneous nerves which are cutaneous branches of the sciatic nerve.
r The deep fascia of the hock.
t The tendons of the perforans and the perforatus.

u The suspensory ligament.
ww The digital veins.
x The external plantar nerve.
y The internal plantar nerve.
z The deep fascia.

& The fibro fatty pad behind the fetlock which supports the ergot.
1 2 The hoof.
1 The wall of the hoof.
2 The sole of the hoof.

The Twelfth Anatomical TABLE of the Muscles, Fascias, Ligaments, Nerves, Arteries, Veins, Glands and Cartilages of the HORSE

In the Head
a The dilator naris lateralis muscle.
bb The superficial part of the buccinator muscle.
cdde The orbicularis oris muscle.
fgh The depressor labii inferioris muscle. This muscle arises from the mandible below the buccinator. Branches of the facial nerves pass between this muscle and the buccinator to gain the region of the lip.
i The deep part of the buccinator muscle.
k The masseter muscle.
l The mylo-hyoid muscle. This muscle arises from the inner side of the mandible near the alveoli. It meets its fellow in the intermaxillary space in a median raphé. It forms the floor of the mouth. It is inserted into the hyoid bone.
mm The parotid gland.
n The submaxillary lymphatic gland.
o The superior and inferior labial branches of the 7th cranial nerve, i.e., the facial.
p The facial or submaxillary artery.
q The facial or submaxillary vein.
r The duct of the parotid gland—Stenson's duct.
st The superficial temporal vein.
u The external ear.

In the Neck
abcd The subscapulo-hyoideus muscle.
a Near its origin.
cd The site of its insertion into the hyoid bone.
e The hyoid part of the sterno-thyro-hyoid muscle.
fg The sterno-maxillaris muscle.
f The insertion into the mandible near the angle of the jaw.
hh The ventral straight muscle. (The rectus capitis anticus major.)
ii A part of the intertransversalis colli muscles.
k The tendon of insertion of the trachelo-mastoideus muscle.
lmnop The splenius muscle. This muscle arises from the 2nd, 3rd, and 4th dorsal spines, the transverse processes of the first six dorsal vertebræ, and from the articular processes of the last six cervical vertebræ. It is inserted into the occipital bone near its crest.
l Near its origin.
m Where one of its tendons joins the trachelo-mastoideus muscle.
p Is near its insertion.
qqrs The rhomboideus muscle. This muscle can be divided into two parts; a cervical part and a dorsal part. The cervical part arises from the funicular portion of the ligamentum nuchæ, and the dorsal part from the supra-spinous ligament of the dorsal region. Both parts are inserted into the cartilage of prolongation of the scapula.
qr The dorsal part.
qq The cervical part.
s The insertion into the cartilage of prolongation of the scapula.
t The funicular portion of the ligamentum nuchæ.
uwxyz The cervical portion of the serratus magnus muscle. It originates from transverse processes of the last four cervical vertebræ. It is inserted into the inner face of the scapula near to the cervical angle. It is often called the levator anguli scapulæ muscle.
1 2 3 The jugular vein and its tributaries.
4 Branches of cervical arteries.
5 Branches of the cervical nerves.

In the Shoulder and Trunk
abcd The infraspinatus muscle. This muscle lies in the infra-spinous fossa and on the posterior border of the scapula. It is inserted into the external tuberosity of the humerus at a point a little above the deltoid tubercle.
effgh The teres minor muscle.
fg The insertion into the humerus.
ik The lower part of the latissimus dorsi muscle.
IK Part of the triceps brachii or extensor cubiti muscle.
L Part of the posterior superficial pectoral muscle.
llmmnnopp The external oblique muscle of the abdomen.
llmm The origin from the ribs.
mmnn The fleshy part.
pp The abdominal aponeurosis.
q The erector coccygis muscle.
r The curvator coccygis muscle.
s The intertransversalis coccygis muscle.
t The depressor coccygis muscle.
uu The sphincter ani.
w The accelerator urinæ muscle.

In the Anterior Limbs
aa The extensor pedis muscle.
ABCDGbcddeffg Indicates the distribution of the deep fascia in the fore limb. It forms a sheath for the muscles and sends in intermuscular septa to be attached to the radius and ulna.
E The tendon of the extensor metacarpi obliquus.
hh The tendon of the deep flexor of the digit.
ikk The tendon of the superficial flexor.
ll The internal and external plantar or digital nerves.
L The internal subcutaneous vein of the forearm.
mm The internal and external digital veins.
op The external lateral ligament of the carpus.
qr The internal lateral ligament of the carpus.
st Site of the pisiform bone.
ww A band of fascia which passes from the pisiform bone to the external small metacarpal bone.
uxy Part of the posterior annular ligament of the carpus.
z 1 2 Part of the fibrous sheath of the flexor tendons. It is part of the deep fascia and to some extent it controls the movement of the tendons.
3 The aponeurosis or tendon of insertion of the deep flexor. It is inserted into the semilunar crest of the os pedis.
4 4 5 5 The suspensory ligament.
6 The sensitive laminæ.

In the Hind Limbs
aaabcd The superficial gluteus muscle.
b The posterior part.
Along the line *bd* its fascia merges with that which covers the middle gluteus muscle.

efffg The middle gluteus muscle. The anterior part which arises near the crest of the ilium.

fff The thick fleshy part which is covered by fascia. This muscle is inserted into the great trochanter of the femur.

hikLlllmnnoop The tensor fascia lata or tensor vaginæ femoris muscle.

h The origin from the external angle of the ilium.

This muscle is inserted into the fascia lata of the upper tibial area. The deep fascia in the gluteal region is strong and is attached to the muscles which lie underneath. It is continuous with that of the leg, i.e., the fascia lata. The fascia forms a sheath or tube which encloses the tibial muscles. It sends in trabeculæ to be attached to the tibia and fibula.

opp The semimembranosus muscle.

qrrsstuwxyz 1 2 3 4 5 6 7 8 9 10 11 12 13 The biceps femoris muscle.

This muscle, the largest in the hind limb, originates superiorly from the spines of the sacrum, the great sacro-sciatic ligament, the gluteal and adjacent coccygeal fascia, and the tuber ischii. It is inserted into the posterior surface of the femur, the patella, the crest of the tibia and the fascia lata. It is a strong fleshy muscle and towards its lower end it shows a tendency to be divided into three parts.

z The insertion into the patella.

z 4 The insertion into the crest of the tibia.

4 4 The insertion into the fascia lata.

14 15 15 16 17 The semitendinosus muscle.

14 The origin.

16 The tendon of insertion which passes internally to the tibial crest.

18 19 19 20 The gracilis muscle. Seen on the posterior and inner aspect of the thigh. 20 shows the beginning of its wide thin tendon of insertion which passes to the internal straight patellar ligament, the internal tuberosity of the tibia, and into the deep fascia.

21 7 8 Part of the fascia lata which covers the gastrocnemius muscle and the posterior aspect of the leg, tendo achillis, etc.

22 23 24 25 26 The tendon of the superficial flexor. It is shown twisting over the tendon of the gastrocnemius muscle and at 23 covering the point of the hock.

26 At this point it partially surrounds the perforans tendon and is passing to be inserted into the os coronæ.

27 The tendon of the deep flexor below the fetlock. The figure 11 indicates its fleshy belly above the hock.

28 The tendon of the peroneus longus muscle.

29 The site where the tendon of the peroneus longus joins that of the extensor pedis. 10 is the fleshy belly of this muscle.

30 The tendon of the extensor pedis muscle. 9 indicates its fleshy belly.

40 Site of the extensor brevis digitorum muscle or the peroneus brevis muscle.

41 42 The flexor accessorius muscle.

42 The thin tendon which is going to join that of the deep flexor.

43 Part of the popliteus muscle.

44 Part of the fleshy belly of the deep flexor. 27 is its tendon near to its insertion.

45 External cutaneous nerves of the thigh.

46 47 The internal and external plantar nerves.

48 The external digital artery.

49 The external digital vein.

50 The internal digital vein.

51 The cuboid tendon of the flexor metatarsi.

52 52 The external lateral ligaments of the hock.

53 The calcaneo-cuboid ligament.

54 Part of the capsular ligament of the hock.

55 Part of the posterior common ligament of the hock.

56 56 57 57 The suspensory ligament.

57 57 The slips of the suspensory ligament which pass to the tendon of the extensor pedis.

58 The posterior annular ligament of the fetlock joint.

59 Ligaments which hold the tendon of the superficial flexor to the second phalanx, during flexion of the foot.

60 The plantar aponeurosis of the deep flexor tendon.

61 The sensitive laminæ.

The Thirteenth Anatomical TABLE of the Muscles, Fascias, Ligaments, Nerves Arteries, Veins, Glands and Cartilages of the HORSE

In the Head

a The upper lip.

bbcc The buccinator muscle.

def The depressor labii inferioris muscle. This muscle arises from the lower jaw and is inserted into the lower lip.

gggh The orbicularis oris muscle.

ii The levator menti muscle.

k The eyeball.

ll The orbicularis occuli muscle and the eyelashes.

m The masseter muscle.

n Branches of the 5th and 7th cranial nerves. For part of their course they are accompanied by the transverse facial artery.

oo The facial or submaxillary artery.

p The facial or submaxillary vein.

q The parotid duct.

rs The superficial temporal vein.

t The external ear.

In the Neck

ab The subscapulo-hyoideus muscle. This has been described previously.

c The hyoid end of the sterno-hyoid part of the sterno-thyro-hyoideus muscle.

d 5 Part of the genio-hyoideus muscle. This muscle extends from the hyoid bone to the symphysis of the jaw.

The line between right and left muscles is continuous with the mid-line of the tongue.

5 The origin.

d The insertion.

6 7 The digastricus muscle.

7 The site of its intermediate tendon.

ee The obliquus capitis inferioris muscle. This muscle arises from the spine of the axis and is inserted into the wing of the atlas. It is covered by the splenius and the complexus muscles.

f The rectus capitis ventralis or anticus major. This muscle arises from the transverse processes of the 3rd, 4th, and 5th cervical vertebræ and is inserted into the basi-occiput and the basi-sphenoid.

ghooo The intertransversalis colli muscles. These muscles arise from the articular processes of the last five cervical and the first dorsal vertebræ and are inserted into the transverse processes of the last six cervical vertebræ.

iklmn A part of the longissimus dorsi muscle in the neck.

pq The trachelo-mastoideus muscle. This muscle arises from the transverse processes of the 1st and 2nd dorsal vertebræ, and also from the oblique or articular processes of the last six cervical bones. It is inserted into the wing of the atlas and the mastoid crest.

p The fleshy belly.

q The tendon of insertion.

Rrssttuwx The complexus muscle. This muscle lies next to the ligamentum nuchæ. It arises from the 2nd, 3rd, 4th dorsal spines, from the transverse processes of the first six or seven dorsal vertebræ, and from the oblique or articular processes of the last six cervical bones. It is inserted into the occipital bone below the occipital crest.
u The tendon.
w The site of insertion.
x Where it joins a part of the ligamentum nuchæ.
yz The funicular part of the ligamentum nuchæ. At *z* the rhomboideus and trapezius muscles have been cut so as to expose the ligament.
1 The upper end of the jugular vein.
2 The facial or submaxillary vein.
3 The jugular vein.
4 Branches of the superior cervical artery and vein.

In the Trunk

aa, etc. Site of the insertion of the serratus magnus muscle into the ribs.
bbbcccc, etc., *dd*, etc. The external intercostal muscles.
cc Marks the origin of the external oblique muscle of the abdomen.
ff, etc. The lower part of the internal intercostal muscles.
hiiklmn The internal oblique muscle of the abdomen. In this region it is muscular. It arises from the external angle of the ilium and Poupart's ligament. It is inserted into the linea alba, the prepubic tendon, and the last four or five costal cartilages. The fibres of this muscle run downwards and forwards which is in the opposite direction to those of the external oblique muscle.
no The rectus abdominis muscle. The fibres of this muscle run in the antero-posterior direction. It is crossed by bands of fibrous tissue called tendinous intersections. Its origin is from the ventral aspect of the sternum and the last four costal cartilages. It is inserted as the prepubic tendon into the os pubis.
p The erector coccygis muscle.
qr The curvator coccygis (sacro-coccygeus lateralis) muscle.
s The depressor coccygis muscle.
t The external sphincter of the anus.
u The accelerator urinæ muscle.
ww Lymphatic glands.
 Blood vessels and nerves indicated in this part are branches of the intercostal and lumbar vessels and nerves.

In the Fore Limbs

ABC The triceps extensor cubiti muscle.
A Part of the long head.
B The external head.
C Their site of insertion into the olecranon process of the ulna.
abc The extensor pedis muscle.
c The tendon which is inserted into the pyramidal process of the os pedis.
dd The lateral extensor or extensor suffraginis muscle. At *c* it is joined by a slip to the extensor pedis. It is inserted into the 1st phalanx or pastern bone.
eghi The flexor metacarpi externus muscle. This muscle arises from the external condyle of the humerus near *e* and is inserted by means of two tendons, one into the pisiform bone, and the other into the head of the external small metacarpal bone. This latter tendon is indicated by the figure 1.
f The flexor metacarpi internus muscle.
kklm The deep flexor (perforans) of the digit.
kk The fleshy belly.
l The tendon.
m The insertion into the semilunar crest of the os pedis.
 Between the points *l* and *o* the deep flexor passes through the ring or loop made by the perforatus (or superficial flexor).

Nno The superficial flexor (perforatus) of the digit.
no The tendon which splits to enclose the deep flexor at the level of *q*.
N The fleshy part.
 It is attached to the radius by a strong band just above the carpus.
pp The internal and external plantar nerves.
q The external digital artery.
s The internal subcutaneous vein of the forearm.
tt The internal and external digital veins.
u Part of the capsular ligament of the shoulder joint.
wx The external lateral ligament of the carpus.
yz The internal lateral ligament of the carpus.
1 2 The continuation of the tendon of the flexor metacarpi externus muscle to the head of the external splint or small metacarpal bone.
3 3 4 4 Part of the suspensory ligament. This ligament has been described previously. Its attachments are similar in all the limbs. It passes downwards from the upper end of the metacarpal or metatarsal bones and the lower row of bones of the carpus or tarsus. It is attached to the sesamoids and sends slips over the pastern to be attached to the extensor pedis muscle.

In the Posterior or Hind Limbs

ab The iliacus muscle. This muscle originates from the ventral or iliac surface of the ilium. It extends outwards beyond the bone where it lies under the middle gluteus muscle. It is closely related to the posterior part of the psoas magnus and these two muscles are inserted by a common tendon into the internal trochanter of the femur or thigh bone.
cddddefgh The middle gluteus muscle.
c The part which arises from the aponeurosis of the latissimus dorsi, i.e., lumbo-dorsal fascia.
dddd The part which arises from the iliac crest and the deep gluteal fascia.
e The origin from the gluteal surface and the internal and external angles of the ilium. It also arises from the sacrosciatic ligament.
f The part which lies under the superficial gluteus and the biceps femoris muscles.
g The insertion into the great trochanter of the femur.
AAB The superficial gluteus muscle.
AA The fleshy part.
B The flat tendon.
C The middle gluteus muscle.
D The posterior head of the middle gluteus muscle showing on the left limb.
E The tensor fascia lata or tensor vaginæ femoris muscle.
F The sartorius muscle.
iklmnGH The posterior head of the middle gluteus muscle of the right limb. It is for a considerable way joined to the anterior part of the same muscle.
H The flat tendon of insertion.
O The adductor magnus muscle. This muscle arises from the ventral surface of the ischium in front of the tuber ischii. It is mainly inserted into the posterior surface of the femur in its middle third. (This area compares with the position of the linea aspera of the human.)
qrst The semimembranosus muscle (i.e., the adductor magnus of Percival). This muscle arises from the lower surface of the ischium, from the tuber ischii, and from the coccygeal fascia. It is inserted into the internal condyle of the femur.
uuw The gracilis muscle. This muscle arises from the ventral surface of the pubis and ischium near the symphysis by a short broad tendon. It is inserted with the sartorius muscle into the inner straight patellar ligament and into the tibia between its internal and anterior tuberosities. Its tendon of insertion is thin and is continuous with the deep fascia of the leg.

xyyz The lower part of the cut semitendinosus muscle. The point of section is marked *x*. This muscle is bifid at its origin. One part arises from the sacral spines and sacrosciatic ligament, and the other from the tuber ischii. It is inserted into the crest of the tibia and the deep fascia of the leg by a tendon. The fascial expansion of this muscle also fuses with the deep fascia in the lower tibial region.

1 2 3 The semimembranosus muscle. One of its origins is indicated at 2, i.e., the tubercle of the ischium. It is closely related to the semitendinosus muscle as it passes to the inner side of the stifle joint to be inserted into the inner condyle of the femur.

(The figures 1 2 3 probably represent a portion of the semimembranosus and a portion of the adductor muscles. The main part of the semimembranosus is represented by the letters *qrst*.)

4 5 6 7 7 8 The vastus externus muscle. This muscle arises from the external surface and the outer half of the anterior surface of the shaft of the femur.

4 Indicates its origin from below the great trochanter.

5 6 The belly of the muscle.

7 7 The insertion into the patella in common with the tendon of the rectus femoris muscle.

9 The rectus femoris muscle. This muscle arises by two heads from two pits which are in the ventral aspect of the shaft of the ilium just anterior to the acetabulum.

10 11 12 12 13 14 15 16 The gastrocnemius muscle.

10 The tendon of origin of its external head which arises from the edge of the supra condyloid fossa of the femur.

11 The internal head which arises from the supra condyloid crest.

12 12 A band of fascia which can be separated from the muscle.

13 14 The fleshy belly of the external head.

15 16 The common tendon of the two heads. This tendon is inserted into the summit of the os calcis and forms part of the tendo achillis.

17 Marks an area over which the fascia derived from the insertion of the semitendinosus muscle has been removed.

18 19 The soleus muscle. This muscle arises from the head of the fibula and its tendon is inserted into the tendon of the gastrocnemeus a little below the point marked 19. The deep fascia in this area is continuous with that of the biceps, semitendinosus, gracilis, etc. This fascia is also attached to the tendon of the gastrocnemius and the tendon of the superficial flexor or the perforatus, all helping to form the tendo achillis.

20 21 22 The tendon of the perforatus or superficial flexor of the digit. The tendon of origin of this muscle arises from the supra-condyloid fossa deep to the origin of the external head of the gastrocnemius muscle.

20 Where it passes over the summit of the os calcis to which it is attached by two lateral fibrous slips.

21 The insertion into the upper part of the second phalanx. At the back of the fetlock joint it forms a ring or tube which gives passage to the deep flexor (perforans) of the digit. This ring or tube assists in the control of the perforans. The two muscles working together, flex the fetlock joint. (The flexor perforatus represents above 20 the plantaris and below 20 the flexor brevis digitorum of man.)

23 25 25 25 26 The deep flexor (perforans) of the digit.

23 Indicates the fleshy belly which in its lower part contains a considerable amount of tendinous tissue. It arises from the external tuberosity of the tibia, from the fibula and the interrosseus ligament between these two bones, and from the rough area in the middle of the posterior surface of the tibia. Its tendon passes through the tarsal canal. In the metatarsal region the tendon is immediately anterior to that of the perforatus. It passes through the sheath provided by the perforatus at the back of the pastern. It is inserted at 26 into the rough semilunar area (i.e., the semi-

lunar crest and adjacent surface) on the ventral aspect of the os pedis.

27 27 28 29 The peroneus longus muscle or lateral extensor. It arises from the external lateral ligament of the stifle, from the fibula and from the intermuscular septum between the fibula and the deep flexor of the digit. Its tendon 28 29 passes through a groove on the external malleolus of the tibia. It then passes forwards over the lateral aspect of the hock and upper third of the metatarsus. It is inserted at 29 into the tendon of the extensor pedis, some of its fibres being continued downwards with that muscle.

30 31 The extensor pedis muscle. This muscle arises in common with the superficial portion of the flexor metatarsi (the peroneus tertius) from the digital fossa, which is situated between the trochlea of the femur and the external condyle of the femur.

30 The fleshy belly.

31 The tendon.

29 The point where it is joined by the peroneus longus tendon.

Part of its fibres are inserted into the 1st phalanx (with the peroneus longus), but its principal insertion is the pyramidal process of the os pedis.

32 The extensor brevis or peroneus brevis muscle.

33 34 The flexor accessorius muscle. This muscle arises from the posterior aspect of the external tuberosity of the tibia.

33 The fleshy belly.

34 The tendon which passes through a special sheath on the inner aspect of the hock. It is inserted into the tendon of the deep flexor behind the metatarsus a little below the hock joint.

35 35 The popliteus muscle. This muscle arises by a tendon from the lower of the two pits in the external condyle of the femur. The tendon lies under the external lateral ligament of the stifle joint. It is inserted into the upper third of the posterior surface of the tibia at 35 35.

36 36 The great sciatic nerve.

37 The lesser sciatic nerve.

38 The internal popliteal nerve.

39 The origin of the internal and external plantar nerves. These nerves are the two terminal branches of the posterior tibial nerve which in turn is the direct continuation of the internal popliteal nerve.

40 The posterior gluteal nerve, a branch of the sciatic nerve which gives branches to the gluteal, the biceps femoris, and the semitendinosus muscles.

41 The external popliteal nerve.

42 42 Branches of the external popliteal nerve. The anterior one is the anterior tibial nerve, and the posterior one is the musculo-cutaneous nerve.

43 A branch of the great sciatic nerve, probably the external saphena nerve.

44 45 46 Branches of the lateral sacral artery, which is a branch of the internal iliac artery.

45 A branch to the biceps femoris.

46 Branches which pass through the deep fascia to supply the semitendinosus muscle.

47 Arteries to the biceps femoris from the deep femoral artery.

48 A branch of the popliteal artery which goes to the biceps femoris muscle.

49 The great metatarsal artery which is the direct continuation of the anterior tibial artery.

50 The external digital artery.

51 52 53 Branches of the internal iliac vein.

52 A tributary from the biceps femoris muscle.

53 Tributaries from the semitendinosus muscle.

54 A tributary of the popliteal vein which comes from the biceps femoris muscle.

55 A tributary of the obturator vein from the femoro popliteal vein.

56 The internal and external digital veins.
57 57 The popliteal lymphatic gland commonly called the "Pope's eye".
58 58 59 59 60 The sacro-sciatic ligament and lateral ilio-sacral ligament which extend from the spines of the sacrum to its edge and from thence to the tuber ischii. The biceps femoris muscle gains origin from these ligaments.
59 59 60 60 Here the intermuscular septum of the deep fascia has been cut to show the sacro-sciatic ligament.
61 62 The external lateral ligament of the hock joint.
63 63 The calcaneo-cuboid or calcaneo-metatarsal ligament. (The seat of curb.)
64 Part of the capsular ligament of the hock joint.
65 Part of the internal lateral ligament of the hock joint.
66 66 67 67 The suspensory ligament or the superior sesamoidean ligament. It represents the interosseus muscles. It arises from the lower row of tarsal bones and upper part of the posterior surface of the great metatarsal bone. It splits into two branches which are inserted into the sesamoid bones. It sends slips 67 67 which are inserted into the tendon of the extensor pedis over the 1st phalanx.

The Fourteenth Anatomical TABLE of the Muscles, Fascias, Ligaments, Nerves, Arteries, Veins, Glands and Cartilages of the HORSE

In the Head
aaa The orbicularis oris muscle.
bbcd The buccinator muscle. This muscle of the cheek with its fibrous raphé has been described previously.
e The mucous membrane of the lip.
fg The levator menti muscle.
h The eyeball.
n The transverse facial artery.
o The facial or submaxillary artery.
p The facial or submaxillary vein.
qrs The superficial temporal vein.
t A branch of the lingual artery.
u The sublingual glands (salivary).
nnx The genio-hyoglossus muscle.
nn The origin from the mandible.
x The posterior part near its insertion into the hyoid bone.
yz The thyro-hyoid muscle.
y The origin from the thyroid cartilage of the larynx.
z The insertion into the hyoid bone.
1 1 2 The wall of the pharynx.
3 4 One of the hyo-glossus muscles.
5 The long cornu of the hyoid bone.
6 The external ear.

In the Neck
abcdef The longus colli muscle. This muscle covers the ventral aspect of the cervical vertebræ.
gg, etc,, hh, etc. The intertransversalis colli muscles.
ikll The obliquus capitis inferioris muscle. This muscle arises from the spine of the axis and is inserted into the wing of the atlas.
ik The origin.
ll The insertion.
mn The obliquus capitis superioris muscle. This muscle arises from the wing of the atlas and is inserted into the mastoid crest and the styloid process of the occipital bone.
m The origin.
n The insertion.
op The rectus capitis dorsalis or posticus major. This muscle arises from the spine of the axis and is inserted into the occiput.
o The origin.
p The insertion.
q The rectus capitis dorsalis or posticus minor. This muscle is sometimes called the medius. It arises from the wing of the atlas and is inserted into the occiput.
rstuvwxyyy The semispinalis colli and multifidus muscles; a group of muscles which occupy the area between the spines, and the oblique and the transverse processes of the cervical vertebræ.
1 1 Branches of the cervical nerves.
2 Branches of the cervical arteries.
3 Branches of the cervical veins.
4 The jugular vein.
5 The facial or submaxillary vein.
6 The jugular vein.
7 8 9 10 The ligamentum nuchæ.

In the Trunk
a A part of the longissimus dorsi.
bbcc, etc. The external intercostal muscles.
ddee The internal intercostal muscles.
f The erector coccygis muscle.
gh The curvator coccygis muscle. (Sacro-coccygeus lateralis.)
i The depressor coccygis muscle.
kklmm The transversalis abdominis muscle and its aponeurosis on the ventral aspect of the abdomen.
l The origin from the lumbar transverse processes.
oo, etc., p Branches of the intercostal and lumbar nerves which run down on the transversalis abdominis muscle to the outer border of the rectus abdominis muscle.
qq Branches of the intercostal and lumbar arteries.
r A branch of the circumflex iliac artery.
s A branch of the circumflex iliac vein.
t The external sphincter of the anus.
u The accelerator urinæ muscle.

In the Fore Limbs
abc The brachialis anticus muscle.
ab The part which arises from the lips of the musculo-spiral groove of the humerus.
c The part which is passing to its insertion on the radius to the inner side of the bicipital tuberosity.
defghi The deep flexor of the digit or perforans. This muscle has three heads of origin. From the olecranon process, from the inner condyle of the humerus and from the posterior aspect of the shaft of the radius. It has a fleshy belly which extends as far as the carpus. This is succeeded by a strong tendon, i.e., h which passes through the carpal canal, through the metacarpal and sesamoid grooves, to be inserted into the semilunar crest of the os pedis at i.
def The fleshy belly.
klmnn The superficial flexor or perforatus. This muscle arises from the internal condyle of the humerus. It is attached to the radius by a strong band and is inserted into the os coronæ by a bifid tendon.
o The posterior annular ligament of the fetlock, and part of the loop of the perforatus.
pq The internal flexor of the metacarpus (flexor metacarpi internus) muscle. This muscle arises from the internal condyle of the humerus, and is inserted into the head of the inner small metacarpal bone at about q.
rr The suspensory ligament.
s The musculo-spiral or radial nerve.
t The internal subcutaneous vein of the fore arm.

uu The interosseous ligaments between the pisiform and radius, and the pisiform and cuneiform and large metacarpal bone.

ww, etc. The internal and external lateral ligaments of the elbow, carpal, fetlock, and pastern joints.

xx The lateral cartilages of the foot.

In the Hind Limbs

abbc The iliacus muscle seen lying under the ilium from which it has origin.

deffgg The deep gluteus muscle. This muscle arises from the shaft of the ilium and the supra-cotyloid ridge or spine. It is inserted into the inner side of the convexity of the great trochanter of the femur which is marked *ff*.

hi The obturator internus muscle. This muscle arises from the floor of the pelvis around the obturator foramen; it passes outward over the lateral border of the ischii at *h* and it is inserted into the trochanteric fossa of the femur near *i*.

kl The gemelli muscle. This muscle arises from the ischium near the supra-cotyloid ridge immediately behind the deep gluteus. It consists of a bundle of muscle fibres. The tendons are inserted into the trochanteric fossa along with the obturator muscles.

m The obturator externus muscle. This muscle arises from the ventral aspect of the pelvis around the obturator foramen and its tendon is inserted into the trochanteric fossa.

n The quadratus femoris muscle. This is a strap-like muscle which arises from the ventral aspect of the ischium in front of the tuber ischii. It is inserted into the posterior surface of the femur behind the internal trochanter.

opqqrst The adductor magnus and parvus. These muscles arise from the ventral aspect of the pubis and ischium and also from the tendon of origin of the gracilis muscle. Their main insertion is into the roughened quadrilateral area which occupies the middle half of the posterior surface of the femur, and there is another insertion into the inner condyle of the femur.

uwx The gracilis muscle. This muscle arises from the pubis and ischium near to the pelvic symphysis. It is a broad and relatively thin muscle which is inserted into the inner straight patellar ligament, and into the adjacent part of the upper end of the tibia.

y The rectus parvus muscle. This muscle arises from the ilium just above the rim of the acetabulum and it is inserted into the anterior face of the shaft of the femur.

1 1 2 2 3 4 5 The cruræus muscle. This muscle may be considered to be part of the vastus externus. It arises from the shaft of the femur and is inserted into the patella.

6 7 7 8 10 The vastus internus muscle. The muscle arises from the anterior and inner aspects of the shaft of the femur and is inserted into the patella and its inner straight ligament.

11 The suspensory ligament.
A The sartorius muscle.
B Part of the adductor magnus muscle.
C The transversus perinæi muscle.
E The gemelli muscle.
F The obturator internus muscle.

12 13 14 15 16 17 18 19 20 21 The superficial flexor (perforatus) of the digit.
12 The origin from the supra-condyloid fossa of the femur.
15 Here it winds round the tendon of the gastrocnemius.
17 At this point it is expanded and sits upon the point of the hock. It is anchored by lateral slips.
18 The tendon.
20 21 The tendons of insertion passing to the os coronæ.
22 23 23 The popliteus muscle.
23 23 Its muscular part which is attached to the back of the tibia.
22 The tendon of insertion which comes from the external condyle of the femur.
24 25 26 The flexor accessorius muscle.
24 25 The fleshy belly.
26 The thin tendon which joins that of the deep flexor.
27 28 29 30 31 31 The deep flexor (perforans) of the digit.
27 The upper end of its fleshy belly, which is at the external tuberosity of the tibia.
28 The fleshy belly.
29 30 31 The tendon.
31 Marks its insertion into the os pedis.
32 (anterior) Branches of the gluteal artery.
32 (posterior) Branches of the iliaco-femoral artery.
33 The great sciatic nerve.
34 The femoral artery and its femoro-popliteal branch.
35 The popliteal artery.
36 The obturator artery.
37 The external popliteal nerve which at this point divides into the anterior tibial and musculo-cutaneous nerves.
38 The posterior tibial nerve.
40 40 The internal and external lateral ligaments of hock, fetlock, and pastern joints.
41 41 The lateral cartilage of the foot.

The Fifteenth Anatomical TABLE of the Muscles, Fascias, Ligaments, Nerves, Arteries, Veins, Glands and Cartilages of the HORSE

In the Head and Neck

a The stylo-glossus muscle.
b The stylo-pharyngeus muscle.
c The stylo-hyoid muscle.
d The hyo-glossus muscle.
e The internal pterygoid muscle.
f The external pterygoid muscle.
gh The wall of the pharynx.
i The crico-arytenoideus lateralis muscle.
k Part of the alæ cartilage of the nose.
l The levator menti muscle.
L The external ear.
mn The intertransversalis muscle.
opqqqqqr The ligamentum nuchæ.
or The funicular portion.
pq The lamellar portion.

In the Trunk

aa The semispinalis muscles.
b The supra-spinous ligament.
c The erector coccygis muscle.
d The curvator coccygis muscle (sacro-coccygeus lateralis).
ee The intertransversalis coccygis muscle.
f The depressor coccygis muscle.

In the Fore Limbs

aabccdd The suspensory ligament. Showing its origin from the lower row of carpal bones, and at *cc* from the upper and posterior part of the large metacarpal bone. It is inserted at *dd* into the sesamoids.
e The internal subcutaneous vein of the forearm.
f The brachial or posterior radial vein.

g The brachial or posterior radial artery.
h The median nerve.
iii The interrosseous ligament of the pisiform bone.
kk, etc. The internal and external lateral ligaments of the elbow, carpal, fetlock, and pastern joints.
lll The inferior sesamoidean ligaments of which there are three. They are named the superficial, the middle and the deep. They are attached to the sesamoids and to the back of the 1st phalanx.
mm The lateral cartilages of the foot.
n The intersesamoidean ligament.

In the Hind Limbs

ABBC The iliacus muscle.
aa The gemelli muscle.
bc The obturator internus muscle.
dee The obturator externus muscle.
fg The quadratus femoris muscle.
hi The pectineus muscle. This muscle arises from the pubis and the pubio-femoral ligament. It is inserted into the inner aspect of the shaft of the femur near to the nutrient foramen.
k Part of the sartorius muscle.
K The adductor magnus muscle.
lmmn The gracilis muscle.
l The origin.
n The flat tendon.
op The rectus parvus muscle.
qrs Site of origin of the rectus femoris muscle.
t The external sphincter of the anus.
uw Part of the internal sphincter of the anus.

xyz The levator ani or retractor ani muscle which arises at *x*, i.e., at the superior ischiatic spine.
1 The transverse perinæi muscle.
2 The accelerator urinæ muscle.
3 The erector penis muscle.
4 The lateral coccygeal artery.
5 The lateral sacral artery.
6 The gluteal artery.
7 A branch of the gluteal artery.
8 The ischiatic artery.
9 Branches of the internal pudic artery, some of which anastomose with the obturator artery.
10 The obturator artery.
11 The femoral artery.
12 The femoro-popliteal artery.
13 The popliteal artery.
14 The popliteal vein.
15 The posterior tibial artery.
16 A muscular branch of the posterior tibial artery.
17 17 The great sciatic nerve.
18 The posterior tibial nerve.
19 19 The internal and external plantar or digital nerves.
20 The interosseous ligament between the tibia and the fibula.
21 The calcaneo-metatarsal ligament.
22 The interosseous ligament of the hock.
23 24 24 The suspensory ligament.
25 The intersesamoidean ligament.
26 27 27 27 The inferior sesamoidean ligaments.
28 28 The lateral cartilages of the foot.
29 29 The internal and external lateral ligaments of the stifle, hock, fetlock, and pastern joints.

FINIS

THE
ANATOMY OF THE HORSE

ORIGINAL VERSION

TO THE

READER

WHEN I first resolved to apply myself to the present work, I was flattered with the idea, that it might prove particularly useful to those of my own profession; and those to whose care and skill the horse is usually entrusted, whenever medicine or surgery becomes necessary to him; I thought it might be a desirable addition to what is usually collected for the study of comparative anatomy, and by no means unacceptable to those gentlemen who delight in horses, and who either breed or keep any considerable number of them.

The Painter, Sculptor, and Designer know what assistance is to be gained from the books hitherto published on this subject; and as they must be supposed best able to judge, how fitly the present work is accommodated to their purpose, any address to them is superfluous.

As for Farriers and Horse-Doctors, the Veterinarian School lately established in France shews of what importance their profession is held in that country; amongst us they have frequent opportunities of dissecting, and many of them have considerable skill in anatomy: but it were to be wished that this, as well as other parts of medical science, were as generally attended to by them,

as by those gentlemen who treat the diseases and wounds of the human body. If what I have done may in any sort facilitate or promote so necessary a study amongst them, I shall think my labour well bestowed.

I will add, that I make no doubt, but Gentlemen who breed horses will find advantage, as well as amusement, by acquiring an accurate knowledge of the structure of this beautiful and useful animal.

But what I should principally observe to the Reader concerning this my performance, is, that all the figures in it are drawn from nature, for which purpose I dissected a great number of horses; and that, at the same time, I have consulted most of the treatises of reputation on the general subject of anatomy.

It is likewise necessary to acquaint him, that the proportions which I have mentioned in several places of the book, are estimated from the length of the head, as is usually done by those who have treated on the proportion of human figures; this length is taken from the top of the head to the ends of the cutting teeth, and is divided into four equal parts, each of which is again divided into twelve minutes.

ERRATA

Page 37, Col. 1, Line 48, *dele* 12

2, 8, *for* A Æ *read* Æ

 12, *for* bone as *read* bone; a

41, 1, 21, *for* os magnum *read* cuneiform bone

2, 11, *for* right *read* left

42, 2, 54, *for* right *read* left

53, 1, 19, *for* anterior *read* arteria

 38, for *kmi* read *km*

2, 38, for *f* read *fg*

57, 1, 9, *after* CDEFGHIK *add* I

59, 2, 60, *for* pasticus *read* posticus

71, 1, 31, *for* form *read* from

 52, *for* this *read* the

 54, *after* of *add* the third vertebræ of

74, 2, 47, *for* angle; *read* angle,

79, 2, 43, *for* capsular *read* capsular ligament

81, 1, 5, *for* tendon; *read* tendon *g*;

The ANATOMY of the HORSE

The First Anatomical TABLE of the Skeleton of a HORSE explained

Bones in the Head.

aaaabcdefg THE os frontis, or forehead bone; *b* a small hole which transmits an artery and nerve out of the orbit to the frontal muscle; *c* a suture which joins the frontal bone with the zygomatic, or jugal process of the temporal bone; *de* the coronal suture; *d* a squamose, or scale-like suture; *e* the part of it which makes a serrated or true suture, common to the frontal bone with the parietal bone; *f* a suture common to the frontal and nasal bones; *g* a suture common to this bone with the os unguis.

hik The vertical, or parietal bone; *i* a squamose suture, common to the parietal bone with the temporal bone; *k* the lambdoid suture, common to the parietal bone with the occipital bone.

lmnoppq The occipital bone; *l* the occipital protuberance, which in this animal is very large, together with the internal spine, or protuberance, which, directly opposite to this, makes a strong body of bone in this place; betwixt *m* and *n* is a suture, which, in young horses, is easily separated, but afterwards becomes firmly united; *o* a process which makes a considerable addition to the mammillary process of the temporal bone; *p* the condyloid process, which is incrusted with a smooth cartilage.

rsstuwx Os temporis, or temporal bone; *r* the zygomatic, or jugal process of the temporal bone; *t* the part which articulates with the lower jaw bone; *uw* a part which, in young horses, may be easily divided, but afterwards becomes firmly united; it is distinguished by the name of os petrosa, or apophysis petrosa; *u* the mammillary process; *w* the bony meatus, or entrance of the ear; *x* a suture common to the cheek bone, with the zygomatic process of the temporal bone.

yz The orbitary portion of the bone of the palate; *y* a suture common to it with the os frontis; *z* a suture common to it with the upper jaw bone.

1 2 3 4 5 6 Os unguis; 1 a small protuberance or roughness from whence arises the orbicular muscle of the eye-lid; 2 a sinus or cavity belonging to the nasal canal; 3 a suture common to this bone with the cheek bone; 4 a suture common to this bone with the bone of the nose; 5 a suture common to this bone with the bone of the forehead; 6 a suture common to this bone with the upper jaw bone.

7 8 9 10 Os jugale, or cheek bone; 8 9 a suture formed by the union of this bone with the upper jaw bone; 10 a suture formed by the union of the orbitary part of this bone with the os unguis.

11 11 12 13 14 15 Os maxillæ superioris, or the upper jaw bone; 12 the foramen or hole of the channel 12 which passes along the bottom of the orbit of the eye; 13 a suture common to this bone with the bone of the nose; 14 a suture common to the anterior part of this bone 15, and the posterior part 11 12 13.

16 Os nasi

17 17 17 17 18 19 19 20 The lower mandible or jaw bone; at 17 17 17 17 are marked roughnesses, from which arise the tendinous parts of the masseter; 18 a hole out of which passes a nerve of the fifth pair and blood-vessels to the chin; 19 19 the coronal or acute process; 20 its condyle or head that is joined with the temporal bone.

21 A moveable cartilaginous plate which is interposed in the articulation of the lower jaw.

The Vertebræ of the Neck.

AÆEEabbcde The atlas or uppermost vertebra; AÆ the posterior and superior part of the left side of this vertebra, which articulates with the condyloid process of the occipital bone; A the anterior and superior part of the right side of the atlas, which articulates with the occipital bone as a large tubercle on the anterior part of this vertebra; *bb* the transverse processes; *c* the protuberance, tubercle, or inequality on the posterior part of this vertebra, which seems to be in the place of a spinal apophysis; *d* the posterior, and inferior part of the right side of this vertebra, which articulates with the second vertebra; *e* the transverse hole through which a nerve and blood-vessels pass. *N. B.* This vertebra receives the articulating part of the occipital bone, as well as the superior articulating part of the second vertebra: the rest of the vertebræ in the inferior articulating parts of their bodies receive the superior articulating parts of the vertebra below, and have their superior articulating parts received by those above, so it is with the back and loins; E the superior and posterior holes.

fghiklmn 1 2 The epistrophæus or second vertebra of the neck; *f* the inferior part of the body which receives and is sustained by the third vertebra of the neck; *g* the superior part of its body, which is received by and sustains the atlas or first vertebra of the neck; *h* the anterior protuberance of the body of this vertebra; *i* the transverse process; *k* the spinal process; *l* the lower oblique process on the right side, which is covered with a smooth cartilage within the dotted lines; *m* the lower oblique process on the left side; at 1 is a hole where the vertebral artery goes in and comes out at 2, called the transverse hole.

opqrstuwxy The third vertebra of the neck; *o* the anterior protuberance of the body of this vertebra; *p* is the superior part of the body of this vertebra, which is received into the inferior part of the body of the second vertebra; and *q* is the inferior which receives the superior part of the body of the fourth vertebra; *r* the transverse process; *s* the right upper oblique process; *t* the right lower oblique process; *u* the spinal process; *w* the transverse holes through which the vertebral arteries and veins of the neck pass; *x* the left upper oblique process; *y* the left lower oblique process seen thro' the large foramen or hole which contains the medulla spinalis, or spinal marrow.

N. B. This explanation may serve for the fourth, fifth, sixth, and seventh vertebra of the neck; only that the anterior protuberance is wanting in the sixth; but instead of that there is a process on each side which is obliquely

placed a little more anteriorly than the transverse process but ascends obliquely outwards to join with it; it is marked *z*.

A continuation of the bones of the spine from the neck.

1*abcdef*G The first or uppermost vertebra of the back; *a* the body; *b* the transverse process; *c* the upper oblique process; *d* the lower oblique process; *e* the spinal process; *f* the lower oblique process of the left side, seen through the large hole which contains the medulla spinalis; G the ligament interposed betwixt the bodies of the first and second vertebra of the back.

2 5 6 7 8 9 10 11 12 13 14 15 16 17 18 The vertebræ below the 1st, to the letters of which the explanation of the first will answer.

ABCDEF The six vertebræ of the loins; the explanation of the first vertebra of the back will answer to the vertebræ of the loins.

ggghiiiiikkklllmmmm The os sacrum or great bone of the spine; *ggg* the anterior part or body of this bone which, in young animals, is divided into as many bodies as there are spines in this bone, it being then like five vertebræ, whose transverse processes make the unequal rough part *h* of this bone; *iiiii* the five spines; *kkk* three inferior and anterior holes, which transmit the nerves on each side; *lll* posterior foramina or holes; these foramina, both anterior and posteria, answer to the foramina through which are seen, in this table, the oblique processes of the left side of the vertebræ both of the neck, back, and loins; the transverse processes of this bone being joined, make two holes, one anterior, the other posterior, of which there is but one in the neck, &c. the transverse processes not being joined; *mmmm* the parts of this bone made by the union of those parts which were oblique processes when it was divided into five vertebræ.

nopq The first bone of the coccyx or tail; *n* the body, *o* the transverse process, *p* the upper oblique process, which articulates with the os sacrum; there is no lower oblique process; *q* the spine; *r* the ligament interposed betwixt the bodies of the first and second bone of the tail, tying them together.

The same letters on the rest of the bones of the tail will answer to the explanation of the first, only it is to be observed, that there is but little appearance of any protuberating parts after four or five of the uppermost; and in the second the uppermost oblique process forms no articulation with the first, there being no lower oblique process, on any other of these bones as observed before: the spinal process of the second bone of the tail is double, arising from the sides of the spinal channel, but not rising high enough to meet over the medulla spinalis as those of the first do; it makes two small processes: these protuberating parts diminish so fast that after the fifth or sixth bone they almost disappear, and the bones below are of an oblong figure thickest towards their extremities.

There are 18 bones in the tail.

Bones in the thorax and shoulder-blades.

aaaaab The sternum or breast bone, of which the parts *aaaaa* are bony, the rest, *b* is chiefly cartilaginous, or ligamentous, by which the bony parts are connected together.

1*cde* The first rib; *c* the head by which it is articulated with the transverse process of the first or uppermost vertebra of the back; *d* the anterior or former part of the said head which is connected to the bodies of the seventh vertebra of the neck and first of the back; *e* the cartilaginous end by which it is continued to the sternum.

This explanation will serve for the rest of the ribs, but it is to be observed, that the eight superior ribs only are connected to the sternum, the others are called false ribs.

1 2 3 4 5 6 7 8 9 10 11 12 13 14 15 16 17 18 Shew the external side of the ribs on the right side, and internal on the left side.

fg The inner side of the left scapula or shoulder-blade.

hikllmmnnopq The right scapula; *h* it's neck; *i* it's spine; *k* the coracoid apopysis, or epiphysis; *ll* it's inferior costa; *mm* it's superior costa; *nn* its basis; *o* fossa sub-spinalis; *p* fossa supra-spinalis; *q* a cartilaginous continuation of the scapula.

Bones in the right upper limb.

*abcdefghik*K*lm* The humerus *or bone of the arm; b* denotes a protuberance into which the teres minor is inserted; *cdefgh* the upper head; *cde* three protuberances which form two sinuses or grooves which are pretty deep and incrusted with a smooth cartilage; they serve to confine the heads of the biceps muscle from sliping sideways; but by their smooth cartilaginous incrustation they suffer them to slide easily up and down; *the heads of this muscle are united over the middle protuberance d and the place of their union is covered with fleshy fibres*: *h* the part of the head which is joined to the cavity of the scapula, covered with a smooth cartilaginous crust; *i* the external condyle of the lower head; *k*K the head covered with a smooth cartilage with which the radius is articulated; K the double articular eminence; *l* the anterior fossula or sinus that receives the upper head of the radius when the cubit is bent as much as it can be; *m* the posterior sinus which receives the olecranon of the ulna when the cubit is extended as much as it can be.

nopqr The radius; *no* the upper head; *o* a protuberance into which the tendon of the biceps muscle of the arm and brachialis are inserted; *pqr* the lower head of this bone; *p* denotes a sinus or groove through which goes the tendon of the extensor carpi radialis; *q* a sinus through which goes the tendon of the extensor digitorum communis; *r* a sinus through which goes the tendon which is analogous to the tendon of the extensor minimi digiti.

sttuu The ulna; *s* the olecranon or elbow; *tt* the part which articulates with the humerus; *uu* the lower part, which is very small and in aged horses becomes one bone with the radius.

wxyz 2 3 The bones of the carpus; *w* os scaphoides or naviculare; *x* os lunare; *y* os cuneiforme; *z* os pisiforme or orbiculare: (the bone called trapezium, which articulates with the thumb is not in the horse; and the bone which lies next it called the trapezoid, cubical, or least of the multangular bones of the wrist, is not seen on this limb in this table; but on the left upper limb in this table is marked 1.) 2 os magnum or the great round-headed bone of the wrist; 3 the unciform or hook-like bone of the wrist.

4 5 6 7 The metacarpal bones in this animal called the shank-bones, of which that marked 4 5 is equal to two of the metacarpal bones joined together, *viz.* that of the middle finger, and that of the ring finger ; 4 the upper head by which it articulates with the carpus; 5 the lower head, in this place incrusted with a smooth cartilage; 6 7 an imperfect metacarpal bone in the place of that in the human skeleton which belongs to the little finger; 6 the upper head by which it articulates with the unciform bone of the carpus; 7 the lower head, which is very small, and (the bones of the little finger being wanting) forms no articulation.

10 11 Two bones which are always to be found in this joint; such bones are called sesamoid bones in the human skeleton, and are frequently found in the first joints of the index and little finger, and in the joints of the thumb; they serve to throw the bending tendons farther from the centre of motion in this joint and form a proper groove for them to slide in.

12 13 A bone which is equal to the bones of the phalanges of the middle and ring finger in the human skeleton; in a horse this is called the great pastern.

14 15 The bone of the second phalanx of the fingers, or the little pastern or coronary bone.

16 The bone of the third phalanx, in a horse called the coffin bone.

17 A sesamoid bone lying over the posterior part of the

articulation of the coffin bone with the coronary bone, or the two last phalanges of the fingers.

In the left upper limb.

cde The os humeri; *cde* three protuberances which form two sinuses or grooves which are pretty deep and incrusted with a smooth cartilage.

op the radius; *o* a protuberance in the upper head into which the biceps muscle of the arm and brachialis internus are inserted; *p* denotes a sinus or groove in the lower head in which the tendon of the extensor carpi radialis lies.

uu A small part of the ulna which in aged horses becomes one bone with the radius, but in young ones is joined to it by ligaments.

wxz 1 2 The bones of the carpus; *w* os sphenoides or naviculare; *x* os lunare; *z* os pisiforme or orbiculare; 1 os trapezium; 2 os magnum, or the great round-headed bone of the wrist.

4 5 8 9 the shank or metacarpal bones; 4 5 is equal to the metacarpal bones of the middle and ring fingers joined together; 4 the head by which it articulates with the bones of the carpus; 5 the lower head incrusted with a smooth cartilage; 8 9 an imperfect metacarpal bone in the place of that which belongs to the fore-finger in the human skeleton; 8 the upper head by which it articulates with the trapezoid bone of the carpus; 9 the lower head which is very small, and the bones of the fore-finger being wanting it forms no articulation.

10 11 12 13 14 15 16 17 The three bones of the finger, or the great pastern; the little pastern or coronary bone and coffin bone with the three sesamoid bones which will all answer to the explanation on the right upper limb in this table.

In the pelvis.

abcdefgghiiklll The right os innominatum or bason bone including three others; *abcd* the os ilium, hip, or flank bone; *bc* the spine; *b* the anterior part of the spine; *c* the posterior part; *d* the protuberance from which arises the rectus muscle of the leg; *efgg* the os ischium, or hich bone; *e* the acute process; *f* the tubercle of the ischium; *gg* the posterior notch for the passage of the internal obturator muscle; *hii* the os pubis; *ii* the spine or ridge of the os pubis; *k* the great foramen of the ischium and pubis; *lll* the external margin of the acetabulum.

aabccdfhiikll The left os innominatum, which will answer to the explanation of the right os innominatum, with this difference only, that the left shews the external view and this the internal view.

In the lower limbs.

abccddefghi The right femur or thigh bone; *a* the body or middle of this bone; *bccdde* the upper extremity, of which, *b* is the neck; *cc* the head incrusted with a smooth cartilage where it is jointed into the acetabulum; *dd* the great trochanter or spoke; *e* the less trochanter or spoke; *f* a very prominent part of the linea aspera, into which the external glutæus is inserted along with a part of the fascia lata; *g* a large fossa or notch, out of and from the borders of which the external head of the gemellus, and the plantaris muscles arise; *hi* the lower extremity; *h* the outer condyle of the lower head, which at *i* is covered with a smooth cartilaginous crust.

klmnopppp The left femur or thigh bone; *l* the less trochanter; *m* a roughness from which arises the internal head of the gemellus; *n* the inner condyle; *o* the outer condyle; *pppp* the smooth cartilaginous crust which covers the part of this lower head where it is jointed to the tibia and patella.

qqqrr The patellæ or knee-pan bones; *rr* that part which is covered with a smooth cartilaginous crust which forms part of the joint at the knee.

ss The inner similunar cartilages which are interposed in the joints of the knees.

tt The outer similunar cartilages in the joints of the knees.

uvwxyuvwxy The tibiæ or greater bones of the legs; *u* the upper head; *v* that part of the upper head which, belonging to the joint of the knee, is covered with a smooth cartilaginous crust; *w* a protuberance in which terminate the anterior ligaments which come from the patella and tie it to the tibia; *y* the lower head of the right tibia; *z* the lower head of the left tibia.

1 2 1 The fibulæ or small bones of the legs; 1 the upper head; 2 the lower extremity which ends here almost in a point.

3 4 5 4 5 6 The astragali or cockal bones; 4 5 the part which forms the juncture with the bone of the leg covered with a smooth cartilaginous crust.

7 7 8 9 The calcanei or heel-bones; 8 the projecting part that sustains the astragalus; 9 the tubercle into which is inserted the tendon of the gemellus, and to which the tendon of the plantaris is attached by ligaments.

10 The cubical bone of the tarsus or ancle.

11 11 The navicular bones of the tarsus.

12 12 The middle cuneiform bones of the tarsus.

13 The less cuneiform bone of the tarsus.

N.B. What are called the great cuneiform bones of the tarsus in the human skeleton are (as well as the bones of the great toe) wanting in this animal.

14 15 16 17 14 15 16 18 19 The bones of the metatarsus or instep; 14 15 a bone which is equal to the metatarsal bones of the second and third little toes both together in the human skeleton; 14 the upper head which articulates with the three lower bones of the tarsus; 15 the lower head, in this place covered with a smooth cartilaginous crust, where it articulates with the upper head of the bone of the first phalanx or order of the small toes; 16 17 an imperfect metatarsal bone in the place of that which, in the human skeleton, belongs to the little toe; 16 the upper head, by which it articulates with the cubical bone of the tarsus; 17 the lower head which is very small, and (the bones of the little toe being wanting) forms no articulation; 18 19 an imperfect metatarsal bone in the place of that which, in the human skeleton, belongs to the first of the small toes; 18 the upper head by which it articulates with the less cuneiform bone of the tarsus; 19 the lower head which is very small, and (the bones of the first of the small toes being wanting) forms no articulation.

20 21 20 21 Bones which are always to be found in these joints, two in each, such as are called sesamoid bones in the human skeleton; they serve, in this joint, to throw the bending tendons farther from the center of motion, and form a proper groove for them to slide in.

22 23 24 22 23 24 The bones which are in the places of the three phalanges, or orders of bones of the small toes in the human skeleton: with farriers the first are called the great pasterns, the second the little pasterns, or coronary bones, the third the coffin bones.

25 25 Sesamoid bones lying over the posterior parts of the articulations of the coffin bones, with the coronary bones.

The Second Anatomical TABLE of the Skeleton of a HORSE explained

In the Head.

Aaabbccddeeffgg THE os frontis, or forehead bone divided into two by the continuation A of the sagittal or longitudinal suture; *bb* the superciliar foramina, or holes transmitting each a small artery and nerve, out of the orbit, to the frontal muscles; *cc* sutures which conjoin the frontal bone with the zygomatic or jugal processes of the temporal bones; *dd* sutures common to the os frontis with the temporal bones, which are squamose parts of the coronal suture; *ee* those parts of the coronal suture which make a true suture, and are common to the frontal bone with the parietal bones; *ff* sutures common to the frontal and nasal bones; *gg* sutures common to the frontal bone with the ossa unguis.

hhiikkl The vertical or parietal bones; *ii* the squamose or scale-like sutures, which are formed by the conjunction of the parietal with the temporal bones; *kk* the lambdoide suture formed by the conjunction of the parietal bones with the occipital bone; *l* the sagittal or longitudinal suture, formed by the union of the two parietal bones.

mnn The occipital bone; *m* the large protuberance which is marked *l* in table the first, and which, in a horse, is called the nole bone; *nn* appendixes or additions to the lambdoid suture formed by the union of the occipital bone with the temporal bones.

ooooppqrr The temporal bones; *oooo* the zygomatic or jugal processes of the temporal bones; *r* sutures common to the zygomatic processes of the temporal bones with the ossa jugalia or cheek bones.

ssttuu The ossa nasi, or bones of the nose; betwixt *s* and *s* is a suture common to the two nasal bones; *tt* sutures common to the nasal bones with the ossa unguis; *uu* sutures common to the nasal bones with the upper jaw bones.

wwxxyyzz The ossa unguis; *x* sutures common to the ossa unguis with the ossa jugalia; *yy* sutures common to the ossa unguis with the ossa maxillaria, or great bones of the upper jaw; *zz* small protuberances or roughnesses, from which arise the orbicular muscles of the eye-lids.

1 1 2 2 3 3 The ossa jugalia, or cheek bones; 3 3 sutures formed by the union of the cheek bones with the upper jaw bones.

4 4 5 5 6 6 7 7 8 8 9 The ossa maxillaria, or great bones of the upper jaw; 5 5 the foramina, or holes of the channels, which pass along the bottoms of the orbits of the eyes; 6 6 parts of the upper jaw bones which belong to the bottoms of the nostrils and arch of the palate; 7 7 8 8 9 the anterior parts, which are joined to the posterior parts of these bones by sutures marked 14 in table the first of the skeleton; 7 7 parts belonging to the bottoms of the nostrils and to the arch of the palate; 9 a suture common to the upper jaw bones.

10 11 12 13 14 15 The six dentes incisores, cutting teeth, or nippers, of the upper jaw.

16 16 18 18 Maxilla inferior, the lower mandible or jaw bone; 18 18 the coronoid apophysis.

In the Spine.

aa The transverse processes of the atlas, or uppermost vertebra of the neck.

1 *d* The transverse process of the fifth vertebra of the neck.

2 *bcddefg* The sixth vertebra of the neck; *b* the anterior and lower part of the body of this vertebra, which receives the superior part of the body of the seventh vertebra; *c* the superior part of the body of this vertebra, which is received by the fourth vertebra; *dd* the transverse process; *e* the anterior oblique process which is peculiar to this vertebra,

and marked *z* & in table the first, *f* the upper oblique process; *g* the lower oblique process.

3 *bcdfg* The seventh or last vertebra of the neck; 3 the body; *b* the anterior protuberance of the body of this vertebra; *c* the head or upper part of the body of this vertebra, which articulates with the vertebra above it; *d* the transverse process; *f* the upper oblique process; *g* the lower oblique process.

hhhhikk&c. *ll*&c The vertebræ of the back; *hhhh* the bodies; *i* the upper oblique process of the first vertebra of the back; those of the rest are not seen in this table; *kk*&c. the transverse processes; *ll*&c the spinal processes.

1 *mnop* The first vertebra of the loins; *m* the upper oblique process; *n* the lower oblique process; *p* the transverse process; *o* the spinal process.

The same explanation will do for all those of the loins.

qrrrr The os sacrum, or great bone of the spine; *q* the upper oblique process, by which it articulates with the lower oblique process of the lowest vertebra of the loins; *rrrr* the spinal processes.

ssss The bones of the tail.

In the Thorax and Shoulder-blades.

aaaaab The sternum, or breast bone, of which the parts *aaaaa* are bony, the rest *b* is chiefly cartilaginous or ligamentous and connects the bony parts together.

C The ensiform cartilage.

1 *cde* The first rib on the right side; *c* the head, by which it is articulated with the transverse process of the first or uppermost vertebra of the back; *d* the anterior or former part of the said head which is connected to the bodies of the seventh vertebra of the neck, and first of the back; *e* the cartilaginous end by which it is continued to the sternum. —This explanation will serve for the rest of the ribs on both sides, which are figured according to their order from the first or uppermost.

fghiikkllmno, *fghkkp* the scapulæ, or shoulder blades; *f* the neck; *g* the spine; *h* the coracoide or crow's-bill process; *ii* the inferior costa; *kk* the superior costa; *ll* the basis; *m* fossa sub-spinalis; *n* fossa supra-spinalis; *o* a cartilaginous continuation of the basis scapulæ; *p* the internal and concave side of the left scapula.

In the Pelvis.

abcddddeeeeff The innominate or bason bones, including three others; *abc* the os illium or flank bone; *b* the anterior part of it's spine; *c* the posterior part of it's spine; *dddd* part of the ischion or hich bone, seen betwixt the ribs; *eeee* part of the os pubis, seen also betwixt the ribs; *ff* the foraminæ or holes of these bones, seen likewise betwixt the ribs.

In the upper Limbs.

abcdefghiklmn, *abcdehiklmn* the humeri, or bones of the arm; *b* denotes a protuberance into which the teres minor is inserted; *cdefgh* the upper head; *cde* three protuberances which form two sinuses or grooves, which are incrusted with a smooth cartilage; they serve to confine the heads of the biceps muscle of the arm from sliping sideways, but suffer them easily to slide up and down; *h* that part of the head which is covered with a smooth cartilaginous crust, and articulates with the scapula; *i* the external condyle of the lower head; *kl* the lower head covered with a smooth cartilage with which the radius is articulated; *k* the round articular eminence; *l* the double articular eminence; *m* the anterior fossula or sinus that receives the upper head of the radius when the cubit is bent as much as it can be; *n* the internal condyle.

opq, opqrr The radii, or the radius of each arm; *o* a protuberance in the upper head, into which the biceps and brachialis are inserted; *p* denotes a sinus, or groove, in the lower head, through which goes the tendon of the extensor carpi radialis; *q* a sinus, through which goes the tendon of the extensor digitorum communis; *rr* a smooth cartilaginous incrustation of the lower head, where it articulates with the bones of the carpus.

ss The olecranons of the ulnæ.

wxy 1 2 3 1 *u* 2 *u* 3 *u wtxty* The bones of the carpus; *wt* os scaphoides, or naviculare; *t* the part which articulates with the radius, covered with a smooth cartilaginous incrustation; *xt* os lunare, or the lunar bone of the carpus, or wrist; *t* the part incrusted with a smooth cartilage by which it articulates with the radius; *y* the cuneiform or wedge-like bone of the carpus; 1 *u* the trapezoid, cubical, or least of the multangular bones of the carpus; at *u* incrusted with a smooth cartilage for it's articulation with the navicular bone of the carpus; 2 *u* os magnum, or the great round-headed bone of the wrist; *u* the part which articulates with the os magnum and os lunare, incrusted with a smooth cartilage; 3 *u* the unciform or hook-like bone of the wrist, at *u* incrusted with a smooth cartilage, by which it articulates with the lunar and cuneiform bones of the carpus: these cartilaginous incrustations do not appear in the left carpus, the joint being fully extended.

4 5 6 7 8, 4 5 6 8 9 The metacarpal bones, called, in the skeleton of a horse, the shank bones; 4 5 the shank bone which is equal to the metacarpal bone of the middle-finger, and that of the ring-finger both together; 4 the upper head; 5 the lower head, incrusted, in this place, with a smooth cartilage for it's articulation with the great pastern or first phalanx of the fingers; 6 7 an imperfect metacarpal bone, in the place of that which, in the human skeleton, belongs to the little-finger; 6 the upper head by which it articulates with the unciform bone of the carpus; 7 the lower head which is very small, and (the bones of the little-finger being wanting) forms no articulation; 8 9 an imperfect metacarpal bone in the place of that which, in the human skeleton, belongs to the index or first finger; 8 the upper head, by which it articulates with the trapezoid bone of the carpus; 9 the lower head, which is very small, and (the bones of the first-finger being wanting) forms no articulation.

10 11 Sesamoid bones.

12 13, 12 13 Bones which are equal to the bones of the first phalanges of the middle and ring-fingers in the human skeleton: in a horse these are called the great pasterns.

14 15, 14 15 bones of the second phalanges; the little pasterns or coronary bones.

16 16 The bones of the third phalanges or coffin bones.

17 A sesamoid bone, lying over the posterior part of the articulation of the coronary bone with the coffin bone, or the two last phalanges.

In the lower Limbs.

abcde, aff The thigh bones; *a* the greater trochanter or spoke; *b* the less trochanter; *c* the protuberating part of the linea aspera, into which the external glutæus is inserted along with a part of the musculus fascia lata; *d* the outer condyle; *e* the inner condyle; *ff* the anterior part of the lower head of the right femur covered with a smooth cartilage for it's articulation with the patella, and it's internal-anterior and internal-lateral ligaments.

g, gg The patellæ or knee-pan bones.

h The outer semi-lunar cartilage in the joint of the knee.

iklm, im The tibiæ, or great bones of the legs; *kl* the upper head; *k* a protuberance, into which is fixed the anterior ligaments of the patella; *l* that part which belongs to the joint of the knee and is covered with a smooth cartilage; *m* the lower head, which articulates with the bones of the tarsus.

M The fibula.

nopp, nop The astragali, or cockal bones; *no* the part which forms the juncture with the bone of the leg, covered with a smooth cartilaginous crust.

qr The os calcis, or heel bone; *r* the projecting part that sustains the astragalus.

s The cuboid, or cubical bone of the tarsus.

tt The navicular bones of the tarsus.

uu The middle cuneiform bones of the tarsus.

w The small cuneiform bone of the tarsus.

xyz&, xyz& The metatarsal, or instep bones; *xy* a bone which is equal to the metatarsal bones, of the second and third small toes both together in the human skeleton; *x* the upper head, which articulates with the three lower bones of the tarsus; *y* the lower head, which, in this place is incrusted with a smooth cartilage, and articulates with the upper head of the first phalanx or order of the small toes; *z&z&* the imperfect metatarsal bones.

1 1 The bones which are equal to the first phalanges of the second and third small toes, in the skeleton of a horse these are called the great pasterns.

2 2 The bones of the second phalanges, called in the horse the little pasterns or coronary bones.

3 3 The bones of the third phalanges, or coffin bones.

4 4 The sesamoid bones, lying over the posterior part of the articulation of the coronary bone with the coffin bone, or the two last phalanges.

The Third Anatomical TABLE of the Skeleton of a HORSE explained

In the Head.

AA **T**HAT part of the os frontis which helps to form the orbit of the eye.

abbc The occipital bone, of which *abb* is that which, in the skeleton of a horse, is called the nole bone; *c* a suture common to this bone with the os sphenoides.

def The temporal bone; *d* the zygomatic or jugal process; *e* a suture common to the temporal bone with the os sphenoides; *f* the bony meatus or entrance of the ear.

*ghh*GG Ossa palati; *g* the orbitary part; betwixt *g* and A is a suture common to this bone with the orbitary part of the frontal bone; *hh* the portia palatina, or part which compleats the arch of the palate; betwixt *h* and *h* is a suture formed by the union of these two bones.

iikllmmnn Os sphenoides; *ii* denote roughnesses into which the anterior recti muscles of the head are inserted; *mm* the pterygoid apophyses; *ln, ln* the large lateral processes of the multiform or sphenoidal bone.

pq Os jugale or cheek bone; betwixt *p* and *d* is a suture common to this bone with the zygomatic process of the temporal bone; *q* a suture common to this bone with the upper jaw bone.

rrstuw, tw The ossa maxillaria, or great bones of the upper jaw; *rrst* the posterior part of this bone; *s* the jugal apophysis; *t* the apophysis palatina of the posterior part of this bone; betwixt *t* and *t* is a suture formed by the union of these two bones; *uw* the anterior part of this bone; betwixt *r* and *u* is a suture, formed by the union of the anterior with the posterior part of this bone; *w* a process belonging to the anterior part of this bone, which helps to form the arch of the palate.

xy Os vomer; *y* that part which forms the posterior part of the septum narium.

1 2 2 *zz* Os ethmoides; 1 the part which helps to form the orbit; 2 the labyrinth of the nostrils; *z* conchæ narium superiores, the upper turbinated, or spongy bone, or the upper shell of the nostrils.

&& Conchæ narium inferiores, the lower turbinated or spongy bones, or the inferior spongy laminæ of the nose.

3 3 3 Dentes molares, or grinding teeth of the upper jaw.

4 One of the canini of the upper jaw.

5 One of the dentes incisores, cutting teeth, or nippers of the upper jaw.

6 6 7 8 Maxilla inferior, or the lower mandible, or jaw bone; 8 it's condyle or head, by which the mandible is articulated to the temporal bone.

9 Dentes incisores, the cutting teeth, or nippers of the lower jaw.

In the Spine.

abbcde The atlas, or uppermost vertebra of the neck; *a* the protuberance, tubercle, or inequality on the posterior part of this vertebra, which seems to be in the place of a spinal apophysis; *bb* the transverse process; *c* the superior and posterior notch; *d* the transverse hole; *e* a large tubercle on the anterior part of this vertebra.

fgghhiikl The epistrophæus, or second vertebra of the neck; *f* the spinal process; at *gg* the spine is divided into two, and continued to the lower oblique processes; *hh* the lower oblique processes; *ii* the transverse processes; *k* the superior part of it's body, which is received by, and sustains the atlas; *l* the transverse hole.

kllmmnnp The third vertebra of the neck; *k* the spinal process; *ll* the upper oblique processes; *mm* the lower oblique processes; *nn* the transverse processes; *p* the internal side of the body of this vertebra—This explanation will serve for those of the neck which are below this; only it is to be observed, that *o* marks the upper part of the body of the fifth vertebra, where it articulates with the fourth at *p*; *r* denotes the anterior oblique process of the sixth vertebra, and *qq* those parts of the oblique processes which are incrusted with smooth cartilages.

rr&css&ctt&c The vertebræ of the back; *rr*&c the spinal processes; *ss*&c the bodies; *tt*&c the ligaments interposed betwixt the bodies of the vertebræ, tying them to each other.

uu&cwwxx&cyyzz&c The vertebræ of the loins; *uu*&c the spinal processes; *www* the bodies; *xx*&c the transverse processes; *yy* the ligaments interposed betwixt the bodies of the vertebræ, tying them to each other; *zz*&c the openings betwixt the transverse processes through which the nerves come from the medulla spinalis.

1 1 1 1 1 2 2 2 2 2 3 3 3 3 3 4 4 &c 5 5 5 5 The os sacrum, or great bone of the spine; 1 1 1 1 1 the rough part, composed of the transverse processes of this bone; 2 2 2 2 the spinal processes; 3 3 3 3 3 the anterior part, which, in a young horse, is divided into as many bodies as there are spines, betwixt which, in the parts 5 5 5 5, are bony lines that were formerly ligaments.

6 6 &c 7 7 &c 8 8 &c 9 9 &c The bones of the coccyx or tail; 6 6 &c the transverse processes; 7 7 &c the spinal processes; 8 8 &c the bodies; 9 9 &c the ligaments interposed betwixt the bodies of the bones of the tail.

In the Thorax and Shoulder-blades.

aa The sternum.

b The ensiform cartilage.

cc &c *dd* &c *ee* &c *ff* &c *gg* &c The ribs; *cc* &c the parts by which they articulate with the bodies of the vertebræ; *dd* &c the cartilages by which they are continued to the sternum, eight on each side; *ee* &c the external side of the ribs; *ff* &c the internal side of the ribs; *gg* &c the cartilages of the false ribs which are ten on each side.

hiikl The right scapula; *h* it's spine; *ii* it's basis; *k* a cartilaginous continuation of its basis; *l* it's fossa subspinalis.

mmno The internal side of the left scapula; *n* the coracoide apophysis; *o* a small part of its neck.

In the Pelvis.

abcdefgghhhii, A*bcfghh* The innominate or bason bones, including three others; *abcd* the os illium on the right side; *bc* its spine; *d* a protuberance, from which arises the rectus muscle of the leg; *ef* the os ischium or hich bone; *e* the acute process; *f* the tubercle; *gg* the os pubis; *hhhh* the great foramen of the ischium and pubis; *ii* the external margin of the acetabulum.

In the upper Limbs.

abcd, A The humeri or bones of the arm; *ab* the upper head; *b* the part of the head which is joined to the cavity of the scapula, covered with a smooth cartilaginous crust; *c* a protuberance into which the teres minor is inserted; *d* the external condyle of the lower head; A a small part of the head of the right humerus.

efgg, *g* The ulnæ; *e* the olecranon; *f* the part which articulates with the humerus; *gg* the lower part of the ulna, which, in aged horses, becomes one bone with the radius.

hiklmnop, *klmnop* the radii; *hi* the upper head of the radius; *klmno* the lower head; *k* a sinus, through which goes the tendon of the extensor minimi digiti in the human body; *m* the part which articulates with the os sphenoides, or naviculare, incrusted with a smooth cartilage; *n* the part which articulates with the os pisiforme or orbiculare, incrusted with a smooth cartilage; *o* a sinus which receives the os lunare when this joint is bent as much as it can be.

P*pqrstuwxyz*, P*pqrstuwxyz* The bones of the carpus; P os pisiforme or orbiculare; *pq* os sphenoides or naviculare; *p* the part covered with a smooth cartilage for it's articulation with the radius; *r* os lunare; *s* os cuneiforme; *tu* os trapezium; *t* the cartilaginous incrustation by which it articulates with the os sphenoides; *wx* os magnum, or the great round-headed bone of the wrist; *w* the round head covered with a smooth cartilage for it's articulation with the os lunare; *yz* the unciform or hook-like bone of the wrist; *y* the smooth cartilaginous incrustation for it's articulation with the cuneiform or wedge-like bones of the wrist.

1 2 2 3 4 5 6 7, 1 3 4 5 6 7 The metacarpal bones; 1 2 2 3 a bone which is equal to the metacarpal bones of the middle and ring-fingers both together in the human skeleton; 1 the head, by which it articulates with the three lower bones of the carpus; 2 2 3 the lower head, incrusted with a smooth cartilage for it's articulation with the ossa sesamoidea; 4 5 an imperfect metacarpal bone in the place of that which, in the human skeleton, belongs to the fore-finger; 4 the upper head, which articulates with the os trapezium; 5 the lower head, which is very small, and (the bones of the fore-finger being wanting) forms no articulation; 6 7 an imperfect metacarpal bone in the place of that which, in the human skeleton, belongs to the little finger; 6 the upper head, by which it articulates with the hook-like bone of the carpus; 7 the lower head, which is very small, and (the bones of the little finger being wanting) forms no articulation.

8 9 8 9 Ossa sesamoidea, two bones which are always to be found in this joint; they serve to throw the bending tendons farther from the center of motion in this joint, and form a proper groove for them to slide in.

10 10 The bones of the first phalanges or order of bones in the fingers, in the horse called the great pasterns.

11 11 The bones of the second phalanges, called in the horse, the little pasterns or coronary bones.

12 12 The bones of the third phalanges, or the coffin bones.

13 13 Sesamoid bones, lying over the posterior parts of the articulations of the coffin bones with the coronary bones, or the two last phalanges of the fingers.

In the lower limbs.

abcddefghik, *acddefghik* Ossa femorum, or the thigh bones; *b* the head, incrusted with a smooth cartilage for its articulation with the acetabulum; *c* the less trochanter; *dd* the great trochanter; *e* a very prominent part of the linea aspera, into which the external glutæus is inserted along with part of the fascia lata; *f* a large fossa or notch, out of and from the borders of which, the external head of the gemellus and the plantaris muscles arise; *g* a roughness from which arises the internal head of the gemellus; *h* the outer condyle of the lower head, covered with a smooth cartilage; *ik* the inner condyle, at *i* incrusted with a smooth cartilage.

ll The patellæ, or knee-pan bones.

mm The outer semi-lunar cartilages, which are interposed in the joints of the knees.

nn The inner semi-lunar cartilages, which are interposed in the joints of the knees.

opqr, *opqr* The tibiæ, or great bones of the legs; *op* the upper head; *r* the lower head.

st, *st* The fibulæ, or small bones of the legs; *s* the upper head; *t* the lower extremity which ends here almost in a point.

uwxxyz& 1, *uwxxyz&* 1 The bones of the tarsus.

uw uw The calcanei, or heel bones.

xx xx The astragali, or cockal bones.

yy The cubical bones of the tarsus.

zz The navicular bones of the tarsus.

&& The middle cuneiform bones of the tarsus.

1 1 The less cuneiform bones of the tarsus.

2 3 4 5 6 7, 2 3 4 5 6 7 The bones of the metatarsus, or instep; 2 3 a bone which is equal to the metatarsal bones of the second and third little toes, both together, in the human skeleton; 2 the upper head, which articulates with the three lower bones of the tarsus; 3 the lower head, covered with a smooth cartilaginous crust; 4 5 an imperfect metatarsal bone, in the place of that, in the human skeleton, which belongs to the first of the small toes; 4 the upper head, by which it articulates with the less cuneiform bone of the tarsus; 5 the lower head, which is very small, and (the bones of the first of the small toes being wanting) forms no articulation; 6 7 an imperfect metatarsal bone in the place of that which, in the human skeleton, belongs to the little toe; 6 the upper head, by which it articulates with the cubical bone of the tarsus; 7 the lower head, which is very small, and (the bones of the little toe being wanting) forms no articulation.

8 9 8 9 Ossa sesamoidea, they are bones which are always to be found in these joints, two in each, they serve to throw the bending tendons farther from the center of motion, and form a proper groove for them to slide in.

10 10 11 11 12 12 The bones which are in the places of the three phalanges or orders of bones in the human skeleton: with farriers the first are called the great pasterns; the second the little pasterns or coronary bones; and the third the coffin bones.

13 13 Sesamoid bones lying over the posterior parts of the articulations of the coffin bones, with the coronary bones.

The ANATOMY of the HORSE

The First Anatomical TABLE of the Muscles, Fascias, Ligaments, Nerves, Arteries, Veins, Glands and Cartilages of a HORSE explained

In the Head.

AA*a* EPICRANIUS, or muscle of the scalp; AA the tendinous expansion that goes to the elevator of the upper lip and wing of the nose; *a* the fleshy part which runs over a part of the orbicular muscle of the eye-lid, and is inserted into the external skin.

bcde The orbicular muscle of the eye-lid; *e* the origin of the fibres from the ligament by which the conjunction of the eye-lids, in the great canthus, is tied to the nasal part of the os unguis.

fg The corrugator of the eye-brow; *f* it's origin; at *g* it is inserted into the skin.

hikllmno The elevator of the upper lip and corner of the mouth; *ik* its origin from the epicranius; *ll* that part which is expanded under the dilator of the nostril and mouth; *m* the part which runs over the dilator of the nostril and mouth, and is inserted into the corner of the mouth; *n* the place where it divides for the passage of the dilator of the nostril and mouth; at *o* it arises from the bone near the inner angle of the eye.

pq The lateral dilator of the nostril and upper lip.

rstuwx Zygomaticus; *t* it's insertion into the orbicularis of the mouth; *wx* it's origin from the orbicularis of the eye; this muscle, in action, pulls down the inferior part of the orbicular muscle of the eye, as well as raises the corner of the mouth (and the epicranius raises the superior part of it:) it is a very thin muscle.

zz&BC The orbicular muscle of the mouth; B fibres which intermix with the fibres of the nasal muscles of the upper lip; C fibres which run over the glands of the lip towards the insertion of the elevators of the chin.

1 2 The depressor of the lower lip.

3 4 Part of the latissimus colli, which at 4 is inserted into the lower jaw bone.

5 The elevators of the chin where they are inserted into the skin, the fibres of which are intermixed with the fat of the chin.

6 The anterior dilator of the nostril.

7 The tendon of the long nasal muscle of the upper lip.

8 Septum marium.

9 The vena angularis, which is a branch of the external-anterior jugular vein here protuberating; it runs to the great or internal angle of the orbit, sending branches on each side to the muscles and integuments; it sends out a branch through the lateral cartilages of the nose, which is distributed to the nares, and another, which runs down in a winding course to the upper lip.

10 A branch of the vena temporalis.

11 Arteria angularis.

12 Branches of the nervus maxillaris inferior, they are branches of the third branch of the fifth pair.

Muscles of the outer Ear.

abbcdee Retrahens; *cdee* the upper or anterior part of the retrahens seen through the origens; this part is inserted tendinous into the ear, a little below the insertion of its middle part; *bb* the middle part of the retrahens, inserted into the external ear in the middle of it's convexity, about one third part of the way from the root of the ear to the tip; *a* the inferior or posterior part of the retrahens, coming from its origin under the middle part to be inserted into the posterior side of the convex part of the ear lower than the medius near the insertion of the lateral depressor *no*.

cdeedh The superior-anterior muscle through which is seen the origens; *ee* the place where it joins it's fellow, having no origin from the bone; *d* it's insertion into the cartilage; *h* a part of it which runs over the cartilage, and is inserted near *h* into the outer ear.

gi Muscles that run from the anterior cartilage *k*, to the external ear.

k The anterior cartilage of the outer ear.

l The lateral muscle of the anterior cartilage of the outer ear; it arises above the orbit of the eye, and is inserted into the anterior cartilage of the outer ear.

m A muscle arising under *l*, which is inserted at the inferior angle of the opening of the ear, anteriorly, with *i*.

no The lateral depressor of the outer ear, arising at *n*, from the quadratus colli it is inserted, close by the muscle *m*, into the lower angle of the opening of the ear posteriorly.

p The outer ear.

In the Neck.

3 4 *aabcdd* Latissimus colli, or quadratus of the neck; *b* it's origin from the sternum, a little below the top; 4 it's insertion into the lower jaw bone; *c* a membranous part going over the jugular vein, from which the fleshy fibres of the lateral depressor of the ear arises; *dd* the edge by which it is attached to that part of the fascia of the superior part of the trapezius which runs over the external surface of the levator humeri proprius.

fghiiklmn Levator humeri proprius; *g* that part which arises tendinous from the processus mastoideus; *h* the part which arises by thin fleshy fibres from the tendino-membranous part of the trapezius, or sends a membranous tendon to the ridge of the occiput; *l* the portion which lies under some of the part *fghiik*, and arises from the transverse processes of the four uppermost vertebræ of the neck near their extremities; it's origin is the same with the angularis called levator scapulæ proprius in the human body; *m* the end near it's insertion into the humerus between the biceps and brachiæus internus. The part *lm* may be called levator humeri proprius; the part *fghiik* musculus ad levatorem accessoris, being a distinct muscle till it comes to be joined or inserted into the levator humeri proprius, just below the opening where the nerve comes out marked 6.

opqqrrstuwxxx The upper part of the trapezius; *op* the origin of the fleshy part; *p* the thickest part; *qq* a part which, in this subject, is thin, but fleshy; the fleshy fibres are inclosed betwixt two fasciæ; the external fascia runs over the levator humeri proprius, and is attached to the

edge of the quadratus colli, it sends off a great number of small white tendinous threads which run across or intersect the fibres of the levator humeri proprius, and firmly adhere to it; the internal fascia goes on the internal surface of the levator humeri propius; *rr* in this line the carnous fibres end, but are covered, in this subject, by some of the fibres of the membrana carnosa; *s* a tendinous part; *t* a thin tendinous part, under which may be seen part of the serratus major anticus; *u* the beginning of the tendon of the carnous fibres marked *ii* of the levator humeri proprius; or a continuation of the tendon of the trapezius; *xxx* the origin of the trapezius from the Ligament of the neck.—The fleshy fibres of this muscle run in the same direction, and are joined in with the levator humeri proprius, it is inserted along with part of the levator humeri into the fascia, which covers the extending muscles on the cubit, and into the tendinous surface of the infra spinatus.

yyz& The inferior part of the trapezius; *yy* the origin; *&* its insertion; from *z* to *y* it is attached to the latissimus dorsi by white threads of tendinous fibres, which intersect the tendinous and carnous fibres both of it and the latissimus dorsi, and firmly adhere to both; these tendinous threads run from the continuation of the ligamentum colli towards this lower angle of the muscle, so that it makes a sort of double tendon for the trapezius to lie in at *z*.

cddv The jugular vein protuberating.

Upon the neck are seen branches of the cervical nerves, veins, and arteries, which go to the integuments.

In the Shoulder and Trunk.

abcddeefgghiiikllmnooooooooppqrs Membrana carnosa; *a* the thickest fleshy part; *b* the thick fleshy parts running upon the extensors of the cubit, becomes tendinous at *c*, and goes to be inserted with the latissimus dorsi and teres major into the humerus; *dd* some of the thick fleshy part going over the muscles of the cubit and tending towards the cubit, forms the membranous tendon *q*, under which may be seen some branches of nerves and blood-vessels which are dispersed in the fleshy pannicle; *ee* the posterior and inferior beginning of the fleshy fibres which arise rather thin but increase in thickness gradually as they advance towards the part *a*; *f* a fleshy part which runs into the duplicature of this membrane, &c. as it goes towards the thigh; at *gg* it is fleshy, but little more than a membrane, being very thin; *h* a membranous part which runs over the penis; *iiii* the tendino-membranous part which runs over the loins, part of the back, and part of the abdomen; *k* the membranous part which helps to form the duplicature; *ll* a feint appearance of the outline of the latissimus dorsi; the part *m* is about as thick as the part *n* and the latissimus dorsi both together; *ooooooo* the part where the carnous fibres of the superior partion of this muscle, or fleshy pannicle, begin to arise, which are but very thin, and all tend towards the cubit, some of which disapper at, or are inserted into the membranous tendon *q* and appear again at or arise from the same at *pp*, then running towards the muscles on the cubit become a meer membrane as they pass over the juncture of the elbow, and are so spread over the muscles, &c. below, adhereing, in some places, to the edges of the tendons, and in others, to the edges of the ligaments which bind down the muscles to keep them in their proper situations.

ttuwxyy Pectoralis; *tt* it's origin from the aponeurosis of the external oblique muscle of the abdomen, this part is inserted into the head of the os humeri internally; *x* a part arising from about two thirds of the inferior part of the sternum, which ends in a fascia descending down the muscle, on the inside the cubit; *yy* the part arising from the superior part of the sternum, for about one third of it's length, and running in a transverse direction over the inferior part, it is inserted along with the levator humeri proprius, by a flat membranous tendon, into the humerus, betwixt the biceps and brachiæus internus.

z A large vein which branches in the fleshy part of the membrana-carnosa.

The blood-vessels and nerves marked on the thorax are those distributed to the integuments which are taken off, the nerves come from the nervi dorsales or costales and nervi lumbares, the arteries from the arteriæ intercostales inferiores, and the exteriæ lumbares, and the veins from the venæ intercostales and venæ lumbares.

& The tail.

Muscles, &c. in the upper Limb or Extremity, as they appear under the Membrana-carnosa, with Remarks where it is principally attached.

abb Extensor carpi-radialis; *a* the fleshy part; *b* the tendon, the lower part of which runs under the tendon of the muscle *cc*, which is analogous to the extensors of the thumb, and under a ligament common to it and the extensor communis digitorum *tte*.

deefgh Extensor ulnaris & digitorum communis; *d* the fleshy part shewing itself under the membrane *ee*; *fg* the tendon which goes under the ligament at *e*, and giving a slip *f* to the tendon *ii* of the extensor, analogous to the extensor minimi digiti; *h* the tendon, sending fibres laterally over the ligament *m*.

iii Extensor minimi digiti, to which the carnous membrane is attached at *ik*, and sends tendinous fibres over it in the direction as marked.

n The bone, which is an imperfect metacarpal bone, to which this membrane is attached.

o A sort of spungy, fatty substance, probably a production of the membrana adiposa, lying over the protuberating part of this joint to preserve the bending tendons from bruises when this part touches the ground, &c.

pq Flexor carpi ulnaris; at *p* the fleshy fibres appear under the membrane, and also under its own tendinous surface; *q* tendinous fibres going off from this muscle to intermix with the ligaments of this articulation.

R*r* Flexor digitorum profundus; R the fleshy part appearing under the tendinous surface of this muscle as well as the carnous membrane.

s The tendon of the sublimis.

T*tt* The inter-muscular ligament to the part of which the carnous membrane has some adhesion.

u Marks the ligaments arising at *u* from the orbicular bone and running obliquely downwards and forwards.

ww Ligamentous fibres which come from the inside of the radius and run over the bending tendons to be inserted into the bone *n*, and join in with the carnous membrane.

xx Vena plantaris externa.

y Nervus plantaris externus.

z A small nerve coming from under the ligaments on the other side the carpus, and descending in an oblique manner to join the nervus plantaris externus.

The carnous membrane joins in with the membranous expansion which is sent down the cubit by part of the pectoralis, and with other membranous productions from the ligaments, forms a sort of ligament, inclosing the tendons of the extending muscles, and confines them in their proper places. This ligament is inserted into the upper part of the first bone of the finger.

The ligament arising at *u* runs down to join the tendon *i* a little below *f*, running over the tendon *i* till it comes to it's insertion near the edge of that tendon next the tendon *f*; the part *ufw* sends the principal part under the tendon *efg* to be inserted into the metacarpal bone at *bf*, the part which runs over that tendon, or those tendons, joins in with the membranous production of the pectoral muscle and carnous membrane.

& The hoof.

In the lower or posterior Limb.

abcdefghikKlmnopqrstuwxyz& Fascia lata, and musculus

faciæ latæ, with the membrana carnosa, and expansions of the muscles; *a* the part which is a continuation of the tendon of the latissimus dorsi, which arises free from the muscle glutæus medius, which lies under it; *b* the origin of the musculus fasciæ latæ from the spine of the illium.

c The anterior fleshy part; *d* the posterior fleshy part; *e* the tendon.

f The part under which the glutæus externus lies and from which it has a fleshy origin; this part is much thicker or stronger than the part *a*.

ghi The part under which the biceps tibiæ lies; this muscle in it's superior part, arises from the fascia lata.

k The semi-tendinosus lying under the said fascia, from which it also arises in the superior part.

K The patella with it's external lateral ligament which binds it to the os femoris, and it's inferior anterior ligament, which binds it to the tibia, protuberating under the fasciæ.

l The extensor longus digitorum; *m* peroneus; *n* flexor digitorum pedis; *o* Gemellus.

p Tendons formed by these fasciæ and expansions to join in with the extensors of the tarsus.

q Nerves expanded upon these fasciæ, or sent off to the external parts, as the adipose membrane and cutis. They are branches of the sciatic nerve.

r A sort of tendon formed by the sefasciæ, &c. which may probably assist the extensor digitorum when the tarsus is extended.

s The tendon of the extensor digiti.

t The tendons of the flexors.

u The interosseus, &c.

ww Veins arising from under the hoof, called venæ plantares, they run into the vena tibialis posterior.

x Nervus plantaris externus.

y A ligament sent off by the interosseus, &c. and the capsula of the fetlock joint to join and bind down the tendon of the extensor digitorum pedis.

About *z* these fasciæ have an attachment as they pass over the tendon and ligaments.

& A sort of spungy, fatty substance, probably a production of the membrana adiposa, lying over the protuberating part of this joint to preserve the bending tendons from bruises when the fetlock touches the ground.

The fascial membrano-tendinous expansions, &c. cover all these muscles, ligaments, blood-vessels, nerves, &c. forming a pretty strong coat over them; the muscles, &c. only making their appearance by protuberating under them, which they will do even when they are covered by the external skin.

A The hoof.

Muscles, &c. protuberating under the membrana carnosa in the left upper limb, viz. on the cubit, carpus, metacarpus and extremity of the limb.

ab Extensor carpi radialis; *a* the fleshy part; *b* the tendon.

c The tendon of the muscle which is analogous to the extensor of the thumb.

d Biceps cubiti.

e Pectoralis.

f Flexor digitorum.

g Flexor carpi radialis.

h Sublimis.

i Profundus.

k The tendon of the extensor ulnaris & digitorum communis.

l A sort of spungy, fatty substance, probably a production of the membrana adiposa.

m vena cephalica.

n Vena plantaris interna.

o Nervus plantaris internus.

p Interosseus, &c.

q A ligament coming from the interosseus and inserted into the extending tendon.

r The hoof.

Muscles, &c. in the internal View of the left lower Limb, as they appear through or protuberate under the fascias which cover them.

a The fleshy part of the tibialis anticus.

b The fleshy part of the sartorius.

c The tendon of the extensor digitorum pedis.

d A ligament coming from the interosseus, and joining with the tendon of the extensor digitorum pedis.

e The interosseus, &c. arising from the upper part of the metatarsal bones and some of the tarsal bones, and is inserted into the sesamoid bones, and first bone of the toe on each side, and sends off the part *d* to the tendon of the extensor digitorum pedis.

ff The tendon of the plantaris.

g A tendon formed by the semi-tendinosus, biceps cruris, &c. to go to the heel.

Betwixt *fg* and *h* are formed, by the expansions of the muscles on the inside of the thigh, two or three flat tendons like those marked *p* on the external side of the leg in this table.

The direction of the tendinous fibres of the fascia are here marked as they run over the inside of the leg, &c. about *h* they are pretty strong (under which the vena saphæna is scarcely discernable) forming a strong tendinous fascia, which joins in with the tendon of the extensor digitorum pedis at *k*.

l A sort of fatty, spungy, glandular substance, lying immediately under the skin, probably a production of the membrana adiposa lying over the protuberating part of this joint to preserve the bending tendons from bruises when the fetlock touches the ground.

m Vena saphæna.

n Branches of the vena saphæna.

o Vena plantaris interna, or a continuation of the vena saphæna.

p Nervus plantaris internus.

q A branch of the nervus cruralis.

r The hoof.

The Second Anatomical TABLE of the Muscles, Fascias, Ligaments, Nerves, Arteries, Veins, Glands and Cartilages of a HORSE explained

In the Head.

abcd THE lateral dilator of the nostril and upper lip, *bc* it's insertion into the upper lip and nostril; *d* it's origin.

f The anterior dilator of the nostril.

ghik The orbicular muscle of the mouth; *g* the part belonging to the lower lip; *h* the corner of the mouth; *i* the part belonging to the upper lip; *k* fibres which tend upwards to the insertion of the nasal muscles of the upper lip.

lmno The long nasal muscle of the upper lip; *lmn* the fleshy part; *m* it's origin; at *n* the tendon begins; *o* the tendon.

ppq The masseter.

r 8 8 Buccinator.

st The broad ligaments of the eye-lids, which are membranous elongations formed by the union of the periostium of the orbits, and pericranium along both edges of each orbit.

uuw The ciliaris muscle; *w* it's origin.

xy A muscle belonging, in part, to the alæ narium *z*, but chiefly to the concha narium inferior; *x* its insertion into the alæ narium; *y* it's origin, by a small tendon from the bone along the nasal muscle of the upper lip; below *x* it passes under the alæ narium to the inside of the nostril, and is there inserted into the concha narium inferior.

z Alæ narium.

& Septum narium.

2 2 3 The temporal muscle; 3 it's insertion into the coronary process of the under jaw bone.

4 4 Muscular fibres which extend and draw outwards the pituitary membrane 5.

5 Membrana pituitaria.

6 7 7 A muscle called caninus, or elevator of the corner of the mouth, arising from the upper jaw bone under the muscle *xy*, and inserted at 7 7 into the buccinator.

9 10 The depressor of the lower lip; it arises along with the buccinator, and is almost divided into two muscles, one superior, the other inferior, for the passage of nerves and blood-vessels to the lower lip ; the superior arises tendinous and is inserted fleshy into the lower lip laterally; the inferior arises fleshy, and is inserted tendinous nearer the middle of the lower lip.

12 The elevator of the chin.

13 A nerve going to the alæ narium.

14 Vena angularis which is a branch of the vena jugularis externa anterior.

15 Arteria angularis.

16 A branch of the vena temporalis.

17 17 Two valves, in a branch of the jugular vein.

18 Branches of the nervus maxillaris inferior. They are branches of the third branch of the fifth pair of nerves.

19 The salivary duct.

20 The anterior cartilage of the outer ear.

21 The outer ear.

22 23 A muscle arising from the anterior cartilage at 22, and inserted at 23 into the outer ear.

24 A muscle which arises by two fleshy heads from the internal surface of the anterior cartilage, and is inserted into the lower convex part of the external ear near the root, nearer the posterior edge than the anterior. It assists the posterior part of the retrahens in action.

25 A muscle which is a sort of antagonist to that marked 24, it arises from the ridge of the occiput under the retrahens, and is inserted into the ear at 25. It helps to turn the opening of the ear forwards.

26 26 26 *c* The parotid gland.

In the Neck.

abc Sterno mastoidæus, or sterno maxillaris; it arises from the top of the sternum at *b*, and is inserted by a flat tendon into the lower jaw bone, under the parotid gland at, or near, *c*, is likewise inserted into the root of the processus mastoidæus by a flat tendon.

d The spungy, fatty substance of the mane cut directly down the middle, and the left side remaining on to shew it's thickness.

e Ligamentum colli.

ff Caracohyoidæus; it arises from the upper and internal side of the humerus, betwixt the insertions of the subscapularis and teres major by a flat membranous tendon; it begins to be fleshy as it comes from under the serratus minor anticus, and is inserted into the os hyoides.

g Sternohyoidæus.

hi Transversalis; *h* the tendinous part; *i* a fleshy part.

kl The tendon of the trachelomastoidæus; *l* a fascia or membranous part.

mn Rectus internus major capitis; *m* it's lowest origin from the transverse process of the fourth vertebra of the neck, and the part *p* of the longus colli, which origin is sometimes continued down almost as low as the lower part of the transverse process of the fifth.

oooo Inter-transversales minores colli; they run from the transverse process of one vertebra to the transverse process of the next to it.

pq Longus colli.

rstuw Splenius; *r* the part coming from the origin of this muscle, which is from the expansion common to it, and the serratus minor posticus, &c. It arises tendinous from the ligamentum colli under the rhomboides, and fleshy about the superior part of the neck.

At *s* it is inserted into, or attached to the transversalis; at *t* to the tendon of the trachelomastoidæus; *u* the part which goes to be inserted into the occiput. It is also inserted into the transverse processes of the fifth, fourth, and third vertebræ of the neck, by flat, strong tendons which run on the internal side of the muscle: it is externally fleshy within a minute or two of these insertions.

x Sternothyroidæus.

y Hyothyroidæus.

z Cricothyroidæus.

& The lower constrictor of the pharinx.

1 1 Vena jugularis communis.

2 Vena jugularis externa anterior.

3 Vena jugularis externa, posterior, or superior.

4 Part of the carotid artery, or carotis communis.

5 Glandulæ claviculares, or axillares (in this animal, as there are no clavicles) or cervicales inferiores or thoracicæ superiores lymphaticæ. They are lymphatic glands.

6 6 6 6, Branches of the cervical nerves accompanied with arteries which are distributed to the musculus levator humeri proprius, &c. and integuments.

7 Branches of the cervical arteries and veins coming out of the splenius to go to the trapezius and integuments.

Muscles in the Neck and Trunk, which are inserted into the Scapula.

aab Rhomboides; *aa* the origin from the ligamentum colli: it has another origin from the superior spines of the vertebræ of the back: *b* it's insertion, or the part going to be inserted into the scapula.

cdef Serratus minor anticus; *cd* the fleshy part arising near *c* from the sternum, and part of the first rib, and from the cartilaginous endings of the second, third, and fourth ribs, near their joining to the sternum; and is inserted into the superior costa near the basis scapulæ and tendinous surface of the supra-spinatus; and is connected to the teres minor by the fascia *ef* which is sent from this muscle over

the infra-spinatus scapulæ and supra-spinatus scapulæ to its outer edge.

It's flat tendon may be separated some part of the way to the basis and spine of the scapula from the tendinous surface of the supra-spinatus scapulæ.

ghiklop Serratus major anticus; *g* part of it's insertion on the external part of the scapula; the rest of it's insertion possesses about one half of the internal part of the scapula; *h* the part which arises from the transverse process of the third vertebra of the neck; *i* that from the fourth; *k* that from the fifth; *l* that from the sixth; *o* it's origin from the seventh rib; *p* from the eighth.

This muscle arises from the six superior ribs, also within about five minutes of the cartilages. It does not adhere to the intercostals as it passes over them; but at the extremity of it's origin sends off a membranous tendon over the intercostals, towards the sternum: it arises all the way, from it's first beginning, from the external surface of the ribs up to the insertion of the tendons of the sacro lumbalis.

Muscles, &c. inserted into the humerus and cubit.

1 1 2 3 4 5 5 6 Pectoralis; 1 1 it's origin from the linea alba abdomenis; 1 2 it's origin from the lower part of the sternum; 3 it's origin from the superior part of the sternum; the part 3 4, which is the superior part of this muscle, sends a flat membranous tendon in betwixt the biceps and levator humeri proprius, to which it is joined before it's insertion into the humerus; 5 5 6 the flat tendon cut off at 5 5; the external part below this runs down the cubit.

abcdef Supra-spinatus scapulæ; it continues it's origin from the scapula from *a* to about *b*, and is inserted at *c* into the head of the os humeri, and capsular ligament on the outside of the origin of the biceps cubiti; and by the other half into the head and capsula ligament of the os humeri, or the inside of the origen of the biceps cubiti; the lower part is covered by a tendinous fascia which runs from the supra-spinatus to the serratus minor anticus, and binds that muscle in it's place; it is pretty strong at *d*, but stronger at *c*, below the protuberating part of the humerus; at *ef* a fascia runs over this muscle from the serratus minor anticus to the teres minor.

hiklmn Infra-spinatus scapulæ; from *h* to *i* are marked traces of the superior part of the trapezius's insertion on the surface of this muscle, it is attached to it at *i*, but strongly inserted into it near *h*; *hk* marks the insertion of the superior part of the trapezius upon this muscle; *l* the beginning of it's origin from the dorsum scapulæ, and the cartilage on the border of that bone; *ikm* marks of the inferior outline of this muscle, where it is bounded by the teres minor, but not easily distinguished, by reason of the tendinous surface by which they are both covered and attached together; *n* it's strongest tendon, by which it is strongly inserted into the protuberating part of the humerus under the tendinous expansion which goes from the teres minor to the lesser anterior saw muscle.

The lines upon this muscle mark the direction of some of the principal fibres of the tendinous covering.

opqq Teres minor; *o* it's origin along with the triceps cubiti; *p* it's insertion into the fascia arising from the humerus; *qq* it's insertion into the humerus; from *q* to *k* it sends off a fascia that connects it to the serratus minor anticus. The outline is much obscured by the fascia or tendinous covering of part of this muscle and the infra-spinatus with the supra-spinatus, which connects them. *kp* Marks the cutting off of the membranous tendon of the superior part of the trapezius, as *hk* marks it upon the infra-spinatus.

rrsttuw Latissimus dorsi; *rrstt* it's flat tendon; *rr* it's origin from the spinal processes of the back; at *rs* this tendon is cut away from it's attachment to the fascia lata; and at *rI* it is entirely cut away to uncover the glutæi; *ttuw* the fleshy part; *tt* the origin of the carnous fibres.

r, ru Mark the traces of the inferior part of the trapezius

inclosed betwixt the tendon of this muscle, and a tendinous fascia which covers them both together; the said fascia being cut off at *ru* and left on the latissimus dorsi leaves the marks of the trapezius very plain; *tuu* shews the direction of the fibres of the tendinous fascia which connects this part of the muscle to the triceps cubiti: these fibres run over the infra-spinatus towards the insertion of the trapezius *hk*; *w* the fleshy part going to be inserted into the humerus; *sI* the aponeurosis which runs towards the obliquus descendens, and seems to be lost upon it, degenerating into a membrane.

In the Trunk.

IIIIIKKKLM Obliquus externus, or descendens abdomenis; IIIII the place where the thickest carnous part ceases to arise from the ribs and begins to run over them without adhereing to them or the intercostals; KKK the ending or insertion of the carnous part into the tendinous part; L the linea alba or strong, broad aponeurosis, formed by this and the internal oblique muscle; it is like a broad, strong ligament, much resembling that of the neck, forming a sort of rugæ which appear on it's external surface, running from above downwards: it has a communication with the serratus major anticus by an aponeurosis, which arises from that muscle; it's first or superior origin is from the fifth rib, it arises tendinous from the back part of the insertions of the indentations of the saw muscle into the ribs, and, at it's origin receives the insertion of the lower part of the indentations of the saw muscle; it arises from the posterior or inferior labeum or edge of the eighth rib, near all the way, from I to the insertion of one of the indentations of the superior, or lesser, posterior serratus; from the posterior labeum of the ninth, almost as high as where an indentation of the lesser serratus postericus is inserted in the superior or anterior labeum of the same rib; it also arises from the tenth; and, in this subject, opposite to the insertion of the serratus minor posticus, it arises from all the ribs below that from the part where the indentations of the serratus major posticus are inserted, or a little higher than that more externally, which is the case generally with the three or four last digitations, but most as they are the lowest and runs over the indentations of the saw muscle; these digitations continue their origin from the ribs all the way down to the part marked IIIII and unite with the intercostal muscles in their passage; this muscle has a communication with the latissimus dorsi by an aponeurosis, which is sent over it by that muscle; I*r* marks the cutting away of the tendon of the latissimus dorsi to uncover the glutæi, &c. it is inserted into the os illium and os pubis and to it's fellow by the linea alba.

The blood-vessels and nerves which are marked on the thorax are those which were distributed to the parts taken off as the membrana-carnasa, &c. and integuments; the nerves come from the nervi dorsales or costales and nervi lumbares; the arteries from the arteriæ inter-costales inferiores and arteriæ lumbares; the veins from the venæ intercostales and venæ lumbares.

In the right upper Limb.

NOP Triceps brachii; N the head, which is called extensor longus major; O the short head of the triceps, called the extensor brevis; P the head called brachialis extensor longus minor. The short head O arises from the humerus, the other two from the scapula; it's insertion is into the ancon.

QRS Biceps brachii, or caraco radialis; Q the belly of the short head; R the belly of the long head; S the fascia of this muscle, which is sent down upon the muscles on the cubit.

aAbcdeegh A fascia or strong membranous production lying over the extending muscles on the cubit; *aA* it's origin from the edge of the triceps from the levator humeri proprius, and from the two protuberating parts of the

humerus, betwixt which it is extended like a strong ligament, and gives origin to some of the fleshy fibres of the extensor carpi radialis; it is inserted into the radius at *bch*; at *hh* into the ligament, and being expanded over all the extending muscles which lie on the cubit, is inserted into the internal side of that bone, all along the bounds of the bending muscles on that side; there lies under it the extensor carpi radialis, of which *d* is the fleshy part; *eef* the tendon; *bc* extensor digitorum communis; *g* what is analogous to the extensors of the thumb.

This fascia is attached to the upper edge of the extensor digitorum communis, and may, perhaps, be properly called a flat tendon, arising common to this muscle, and the extensor carpi radialis, and sending an expansion not only over but also under them, and being attached to the bone on each side down to the carpus, and also to the ligaments that bind down the tendons, running over the carpus, it makes a continued case for them from their originations down to the carpus, confining them steady in their proper places. It communicates with the fascia of the biceps muscle, and with it is inserted into the tendon of the extensor carpi radialis.

f The tendon of the extensor carpi radialis inserted into the metacarpal bone.

i The tendon of the extensor digitorum communis going to its insertion into the coffin bone.

mnooPpqrst An expansion arising at *oo* from the articulating ligament, and at *n* from the olecranon: it receives an addition from the longus minor, and internal protuberance of the humerus, and expansion of the biceps muscle, then descends over the bending muscle down to the ligaments on the carpus, to which it is attached, as well as to the bones of the cubit on each side of the bounds of the bending muscles; the different directions of it's fibres being marked as at *q*, *r*, &c. and it's insertion into the bone on the external side as at P*mb*; it then runs into the ligaments. It gives rise to fleshy fibres of the muscle *m*, which is analogous to the extensor minimi digiti, all the way from the out-line *qmb* to the bone where the expansion is inserted. It has a strong insertion at P into that protuberating bone of the carpus called the os pisiforme or orbiculare, and another betwixt the tendons *ss* of the flexor carpi ulnaris, besides it's conjunction with the ligaments on the carpus to which it is a considerable addition; *t* a part of the expansion which appears like a number of small tendons.

At *z* a ligament arises which joins the tendon *m* near *mw*, and goes along with it to be inserted into the great pastern.

A slender ligament arises about P which covers the tendon *m* and then runs betwixt it and the tendon *i* to be inserted into the upper and anterior part of the great pastern.

hhPpuwxyyz Ligaments which bind down the tendons lying upon the carpus.

16 *hhyyu* A ligament whose fibres run in a transverse direction over the anterior part of the carpus to which the carnous membrane adheres at *u*; at 16 the ligament *hhyy* 16 adheres to the bursal ligament; *xw* the insertions of the articular ligament; betwixt *c* and *h* is a ligament proper to the extensor digitorum communis, inserted at two protuberating parts of the radius, one on each side the channel in which the tendon lies; *pzw* a ligament, the fibres of which run in the upper part transverse, in the lower rather obliquely downwards, it lies on the lateral or external part of the carpus, it was covered in table the first by the production of the membrana carnosa, and pectoralis, but rather the membrana carnosa, as it lies on the external part.

1 2 A ligament arising at 1 and inserted at 2 *w*; it helps to bind down the projecting bone of the carpus, and serves as a stay to it when the flexor carpi ulnaris is in action: there is a large vein protuberating under it.

3 A ligament which helps to bind down the tendons of the sublimis and profundus.

4 The tendon of the profundus.

5 The tendon of the sublimis.

6 A vein arising from under the hoof called vena plantaris externa.

7 Nervus plantaris externus.

9 An articular ligament.

10 A ligament sent from the interosseus and inserted into the tendon of the extensor digitorum communis, which it binds down.

11 12 The horny part of the hoof; 11 the superior part; 12 the sole, or inferior part going under the coffin bone.

13 A substance resembling the villous surface of a mushroom arising from the coffin bone, received by the like arising from the hoof, which it mutually receives.

In the right lower Limb.

abccdddDefgghikl Musculus fascia lata; *a* it's origin from the ilium; *b* it's anterior fleshy belly; D the posterior fleshy belly, over which the fascia lata sends a strong membrane, as well as under, so that it is received or contained in a duplicature of the fascia lata; the fibres *dddDc* arising from the superior or external fascia, and descending to be inserted into the inferior on it's external side; the part *abc* arises from the spine of the os ilium internally tendinous; fleshy fibres arising from that flat internal tendon, and descending to be inserted chiefly into the inside of the fascia in the angle *cdgg*; the fleshy part in the superior angle *d* being thickest it gradually diminishes till it is lost in the line *gg*; the dark colour of the fleshy fibres makes some appearance in this angle though the fascia is very strong, but not near so much as the part *abg* because the covering of that is little more than a common membrane; the line *ae* marks the place where the fascia lata is cut off before it passes betwixt this muscle and the glutæus externus to be inserted into the anterior costa of the os ilium; *de* marks the place where the production of the fascia lata, which is sent over this muscle, is cut off; and *ddd* the place where it joins to the broad tendon of this muscle in which place it is cut off; *ef* shews the place where the fascia lata is cut from it's conjunction with what may be called the broad tendon of this muscle; *fg* marks the place where the fascia lata ceases to adhere to the tendon of this muscle, in order to pass down over the leg and foot; at *h* the tendinous surface of the rectus cruris makes it's appearance through the tendon of this muscle; *ik* shews the tendon or ligament which binds the patella to the tibia protuberating; *l* the ligament which binds the patella to the external protuberance of the os femoris.

This muscle is inserted, by a strong tendon, into the tibia at *i*, adhering to the tendon of the anterior and middle part of the biceps muscle in it's way; it's adhesion is all the way from *i* to the superior 4 where it has a little insertion into the patella.

mnoop Glutæus externus; *m* a fleshy origin from the ligament which runs betwixt the spinal and transverse processes of the os sacrum; *mn* the place where the fascia lata is cut off from the production which it sends under this muscle, or from it's attachment to the tendinous surface of the internal part of this muscle, which arises from the ligament running betwixt the os sacrum and ischium; and which receives first the insertion of those fleshy fibres which arise betwixt it and the ends of the spinal processes of the os sacrum from the same ligament, and then the fibres *mnoo*, which arise from the fascia lata and descend obliquely inwards and downwards to be inserted into it; *oo* the place where this muscle ceases to arise from the fascia lata and goes to be inserted at *p* into the lateral protuberance of the thigh bone; it sends off a fascia over the posterior part of the thigh bone, which runs in a transverse direction, and into which the pyramidalis is inserted, or joins in with it before it's insertion into the superior or rather posterior part of this protuberance.

qQrst Glutæus medius; *qrs* it's origin from the tendinous

surface of the sacro lumbalis; *s* it's origin from the illium; *qQrs* the part which is covered by it's own proper membrane, and does not adhere to the tendon of the latissimus dorsi, &c. nor fascia lata; *qQt* the part which receives fleshy fibres from the fascia lata, going under the glutæus externus to be inserted into the great trochanter.

ikluuwwxyz 3 4 4 5 7 7 8 8 9 11 Biceps cruris; *uuww* mark the superior or anterior head where it arises by carnous fibres from the fascia lata; it's principal origin is from the ligaments which run from the spinal to the transverse processes of the os sacrum, and from thence to the tubercle of the ischium; *w* 5 *yz* mark the inferior or posterior head, where it arises by carnous fibres from the fascia lata; it's principal origin is from the tubercle of the ischium beginning at the extremity of that tubercle from the inferior angle, and continuing its origin by a flat strong tendon about six minutes along the inferior edge of that bone; this tendon is continued down from the tubercle towards 5 betwixt *y* and *z*, from which, a little above *y*, the fleshy fibres *y* 5 7 *l* begin to arise; but the fleshy part *xz* 7 begins it's origin from the tubercle, and continues it down the said tendon; *wwl* 4 the fleshy part of the anterior head where it does not arise from the fascia lata, it is inserted into the patella and superior and anterior part of the tibia; betwixt *p* and *w* are marked tendinous fibres which bind the anterior part of this muscle to the external glutæus; and a little below that it is inserted into the thigh bone by a flat tendon, and by this insertion the anterior part of this muscle is kept from starting too much forwards, the fibres of this tendon or ligament running in almost a transverse direction; the part *f* 4 4 *lw* lies under a fascia sent from the anterior part of the posterior head, to the tendon of the musculus fascia lata, which is cut off at *wf*, and on which the direction of its fibres are marked; *xz* 5 *ywl* 7 7 the fleshy part of the posterior head where it does not arise from the fascia lata; *li* 8 8 9 3 7 7 the tendon of the posterior head which joins the tendon of the anterior head near the patella, and is likewise inserted at *i* 8 8 into the anterior part of the tibia all the way down to the ligament common to the extensor longus digitorum pedis, and tibialis anticus, and into part of the upper edge of that ligament and forms the tendon 11 with the fascia lata (which is cut off at 3 9) and is inserted into the os calcis; 7 7 3 is the strongest part of the posterior tendon which is inserted into the os calcis.

15 The tendon of the plantaris.

16 17 17 18 19 Semi-tendinosus; 16 it's origin from the ligament which runs betwixt the spines of the sacrum and the ischium, from the ligament betwixt the spinal and transverse processes of the os coccygis; 16 17 17 marks the part which receives fleshy fibres from the fascia lata; 18 the fleshy part which does not adhere to the fascia lata; 19 the tendinous production which wraps over the gemellus and join in with the fascia lata and tendon of the biceps cruris; the lines 16 17 betwixt this muscle and the biceps mark the fascia lata where it runs in betwixt these muscles; the posterior of the two lines marks the cutting off of the part of the fascia which runs over the semi-tendinosus to the large adductor of the thigh: it's principal insertion is by a flat tendon into the superior and anterior part of the tibia internally, it is also attached to the plantaris near the bottom of it's fleshy part by a flat tendon or expansion.

22 The large adductor of the thigh.

24 25 25 26 27 30 31 32 33 34 Ligaments which bind down the tendons, &c. on the tarsus, the inferior and anterior part of the leg or tibia, and the superior part of the metatarsus laterally and anteriorly; 24 25 25 a strong ligament common to the tendon of the extensor longus digitorum pedis and tibialis anticus; at 24 it falls off to be very thin, but continues to receive some origin of tendinous fibres from the tibia for some way upwards, which run internally till they are lost in the tendinous expansion of the biceps muscle, &c. which is inserted into the upper internal edge of this ligament pretty strongly, but falls away

to little or nothing in it's way towards the external lateral part of this ligament; from 24 downwards this ligament strengthens as it descends towards 25 25, where it is thick and strong: it's origin on the external lateral part of the tibia is marked 25 33: there is another strong ligament marked 26 proper to the tendon of the extensor longus digitorum pedis, which shews itself under the common membranous ligament 27 which covers it, and the articular ligament as well as blood-vessels, &c. upon the tarsus, and is attached to the ligament 24 25 25; at 25 25; at 30 are marked the directions of tendinous fibres, in this ligament, which arise from the bones of the tarsus and descend obliquely inwards and downwards; 31 marks fibres arising from the splint bone, or a bone of the metatarsus, and running transversely over the anterior part of the metatarsus joins in with the part 30; it is inserted into the superior and anterior part of the metatarsal bone; 34 marks some little appearance, by protuberation, of a ligament common to the tendon 37, and the blood-vessels marked 14; 32 marks a ligament proper to the said tendon 37, it's origin and insertion being both from the tibia.

35 A ligament which binds down the tendons of the flexors.

36 36 Extensor longus digitorum pedis.
37 37 Peroneus anticus.
38 Flexor digitorum pedis.
39 A branch of the arteria tibialis anterior.
40 Plantaris.
41 Flexor digitorum pedis.
42 46 Vena plantaris externa.
43 Nervus plantaris externus.
44 The interosseus, &c.

45 A ligament sent from the interosseus, &c. by which the tendon of the extensor longus digitorum pedis 36 is bound down, otherwise it would start from the bone when the fetlock joint gives much way.

47 48 The horny part of the hoof; 47 the superior part; 48 the sole, or inferior part going under the coffin bone.

49 A substance resembling the villous surface of a mushroom arising from the coffin bone, received by the like arising from the hoof, which it mutually receives.

In the internal Side of the left lower Limb.

a The tendon of the rectus cruris.
b Vastus internus.
cd Sartorius.
eef Gracilis.
ghkl Semi-tendinosus; *g* the fleshy part; *kl* the tendon which is inserted into the tibia at *k*; at *l* it sends off a tendon to the gemellus, to which, at *o*, the fasciæ are attached.

mmm Gemellus; *m* a fleshy part; under *n* lies the tendon over which the tendon of the plantaris is twisted.

n A tendon formed by that going off from the semi-tendinosus at *l*, and by another tendinous fascia.

opqrs The fasciæ which are inserted into the os calcis gemellus and plantaris; *o* the place where the fascia lata is cut off; *p* the part going to be inserted into the os calcis on the external side; the part *q* joins with the part *r* to be inserted into the os calcis at *s*.

tuuwx The tendon of the plantaris coming from under the fascias and twisting over the gemellus at *t*; *w* a part which it sends off to the os calcis, which makes a sort of ligament to bind in the tendon of the flexor digitorum pedis; it is spread a little upon the ligament 8 9 9 and inserted into it near it's origin from the os calcis about 8.

y The tendon of the flexor digitorum pedis lying under the thin ligament marked 35 on the right leg in this table; the bounds of it are here marked though it falls off gradually into nothing more than a common membrane, and is insensibly lost as it descends from about *y*; the lowest part of it's insertion into the splint bone is about *y*, but is here hid by the blood vessel.

z 1 The tibialis anticus appearing under the fascia.

2 3 3 The ligament marked 24 25 25 33 36 in this table of the right leg; 3 3 it's insertion into the tibia.

4 The ligament marked 30 on the right lower limb in this table.

5 A ligament which covers the tendon of the tibialis posticus arising from the posterior and inferior part, or internal inferior angle, and inserting itself into the articular ligament 9 9.

6 6 7 A ligament arising at 7 from the astragalus, and inserted at 6 6 into a cartilage lying under the tendon of the flexor digitorum pedis, which, assisted by another ligament on the other side the limb, confines it in it's place. These ligaments seem to be a part of the fascia which covers the muscles on the external side of the limb, which (passing under the tendon of the flexor digitorum pedis) forms a cartilaginous substance as it passes and is a smooth proper bed for that tendon to slide upon.

8 9 9 A strong ligament which binds the os calcis to the astragalus, os naviculare, ossa cuneiformia, and splint-bone, arising from a protuberance about 8, and inserted into the other bones of the tarsus and metatarsus about 9 9.

9 9 The articular ligament which binds the tibia to the bones of the tarsus.

10 11 A ligament running over the tendon of the plantaris, inserted into the ligament 8 9 9, and splint-bone. It is marked 35 on the right leg in this table.

12 12 12 A sort of ligamentous fascia betwixt which and the bursal ligament the mucilaginous glands are contained.

13 The ligament proper to the tendon of the extensor longus digitorum pedis, marked 26 in the right limb in this table.

14 15 16 17 The tendon of the extensor digitorum, at 14 going to be inserted into the last bone of the toe, or coffin bone: it receives the ligament 19 at the part 16, and the ligament 20 at the part 17; and, in it's passage down the toe, it adheres to the bursal ligaments under 21 and 20. It is marked 5 in table the first.

18 Interosseus, &c.

19 The ligament marked *d* in table the first. It arises from the interosseus, &c. and is inserted into the tendon of the extensor longus digitorum pedis, and binds it down.

20 A ligament which arises from the internal-lateral and inferior part of the first bone of the toe, and is inserted into the tendon of the flexor digitorum pedis, and binds it to this side, as 46 on the right lower limb, doth the same tendon to the other side.

21 Vena sapphena.

22 Nervus sciaticus internus.

23 Nervus plantaris internus.

24 Vena plantaris interna.

25 26 The horny part of the hoof; 25 the superior part; 26 the sole or inferior part going under the coffin bone.

27 A substance resembling the villous surface of a mushroom arising from the coffin bone, received by the like arising from the hoof, which it mutually receives.

In the left upper Limb.

c Part of the biceps which sends an expansion over the bending muscles lying upon the cubit.

def The expansion marked *mnoopPqrsst* on the left upper limb in this table.

gg The fascia marked *aAbcdeegh* on the left upper limb in this table.

h The tendon of the muscle which is analogous to the extending muscles of the thumb, marked *g* on the right upper limb in this table.

iiklm The ligament marked 16 *hhyyu* on the left upper limb in this table: the articular ligament appears under this: from *k* to *l* this ligament communicates with the fascia *def*.

no A ligament arising at *n*, and inserted, about *o*, like the ligament marked 1 2 on the right upper limb in this table.

p The ligament marked 3 on the right upper limb in this table. It is a continuation of the ligaments marked *no* on the right, and 1 2 on the left upper limb in this table, it is here something thinner than the ligaments *no* and 1 2, but as it descends down the limb is soon insensibly lost in a membrane.

q The tendon of the profundus.

r The tendon of the sublimis.

s A vein arising from under the hoof, called vena plantaris interna.

t Nervus plantaris internus.

wx The tendon of the extensor digitorum communis; *w* the part which is sent off from the principal tendon to be inserted into the superior and internal part of the great pastern; *x* the principal tendon inserted into the coffin bone, but in it's way is attached to the coronary bone on it's anterior and superior part.

y A ligament which arises from the interosseus, &c. and is inserted into the tendon of the extensor digitorum communis, which it binds down.

z The interosseus, &c.

1 2 The horny part of the hoof; 1 the superior part; 2 the sole or inferior part going under the coffin bone.

3 A substance resembling the villous surface of a mushroom arising from the hoof, received by the like arising from the coffin bone, which it mutually receives.

The Third Anatomical TABLE of the Muscles, Fascias, Ligaments, Nerves, Arteries, Veins, Glands and Cartilages of a HORSE explained

In the Head.

ab THE elevator of the upper eye-lid, so thin and transparent that the dark coloured part appears through at *a*, and the white at *b*.

c The lachrymal gland.

d The under eye-lid.

ee The tarsi ligamentum cilliare, or cilliar edges.

f Alæ narium.

ghii A muscle arising by a small tendon at *h*, and by a flat membranous tendon at *ii*; it is inserted near *g* into the pituitary membrane which covers the concha narium inferior: it has another insertion into the alæ narium.

k The septum narium.

mmn Caninus or elevator of the corner of the mouth; *mm* it's insertion from the corner of the mouth along the buccinator.

oo Orbicularis oris.

pqr The depressor of the lower lip.

ss Buccinator.

t The anterior dilator of the nostril.

u The elevator of the chin.

w The masseter.

1 Vena jugularis externa, posterior or superior; in a branch of which at

2 2 Are two valves, anastomasing between the anterior and posterior external branches of the jugularis.

3 Vena temporalis.

4 Vena angularis.

5 Arteria angularis.

6 7 8 Nervus maxillaris superioris; the second branch of the fifth pair of nerves; 7 branches going to the upper lip; 8 a branch which goes to the long nasal muscle of the upper lip.

9 Branches of the nervus maxillaris inferioris; they are branches of the third branch of the fifth pair of nerves; they communicate with the nervus maxillaris superioris.

10 Glandulæ labiales, part of which are cut away to shew something of the spreading of the nerves of the lip.

11 The salivary duct.

12 The anterior cartilage of the outer ear.

13 The outer ear.

In the Neck.

abcde Caracohyoidæus; *b* the part coming from it's origin at the upper and internal side of the humerus, betwixt the insertions of the sub-scapularis and teres major, by a flat membranous tendon, beginning to be fleshy as it comes from under the seratus minor anticus; *c* fibres which run towards the angle *d*, attached to the rectus anticus major, and having an origin by a flat tendon along with the insertion of that muscle from the os sphenoides; *a* fibres which intersect the wind-pipe, going from the part *cd* towards *e*, to be inserted into the os hyoides.

fg Sternohyoidæus arises at *f* from the middle tendon of the sternohyoideus, and goes, at *g*, along with the caracohyoideus to be inserted into the os hyoides.

hik Sternothyroidæus; *h* it's middle tendon; *i* the fleshy part coming from it's origin at the superior and internal part of the sternum, it runs close along with it's fellow a little higher than the part *h*, where it is tendinous, from whence it goes to be inserted at *k* into the thyroid cartilage about 3 minutes from it's fellow.

l Part of the carotid artery; at *l* goes off a branch to the sternothyroidæus.

m Nerves of the eighth pair.

n The thyroid gland.

oooo Glandulæ lymphaticæ.

q The lower constrictor of the pharinx.

r Hyothyroidæus.

s Cricothyroidæus.

t Cricoarytenoidæus posticus.

u The inferior maxillary gland.

wxy Rectus internus major capitis, or rectus anticus longus; *w* it's origin from the transverse process of the third vertebra of the neck; *x* it's origin from the transverse process of the fourth vertebra, and a part of the scalenus. It is inserted into the os sphænoides.

ABCDEFGH Transversalis cervicis; AB the superior part, which arises from the third, fourth, fifth, sixth and seventh oblique processes of the neck, and two uppermost of the back, viz. the lower oblique process of the third, and and upper oblique process of the fourth, and so of the rest: it is inserted into the transverse process of the first vertebra of the neck. CDEFGH the inferior part which arises from the transverse processes of eight of the superior vertebræ of the back, and is inserted into the transverse processes of the four inferior vertebræ of the neck, partly fleshy, but chiefly by broad thin tendons, as at DEFGH. Between the superior part AB and D the inter-transversales appear. At the extremity of it's origin it is spread out about three inches by a flat tendon expanded from it's first origin, from the eighth transverse process, to the broad tendon of the complexus to which it is strongly attached, and from the whole breadth of which fleshy fibres arise.

IKL Trachelo-mastoidæus, complexus minor, or mastoidæus lateralis; I the tendon, going to be inserted into the root of the processus mastoidæus; KL the fleshy part arising from the oblique processes of the third, fourth, fifth, sixth, and seventh vertebræ of the neck, the uppermost of the back, and transverse processes of the second and third vertebræ of the back.

MOOPPPQST Complexus; M shews some external appearance of the principal tendon towards which the fleshy fibres are directed as marked PP, &c. OO tendinous lines by which the carnous fibres PP, &c. are intersected; Q a tendinous origin from the ligamentum colli; S the part going to be inserted by a strong round tendon into the occiput near the insertion of it's fellow; at T are marked the directions of some tendinous threads which attach it to the ligamentum colli.

It begins it's origin from the upper oblique process of the third vertebra of the neck and continues it's origin from all the oblique processes of the neck below that, and from the upper oblique process of the first vertebra of the back, and, by a pretty strong flat tendon, from the transverse process of the second and third vertebræ of the back, from the last of which the tendon is reflected from the transverse process to the top of the spinal process of the same vertebra, and makes a communication betwixt this part of the muscle and that arising from the third, fourth, fifth, sixth and seventh spinal processes.

UU Obliquus capitis inferior.

WW Obliquus capitis superior.

XY Longus colli.

1 1 1 1 2 2 2 2 2 Branches of the cervical arteries and veins.

3 Part of the jugular vein.

Muscles on the Shoulder.

ab The subscapularis, which is outwardly tendinous; at *a* is marked a membranous tendon, from which the supra spinatus receives some part of it's origin; *b* marks a tendinous slip sent from this muscle which leaves it about *a*, and is inserted into the caracoid process a little below *b*.

cdeefgh Triceps extensor cubiti; *cdeee* the head, which is called extensor longus major, arising at *eee* from the

inferior costa scapulæ; *c* marks the Traces of the teres minor; at *d* are left some strong tendinous threads belonging to the infra-spinatus scapulæ which adhere to this muscle; the marks of the infra-spinatus appear all the way from *d* to the humerus; *f* the origin of that part called extensor brevis from the humerus; *g* the head called brachialis externus longus minor.

iiklmn Biceps brachii, or rather caraco radialis; *ii* the tendon arising from the scapula; *k* a fleshy part lying upon the tendon; *l* the belly of the long head; *m* the belly of the short head; *n* the aponeurosis arising from this muscle, which it sends to the tendinous fascia or covering of the cubit.

 o Nervus cubitalis.

 p Nervus radialis.

 q Nervus musculus cutaneus.

 r Nervus medianus.

 s Branches of the arteria and vena axillaris.

 t A branch from the anteria axillaris.

In the Trunk.

aabbbcd Serratus minor posticus; *aa* the beginning of it's fleshy fibres; *bbb* the flat tendons by which it is inserted into the ribs; *aac* the fleshy part; *d* the flat tendon by which it arises. In this subject this muscle runs fleshy under the serratus major posticus, and is inserted into the twelfth, thirteenth, and fourteenth ribs. It's first or superior insertion is into the fifth rib.

eefghh, &c. Serratus major posticus; *eefg* it's broad tendon; from *g* to *f* is marked the place where the tendon of the latissimus dorsi is cut off from it's insertion with this tendon into the fascia lata; *eehh*, &c. the fleshy part; *ee* the beginning of the fleshy part; *h* it's insertion into the ribs which in some subjects is only into seven inferior ribs, as in this subject, though, as here, it is more frequently inserted into eight.

l Serratus major anticus.

mm, &c. *nnnoo*, &c. *pp*, &c. *qq*, &c. *rr*, &c. Intercostals; *kmi* mark the origin of the external oblique muscle from the ribs, where they are described by shaken lines; the same kind of line marks also where they unite with the intercostals, or arise from the tendinous covering of the intercostals; *oo*, &c. mark the parts of the external intercostals which are above and below the insertion and adhesion of the external oblique muscle; *pp*, &c. some appearances of the internal intercostals: out of these places come nerves and blood-vessels which go to the external oblique muscle; *qq*, &c. some fleshy fibres which arise partly externally tendinous but chiefly fleshy, and run in a transverse direction from one rib to another. They belong to the internal intercostals. *rr*, &c. Fleshy fibres which run in the same direction of the external intercostals from one cartilaginous ending of the ribs to another. Betwixt most of the ribs there are marked blood-vessels and nerves, some of which go to the external oblique muscle, they are called intercostales.

sstuuwxy Obliquus internus, or ascendens abdominis. It arises at *ss* from the spine of the ilium tendinous and fleshy, it's origin is continued to the ligamentum fallopii, from which it arises, and from the symphysis of the os pubis: it is inserted into the cartilage of the lowest rib tendinous and fleshy, and into the cartilaginous endings of the ribs as far as the cartilago ensiformis; *sstuuw* the fleshy part ending at *uu:* the nerves and blood-vessels which are seen on this part of the muscle pass to and from the external oblique muscle and parts which are taken off; *xy* the flat tendon; that part of the tendon which runs over the rectus is cut off from *t* to *y*.

z Rectus abdominis: it arises from the os pubis, and is inserted into the cartilago ensiformis and into the cartilages of the third, fourth, fifth, sixth, seventh, eighth and ninth ribs, and into the sternum betwixt the cartilages of the third and fourth ribs; there are fleshy fibres arising from

the first rib which join it at it's origin from the sternum. This is called a distinct muscle and named musculus in summo thorace situs.

The blood-vessels and nerves which are marked on the thorax are those which were distributed to the parts taken off, as the obliquus externus, latissimus dorsi, membrana carnosa, &c. and integuments; the nerves come from the nervi dorsales or costales, and nervi lumbares; the arteries from the arteriæ intercostales inferiores, and the arteriæ lumbares, the veins from the venæ intercostales and venæ lumbares.

In the Cubit and right upper Extremity.

abcdd Extensor carpi radialis; *a* it's origin from the superior protuberating part of the humerus; *b* the part which arises fleshy from the fascia which is extended betwixt the two external protuberating parts of the os humeri; it arises above the part *b* and ligament or fascia from the external ridge of the external condyle all the way up as far as the brachialis internus does not cover, but it's most considerable origin is from the anterior part of the external condyle of the os humeri, from which place it continues it's origin into the great cavity on the anterior and inferior part of the os humeri; from whence it arises by a very strong tendon firmly adhering to the tendon of the extensor digitorum communis; *abc* the fleshy part; *dd* the tendon inserted into the metacarpal bone, at *d* adhering to the bursal ligament a little before it reaches the lower bone of the carpus, or about three minutes from it's insertion into the metacarpal bone; *c* marks the place where the fascia, proper to the extending muscles on the cubit, is cut off from the fascia of the biceps muscle *nc*, which it joins to be inserted along with it into the tendon of the extensor carpi radialis.

The origin of this muscle is as extensive as the originations of the long supinator and radialis longus and brevis, and may be called a combination of all three in one, which is assisted by the biceps, the fascia of which is like a strong flat tendon, inserted into the tendon of this muscle.

f The muscle which is analogous to the extensors of the thumb in the human body; *f* the fleshy part arising from the lateral part and ridge of the radius; *g* the tendon going to be inserted into the false metacarpal bone or lost in the ligament inserted into that bone, or rather attached to it before it's insertion. It is a combination of the abductor policis manus, extensor longus, and extensor brevis pollicis manus and indicator.

hiklmn Extensor digitorum communis; *h* it's origin from the external condyle of the humerus; *i* the origin it receives from the fascia which is extended betwixt the two external protuberating parts of the os humeri: it is a strong membranous tendon: *hl* it's origin from the upper and lateral part of the radius; *k* the fleshy belly; *mn* the tendon; *n* the part inserted into the coffin bone; *m* the tendon which it sends off to the tendon of the extensor minimi digiti. It's principal origin is by a flat strong tendon from the lateral anterior and lower part of the os humeri, from the cavity above the articulation under the extensor carpi radialis, to the tendon of which it adheres for about three minutes from it's beginning, as well as to the bursal ligament which lies under it.

ooo Ligamentous fascias.

pqrs Extensor minimi digiti; *p* the part arising from the superior part of the radius. It has an origin from the ulna. The part marked with shaken lines from *p* to *q* receives a fleshy beginning from the vagina or case which binds together the bending muscles on the cubit. *rs* It's tendon which is joined by the slip from the extensor digitorum communis *m*, to be inserted at *s* into the first bone of the finger.

tuwxyz Flexor carpi ulnaris; *t* the origin of it's external head from the external protuberance of the os humeri posteriorly; *u* the internal head which arises from the

internal protuberance of the os humeri: it is inserted into the external false metacarpal bone a little below *w*, and at *x* into the pisiforme bone; *y* the tendon; *z* the fleshy parts.

1 2 3 The profundus arises by four distinct heads, 3 is the common tendon of the four heads; the head 1 arises from the internal protuberance of the os humeri posteriorly under, and in common with the sublimis, with which it seems to be confounded, in some degree, all the way down the fleshy part till it comes to the tendon where the four heads unite, and then the profundus and sublimis make two distinct tendons; the next head arises under that from the same protuberance by a small flattish tendon, it soon swells into a round fleshy belly, then gradually tapering becomes a round tendon, joins in with the tendon of the first described head a little above the projecting pisiforme bone of the carpus; the next head, marked 2, arises fleshy from the ancon near it's extremity and soon becoming a small long tendon joins in as the former; the fourth head arises fleshy from the flat posterior part of the radius about it's middle, and first becoming tendinous joins in with the other heads about the same place.

There is a strong tendinous ligament arising from the projecting pisiforme bone, and another of the carpal bones inserted into the tendon of the profundus: it arises from all the internal face of the carpus: there is such a ligament arising from the internal edge of the radius, which is inserted into the sublimis about the same place, where the four tendons of the profundus unite.

5 Interosseus, &c.

6 A ligament from the interosseus to the tendon of the extensor digitorum communis.

8 8 The bursal ligament belonging to the anterior part of this joint.

9 The articular ligament.

10 The tendon of the sublimis.

11 Nervus plantaris externus.

12 Vena plantaris externa.

13 The villous covering of the coffin bone is here left on to shew it's thickness.

In the right lower Limb.

aaabbbcdd Glutæus medius; *aaa* it's origin from the sacro-lumbalis; *bbb* an origin from the fascia lata; *c* an origin from the ilium; below *bbb* it is covered by the glutæus externus and biceps cruris; *dd* it's insertion into the great trochanter. It's origin is continued from *c* to the posterior part of the spine, and all that space of the ilium which lies betwixt the spine and the glutæus internus partly tendinous but chiefly fleshy, and from the ligament which goes betwixt the ilium and the transverse processes of the os sacrum.

e Iliacus internus arises fleshy from all the internal cavity of the os ilium and inside of it's anterior spine; it is joined by the psoas magnus and with it inserted into the lesser trochanter. They seem, to me, to be but one muscle.

f Large arteries and veins which go to the musculus membranosus, and in betwixt the rectus and vastus externus. They are part of the first ramus of the pudica communis.

ghiik Rectus cruris; *g* the part coming from it's origin from the external or posterior part of the inferior spine of the ilium by one tendon, and by another from the anterior part of the same spine; *h* it's fleshy belly; *k* it's insertion into the patella.

nopqrrs Vastus externus; *o* it's origin from the posterior part of the great trochanter; *p* an origin from the anterior side: they are both externally tendinous; *rr* it's insertion into the patella; *rs* it's insertion into the lateral ligament of the patella; *n* it's principal fleshy part; *q* the thin fleshy part which goes to the lateral ligament, and over which the anterior part of the biceps goes to be inserted into the patella at *rruu*.

rruuw The insertions of the anterior part of the biceps; *rruu* that into the patella; *w* that into the tibia.

yz The inferior ligament of the patella, inserted at *y* into the patella, and at *z* into the tibia.

1 2 The lateral ligament of the patella, inserted at 1 into the patella, and at 2 into the os femoris.

3 4 The bursal or capsular ligament of the knee.

5 The place where the tendon of the glutæus externus is cut off from its insertion.

6 The place where the expansion is cut off which it sends to the pyramidalis.

8 8 8 8 The ligament which runs from the spinal to the transverse processes of the os sacrum, upon which is marked the fleshy origin of the biceps.

8 8 9 10 The ligament which runs from the transverse processes of the os sacrum to the ischium, on which is marked the fleshy origin of the biceps cruris.

8 9 Shews the place where the fascia lata is cut off betwixt the biceps and semi-tendinosus.

9 9 11 The origin of the biceps from the tubercle of the ischium; 9 9 that from the end; 9 11 that from the inferior edge, where there is a little of the flat tendon left on to shew it's breadth.

12 13 14 15 16 Blood-vessels; 12 an artery; 13 a vein, the branches of which, 15 and 16, run to the semi-tendinosus, the branches 14 to the biceps. The artery is a branch of the first ramus of the pudica communis, which is a branch of the internal iliaca or hypogastrica; the vein is a branch of the vena hypogastrica.

18 Blood-vessels which go to the semi-tendinosus; the superior is an artery, the other a vein.

19 20 21 22 23 24 25 30 Extensor longus digitorum pedis; 19 an origin from, or an attachment to, the tibia; 20 it's origin from the femoris along with the tendon of the tibialis anticus inseperably joined to that strong tendon; 22 23 24 25 it's tendon running under the ligament 26; 21 it's fleshy belly; at 22 it is joined by the tendon of the peroneus; at 23 it is joined by a ligament from the interosseus, &c. which binds it down to the great pastern; the principal part of the tendon 24 goes to be inserted into the coffin bone, where it is joined by the tendon of the peroneus; it sends off a slip to be inserted into the first bone of the toe or great pastern at 30.

26 A ligament which binds down the tendon of the extensor longus digitorum pedis.

27 Extensor brevis digitorum pedis.

28 29 The tibialis anticus; 28 it's origin from the superior and anterior part of the tibia; it arises also by a very strong tendon from the inferior part of the os femoris, and is inserted into the bones of the tarsus and metatarsus. It is more fully explained in table the eighth.

31 31 32 33 Semi-membranosus arising tendinous, and at it's origin attached to the origin of the biceps at 31 31; at 33 it is joined in with the semi-tendinosus, and is with it inserted into the tibia.

34 35 The inferior part of the semi-tendinosus cut off at 34; at 35 it sends off an expansion attached to the tendinous ligament which lies over the gemellus, and covers some blood-vessels and nerves which pass over the gemellus, and run down the leg: it is also inserted by a flat tendon or expansion into the plantaris near the bottom of the fleshy part, through which expansion there is an opening for the passage of a large nerve. It's principal insertion is by a flat tendon into the superior and anterior part of the tibia internally.

15 36 36 37 38 39 39 40 The large adductor of the thigh; 15 36 36 shew the fleshy origin of the semi-tendinosus from the flat tendon of this muscle or ligament running from the sacrum and coccygis to the ischium; 15 39 mark the place where the semi-tendinosus ceases to arise from this tendon or ligament on this side, and where the fleshy fibres of this muscle begin to arise on the other side of the tendon; at 37 and 38 the surface is tendinous, but strongest about 37,

where tendinous fibres run as marked in a transverse direction from the ligament or fascia lata; 39 39 the place where the expansion is cut off which is sent from the fascia lata before it runs in betwixt the biceps and semi-tendinosus; 40 the external fleshy part of this muscle. The fascia sending off an expansion before it goes in betwixt the biceps and semi-tendinosus, which is fixed to the large adductor of the thigh at 39 39, and this fascia being attached to the edge of the broad tendon of this muscle or running over it, as at 37, makes a compleat case for the semi-tendinosus above the process of the ischium, which keeps it firmly in it's place. This muscle arises from the ligament running from the sacrum and coccyx to the ischium; it's principal origin is from the tubercle of the ischium; it is inserted by a strong tendon into the internal condyle of the humerus behind the origin of the articular ligament and a little below it, and by a flat tendon into the articular ligament and tendon of the semi-tendinosus. It joins in with the long adductor near it's insertion.

50 51 52 53 Peronæus; 50 it's origin from the upper part of the fibula and articular ligament 54; 51 it's fleshy belly; 52 53 it's tendon joining in with the long extensor of the toes at 53, part of which is inserted into the great pastern along with part of that tendon at 30.

58 59 Flexor digitorum; 58 the fleshy part; 59 the tendon.

60 60 61 62 62 63 64 Gemellus; 60 60 a sort of flat tendon which may be easily separated from the muscle to which it only adheres by it's external edge: it runs over the surface of the muscle and joins in with the fascias sent from the semi-tendinosus, &c. which joins in both above and below, and by that means makes a case for the tendon of the gemellus and plantaris; 61 the externally tendinous origin of the external head of the gemellus; 62 62 the fleshy parts; 63 the fleshy part under the expansion 60; 64 the tendons of the external and internal head of the gemellus; that upon which the 6 lies is the tendon of the internal head, and that which the 4 lies on is the tendon of the external head; the tendon 60 wraps over it a little above 6 to be inserted more internally into the os calcis; so that these three tendons, along with that of the plantaris, are twisted like a rope.

68 69 The tendon of the plantaris, wraping over the tendon of the gemellus at 68. This muscle arises under the external head of the gemellus (in which it is in a manner wrapt up) out of the large fossa or notch in the os femoris: above the external condyle on the external side of it's fleshy belly the gemellus is attached to it by fleshy fibres; at 68 it runs over the end of the os calcis, where it is bound on each side by ligaments which prevent it's slipping either way; at 69 it divides to be inserted on each side of the inferior part of the great pastern posteriorly, and to give passage to the tendon of the flexor digitorum pedis, to which tendon it serves as a ligament to confine it to the great pastern when the fetlock joint is bent, and by that means it receives assistance from that tendon in bending the fetlock joint. This is analogous to the plantaris and short flexor of the toes in the human body, viz. the part above 68 to the plantaris, and the part below to the short flexor of the toes.

70 71 71 Articular ligaments; 70 that which binds the tibia to the bones of the tarsus; 71 71 that which binds the os calcis to the splint bone.

72 A capsular ligament.

74 75 Interosseus, &c. it arises from some of the tarsal bones and the upper part of the metatarsal bones, and is inserted into the sesamoid bones and great pastern on each side; it sends off the ligament 75 and another on the other side to bind down the tendon of the extensor digitorum pedis. This is of a ligamentous nature, but supplies the places of the interosseus, the short flexor, adductor, and abductor of the great toe, the abductor and short flexor proper to the little toe, and a ligament which arises from

the calcaneum and belongs to the cuboid bone, but sends off an excursion which joins the origins of the short flexors of the little toe in the human body: the ligamentous aponeurosis 75 is sent partly from the interosseus, &c. and partly from the capsula of the fetlock joint to the tendon of the extensor digitorum pedis.

76 Arteria tibialis anterior.

77 A vein from the biceps cruris on which appears a valve. It is a branch of the obturatrix. It is accompanied with a nerve.

81 A large vein, on which several valves are marked.

82 A nerve which accompanies the vein 81 to go under the fascia 35, and which is marked 9 in the first table. It is a branch of the large crural nerve.

83 Nerves going to the tibialis anticus. They are some of the small siatic ramus.

84 The external nervus plantaris.

85 The external vena plantaris.

86 A substance which resembles the villous surface of a mushroom, marked 13 and 3 in table the second, is here left to shew it's thickness or depth: it is the same on all the feet.

In the internal Side of the left lower Limb.

A*a* The tendinous surface of the rectus cruris, inserted at A into the patella.

bbc 12 Vastus internus, inserted at *bb* into the patella; at A*a* into the rectus; and at 12 into the ligament 13 14.

d The long adductor of the thigh.

e A flat tendon or fascia from the large adductor of the thigh.

fg Gemellus; *f* the fleshy belly, the external surface of which is tendinous at *f*; the tendon of this internal head wraps over the tendon of the plantaris to go to the external side of the heel: *g* the tendon of the external head.

h The tendon of the solæus.

lmnnpr The tendon of the plantaris; *l* the part marked *t* in table the second; *m* the part marked *u* in table the second; *nn* the part marked *s*, the part marked *qr* in table the second, being here cut off at *p*; the part marked *w* in table the second is cut off in this place; *r* the tendon on this side going to it's insertion into the first bone of the toe.

uwxyz 30 The extensor digitorum pedis; *u* the fleshy part, marked 21 on the right limb in this table; *w* the part marked 22 on the right limb in this table; *x* the part marked 24 in this table on the right lower limb, and 14 in table the second on the left limb; *y* the part marked 16 in table the second; *z* the part marked 17 in table the second. It has an insertion at 30 into the great pastern with part of the tendon of the peronæus.

z The ligament marked 20 in table the second.

1 2 3 Tibialis anticus.

6 Popliteus; externally tendinous, particularly near it's insertion.

7 Tibialis posticus.

8 8 Flexor digitorum pedis.

9 10 The bursal ligament.

11 The intermuscular ligament marked 26 on the left limb in this table.

12 13 14 The internal anterior ligament which binds the patella to the tibia.

15 15 15 A membranous covering of the bursal ligament, betwixt which and the bursal ligament are contained the mucilaginous glands of this joint.

16 The internal articular ligament which connects the os femoris to the tibia.

18 18 The articular ligament which binds the tibia to the bones of the tarsus.

22 23 23 The ligament marked 8 9 9 in table the second. It is a strong ligament which binds the os calcis to the astragalus, os naviculare, ossa cuneiformia and splint bone, arising from a protuberance about 22 and inserted into the other bones of the tarsus and metatarsus about 23 23.

25 A nerve called sciaticus internus.

26 The ligament marked 19 in table the second.

27 Interosseus, &c. marked 18 in table the second.

28 Nervus plantaris internus. It is a branch of the nervus sciatica-tibialis.

29 Vena plantaris interna.

36 The villous covering of the coffin bone, is here left on to shew it's thickness.

In the internal Side of the left upper Limb.

abc Extensor carpi radialis, marked *abcdd* on the right upper limb in this table; *a* the fleshy belly; *bc* the tendon; *c* it's insertion into the metacarpal bone.

d A ligamentous fascia.

e Profundus.

fg The muscle which is analogous to the extensors of the thumb, marked *fg* on the left upper limb in this table.

h The tendon of the extensor digitorum communis.

i Nervus medianus.

k Arteria brachialis, or the humeral artery.

llmm The bursal ligament on the anterior part of this juncture.

n Flexor carpi radialis.

o Sublimis.

p Flexor carpi ulnaris.

q Interosseus, &c. It arises from the bones of the carpus and upper part of the metacarpal bones, is inserted into the sesamoid bones and great pastern on each side, and sends off the ligament *r* on this side to the tendon of the extensor digitorum, which it binds down. It is of a ligamentous nature, but supplies the places of the interossei manus and abductors of the fore finger, little finger, and short abductor of the thumb, with the adductors of the thumb and little finger.

s Vena cephalica.

t Vena plantaris interna.

u Nervus plantaris internus.

w The villous covering of the coffin bone is here left on to shew it's thickness.

The Fourth Anatomical TABLE of the Muscles, Fascias, Ligaments, Nerves, Arteries, Veins, Glands and Cartilages of a HORSE explained

In the Head.

ab THE globe or ball of the eye; *a* the pupil; *b* the white of the eye, or tunica scleratica, covered with the albuginea or tendons of the streight muscles only, and not covered with the tunica adnata or conjunctiva.

c One of the lachrymal glands placed in the great canthus of the eye, called carancula lachrymalis and glandula lachrymalis inferior.

d The semi-lunar fold, formed by the conjunctiva.

e Attollens.

f Deprimens.

g Adducens.

h Abducens.

i Obliquus superior.

k Obliquus inferior.

l The trochlea.

mmnno Caninus, or the elevator of the corner of the mouth; *mm* it's origin; *nn* it's insertion into the orbicularis oris; *no* it's insertion into the buccinator.

pp Orbicularis oris, or the orbicular muscle of the mouth.

qr The glandulous membrane which lines the inside of the lips; *q* that of the lower lip; *r* that of the upper lip, the glands of which are called glandulæ buccales.

s The elevator of the chin.

tu The short nasal muscle of the upper lip.

ww Buccinator; it arises from three different places; the superior fibres arise from the alvioli of the upper jaw; the middle fibres from the ligamentum inter maxillares, and the inferior from the lower jaw: it is inserted into the glandulous membrane of the inside of the cheek and lips, and into the orbicularis oris.

x The anterior dilator of the nostril.

y The pituitary membrane on the inside of the alæ narium.

z The salivary duct.

1 Vena jugularis externa posterior or superior.

2 Vena temporalis.

3 Arteria angularis.

4 Vena angularis.

5 Nervus superciliaris, the ramus superior, or frontalis: it is the most considerable of the three rami of the nervus orbitarius commonly called ophthalmicus, which is the first branch of the fifth pair of nerves: it passes through the foramen superciliare, is spent on the musculus frontalis, orbicularis and integuments.

6 7 8 9 The second branch of the fifth pair of nerves called nervus maxillaris superior; 7 a branch which goes to the long nasal muscle of the upper lip; 8 a branch which goes to the inside of the nares towards the top of the nose; 9 branches which go to the upper lip.

10 The anterior cartilage of the outer ear.

11 The ear.

In the Neck.

a Glandula thyroides.

bbccddefff The carotid artery: it sends branches at *bb* to the glandula thyroides; *dd* branches which give off ramifications to the sterno thyroidæus; *e* branches which go to the caracohyoidæus; *fff* branches going to the aspera arteria: these branches of arteries are all accompanied with veins.

g An artery and vein running over the gula.

hh The third branch of the eighth pair of nerves.

iiii OEsophagus.

kk Trachea arteria, aspera arteria, or wind-pipe.

lmn Sternothyroidæus; *m* the thick fleshy part near it's origin at the superior, and internal part of the sternum; *l* it's middle tendon; *n* it's insertion into the thyroid cartilage.

op Crycothyroidæus; *p* it's origin from the crycoide cartilage; *o* it's thyroidal insertion.

qq The lower constrictor of the pharynx.

r Hyo-thyroidæus, or thyro-hyoidæus.

s The lower, and anterior part of the thyroid cartilage.

tu Rectus capitis posticus major; *t* it's origin from the spine or ridge of the lower oblique process of the second vertebra of the neck.

wx Rectus capitis posticus minor, or rather medius; *w* the part coming from it's origin at the spine of the second vertebra of the neck: it begins it's origin at the root of the spine of the oblique process, just where the rectus major ceases to arise, and continues it's origin about three minutes up the spine or ridge; *x* the part going to be inserted by a tendon, short and broad, into the occiput, wraping over the surface of the intervertebralis.

yz Obliquus capitis superior: *y* it's fleshy origin, which is pretty deep, from the broad transverse process of the atlas; *z* it's insertion into the occiput.

AB Obliquus capitis inferior; A it's origin from all the length of the spine of the oblique process of the second vertebra of the neck above A, where it runs under the rectus capitis posticus longus: it is externally tendinous: it arises from all the posterior part of that vertebra which the intervertebralis does not cover: B it's insertion into the anterior part of the broad transverse process of the atlas which the intervertebralis does not cover.

CDEFGHIK Longus colli; CHDEF the parts arising from the transverse processes of the third, fourth, fifth, and sixth vertebræ of the neck: H the part which is inserted into the anterior part of the body and transverse processes of the second vertebra, as CDEF run in part to be inserted into the anterior parts of the transverse processes and bodies of the vertebræ above them, as well as join the part I, which goes to be inserted into the anterior part of the body of the first vertebra; the part H may be divided into a distinct muscle, or nearly so, and probably the parts DEF may be so too; IK the part inserted into the anterior oblique process of the sixth vertebra; I the tendon; K a fleshy part. It's inferior origin is from the anterior lateral part of the body of the last vertebra of the neck, and the five uppermost of the back.

LL, &c. MM, &c. Intertransversarii posteriores colli; LL, &c. their insertions into the transverse processes of the vertebræ of the neck; MM, &c. their origins from the roots of the oblique processes, and the part betwixt them and the transverse processes. For each insertion there seems to be an origin from the lower oblique process of the vertebra below it, and the upper oblique process; or it rather seems to be at the root of the upper oblique process, and almost down to the lower oblique process of that vertebra, and betwixt the oblique and transverse processes where the intervertebralis does not cover. The lowest origin is from the first vertebra of the back, part of which is inserted into the transverse process of the seventh vertebra of the neck.

NNN Intervertebrales appearing betwixt the originations of the intertransversarii posteriores colli: they arise from the ascending oblique processes of the five inferior vertebræ of the neck, and from the space betwixt the oblique processes of the uppermost vertebræ of the back: they are each of them inserted into the lateral parts of the bodies of the vertebra above their origin.

OOOOPQ The multifidæ of the spine, arising at OOOOP from the descending oblique processes of the vertebræ of the neck, partly externally tendinous, as marked at OOOO; the part O, from the descending process of the third vertebra, is wholly inserted into the spine of the descending process of the second vertebra of the neck, and the external part marked OO of the two vertebræ below that; so that there are originations from three different vertebræ which unite in their insertions into one: the short parts, or those originations which are nighest their insertions, arise most internally, and those of a middling length, arise betwixt the long ones and short ones: the longest fibres, or those which arise most externally, have their insertions nighest the spinal processes, or their fellows on the other side; and the short ones nighest the oblique processes: those of a middling length have their insertions betwixt the two.

RTU Spinalis cervicis; R it's origin from the second spine of the back, which origin is continued for about one third of the way down that spine towards it's root: it arises also from the third spine or the ligamentum colli; near R it communicates with the semi-spinalis dorsi: T the part going to be inserted into the spinal process of the fourth vertebra of the neck; it is also inserted into the fifth spinal process; U the part going to be inserted into the spinal process of the sixth vertebra of the neck by a strong flat tendon: there is also a part under this which arises from the spine of the first vertebra of the back, from it's tip about half way down to it's root, and goes to be inserted into the spine of the seventh vertebra of the neck: it has an origination also from the ligament that goes from the spine of the second

vertebra of the back to the first for it's whole length, which is inserted into the spines of the neck.

This might be called interspinalis dorsi et cervicis, because it's situation is entirely amongst the spines arising from those of the back to be inserted into those of the neck.

1 1 1 1 Branches of the cervical nerves.
2 2 Branches of the cervical arteries.
3 3 Branches of the cervical veins.
4 Part of the jugular vein.
5 Ligamentum colli.

In the Shoulder.

ab Sub-scapularis.

def Teres major; d it's origin from the inferior costa of the scapula; e a part externally tendinous, going to be inserted into the humerus betwixt the brachialis externus and caraco brachialis; f a part covered with communicating tendinous fibres, by which it and the fifth head of the extensor of the cubit are joined.

ghiikklm Longus minor, or the fifth extensor of the cubit; dg it's origin from the inferior angle of the scapula, and tendinous surface of the teres major; h shews some remaining fleshy fibres where the longus major was attached to it's flat tendon; ghiik it's flat tendon from which the fleshy part iil arises at ii, and runs towards the tendon m to be inserted into the inside of the ancon; k shews the outline of the tendon of the latissimus dorsi and membrana carnosa, which is inseparably joined to the teres major, and makes with it but one tendon, though the fibres from this muscle, in some measure, intersect those of the teres major, and are inserted into the humerus, making the upper angle of the tendon along with the upper part of the teres major. The fibres which come from the anterior part of the latissimus dorsi are inserted the highest (being intersected by the posterior part which runs over the inferior angle of the scapula) going to their insertion with the lower part of the tendon of the teres major.

no Brachialis externus; arises from the upper part of the os humeri betwixt the beginning of the brachialis internus and the tendons of the teres major; o the part where it begins to be tendinous and goes to be inserted into the extremity of the ancon.

ppq The inferior part of the serratus major anticus.
r Nervus cubitalis.
s Nervus radialis.
t Nervus musculo-cutaneus.
u Nervus medianus.
w Branches of the arteria and vena axillaris.

Muscles, &c. on the Trunk.

1 1, &c. 2 2, &c. The external intercostals; they arise at 1 1, &c. from the inferior edge and a little of the outside of each rib, the last excepted; they are a little tendinous, and descending obliquely downwards, are inserted at 2 2, &c. into the upper edge and a little of the outside of each rib, the first excepted.

3 3, &c. 4 4, &c. The internal intercostals: they arise at 3 3, &c. from the superior edge of the bony part of each rib except the first, not covering any of the outside, and from the edges of the cartilages of the ribs and a considerable part of the outside of them; they are chiefly externally tendinous, but partly fleshy, and ascending obliquely upwards, and forwards are inserted into the lower edge of the bony part of each rib, and into the edges and part of the outside of their cartilages, the last rib excepted.

5 5 5 5 5 Branches of the nervi costales, lying upon the transversales, which go to the abdominal muscles and integuments.

The nerves and blood-vessels which are marked on the thorax are those which were distributed to the parts taken off, as the obliquus internus and externus, latissimus dorsi, membrana carnosa, &c. and integuments; the nerves come

from the nervi dorsales, and nervi lumbares; the arteries from the arteriæ intercostales inferiores, and arteriæ lumbares, the veins from the venæ intercostales and venæ lumbares.

aabccdeeff The semi-spinalis and spinalis dorsi; *aabeff* semi-spinalis dorsi, which arises fleshy from all that space of the tendinous surface of the longissimus-dorsi that lies betwixt it's out-line marked *aa*, and the dotted out-line marked *bd* of the spinalis dorsi which lies under it, and then running over it's strong tendinous surface marked with dotted lines; *bdee* communicates with it's fleshy fibres, and with them goes to be inserted into the spinal apophysis *ff:* it communicates with the spinalis cervicis, and is inserted under that part of it, R, which arises from the spine of the third vertebra of the back, or from the ligamentum colli: betwixt those two spines it sends a strong tendon also down to the spine of the first vertebra of the back: *ccd* spinalis dorsi, which arises by a strong ligamentous tendon under the semi-spinalis marked with dotted lines *bdee*, which sends off fleshy fibres communicating with the semi-spinalis, and are inserted with it into the spines of the back *ff*; it is also inserted into the inferior ridge of the second spine of the back, which insertion is continued about half way down from the end towards the root, and into the spine of the first dorsal vertebra, beginning it's tendinous and fleshy insertion near the end, below the insertion of the tendon of the semi-spinalis, and continuing it for about half the length of that spine along it's inferior ridge: it's principal or strongest insertion is by a short, strong, roundish tendon into the spine of the seventh vertebra of the neck, which is the only part appearing as at *ccd*, the rest being under the scapula and semi-spinalis dorsi.

The semi-spinalis seems to make it's insertions into the extremities, or very near them, of the ten superior spines of the back, and the spinalis makes it's insertions all the way from the insertion of the semi-spinalis along their inferior ridges down to the insertions of the multifidæ spinæ, which is half the length of the seven uppermost, the insertion then diminishes till it comes almost to a point in the tenth spine: it's origin is entirely tendinous from the eleventh, twelfth, thirteenth, fourteenth, fifteenth, and sixteenth spinal processes of the back.

ghhiikkk Longissimus dorsi; *g* the tendon inserted into the transverse process of the seventh vertebra of the neck: it is inserted by distinct flat tendons into the transverse processes of the vertebræ of the back; the lateral part of it is inserted into the lower convex edge of all that part of the ribs that lies betwixt the sacro-lumbalis and elevators of the ribs, tendinous and fleshy; or it is inserted into the rib of those that appear from under the sacro-lumbalis and elevators of the ribs, (which are about seven,) at it's protuberating part, where it joins to the vertebra, and then the insertion becomes in each rib gradually broader, partly tendinous, and partly fleshy, till it comes to the last rib, where it is about nine minutes broad: it is also inserted into all the transverse processes of the vertebræ of the loins the whole length of their inferior edges: it's externally tendinous part, near the spines, is very thick, but diminishing as it advances towards the sacro-lumbalis. The fleshy part *hh* appears through the tendinous surface of this muscle; it arises from the spine of the last vertebra of the loins, and from the three uppermost spines of the sacrum strongly tendinous, as well as from the superior posterior edge of the ilium *ii*, and fleshy from the inside of the ligament *kkk*, which is a very strong one, especially near the ilium; at *b* it arises fleshy from all the anterior side of the ilium which is behind the transverse process of the os sacrum.

lmnn, &c. *o* Sacro-lumbalis; *l* the part that arises from, or with, the longissimus dorsi by a small tendon: in this subject it receives originations by flat tendons about half the breadth of the muscle from the superior edge of all the ribs except two or three of the uppermost; and is inserted, by distinct flat tendons, into the inferior edge of all the ribs

except two or three of the lowest; and into the transverse process of the seventh vertebra of the neck, as at *o*; *nn*, &c. mark it's insertions into the ribs, each tendon running upon the surface of the muscle over about three ribs below it's insertion; *m* the part externally fleshy.

Ppqrstu Transversalis abdominis; *pp* the part coming from it's origin from the transverse processes of the three or four uppermost vertebræ of the loins; at P it is joined by a tendinous origin from the spine of the ilium; *pr* it's origin from the lowest rib, which is continued down all the length of the inferior edge of the bony part of the rib from *r* to it's conjunction with the vertebra; *Ppqrst* it's fleshy part; *u* it's tendon which is inserted into the ensiform cartilage and linea alba. It is more fully explained in table the fourteenth.

w Arteria epigastrica, or the internal branch of the external iliaca.

xxx Branches of the nervi lumbares which go to the abdominal muscles and integuments.

yy The external branch of the outer iliaca in two ramifications, accompanied by the external branch of the outer iliac vein in two ramifications.

z Mammaria interna.

In the right lower Limb.

effg The iliacus internus; *ff* it's origin from the ilium; at *g* it is tendinous on the surface; at *eg* it has an origin from the fascia lata: it joins in with the psoas magnus from it's origin, and is with it inserted into the little trochanter of the thigh bone.—They seem to be but one muscle.

hikkkll Glutæus internus; *h* it's origin from the ilium, externally tendinous, but inwardly fleshy; it is externally fleshy at *i*; at *kkk* are tendinous lines. It is inserted into the great trochanter at *lkkkl*.

pqqrst The large adductor of the thigh; *p* the flat tendon by which it arises from the ligament running from the sacrum and coccyx to the ischium; *qq* the beginning of the fleshy part on this side, externally tendinous; *r* the external fleshy part; *s* the place where it's thick belly begins to diminish, conforming to the belly of the gemellus; it is inserted by a strong tendon into the internal condyle of the os femoris behind the origin of the articular ligament and a little below it.

uw The gracilis; *u* the fleshy part; *w* the tendon.

xy Musculus parvus in articulatione femoris situs; *x* the fleshy part; *y* the tendon.

1 1 1 2 2 3 4 5 6 Cruralis; 1 1 1 it's origin by small flat tendons externally, but internally fleshy; 2 2 the place where the tendinous surface begins to disappear; 3 4 it's insertion into the patella and lateral ligament; at 3 it is partly divided for the reception of blood-vessels; and it's origin at 6 is confounded with the two vastii.

7 8 9 Vastus internus; 8 it's origin along with the cruralis from the femoris; 9 it's tendinous insertion into the patella; it has a fleshy insertion about half way up the femur into the external tendinous surface on the internal side of the cruralis; or these two may be joined together, and called but one penniform muscle, the tendon spoken of receiving the fleshy insertions of the vastus inturnus on one side, and on the other of that part of the cruralis marked 1 1 1 2 2 5 3; and the part 3 4 6 only may be called cruralis, being distinct from the patella up to the part 6, where, at it's origin, it is confounded with the fleshy fibres of the two vastii; the origin of these muscles, except 3 4 6 is from the upper part of the thigh bone, and continued down that bone to 6.

10 The lateral ligament of the external side of the patella which binds that bone to the external condyle of the os femoris.

11 The middle or anterior ligament of the patella which binds that bone to the tibia.

12 The lateral ligament of the internal side of the patella which binds that bone to the tibia.

13 13 The bursal ligament of the knee, betwixt which

and that marked 34 in table the third, lie the mucilaginous glands.

14 14 15 16 17 18 19 20 Tibialis anticus; 14 14 it's origin from the superior and anterior part of the tibia; 15 it's tendinous origin from the inferior part of the os femoris: this is a very strong tendon, into which the fleshy part, which arises from the tibia at 14 14, begins to be inserted, after running down about one third of the length of the tibia; soon after which insertion fleshy fibres run from this, obliquely downwards and inwards, to be inserted into a flat tendon, which is a continuation of what may be called the proper and inferior tendon of the tibialis anticus marked 20: the internal or posterior part of this muscle, which is externally tendinous, makes a fleshy body much thicker than, or about twice as thick as, the anterior fleshy part: the superior part, running from the tibia obliquely downwards and outwards, and then from the external posterior surface obliquely downwards, is also inserted into the middle tendon: it ceases to be fleshy about the bottom of the tibia, where the internal or posterior tendon and middle tendon form the tendon 20, which is inserted into the ossa cuneiformia and metatarsal bone; the part 19 into the os cuboides, it divides for the passage of some blood-vessels and then unites again; and the part 18 into the ossa cuneiformia posteriorly running over the internal articular ligament as far back as the posterior edge of the splint bone.

23 24 25 25 26 26 27 27 Flexor digitorum pedis; 23 it's tendinous and fleshy origin from the fibula and articular ligament, and from the superior and posterior part of the tibia, which origination is continued near half the way down that bone from a considerable roughness; the protuberating parts of which give rise to the four or five tendinous parts composing this muscle: they intermix with the carnous part in this manner, the fibres descend obliquely downwards from the fascia 26 26 27 27 to be inserted into the tendon which lies next it; and that tendon receives the carnous fibres descending from the tendinous part which is next to it more internally; and that tendon sends fibres obliquely downwards to the next which is still more internal, and so on of the rest; one receiving fleshy fibres from each side, and that next it sending them off to each side, the external fascia only excepted, which sends fleshy fibres to this muscle only inwards, being the cover of this muscle: this fascia on the external side, where it is marked 26 26, gives origin to the fleshy fibres of the peronæus: it is joined by the fascia which arises from the internal posterior edge of the tibia when that fascia has run over the tibialis posticus, which it serves to bind down in it's proper place. There is some part of the origin seen at 28 from betwixt the tibia and fibula: 27 27 The origin of the fascia which covers this muscle, which is strong and tendinous near it's origin, from the articular ligament, and fibula, or rather from the articular ligament which runs from the external condyle of the humerus all the way down the external side of the tibia, and by which the fibula is attached to the tibia, as well as by a ligament which arises from the external edge of the tibia and descends obliquely downwards to be inserted into the fibula; 24 the external part of this muscle where the fleshy fibres may be seen through the fascia; 25 25 the tendon.

28 29 Poplitæus; 28 the tendon arising under the articular ligament.

30 The articular ligament, which runs all the way down the fibula, and to the bottom of the tibia.

31 An articular ligament.

32 A ligament which binds the os calcis to the splint bone.

33 An articular ligament.

34 Arteria sciatica, accompanied with a vein.

35 35 Branches of the arteria glutæa, accompanied with veins and nerves.

36 A branch of the arteria obturatrix, accompanied with a vein.

37 A branch of the arteria obturatrix.

38 A branch of the vena cruralis, in which appear some valves.

39 A branch of the arteria poplitæa.

51 A branch of the vena poplitæa.

52 Arteria poplitæa.

53 Vena poplitæa, in which appears a valve.

54 Nerves going to the tibialis anticus. They are rami of the small sciatic branch.

55 Arteria tibialis anterior.

56 Vena tibialis anterior, in which appear some valves.

57 Glandula poplitæa, commonly called the pope's eye.

58 Vena saphæna.

59 The outer cartilage belonging to the coffin bone.

60 The inner cartilage belonging to the coffin bone.

40 41 42 42 43 44 45 49 The plantaris; 40 it's origin from the os femoris; 41 a place where the gemellus is attached to it by fleshy fibres; 42 42 the tendon inserted at 43 into the first bone of the toe; 49 a ligament arising from the os calcis and inserted into this tendon, which keeps it steady upon the end of that bone; 44 a ligament arising from the first bone of the toe, and inserted into this tendon; the ligament 45, which arises from the sesamoid bone, is not attached to it but runs over it, and serves as well as the ligament 44 to prevent it's starting from those bones when the joint is bent.

The insertion 43 is but half of it's tendon, it being divided, and the other half inserted into the internal posterior edge of the same bone, leaving, by that division, a passage for the flexor digitorum pedis, which is seen at 25 lying betwixt the tendon of the plantaris and the bone.

46 A capsular ligament.

47 An articular ligament.

48 A capsular ligament.

49 A ligament which binds the tendon of the plantaris to the os calcis, and may be called part of the origin of the short flexor of the toes.

50 An articular ligament.

In the left lower Limb.

a Arteria cruralis.

b Vena cruralis.

hhi Poplitæus; hh it's insertion into the tibia externally tendinous; i the fleshy part coming from it's origin from the external condyle of the femoris which is marked 28 on the left limb in this table.

kllmnop Plantaris; k the fleshy belly; llmn the tendon; o a ligament arising from the os calcis and inserted into the tendon m of the plantaris, which it confines in it's place; it's fellow is marked 49 on the left limb in this table. This ligament may be called part of the origin of the short flexor of the toes; n it's insertion into the first bone of the toe; the external insertion is marked 43 on the right lower limb in this table; betwixt these insertions the tendon of the flexor digitorium pedis runs down to it's insertion into the coffin bone; p a ligament arising from the first bone of the toe and inserted into the tendon.

q A ligament which arises from one sesamoid bone and runs over the tendon of the plantaris to be inserted into the other, and serves to bind down that tendon.

1 2 3 Tibialis pasticus; 1 the fleshy belly; 2 3 the tendon inserted into the tendon of the flexor digitorum pedis.

4 Flexor digitorum pedis, marked 23 24 25 25 26 26 27 27 27 on the right limb in this table.

10 11 12 13 15 16 Tibialis anticus; 10 the fleshy part marked 14 on the left limb in this table; 11 the part marked 16; 12 the part marked 19; 13 the part marked 18; and 15 is one tendon of the fleshy part of this muscle, inserted into the ossa cuneiformia posteriorly running over the internal articular ligament as far back as the posterior edge of the splint bone; the part 16 is inserted into the superior and anterior edge of the metatarsal bone; the part marked 13

runs under the tendon 15 to it's insertion into the ossa cuneiformia.

17 17 18 The internal lateral ligament, which binds the patella to the os femoris; 18 it's origin from the os femoris; 17 17 it's insertion into the patella.

19 19 20 The internal lateral ligament, which binds the patella to the tibia; 20 it's origin from the tibia; 19 19 it's insertion into the patella.—This is marked 12 on the left limb in this table.

21 22 The external lateral or anterior ligament, which binds the patella to the tibia, marked 11 on the left limb in this table; 21 it's origin from the tibia; 22 it's insertion into the patella.

23 24 The internal, lateral, articular ligament, which binds the tibia to the os femoris.

25 25 The bursal ligament of the knee, with some few of the mucilaginous glands left on which lie betwixt this ligament and that marked 15 15 15 15 in table the third.

26 Interosseus, &c.

27 28 An articular ligament.

34 The articular ligament of the fetlock joint.

35 The bursal ligament. This is a strong thick ligament, and about this place almost cartilaginous. To this the tendon of the extensor digitorum is strongly attached.

36 A bursal ligament.

37 An articular ligament.

38 An articular ligament.

39 Branches of the vena tibialis anterior.

40 A nerve called sciaticus internus.

41 The inner cartilage belonging to the coffin bone.

In the right upper Limb.

abc Brachialis internus. It arises at *a* from the neck of the humerus, and the internal lower part of the scapula; *c* the part which goes to be inserted into the radius a little below the insertion of the biceps and more internally.

deffghi Flexor digitorum profundus; *de* the first or largest head, explained in table the third, with the other three heads of this muscle; *d* the fleshy part; *e* the tendinous part; *gh* the third described head; *g* the fleshy part; *h* the tendon; *i* the last described head, appearing here a little; *ff* the common tendon, inserted into the coffin bone.—See table fourteen for a fuller explanation.

k A ligament which runs down the small end of the ulna, to be inserted into the ligament or bones of the carpus, and to which the fascia is inserted on this side, which covers the bending muscles on the cubit.

lm Flexor digitorum sublimis; *l* a little of the fleshy part; *m* the tendon inserted into the great pastern.

nnnn Articular ligaments.

ooo Bursal ligaments.

p Vena cephalica.

q Interosseus, &c.

r The outer cartilage belonging to the coffin bone.

In the left upper Limb.

abc Brachialis internus, made a little concave at *b* by the biceps; *c* it's insertion into the radius.

d Nervus medianus.

e Arteria brachialis.

f Vena brachialis.

g Vena cephalica.

i Flexor carpi radialis.

lm Flexor digitorum sublimis; *l* the fleshy part; *m* the tendon.

nopp Flexor digitorum profundus; *n* the head marked *gh* on the right upper limb in this table; *pp* the tendon.

qqqq Articular ligaments.

rrr Bursal ligaments.

s Interosseus, &c.

t The inner cartilage belonging to the coffin bone.

The Fifth Anatomical TABLE of the Muscles, Fascias, Ligaments, Nerves, Arteries, Veins, Glands and Cartilages of a HORSE explained

In the Head.

a MUSCULUS septimus oculi suspensorius, arises from the margin of the hole through which the optic nerve passes into the eye, and is inserted (being divided into several fleshy portions) into the lower or posterior part of the sclerotica below the termination of the other muscles.

b Obliquus superior.

c The trochlea.

d Obliquus inferior.

e Attolens.

f Deprimens.

g Adducens.

h Abducens.

i The semi-lunar fold, formed by the conjunctiva, which incloses a sort of gland, the internal part of which is a thick and firm glandular substance terminating in fat; the external or lunar edge is broad and very thin, of a cartilaginous nature, before which lies the caruncula lacrymalis, or glandula lacrymalis inferior.

k The optic nerve, where the eye is cut away.

llmnnooop The glandulous membrane of the inside of the lips and cheek; *ooo* the part in which the buccinator is inserted, which is thicker than the rest and more free from glands; *llmp* the glands called glandulæ labiales; they are thickest near the corners of the mouth and beginning of the upper lip; *nn* Glandulæ buccales.

q The elevator of the chin.

1 Vena angularis.

2 Arteria angularis.

3 Nervi maxillaris inferioris; they are the third branch of the fifth pair of nerves.

4 5 6 Nervi maxillaris superioris; they are branches of the third branch of the fifth pair of nerves; 4 branches which go to the upper lip; 5 a branch which goes to the inside of the nostril towards the tip of the nose; 6 a branch which goes to the long nasal muscle of the upper lip.

7 8 9 The cartilages of the nose; 7 the middle portion; it is a broad cartilaginous lamina, joined by a kind of symphysis to the anterior edge of the middle lamina of the os ethmoides, to the anterior edge of the vomer, and to the anterior part of the groove formed by the ossa maxillaria, as far as the nasal spines of these bones: this lamina compleats the septum narium of which it forms the principal part; 8 the anterior lateral cartilage which forms the tip of the nose, or the superior anterior part of the nostril; 9 the posterior and inferior lateral cartilage, or rather bone, for in aged horses it seems to be perfect bone, which helps to form the inferior part of the nostrils.

10 The anterior cartilage of the outer ear.

11 The outer ear.

In the Neck.

a Rectus anticus brevis, or minor; *a* it's origin from the lateral part of the body, rather anteriorly, and from the root of the transverse process of the first vertebra of the neck. It is inserted into the occiput in it's anterior process or appendix, or to the edge of the bone adjoining to it.

d Cricoarytanoidæus lateralis.

e Cricoarytanoidæus posticus.

f A very small part of the arytenoidæus.

ghhhh OEsophagus; *g* the membrane bared by taking away the lower constrictor of the pharynx, and freed a little from it's attachment to the thyroid cartilage *i* to shew the insertion of the cricoarytanoidæus lateralis.

ik The thyroid cartilage; at the lower process, tied to the crycoid cartilage by the ligament *m*.

l The annular, or crycoid cartilage.

n The ligament by which the thyroid or scutiform, and the crycoid or annular cartilages are tied one to the other in the anterior part.

m A ligament which ties the lower process of the thyroid or scutiform cartilage to the crycoid cartilage.

ooo Trachea arteria, aspera arteria, or wind-pipe.

pp The carotid artery, or carotis communis.

1 Arteria carotis externa, or the external carotid.

2 Arteria carotis interna, or the internal carotid.

qq The trunk of the eighth pair of nerves.

3 A branch of the eighth pair of nerves.

4 Arteria cervicalis, or the cervical artery.

5 Vena cervicalis.

rs Rectus posticus brevis, or internus; *r* it's origin from the atlas; *s* it's insertion into the occiput.

tu Intervertebralis; *t* it's origin from the ascending oblique process of the third vertebra; *u* it's insertion into the lateral part of the body of the second.

uw, &c. The five inferior intervertebrales, which answer to the same explanation as the superior, only that the lowest arises from the space betwixt the oblique processes of the uppermost vertebra of the back, and the rest arise from the superior oblique processes only: their anterior and inferior fleshy parts seem to be confounded with the inter-transversarii posteriores colli, but their upper and posterior parts are distinct, the nerves and blood-vessels coming from betwixt the vertebræ to go to the back of the neck running betwixt them.

xxxxy The multifidus of the spine arising at *xxxx* from the descending oblique processes of the vertebræ of the neck, externally tendinous; *y* it's uppermost insertion into the spine of the descending process of the second vertebra of the neck. This is more fully explained in tables the fourth and fourteenth.

z One of the scalenæ, or rather the elevator of the first rib arising at *z* from the transverse process of the seventh vertebra of the neck. It is inserted into the first rib.

1 2 2 3 4 5 6 6, &c. 7 8 8, &c. Ligamentum colli; it is a double ligament; 1 the superior or posterior part, which begins to distinguish itself about the fifteenth spine of the back on the lateral part of it's extremity, by being broader than the extremity of the spine; from which projecting part the inferior part of the trapezius begins about the fourteenth spine; it distinguishes itself about this place also by a small groove or channel that is formed betwixt it and it's fellow; but it's origin is not to be absolutely fixed in this place, because in conjunction with the interspinal ligaments it runs down the back and loins, and probably to the end of the tail, joining both sides together, they are on the spinal process of the vertebræ of the back, about one minute broad, or rather more, then extending in breadth as they arise from the superior vertebræ till they come to the third spinal process, where they are about four minutes broad, they leave their origin in two distinct portions, joined only by an intervening ligament, the fibres of which run in a transverse direction from one part to the other: there is a deep groove or channel continued betwixt them for about one part and six minutes, as they ascend towards the occiput, as far as 2; then diminishing in breadth, they become almost round, and insert themselves into the occiput at 5 about two minutes diameter lying both close together; 3 the part of the ligament arising from the spines

of the second and third vertebræ of the back; 4 an intervening ligament, which joins the two origins of the ligamentum colli together; 6 6 6 6 6 6 the insertions into the spinal processes of the superior vertebræ of the neck; 7 the interspinal ligament betwixt the first and second vertebræ of the neck; 8 8 8 8 a strong communicative membrane which fills up the opening betwixt the insertions of this ligament, on which some stragling filaments of the ligament are expanded.

13 13 14 15 The capsular ligament of the articulation betwixt the head and first vertebra of the neck; 13 13 the part inserted into the first vertebra; above 14 it is inserted into the occiput; 15 it's insertion into the long process of the occipital bone, which seems to be a considerable addition to the mamillary process of the temporal bone.

16 The capsular ligament of the articulation betwixt the first and second vertebræ of the neck; the posterior part covers the spinal marrow, the lateral part covers the articulating part of the second vertebra of the neck, where it is covered with a smooth cartilage.

17 17 17 17 Shew the capsular ligaments of the articulations of the five inferior vertebræ of the neck, made by their oblique processes: they arise free from the bone just at the extremity of the oblique processes, and continue their origin round the articulating cartilages.

18 18, &c. The vertebral veins, arteries, and nerves of the neck.

19 Part of the jugular vein.

In the Trunk.

ab, &c. The elevators of the ribs; they arise at *a* externally tendinous, from the transverse processes of all the vertebræ of the back (except the last) and from the last of the neck, to be inserted into the superior edge of all the ribs, each being inserted into the rib immediately below it's origin, and running from it's origin in a radiated manner; the posterior part, or that next the spine, running to the upper part of the rib almost transversely; the anterior part, or that farthest from the spine, running in an oblique direction downwards, to be inserted into the rib about nine minutes from it's articulation with the vertebra, for about ten of the inferior ribs; then they diminish in length gradually, 'till the length of their insertion is but about six minutes from their articulation at the uppermost ribs.

cc, &c. *dd*, &c. Multifidi spinæ; *cc*, &c. their tendinous originations from the transverse processes of the vertebræ of the back; *dd*, &c. their tendinous and fleshy insertions into the spines of the back, loins, and sacrum; their origins and insertions are both tendinous and fleshy, but at the external parts of the origins, from the extremities of the posterior protuberances of the transverse process, are the strongest tendinous parts, the external tendon expanding itself as it advances towards the insertions, leaves it externally fleshy near the insertions; but upon some of the superior spines, particularly those which lie under the scapula, it becomes externally tendinous near it's insertions; the insertions nearest the ends of the spines are tendinous for the most part, those of the loins forming a roundish tendon about half a minute broad, and a quarter, or near it, thick.

ef The lateral muscle of the tail arising at *e* from the spine of the last vertebra but one of the loins; *f* the fleshy part; it goes to be inserted by a tendon into the oblique process of the third vertebra of the tail, and also into two or three of the lower ones, and then joins in with the elevating muscles of the tail.

gg, &c. The inter-transverse muscles of the tail arising from one vertebra, and inserted into the next, and so on through the whole length of the tail. There are muscles which arise from the upper or posterior part of the transverse processes, and are inserted into the oblique processes of the next but one or two below them.

h The ligament which runs over the spines of the os sacrum.

i The elevating muscle of the tail, beginning its origin from the inferior or posterior edge of the third spinal process of the os sacrum, which origin is continued from near the end of the spine about half way towards it's root, it's origin is continued fleshy from the sides, edges and inter-spinal ligaments of the spines of the sacrum below that, from the whole length of the last of them, and after passing over one is inserted into the next oblique process, or next but one, below.

k The depressing muscle of the tail, beginning it's origin from under the transverse process of the third vertebra of the sacrum, and continuing from the transverse processes of those below from the whole breadths of them, and the inter-transverse ligaments. The fleshy fibres are inserted into the bodies of the vertebræ or bones of the tail.

lll The lungs appearing through the pleura.

mmmnnn The diaphragm appearing through the pleura; *mmm* the fleshy part; *nnn* the tendinous part.

oo, &c. Nervi intercostales.

pp, &c. Arteriæ intercostales.

q The intestines, seen through the peritonæum.

In the right lower Limb.

abc Musculus parvus in articulatione femoris situs; *a* it's round fleshy belly; *b* the flat tendon by which it arises over the tendon of the rectus cruris; *c* the flat tendon by which it is inserted into the os femoris.

def The head of the rectus, left on to shew how that muscle arises from the os innominatum, being hid in table the third under the glutæus medius, and glutæus internus, and in table the fourth under the glutæus internus; *d* it's origin from the external or posterior part of the inferior spine of the ilium, covered at *b* by the thin flat tendon of the musculus parvus in articulatione femoris situs; *e* it's origin from the anterior part of the inferior spine of the ilium; *f* the place where the muscle is cut off.

iiklo Iliacus internus; *ii* the anterior part arising from the spine of the ilium; *kl* posterior part arising at *kl* from the fascia lata; *o* the tendon, inserted into the lesser trochanter; at *l* a fascia arises which runs over the posterior part of this muscle.

mnnoo Levator ani, coming from it's origin from the acute process of the ischium near *m*; it is inserted at *nn* into the transverse processes of the second, third and fourth bones of the tail, and at *oo* into the internal sphinctor ani.

p The internal sphincter ani.

ss The insertion of the pectinæus into the os femoris.

tu Sartorius; *t* the fleshy part, or rather the muscle, which is flat and fleshy; *u* being only a fascia by which the muscle is confined in it's proper place.

T A sort of fascia under which these nerves and blood-vessels lie, and to which they are attached as well as the neighbouring muscles, and by that means kept in their proper places. The nerves and blood-vessels are marked as protuberating under it and seen through it.

wxx The gracilis; *w* the fleshy part; *xx* the fascia by which it is confined in it's proper place.

z Part of the adductor of the thigh, arising at *z* from the ischium; it is inserted externally tendinous into the os femoris.

1 2 3 Obturator internus with the gemini; 1 the inferior of the gemini, arising from the ischium; 2 the tendon of the obturator internus coming from the inside of the ischium; 3 the superior of the gemini going to it's insertion with the tendon of the obturator internus, and the other gemini into the internal lateral part of the great trochanter.

4 A tendinous fascia arising at 4 from the point of a little protuberance of the ischium, which spreading and descending is attached to the adductor magnus; it serves to bind down the tendon of the obturator internus, obliging it to lie in a concave form posteriorly: it is a guard for the nerve which accompanies it (lying partly over it) preventing it's being over braced by that tendon's starting from the bone, by bringing itself into a streight line when in action.

10 11 11 The bursal ligament of the hip joint arising at 10 from the os innominatum, at 11 11 from the neck of the os femoris.

13 13 Mark where the bursal ligament had it's origin from the os femoris, which inserts itself into the patella and tibia.

14 A ligament which binds the cartilage 15 to the tibia; behind 14 the top of the tibia is incrusted with a smooth cartilage, which serves the tendon of the poplitæus to slide upon.

15 The outer semi-lunar cartilage in the joint of the knee.

18 19 The articular ligament of the knee; 18 it's origin from the os femoris; 19 it's insertion into the fibula.

20 A ligament which binds the fibula to the tibia.

21 The external lateral ligament which binds the patella to the os femoris.

22 The internal lateral ligament which binds the patella to the tibia.

23 The anterior ligament which binds the patella to the tibia.

24 Part of the tendon of the gemellus, which is inserted into the os calcis, cut off at 24.

25 A strong ligament which binds the os calcis to the splint bone.

26 26 26 26 The external articular ligaments of the foot.

27 A ligament running from the astragalus to the metatarsal bone.

28 Interosseus, &c.

29 Iliaca minor.

30 Arteria glutæa.

31 Pudica communis.

32 32 Arteria obturatrix.

33 Arteria cruralis.

34 Vena cruralis.

35 Nervus cruralis.

36 Arteria poplitæa.

37 Vena poplitæa.

38 The outer cartilage belonging to the coffin bone.

39 The inner cartilage belonging to the coffin bone.

In the internal Side of the left lower Limb.

1 The internal lateral ligament of the patella, which binds that bone to the os femoris.

2 The internal lateral ligament of the patella, which binds that bone to the tibia, marked 22 on the right limb in this table.

3 The anterior ligament, which binds the patella to the tibia, marked 23 on the right limb in this table.

4 The internal articular ligament of the knee joint.

5 A ligament which binds the os calcis to the astragalus and os naviculare.

6 6 6 6 The internal articular ligaments of the foot.

7 A ligament which runs from the astragalus to the metatarsal bone, marked 27 on the right lower limb in this table.

8 Part of the tendon of the gemellus, which is inserted into the os calcis, cut off at 8.

9 Interosseus, &c.

10 Arteria cruralis.

11 Vena cruralis.

12 The inner semi-lunar cartilage in the joint of the knee.

13 The outer semi-lunar cartilage in the joint of the knee.

14 The inner cartilage belonging to the coffin bone.

Muscles, &c. on the right upper limb.

aab Subscapularis; *b* it's insertion into the humerus.

c Interosseus, &c.

ddd Ligaments which bind the orbicular bone to the radius, the bones of the carpus, and metacarpal bone.

eee Articular ligaments.

f Nervus cubitalis.

g Nervus axillaris.

h Nervus radialis.

i Nervus musculo-cutaneus.

kk Nervus medianus.

ll Arteria axillares.

m Vena axillares.

n Vena cephalica.

o The outer cartilage belonging to the coffin bone.
p The inner cartilage belonging to the coffin bone.

In the internal Side of the left upper Limb.

aaaa Articular ligaments.

b Interosseus, &c.

c Nervus medianus.

d Arteria brachialis, or the humeral artery.

e Vena brachialis, or the humeral vein.

f Vena cephalica.

g The inner cartilage belonging to the coffin bone.

The Sixth Anatomical TABLE of the Muscles, Fascias, Ligaments, Nerves, Arteries, Veins, Glands and Cartilages of a HORSE, viewed in front, explained

In the Head.

aabaab THE anterior muscles of the anterior cartilage: they arise under the epicranius thick and fleshy, and are inserted into the anterior angle of the anterior cartilage of the outer ear.

cc The lateral muscles of the anterior cartilage of the outer ear: they arise from above the orbits of the eyes; and are inserted into the anterior cartilages of the external ear.

dd The origenes. Their origin is, probably, from the epicranius; as they are not connected to the bone: they are inserted into the anterior cartilage.

ee The insertion of the middle parts of the retrahens, which is about one third of the way from the root of the ear to the tip; and about the middle of it's convexity.

ff Muscles which run from the anterior cartilage to the external ear.

hh Muscles which arise from under the lateral muscles *cc* in this table, and are inserted at the inferior angles of the openings of the ears anteriorly.

i The lateral depressor of the outer ear; arising from the quadratus colli, and inserted close by the lateral muscle of the anterior cartilage *c* in this table into the inferior angle of the opening of the ear posteriorly.

kkK the epicranius, or muscle of the scalp; K the tendinous expansion that goes to the elevators of the upper lip, and wings of the nose; *kk* the fleshy parts which run over part of the orbicular muscles of the eye-lids, and are inserted into the external skin.

lll 2 *mlll* 2 *m* The orbicular muscles of the eye-lids; 2 the origin of the fibres from the ligament, by which the conjunction of the eye-lids in the great canthus is tied to the nasal part of the os unguis.

LL The corrugators of the eye-brows.

*nn*NN 44 *nn*N The elevator of the upper lip and corner of the mouth: about the inner angle of the eye it arises from the bone: from *n* to *n* it arises from the epicranius; NN that part which is expanded under the dilator of the nostril and mouth; 4 4 the part which runs over the dilator of the nostril and mouth, and is inserted into the corner of the mouth.—The part 4 4 is the elevator of the upper lip; the part NN the elevator of the alæ nasi and upper lip.

o 3 5 *o* 3 The zygomatici; 3 5 it's origin from the orbicular muscle of the eye-lid; *o* the part which goes to be inserted into the corner of the mouth.

p The lateral dilators of the upper-lip and nostrils.

qqqr The orbicular muscle of the mouth; *r* fibres which intermix with the fibres of the long nasal muscles of the upper lip.

ss Part of the latissimus colli, which is inserted into the lower jaw bone.

tuu The tendons of the long nasal muscles of the upper lip; *t* the union of the tendons.

ww The anterior dilators of the nostrils.

xx Part of the membrana pituitaria, which lines the whole internal nares, the cellular convolutions, the conchæ, the sides of the septum narium, and, by an uninterrupted continuation, the inner surface of the sinus frontalis and maxillares, and of the ductus lacrymalis, palati, and sphenoidalis: it is likewise continued down from the nares to the pharynx.

In the Neck, Breast, Shoulders and Trunk.

abcdefghss The quadratus genæ latissimus colli, or broad muscle of the neck; *a* it's origin from the sternum, a little below the top; *b* it's origin from the proper, or inverting membranes of the pectoral muscle, or from the membranous continuation of the membrana carnosa; over that muscle at *c* the fleshy parts of each side recede from each other; and are united only by the tendinous expansion *d*, which becomes fleshy again, or gives rise to fleshy fibres at *e*; *f* the part under which the jugular vein protuberates; *g* the part under which the sterno-mastoideus, or rather sterno-maxillaris, protuberates; *h* a part which runs over the levator humeri proprius; at *ss* it runs over the lower jaw, and is, about the lower *s*, inserted into that bone.

ikll The proper elevator of the humerus; *i* that part which arises tendinous from the processus mastoideus, and by a tendinous membrane from the ridge of the occiput: this part alone may be called levator humeri proprius; and the part *k*, which lies partly under it and arises from the transverse processes of the four uppermost vertebræ of the neck, may be called musculus ad levatorem accessoris, being a distinct muscle, 'till it comes to be joined with or inserted into the levator humeri proprius, just below the opening where the nerve *m* comes out; *ll* the part which goes to be inserted into the humerus along with the transverse or superior part of the pectoralis between the biceps, and brachiæus internus.—The part arising from the processus mastoideus, and ridge of the occiput is the anterior and superior part of the trapezius: it has the coracohyoideus strongly attached to it, which it confines in it's proper situation agreeable to the curvature of the neck.

mm Nerves.

nnoppqqr The pectoral muscle; *nno* the superior part which arises from the superior part of the sternum for about one third of it's length, and running in a transverse direction over the inferior part is inserted along with the levator humeri proprius by a flat membranous tendon into the humerus, betwixt the biceps and brachiæus internus; *ppqq* the part of this muscle which arises from the anterior and inferior part of the sternum for about two thirds of it's length, and runs down upon the muscles lying on the inside of the cubit; a little below *qq* it ceases to be fleshy; *r* the part which arises from the aponeurosis of the external oblique muscle of the abdomen, and is inserted into the head of the os humeri internally.

s Some of the superior parts of the trapezius. In this view none of the inferior parts can be seen.

ttuwwxxyyyzzzz&&& Membrana carnosa; *tt* the posterior and inferior origin of the fleshy fibres; *u* the thickest part of this fleshy pannicle going to be inserted along with the latissimus dorsi and teres major into the humerus; *ww* large branches of veins which are spread in this muscle; *xx* the origin of the superior portion of the carnous fibres of this muscle, which are but very thin, all tending towards the cubit, and becoming a mere membrane as they pass the juncture of the elbow, are thus expanded over the muscles, &c. below, adhereing in some places to the edges of the muscular ligaments or those ligaments which bind down the tendons of the muscles to keep them in their proper places; *yyyzzzz* the posterior and inferior tendino-membranous part which runs over the loins, back, and part of the abdomen; the parts lying under which protuberate, as the serratus major posticus at *yyy*, and the ribs at *&&*; it then goes down the lower limbs with, or is lost in the fascia of the latissimus dorsi, fascia lata, and other membranous expansions which are spread upon the muscles, &c. of the lower limbs.

In the upper Limb.

abbcdefghiiikkk The membranous continuation of the fleshy pannicle down the upper limb, as it covers the muscles, &c. which lie upon that limb; *abb* the extensor carpi radialis; *a* the fleshy belly; *bb* the tendon; *c* the tendon of a muscle which is analogous to a combination of the abductor policis manus, extensor longus, and brevis policis manus, and indicator in the human body: it arises from the lateral part and ridge of the radius, and (in a horse, the thumb and fore-finger being wanting,) is inserted into the imperfect metacarpal bone of the fore-finger, or lost in the ligaments inserted into that bone, or rather attached to them before their insertion: *def* extensor digitorum communis; *d* the fleshy belly; *ef* the tendon; *g* flexor carpi radialis; *h* flexor carpi ulnaris; at *iii* this membranous expansion goes under the hoof; *kkk* vena cephalica, which arises from under the hoof, and falls into the jugularis externa, on the radius it is called vena radialis, and below that, vena plantaris.

l The hoof.

In the lower Limbs.

ABCDabcdeghhiik The membranous continuation of the fleshy pannicle down the lower limbs along with the fascia lata, &c. as they cover the muscles, &c. which lie upon those limbs; *A* the musculus fascia lata protuberating; *B* vastus externus; *C* the patella; *D* the anterior ligament which binds the patella to the tibia; *a* the fleshy part of the tibialis anticus, making it's appearance through the fasciæ that cover it; *bcd* the extensor longus digitorum pedis; *b* the fleshy belly; *cd* the tendon; *e* a sort of tendon formed by these fasciæ, which joins with the tendon of the extensor longus digitorum pedis; *g* the fleshy belly of the peroneus; *hh* a branch of the crural vein, called vena saphæna, or saphæna major; *iik* the tendon of the plantaris.

l The hoof.

The Seventh Anatomical TABLE of the Muscles, Fascias, Ligaments, Nerves, Arteries, Veins, Glands and Cartilages of a HORSE, viewed in front, explained

In the Head.

a THE anterior dilator of the nostril.

bcdd The lateral dilator of the nostril and upper lip; *c* it's origin; *dd* the part which is inserted into the nostril.

efgh The long nasal muscle of the upper lip; *f* it's origin; *g* it's tendon, where it unites with it's fellow; *h* it's insertion into the upper lip.

kk Ales naris.

lmno A muscle arising by a small tendon along with the long nasal muscle of the upper lip at *m*; *n* it's insertion by a small portion into the wing of the nose; *o* the principal part going to be inserted into the concha narium inferior.

p Part of the membrana pituitaria which lies upon the opening of the nares. See table six, *x*.

P Musculus caninus, or the elevator of the corner of the mouth.

QQQ The orbicular muscle of the mouth.

qrr Musculus ciliaris; *q* it's origin.

st The broad ligament of the eye-lids, which are membranous elongations formed by the union of the periostium of the orbit and pericranium, along both edges of each orbit.

uw The ball of the eye; *u* the pupil; *w* the iris.

xxy The temporal muscle; *xx* it's origin; *y* it's insertion into the coronary process of the under jaw bone.

z The masseter.

1 Arteria angularis.

2 Vena angularis.

3 The salivary duct.

4 Branches of the nervus maxillaris inferior: they are branches of the third branch of the fifth pair of nerves: they are accompanied with an artery from the temporal artery which communicates with the arteria angularis.

In the Ear.

ab A muscle arising at *a* from the anterior cartilage, and inserted at *b* into the external ear.

c A muscle which arises by two fleshy heads from the internal surface of the anterior cartilage, and is inserted into the lower convex part of the external ear near the root, nearer the posterior edge than the anterior: it assists the posterior part of the retrahens in action.

d A muscle which is a sort of antagonist to *c*; it arises from the ridge of the occiput under the retrahens, and is inserted into the ear at *d*: it helps to turn the opening of the ear forwards.

f The anterior cartilage of the outer ear.

g The outer ear.

In the Neck.

abc Sterno-mastoideus, or sterno-maxillaris, because it arises at *a* from the top of the sternum, and is inserted tendinous into the lower jaw bone under the parotid gland, and by a continuation of the same flat tendon into the root of the processus mastoideus.

dd Caracohyoideus arises from the upper and internal side of the humerus, betwixt the insertions of the subscapularis and teres major by a flat membranous tendon, and is inserted into the os hyoides; it has a strong attachment to the anterior part of the levator humeri proprius, or rather the anterior part of the trapesius, by which it is confined in it's proper place, being prevented forming a streight line when the neck is curved.

ee Longus colli.

ff Scaleni.

gh Inter-transversalis minor colli.

iklm Serratus major anticus; *i* the part which arises from the transverse processes of the third and fourth vertebræ of the neck; *k* that from the fifth, *l* that from the sixth, *m* that from the seventh: it is inserted into the scapula. Betwixt these parts are marked arteries and nerves which go to the parts lying over them.

nnoo The jugular veins; at *oo* are valves.

p Glandulæ cervicales inferiores. See table second, 5

In the Shoulders and Trunk.

abc Serratus minor anticus arises from the sternum and part of the first rib, and from the cartilaginous endings of the second, third, and fourth ribs near their joining to the sternum: it is inserted into the superior costa near the basis of the scapula and tendinous surface of the supra-spinatus; and is connected to the teres minor by a fascia, which is sent from this muscle over the infra and supra-spinatus scapulæ to it's outer edge. It's flat tendon may be separated, some part of the way, to the basis and spine of the scapula, from the tendinous surface of the supra-spinatus scapulæ.

ddeeffggh Pectoralis; *ddee* the superior part arising from the sternum at *dd*, which is, at *ee*, going to be inserted, by a flat membranous tendon, along with the levator humeri proprius into the humerus, together with or betwixt the biceps and brachiæus internus; *ffgg* the part of this muscle which arises from the anterior part of the sternum at *ff*, thence running towards the muscles lying on the cubit ceases to be fleshy about *gg*, and sends a membranous tendon or fascia down the muscles on the inside the cubit, which is joined by the membrana carnosa; *h* the part which arises from the aponeurosis of the external oblique muscle of the abdomen, and is inserted into the head of the os humeri internally.

ikklmn Supra-spinatus scapulæ; *kk* it's origin from the spine of the scapula; *l* it's insertion into the head of the os humeri and capsular ligament on the inside of the biceps cubiti; *m* it's insertion into the head of the os humeri and capsular ligament on the outside of the biceps cubiti.

opq Infra-spinatus scapulæ; *q* the tendon by which it is inserted into the protuberating part of the humerus.

r Teres minor.

ssttuw Latissimus dorsi; *ss* the aponeurosis, or tendon of this muscle; *tt* the origin of it's fleshy fibres; *u* a fleshy part of this muscle, which runs over the inferior angle of the scapula; *w* the fleshy part going to be inserted into the humerus.—The serratus major posticus protuberates a little under the aponeurosis of this muscle.

x Coraco-radialis.

yz Triceps brachii; *y* the head, called extensor longus; *z* extensor brevis.

1 1 1, &c. 2 2 2, &c. 3 3 4 4 4 5 6 6 Obliquus externus, or descendens abdomenis; it's superior origin is from the fifth rib: about 1 1 1, &c. it begins it's origin from the ribs and intercostals, and continues it down to about 2 2 2, &c. where it ceases to adhere to them; 4 4 4 the fleshy part which does not adhere to the ribs, and intercostals; 3 3 mark the fleshy fibres arising from the fascia lata; 5 the fleshy part of this muscle which lies over the abdomen; 6 6 part of it's insertion into the spine of the ilium.—Upon this muscle are marked a great many small branches from the intercostal arteries which go to the membrana carnosa and integuments.

7 7 Longissimus dorsi.

In the upper Limbs.

aabcdefghi A fascia or strong membranous production, lying over the extending muscles which are upon the cubit: *aa* it's origin from the two external protuberating parts of the humerus, from the levator humeri proprius, from the trapezius, and from the anterior edge of the triceps: it is expanded like a strong ligament betwixt the two protuberating parts of the humerus, and gives origin to some of the fleshy fibres of the extensor carpi radialis; it is inserted into the radius on each side of the extending muscles, and into the muscular ligaments on the carpus; it makes a continued case for the extending muscles from their originations down to the carpus, and confines them steady in their proper places; there lies protuberating under it, at *abcdef*, the extensor carpi radialis, of which *bcd* mark the fleshy part; *ef* the tendinous, which is inserted at *f* into the metacarpal bone; at *g* the muscle protuberates, which is analogous to

the extensors of the thumb in the human body, and at *hi* the extensor digitorum communis of which *h* is the fleshy part; *i* the tendon.

klm The tendon *i* inserted at *k* into the coffin bone; at *lm* into the great pastern or first bone of the finger.

nn Ligaments which confine the tendon of the extensor digitorum communis down to the great pastern, which is analogous to the first bone of the finger in the human subject: they are sent from the interosseus, &c.

op An expansion which arises from the external articular ligament betwixt the humerus and cubit and from the olecranon; it receives an addition from the longus minor and then descends over the bending muscles to form the ligaments on the carpus to which it is attached, as well as to the bones of the cubit on each side of the bounds of the bending muscles; there lies protuberating under it at *o*, the flexor carpi radialis; and at *p* flexor carpi ulnaris.—It forms the ligament which binds down the tendons of the bending muscles on the carpus, and descends more than half way down the splint bones, then degenerates into a membrane, and joins the ligament which arises from the sesamoid bones.

qr Vena cephalica: it arises from under the hoof and falls into the jugularis.

ss Vena plantaris.

t Nerves which go to the integuments.

u A ligament proper to the tendon of the extensor digitorum communis, inserted, at two protuberating parts of the radius, on each side the channel in which the tendon lies.

wxyy A ligament whose fibres run in a transverse direction over the anterior part of the carpus, to which the carnous membrane adheres at *w*, and the bursal ligament which lies under it about *x*: it seems to arise from the fascia which covers the bending muscles on the cubit, and the articular ligaments protuberating under it at *yy*.

zz The articular ligaments of the fetlock joint.

& A substance resembling the villous surface of a mushroom, arising from the coffin bone, received by the like substance arising from the hoof, which it mutually receives.

In the lower Limbs.

a Part of the gluteus externus.

bbbcd Gluteus medius; *bbb* it's origin from the tendinous surface of the sacro-lumbalis; *c* it's origin from the ilium.

efghik Musculus fascia lata; *e* the posterior fleshy belly; *f* the fleshy part lying betwixt the two fleshy bellies; *ghik* the broad tendon; at *g* it is covered by the fascia lata, which, in this place, is inseparably united with it, but ceases to adhere to it betwixt *g* and *h*, where it is cut off; at *i* the tendon of this muscle is inserted into the tibia; at *gh* the vastus externus protuberates; at *k* the patella; and betwixt *k* and *i* is the external anterior ligament which binds the patella to the tibia.

lmnopqrssst Biceps cruris; *lm* the anterior fleshy part, which is inserted into the patella near *m*, and by a strong tendon *mn* into the tibia at *n*; the part *m* lies under the flat tendon of the middle part *o*, which joins the flat tendon of the musculus fascia lata; *o* the middle part of this muscle going to be inserted into the anterior and superior ridge of the tibia, and the tendon of the anterior part running from the patella to *i*; *pqrssst* the tendon of the posterior part of this muscle, which is inserted at *sss* into the anterior ridge of the tibia, and under which protuberates, at *p*, the extensor longus.

uuuuwwxz 1 2 2 The tendon of the extensor longus digitorum pedis, of which *p* is the fleshy belly; and *uuuuwwx* the tendon inserted at *u* into the coffin bone, and at *ww* into the great pastern or first bone of the toe; *x* the place where the fasciæ are cut off which join in with this tendon; at *q* the tibialis anticus protuberates under the tendon of the biceps cruris, of which *q* is the fleshy part, and *z* 1 the tendons protuberating under the ligaments; at *r* the peroneus protu-

berates, of which *r* is the fleshy part, and 2 2 the tendon which joins in with the long extensor of the foot.

3 Extensor brevis digitorum pedis arises tendinous from the upper part of the anterior protuberance that stands forwards from the calcaneum, and soon becoming fleshy is inserted fleshy and tendinous into the tendon of the long extensor digitorum pedis a little above that tendon's being joined by the peroneus.

4 A ligament common to the extensor longus digitorum pedis and tibialis anticus; it receives a little of the insertion of the biceps cruris into it's superior edge internally; the part 4 is the strongest part of it: it arises from the tibia close to the insertion of the flat tendon of the biceps with which it is united: it's fibres run obliquely downwards and outwards from the internal edge of the tibia to the external.

5 A ligament proper to the extensor longus digitorum pedis protuberating under the membranous ligament.

6 A ligament common to the extensor longus digitorum pedis with the tendon of the peroneus: it arises from the bones of the tarsus and splint bone, and is inserted into the anterior and superior part of the metatarsal bone, and running membranous over the ligament 5 joins the ligament 4; it's tendinous fibres run chiefly transverse, but some scattered irregular tendinous stripes from about 7 run obliquely downwards and inwards: there is an expansion running to this from the fascia which covers the flexor digitorum over the peroneus which compleats a case for that muscle.

7 A ligament which binds down the tendon of the peroneus; it runs from the tibia to the os calcis: it is marked 3 4 in table the second.

8 8 A sort of ligamentous fascia, betwixt which and the bursal ligament the mucilaginous glands are contained; it is attached above, to the ligament 4, and below, to the ligament 6, on the inside to the articular ligament.

9 10 10 Interosseus, &c. it is like a strong ligament arising from the upper part of the metatarsal bones, and some of the tarsal bones, and is inserted into the sesamoid bones and first bone of the toe on each side, and sends off the ligaments 10 10 to the tendon of the extensor longus digitorum pedis.

11 The tendon of the flexor digitorum pedis.

12 12 The tendon of the plantaris.

13 13 Vena saphæna.

14 Vena plantaris externa.

15 Vena plantaris interna, or a continuation of the vena saphæna.

16 The vena plantaris arising from under the hoof.

17 The tendon of the gemellus, or tendon achilles, inserting itself into the os calcis, covered by the fasciæ which are inserted into the os calcis.

18 Tibialis posticus.

19 A substance resembling the villous surface of a mushroom, arising from the coffin bone, received by the like substance arising from the hoof, which it mutually receives.

The Eighth Anatomical TABLE of the Muscles, Fascias, Ligaments, Nerves, Arteries, Veins, Glands and Cartilages of a HORSE, viewed in front, explained

In the Head.

a THE anterior dilator of the nostril; the superior part is inserted into the superior edge of the alæ nasi, the middle part *a* into the cartilage, and the lower part into the anterior edge of the nostril below the anterior lateral cartilage, and above the posterior and inferior lateral cartilage.

*bc*D A muscle which arises by a small tendon along with the long nasal muscles of the upper lip, and from the musculus canini, or is attached to it by a membranous tendon which runs over the nerves 1 1 2 3: it is inserted into the wing of the nostril, but chiefly into the concha narium, or pituitary membrane which incloses the concha narium inferior; *b* it's origin; *c* the fleshy part which goes to be inserted into the concha narium; at D those few fibres are cut away which were inserted into the wing of the nose; it is inserted into the alæ nasi fleshy all the length of it's inferior edge.

dd Orbicularis oris.

e Canini, the elevators of the corners of the mouth.

f The masseter.

ggh The temporal muscle; *gg* it's origin; *h* it's insertion into the coronary process of the under jaw bone.

i Part of the membrana pituitaris. See table the sixth *x*.

K The alæ narium.

kl The eye-ball; *k* the pupil, *l* the iris.

mnn Musculus ciliaris; *m* it's origin.

o The elevator of the eye-lid, so thin and transparent that the white part of the eye is seen through it, and the tunica adnata, or conjunctiva, which lies under it, as well as the tendon of the streight muscles of the eye.

1 1 2 9 Nervus maxillaris superior, the second branch of the fifth pair of nerves; 1 1 branches going to the upper lip; 2 a branch which goes to the inside of the nostril towards the tip of the nose; 9 a branch which goes to the long nasal muscle of the upper lip.

3 Branches of the nervus maxillaris inferior; they are branches of the third branch of the fifth pair of nerves; and accompanied with an artery from the temporal artery which communicates with the arteria angularis; the nerve also communicates with the nervus maxillaris superior.

4 Arteria angularis.

5 Vena angularis.

6 The salivary duct.

7 The anterior cartilage of the outer ear.

8 The outer ear.

In the Neck.

ab Sterno-thyroideus; *a* it's origin from the sternum internally; it's insertion is into the thyroid cartilage.

cd Caracohyoideus; *c* the flat membranous tendon coming from it's origin from the upper and internal side of the humerus, betwixt the insertions of the subscapularis and teres major: it is inserted into the os hyoides; *d* the fleshy part: it is attached to the anterior part of the trapezius, which prevents it's starting into a right line when the neck is curved: it has an attachment to the rectus anticus major, or an origin by a flat tendon along with it's insertion from the os sphenoides.

f Scalenus; it arises from the transverse processes of the fifth, sixth, and seventh vertebræ of the neck, and is inserted into the first rib.

gg The inferior part of the transversalis cervices: it arises from the transverse processes of eight of the superior vertebræ of the back, and from the fascia betwixt that and the broad tendon of the complexus, &c. by fleshy fibres: it is inserted into the transverse processes of the four inferior vertebræ of the neck partly fleshy, but chiefly by broad thin tendons, as *gg*.

h The superior part of the transversalis cervices, which arises from the third, fourth, fifth, sixth, and seventh oblique processes of the neck, and the two uppermost of the back, viz. beginning at the lower oblique process of the third and at the uppermost of the fourth, and so of the rest. It is inserted into the transverse process of the first vertebra.

i Part of the trachelo-mastoidæus, complexus minor, or mastoidæus lateralis, which arises from the oblique processes of the third, fourth, fifth, sixth, and seventh vertebræ of the neck, the uppermost of the back, and transverse processes of the second and third vertebræ of the back. It is inserted tendinous into the root of the processus mastoidæus.

k Arteria carotis.

l Part of the jugular vein.

In the Trunk.

aabc Musculus in summo thorace situs, arises at *aa* from the first rib, and is inserted into the sternum about the root of the cartilage of the fourth rib; at *b* the edge *c* joins in with the rectus abdominis of which this muscle seems to be a continuation.

ffgghhiii Serratus minor posticus; *ffgg* the broad tendon by which it arises, cut off at *ff* to shew the gluteus medius; *gghh* the fleshy part, beginning at *gg*; *iii* the flat tendons by which it is inserted into the ribs: it's first insertion is into the fifth rib. In some subjects this muscle runs fleshy under the serratus major posticus, and is inserted into the ribs from the fifth to the fourteenth.

FFG The serratus minor anticus arising from the sternum and cartilages of the four superior ribs at FF.

kkllmm, &c. Serratus major posticus; *kkll* it's broad tendon, cut from the tendon of the latissimus dorsi at *kk*; *llmm*, &c. the fleshy part, inserted into the ribs at *mm*, &c. it is, in some subjects, inserted into eight inferior ribs, in others only into seven.

H Supra-spinatus scapulæ.

I Infra-spinatus scapulæ.

nop Longissimus dorsi; *n* the strong thick part of it's tendinous surface; *o* the thin part of it's tendinous surface, through which the fleshy fibres make some appearance; *p* it's superior tendon, inserted into the transverse process of the seventh vertebra of the neck.

qrst Sacro lumbalis; *q* the part arising by a small tendon along with the longissimus dorsi; *r* it's uppermost insertion into the transverse process of the seventh vertebra of the neck; *s* it's insertion into the first rib; *t* that into the second.

yy, &c. *zz*, &c. 1 1, &c. 2 2, &c. The external intercostals; *yy*, &c. *zz*, &c. the anterior part over which the external oblique muscle of the abdomen runs without adhereing; *zz*, &c. 1 1, &c. the part to which the external oblique muscle adheres, which is about as extensive as it's origin from the ribs; 2 2, &c. the parts which lie above the adhesion of the oblique muscle of the abdomen.

3 3, &c. Fleshy fibres which arise partly externally, tendinous, but chiefly fleshy, and run in a transverse direction from one rib to another.

4 4, &c. Parts of the internal intercostals.

5 5 6 6 7 Obliquus internus, or ascendens abdominis; 5 5 it's origin from the spine of the ilium, tendinous, and fleshy: it's origin is continued to the ligamentum fallopii; it is also continued from the said ligament and symphisis of the os pubis: 6 6 it's insertion into the cartilage of the lowest rib partly tendinous: it is likewise inserted into the cartilaginous endings of the ribs as far as the cartilago ensiformis.

8 9 9 Some appearance of the transversalis abdominis.

10 10, &c. Some branches of the nervi lumbares.

11 A branch of the external branch of the outer iliac artery, accompanied by 12.

12 A branch of the external branch of the outer iliac vein.

13 13, &c. Branches of the arteriæ intercostales inferiores.

14 14, &c. Branches of the arteriæ intercostales superiores.

15 15, &c. Branches of the arteriæ lumbares.

In the Shoulders and upper Limbs.

A Nervus musculo-cutaneus.

B Nervus medianus.

C Nervus cubitalis.

D Nervus radialis.

E Nervus axillaris.

F Vena axillaris.

abc Subscapularis, which is outwardly tendinous; *a* marks the place where the membranous tendon is cut off, by which the supra-spinatus receives some origin from the surface of this muscle; *b* marks a tendinous slip sent from this muscle which leaves it about *c*, and is inserted into the processus coracoides: it serves to guard some nerves which pass under it.

de The internal part of the pectoralis, coming at *d* from it's origin from the aponeurosis of the external oblique muscle of the abdomen; *e* it's insertion into the head of the os humeri.

fgh Triceps brachii; *f* the head called extensor longus, arising from the interior costa of the scapula; *g* the head called extensor brevis, arising from the humerus and expansion which covers the extending muscles on the cubit; *h* the part going to be inserted into the ancon.

iklmn Biceps brachii, or rather coraco-radialis; *i* it's origin from the processus coracoides scapulæ; *k* a fleshy part lying upon the tendon; *l* the external belly; *m* the internal belly; *n* the aponeurosis arising from this muscle which it sends to the tendinous fascia, or covering of the cubit, and tendon of the extensor carpi radialis.

o Part of the brachialis internus: it arises from the neck of the humerus and internal lower part of the scapula; and is inserted into the radius a little below the insertion of the coraco-radialis, but more internally.

pqrstuwxy Extensor carpi radialis; *p* it's origin from the superior external protuberating part of the humerus; *q* some of the part which arises fleshy from the fascia which is extended betwixt the two external protuberating parts of the os humeri: it arises above the part *q*, and ligament or fascia from the external ridge of the external condyle all the way up as far as the brachialis internus does not cover: but it's most considerable origin is from the anterior part of the external condyle of the humerus; from which place it continues it's origin into the great cavity on the anterior and inferior part of that bone, from whence it arises by a very strong tendon, firmly adhering to the tendon of the extensor digitorum communis.—The origin of this muscle is as extensive as the originations of the long supinator, radialis longus and brevis in the human body: it appears to be a combination of all the three; it is assisted by the biceps, the fascia of which is like a strong flat tendon inserted into this muscle; *rst* the fleshy part; *uwx* the tendon inserted into the metacarpal bone at *w*; about *x* it adheres to the bursal ligament; *y* marks the place where the fascia, proper to the extending muscles on the cubit, is cut off from the fascia of the biceps muscle *ny*, which it joins, to be inserted, along with it, into the tendon of this extensor carpi radialis.

zz A ligamentous fascia.

1 2 2 3 4 5 6 6 Extensor digitorum communis; 1 the fleshy belly which arises from the external condyle of the humerus, the upper and lateral part of the radius and fascia which covers the extending muscles on the cubit; but it's principal origin is by a strong flat tendon from the anterior part of the external condyle of the humerus; from which place it continues it's origin into the great cavity on the anterior and inferior part of that bone called it's anterior fossula above it's articulation with the radius; it lies under the extensor carpi radialis, to the tendon of which it adheres for about three minutes from it's beginning as well as to the bursal ligament which lies under it: 2 2 3 4 5 6 6 the tendon; 3 the part which is inserted into the coffin bone; 4 the insertion of a slip of this tendon, along with the tendon of the extensor minimi digiti, into the great pastern, externally; 5 the insertion of a slip of this tendon into the great pastern internally; 6 6 the insertions of the ligaments into

this tendon, which bind it down to the great pastern.

7 7 8 The muscle which is analogous to the extensors of the thumb in the human body; 7 7 the fleshy part arising from the lateral part and ridge of the radius; 8 the tendon going to be inserted into the internal splint: it is a combination of the abductor pollicis manus, extensor longus and brevis, pollicis manus, and indicator.

9 Flexor carpi radialis, arises from the inner condyle of the humerus and is inserted into the internal splint bone.

10 Flexor carpi ulnaris internus; that part of it which arises from the internal protuberance of the humerus.

12 Vena cephalica, it arises from under the hoof (where it is called vena plantaris) and falls into the jugularis.

13 13 The bursal ligament, belonging to the anterior part of this joint.

14 14 The articular ligaments of the carpus.

15 15 The articular ligaments of the fetlock joint.

16 Vena plantaris.

In the lower Limbs.

abbbcd Gluteus medius; *bbb* it's origin from the tendinous surface of the sacro-lumbalis; *c* it's origin from the ilium; near *d* it is inserted into the great trochanter of the thigh bone.

efG Vastus externus; *e* it's principal fleshy part, inserted at *f* into the patella; G the thin fleshy part, inserted into the external lateral ligament of the patella.

ghik Tibialis anticus; *g* it's origin from the superior, and anterior part of the tibia; it arises also by a very strong tendon from the inferior part of the os femoris into which the fleshy part, arising from the tibia about *g*, is inserted, having first run down about one third of the length of the tibia, after which insertion fleshy fibres arise from this tendon and run obliquely downwards and inwards: the internal surface of this muscle, which is externally tendinous and arises from the tibia, sends off fleshy fibres obliquely downwards and outwards, which form a belly about twice as thick as those from the external tendon, which they meet, and with it form the tendon *h*, which is inserted into the superior and anterior edge of the metatarsal bone, and into the ossa cuneiforma: the external tendinous surface of this muscle, which arises from the os femoris, divides about the bottom of the tibia into two parts *i* and *k*, which serve as ligaments to keep the tendon *h* from starting from the tibia when this joint is bent: the

part *i* is inserted into the lesser cuneiform bones of the tarsus, posteriorly running over the internal articular ligament as far back as the posterior edge of the splint bone; and the part *k* is inserted into the os cuboides: it divides for the passage of some vessels, and then unites again.

lmnnopqrstt Extensor longus digitorum pedis; *l* it's origin from the os femoris along with the strong tendon of the tibialis anticus, to which it is inseparably joined near it's origin: it arises also from the tibia; *m* it's fleshy belly; *nn* it's tendon, joined at *o* by the tendon of the peroneus; with part of which it sends off a slip to be inserted into the first bone of the toe, or great pastern at *p*; at *q* it is joined by the fasciæ, which are here cut off, and sends with them a slip which is inserted into the great pastern at *r*; *s* the principal part of the tendon going to be inserted into the coffin bone; *tt* the insertions of the ligaments into this tendon, which bind it down to the great pastern.

uu Extensor brevis digitorum pedis.

wxx Peroneus; it arises from the external articular ligament, which runs from the external condyle of the femoris down the fibula, and from the fascia or tendinous covering of the flexor digitorum pedis; *w* it's fleshy belly; *xx* it's tendon, which joins in at *o* with the tendon of the extensor longus digitorum pedis.

y Tibialis posticus, arises from the external side of the posterior part of the head of the tibia, and from the tendinous surface of the flexor digitorum pedis; the tendon of which muscle it joins in with, after running through a groove on the internal side of the heel.

z The tendon of the gemellus.

& The tendon of the plantaris.

1 Arteria tibialis anterior.

2 Vena saphæna.

3 Vena plantaris externa.

4 Vena plantaris interna.

5 A ligament proper to the extensor longus digitorum pedis.

6 6 A bursal ligament.

7 8 Articular ligaments.

9 The interosseus, &c. it is like a strong ligament arising from some of the tarsal bones, and the upper part of the metatarsal bones; and is inserted into the sesamoid bones of the fetlock joint, and upper parts of the great pastern on each side, and sends off the ligaments 10 10 to the tendon of the extensor longus digitorum.

The Ninth Anatomical T A B L E of the Muscles, Fascias, Ligaments, Nerves, Arteries, Veins, Glands and Cartilages of a H O R S E, viewed in front, explained

In the Head.

a THE anterior dilator of the nostril.

ef The short nasal muscle of the upper lip.

gg The orbicular muscle of the mouth.

hhhiik Caninus, or the elevator of the corner of the mouth; *hhh* it's origin from the upper jaw bone; *ii* it's insertion into the buccinator; *ik* it's insertion into the orbicularis oris.

llm Part of the buccinator; it arises from three different places: the superior fibres arise from the alveoli of the upper jaw; the middle fibres from the ligamentum inter maxillaris, and the inferior ones from the lower jaw: it is inserted into the glandulous membrane of the inside of the cheek and lips; and at *m* into the orbicularis oris.

nop The globe, bulb, or ball of the eye; *n* the pupil; *o* the iris; *p* the white of the eye, or tunica sclerotica, covered with the albuginea, or tendons of the streight muscles only.

q One of the lachrymal glands placed in the great canthus of the eye, called caruncula lachrymalis, and glandula lachrymalis inferior.

r The semi-lunar fold, formed by the conjunctiva.

s Attollens; it arises from the bottom of the orbit near the foramen opticum, from the elongation of the dura-mater by a short narrow tendon, and is inserted into the tunica sclerotica forming the albuginea.

t Deprimens; it arises and is inserted as the attollens, only the attollens is on the superior, and the deprimens on the inferior part of the globe.

u Adducens; it has it's origin betwixt the attollens and deprimens, and is inserted betwixt them lying on the internal side of the globe: it's tendon is joined by the attollens above, and deprimens below; and on the external side of the globe, those two muscles are joined in like manner before they reach the cornea, by the abducens; these four streight muscles altogether forming the tunica albuginea, are inserted into the tunica sclerotica near the edge of the cornea lucida.

w Obliquus inferior.

xyz Nervi maxillares superiores; they are branches of the third branch of the fifth pair of nerves; *x* branches which go to the upper lip; *y* a branch which goes to the inside of the nostril towards the tip of the nose; *z* a branch

which goes to the long nasal muscle of the upper lip.

1 Arteria angularis.

2 Vena angularis.

3 The anterior cartilage of the outer ear.

4 The outer ear.

In the Neck.

ab Sterno-thyroideus, arising at *a* from the superior and internal part of the sternum fleshy, it becomes tendinous in about half it's ascent up the wind-pipe, from which tendon the sterno-hyoideus arises; it soon becomes fleshy again and is inserted into the thyroid cartilage.

c Trachea arteria, asperia arteria, or wind-pipe.

defgh Longus colli; *d* the part which comes from it's inferior origin, which is from the lateral parts of the bodies of the five uppermost vertebræ of the back and the lowest of the neck, and from the transverse processes of the sixth, fifth, fourth, and third vertebræ of the neck; it is inserted at *g* into the anterior oblique process of the sixth vertebra of the neck, and into the bodies of the fifth, fourth, third, and second, laterally, near the transverse processes, and into the anterior eminence or tubercle of the body of the first vertebra of the neck.

iikk Inter-transversarii posteriores colli; they arise from the roots of the oblique processes, and betwixt them and the transverse processes; also from the posterior part of the transverse processes of the four inferior vertebræ of the neck, and the uppermost of the back: they are inserted into all the transverse processes of the neck, except the first and last, though the obliquus capitis inferior seems to be a muscle of the same kind.

m Nerves coming from betwixt the sixth and seventh vertebræ of the neck, betwixt that and the first of the back, and betwixt the first and second of the back: they form the brachial nerves.

n Arteria carotis.

o Part of the vena jugularis.

p Part of the vena cephalica, where it falls into the jugularis.

In the Trunk.

a Semi-spinalis dorsi, arises fleshy from the tendinous surface of the longissimus dorsi: it is inserted into the spines of the ten superior vertebræ of the back: and communicates with the spinalis cervicis as well as the fleshy fibres of the spinalis dorsi, before it's insertion into the superior parts of the spines, the spinalis dorsi being inserted below it.

bbccdefgh Longissimus dorsi; it arises at *bb* from the posterior spine of the ilium, and at *cc* by a strong aponeurosis from the three uppermost spinal processes of the os sacrum, from all those of the loins and seven or eight of the back; this aponeurosis, or tendinous surface, is very strong near the spines as at *d*, but diminishes in thickness so as to shew the carnous fibres through at *e:* it arises also fleshy from the inside of the ligament which binds the posterior part of the ilium to the transverse processes of the os sacrum, and from all the anterior side of the ilium which is behind the transverse processes of the os sacrum, and is inserted into the whole length of the inferior edges of the transverse processes of all the vertebræ of the loins, into the inferior or lower convex edges of about seven of the inferior ribs, betwixt their articulations and the sacro-lumbalis; the insertion into the lowest is about nine minutes broad, the insertions into those above, diminish gradually in breadth 'till they come to the seventh or eighth, where they end in a point: the sacro-lumbalis in those above lying close up to the transverse processes of the vertebræ of the back. It is inserted, by distinct tendons, into all the transverse processes of all the vertebræ of the back, and ligaments of the true ribs, and at *g* into the transverse process of the seventh vertebra of the neck; *bbfh* shew the carnous origin of the gluteus medius from the tendinous surface of this muscle.

ikkllllllL Sacro-lumbalis; *i* the part which, in this subject, arises from or along with the longissimus dorsi; it

receives origins from the superior edges of all the ribs, except two or three of the uppermost, by flat tendons about half the breadth of the muscle, and is inserted, by distinct flat tendons, into the lower convex edges of all the ribs except two or three of the lowest, as at *llllll*, and into the transverse process of the seventh vertebra of the neck at L: each of these tendons run upon the surface of the muscle, going over about three ribs below it's insertion.

nooppp Levatores costorum; *noo* that which arises at *n* from the transverse process of the seventh vertebra of the neck, being inserted into the first rib at *oo*; it is sometimes called one of the scaleni: *ppp* those which arise from the transverse processes of the back, and the neighbouring ligaments, each being inserted into the back part of the outside of the rib below it's origin.

qqrr, &c. The external intercostals; they arise at *qq* from the inferior edge, and a little of the outside of each rib, the last excepted, are a little tendinous, and, descending obliquely downwards, are inserted at *rr* into the upper edge and from a small portion of the outside of each rib, the first excepted.

sstt, &c. The internal intercostals, they arise at *ss* from the superior edge only of the bony part of each rib, except the first, not covering any of the outside, and from the edges of the cartilages of the ribs, and a considerable part of the outside of the cartilages: they are, chiefly externally, tendinous, but partly fleshy, and ascending obliquely upwards, and forwards, are inserted into the lower edges of the bony parts of the ribs, and into the edges and part of the outsides of their cartilages, the last excepted.

uuwwxyy Transversalis abdominis; the part *uu* arises from the inside of the ribs below the triangularis of the sternum and diaphragm by fleshy digitations; the part *ww* arises tendinous from the transverse processes of the three or four uppermost vertebræ of the loins, by an aponeurosis, or tendinous plain, and fleshy from the internal labeum of the crista of the ilium, and a great part of the ligamentum fallopii, or tendinous margin of the internal obliquus of the abdomen, and is inserted into the ensiform cartilage, and linea alba, adhereing to the posterior plate of the aponeurosis of the internal oblique muscle of the abdomen at it's first passing under the rectus. The lower part of the aponeurosis of the transversalis is separated from the upper in a transverse direction, from the edge of the rectus to the linea alba, about half way betwixt the navel and synchondrosis of the pubis, the upper part going behind the rectus, and the lower before it and the pyramidalis, if there is any; at *x*, from the spine of the ilium, arises an aponeurosis common to this muscle, with the lower posterior serratus and internal obliquus, cut off at *xi*, where it joins the serratus, and *yy* where it joins the internal obliquus.

z The elevating muscle of the tail.

1 The lateral muscle of the tail.

2 2 The inter-transversal muscles of the tail.

3 The depressing muscle of the tail.

The origins and insertions of the muscles of the tail are shewn in the next table.

4 Branches of the nervi lumbares, coming out of the sacro lumbaris, which run under the gluteus medius to go to the integuments.

5 5, &c. Branches of the nervi costales, lying upon the transversales, which go to the abdominal muscles and integuments.

6 Branches of the nervi lumbares which go to the abdominal muscles and integuments.

7 Small arteries coming out of the sacro-lumbalis to go to the gluteus medius.

8 8 Arteries from the intercostales inferiores.

9 9, &c. Branches of the arteriæ intercostales superiores.

10 The external Branch of the outer iliac artery in two ramifications, accompanied by 11.

11 The external branch of the outer iliac vein, in two ramifications.

In the Shoulders and upper Limbs.

abcde Sub-scapularis; it arises from all that space of the inner or concave side of the scapula, betwixt the insertion of the serratus major anticus and near it's neck, and from this situation it has it's name: it is thick and made up of several penniform portions: *a* the part above the superior costa of the scapula, where there is yet remaining a part of the flat tendon by which the supra-spinatus receives some origin from the tendinous surface of this muscle; *b* the part below the inferior costa of the scapula, which is externally tendinous; *c* marks a tendinous slip sent from this muscle, which leaves it about *d*, and is inserted into the processus coracoides: it serves to guard some nerves which pass under it: this muscle is inserted at *e* into the head of the os humeri, which insertion is continued down to the insertion of the teres major.

fgh Teres major; *f* it's origin from the inferior costa of the scapula; *g* the part which is externally tendinous, going to be inserted into the humerus.

ikllmno Longus minor; *iklln* it's broad tendon by which it begins, at *i* from the inferior angle of the scapula, and at *ik* from the tendinous surface of the teres major; *ll* the beginning of it's fleshy fibres, which become tendinous again at *m*, and are inserted into the inside of the ancon; at *n* may be seen, through the flat tendon of this muscle, the tendons of the membrana carnosa and latissimus dorsi, going to their insertions into the humerus, along with the teres major, to the tendon of which muscle they are inseparably joined; but before their insertion their fibres intersect each other in this manner, viz. the tendinous fibres from that part of the latissimus dorsi which lies over the inferior angle of the scapula, are inserted along with the inferior angle of the tendon of the teres major, running over the fibres of the inferior angle and those of the membrana carnosa, which are inserted along with the superior angle of that tendon; at *o* are left some of the carnous fibres of the longus major, which was attached to, or received some origin from the flat tendon of this muscle.

pq Coraco brachialis; *p* it's origin from the processus coracoides of the scapula; *q* it's insertion into the humerus.

rs Brachialis internus; *r* the part which arises from the neck of the humerus, and the internal lower part of the scapula; and is inserted at *s* into the radius a little below the insertion of the coraco radialis and more internally.

t Flexor carpi radialis; it arises from the inner condyle of the humerus, and is inserted into the internal splint bone.

u The first head of the profundus or perforans.

w Nervus musculus cutaneus.

x Nervus medianus.

y Nervus cubitalis.

zz Nervus radialis.

1 Nervus axilaris.

2 Arteria axillaris.

3 Vena axillaris.

4 Arteria brachialis, or the humeral artery.

5 Vena cephalica.

6 6, &c. Bursal ligaments.

7 7, &c. Articular ligaments.

8 8 Cartilages belonging to the coffin bone.

In the lower Limbs.

aab Iliacus internus; *aa* Part of it's origin which is con-tinued from all, or most of the inside of the os ilium, which lies before the transverse processes of the loins and sacrum, and has some origin from that part of the fascia lata which lies betwixt it and the glutei: it joins in with the psoas magnus from it's origin, and is, with it, inserted into the little tro-chanter of the thigh bone; they seem to be but one muscle.

ccdefghi Tibialis anticus; *cc* it's origin from the superior and anterior part of the tibia; *d* the origin of it's strong tendon, *deghi*, from the inferior part of the femoris, to which, near it's origin, the tendon of the extensor longus digitorum pedis is inseperably attached; about *e* the super-ior part of the fleshy fibres, which arise at *cc*, are inserted into the inner side of this tendon, after which insertion, fleshy fibres run from the inner side of this tendon obliquely downwards, and inwards, and are met by fleshy fibres aris-ing from the tendinous covering of the internal side of this muscle, which run obliquely downwards and outwards; this fleshy part is about twice as thick as that from the outside tendon, and with it forms the principal tendon *f*, by which it is inserted into the superior and anterior edge of the meta-tarsal bone, and into the ossa cuneiformia: *g* the place where the external tendon divides, and is inserted, by the part *h*, into the less cuneiform bone of the tarsus, poster-iorly running over the internal articular ligament as far back as the posterior edge of the internal splint bone, and by the part *i* into the os cuboides; at *i* this part divides for the passage of some blood-vessels, and then unites again.

kl Flexor digitorum pedis.

1 1 Arteria tibialis anterior.

2 Vena tibialis anterior, in which appear some valves: it is covered by a thin fleshy part of the tibialis from about 1 upwards.

3 The external anterior ligament of the patella, which binds that bone to the tibia.

4 The external lateral ligament, which binds the patella to the external condyle of the os femoris.

5 The external articular ligament, which binds the os femoris to the fibula, and tibia: it runs all the way down the fibula, and to the bottom of the tibia.

6 A bursal ligament, upon which lie mucilaginous glands.

7 The external articular ligament of the tarsus.

8 The internal articular ligament of the tarsus.

9 9 The articular ligaments of the fetlock joint.

10 10 The articular ligaments of the great pastern with the coronary bone.

11 11 The articular ligaments of the coronary bone with the coffin bone.

12 12 12 12 The anterior part of the bursal ligament of the tarsus.

13 13 The anterior part of the bursal ligament of the fetlock joint.

14 14 The anterior part of the bursal ligament of the articulation of the great pastern with the coronary bone.

15 The anterior part of the bursal ligament of the arti-culation of the coronary bone with the coffin bone.

16 17 Interosseus, &c. it is like a strong ligament arising from some of the tarsal bones, and the upper part of the metatarsal bones, and is inserted into the sesamoid bones, and upper part of the great pasterns; on each side at 17 17 are cut off small ligaments, which were inserted into the tendon of the extensor longus digitorum pedis.

18 18 Cartilages belonging to the coffin bone.

The Tenth Anatomical TABLE of the Muscles, Fascias, Ligaments, Nerves, Arteries, Veins, Glands and Cartilages of a HORSE, viewed in front, explained

In the Head.

ab THE glandulous membrane of the inside of the lips; *a* glandulæ labiales; *b* glandulæ buccales.

c The concha narium inferior, covered by the pituitary membrane.

defg The four recti muscles, or musculi recti of the eye; of which *d* is called attollens, *e* deprimens, *f* adducens, and *g* abducens: these muscles arise from the bottom of the orbit near the foramen opticum, in the elongation of the dura-mater, by short narrow tendons, in the same order as

they are inserted into the tunica sclerotica, near and at the edge of the cornea lucida; the flat tendons, before they reach the cornea lucida, join and form the tunica albuginea, or white of the eye.

h Obliquus inferior.

i Musculus septimus occuli suspensorius, arises from the margin of the foramen opticum, and is inserted (being divided into several fleshy portions) into the posterior part of the sclerotica, below the terminations of the musculi recti.

k Arteria angularis.

l Vena angularis.

m The middle portion of the cartilage of the nose: it is a broad cartilaginous lamina, joined by a kind of symphysis to the anterior edge of the middle lamina of the os ethmoides, to the anterior edge of the vomer, and to the anterior part of the groove formed by the ossa maxillaria, as far as the nasal spines of these bones: this lamina compleats the septum narium, of which it forms the principal part.

no The part *o* is but a continuation of the part *n*, which, both together, form the lateral cartilage of the nose: they are continuations of the middle cartilages.

pqr Nervi maxillares superiores; they are branches or the third branch of the fifth pair; *p* branches which go to the upper lip; *q* a branch which goes to the inside of the nostril towards the tip of the nose; *r* a branch which goes to the long nasal muscle of the upper lip.

s The anterior cartilage of the outer ear.

t The outer ear.

In the Neck and Trunk.

ab Inter-vertebrales; they arise from the ascending processes, and form the space between the oblique processes of the uppermost vertebræ of the back: they are inserted into the lateral part of the body of the vertebra above it's origin.

cc, &c. *dd*, &c. The multifidus of the spine; *cc* the origins from the upper part of the transverse processes of the vertebræ of the back, and from the oblique ascending processes of the loins, and sacrum; *dd*, &c. the insertions into the spinal processes of the sacrum, loins, and back.

e The elevating muscle of the tail, beginning it's origin from the inferior or posterior edge of the third spinal process of the os sacrum, which origin is continued from near the end of the spine, about half way towards it's root: it's origin is continued fleshy from the sides and edges, and interspinal ligaments of the spines of the sacrum, below that from the whole length of the last of them, and is inserted into the first and second oblique processes of the os coccygis by two tendons; it then begins to arise from the spinal processes of the coccyx, and after passing over one, or two, is inserted into the next, or next but one below that: This seems to be a continuation of the multifidus of the spine.

fgh The lateral muscles of the tail or coccyx: *fg* the tendon by which it arises, at *f*, from this spine of the lowest vertebra but one of the loins; *h* the fleshy part: it is inserted tendinous into the oblique process of the coccyx or tail, and into two or three below that, and then joins in with the elevating muscle of the tail.

i The inter-transverse muscles of the tail, arising from the transverse process of one vertebra of the coccyx or tail, and inserted into that of the next, and so on through the whole length of the tail.

There are muscles which arise from the upper, or pos-

terior part of the transverse processes, and are inserted into the oblique processes of the next but one or two below them; they are like the inter-transversales posteriores of the neck.

k The depressing muscle of the tail, which begins it's origin from under the transverse process of the third vertebra of the sacrum, and continues it from the whole length of the transverse processes of the sacrum below that, and from the inter-transverse ligaments, and so on down the tail almost to the last, and is inserted into the bodies of the bones of the tail.

ll, &c. The elevators of the ribs.

m Arteria cervicalis.

n The vertebral vein and artery of the neck.

o Arteria carotis communis.

p The trunk of the eighth pair of nerves.

q Part of the jugular vein.

r Arteria mammaris interna.

In the Shoulders and upper Limbs.

1 2 3 4 4 Sub-scapularis; it arises from all that space of the inner or concave side of the scapula, between the insertion of the serratus major anticus, and near it's neck: from this situation it has it's name, it is thick and fleshy, made up of several penniform portions; 1 the part above the superior costa of the scapula, which is externally tendinous; 2 marks a tendinous slip sent from this muscle, which leaves it about 3, and is inserted into the processus coracoides; some nerves and blood-vessels pass under it: this muscle is inserted, at 4 4, into the head of the os humeri.

5 Nervus musculo-cutaneus.

6 Nervus medianus.

7 Nervus cubitalis.

8 Nervus radialis.

9 Nervus axillaris.

10 Arteria axillaris.

11 Vena axillaris.

12 Arteria brachialis, or the humeral artery.

13 Vena cephalica.

14 Vena plantaris.

16 16 Ligaments which bind together the bones of the carpus.

17 17, &c. Articular ligaments.

18 18 Cartilages belonging to the coffin bone.

In the lower Limbs.

aa Iliacus internus; *aa* part of it's origin which is continued from all, or most of the inside of, the os ilium, which lies before the transverse processes of the loins and sacrum, and has some origin from the posterior part of the anterior spine of the ilium, and that part of the fascia lata which lies betwixt it and the glutei: it joins in with the psoas magnus from it's origin, and is, with it, inserted into the little trochanter of the thigh bone.

b Interosseus, &c.

c Vena tibialis anterior.

d Vena saphena.

ee Vena plantaris externa and vena plantaris interna.

f A ligament which runs from the astragalus to the metatarsal bone.

gg, &c. Articular ligaments.

h The outer semi-lunar cartilage in the joint of the knee.

ii Cartilages belonging to the coffin bone.

The Eleventh Anatomical TABLE of the Muscles, Fascias, Ligaments, Nerves, Arteries, Veins, Glands and Cartilages of a HORSE, viewed posteriorly, explained

In the Head.

A THE outer ear.

ab Muscles running from the anterior cartilage to the external ear.

1 2 Retrahens; the posterior part 1 arises under the part

2, and is inserted into the ear near the inferior muscle of the outer ear, or the depressor; the part 2 arises from the ligamentum colli and occiput, and is inserted into the convex part of the outer ear.

c The superior lateral muscle of the outer ear, which

arises under the lateral muscle of the anterior cartilage, and is inserted into the inferior angles of the openings of the ears anteriorly.

d The lateral muscle of the anterior cartilage of the outer ear, which arises from above the orbit of the eye, and is inserted into the anterior cartilage.

3 The inferior lateral muscle or depressor of the outer ear: it arises from the quadratus colli, and is inserted close by the lower angle of the opening of the ear posteriorly.

e The orbicular muscle of the eye-lids, which arises from the ligament by which the conjunction of the eye-lids, in the great canthus, is tied to the nasal part of the os unguis.

4 4 5 6 Part of the latissimus colli, inserted about 5 into the lower jaw; at 6 the parotid gland protuberates under the latissimus colli.

f The globe, or ball of the eye.

gh Depressors of the lower lip, chiefly covered by the quadratus colli.

iii The orbicular muscle of the mouth.

k The elevators of the chin, where they are inserted into the skin, the fibres of which are intermixed with the fat of the chin.

l Caninus, or the elevator of the corner of the mouth.

m Zygomaticus; it's origin is from the orbicularis of the eye; and it's insertion into the orbicularis of the mouth.

n The lateral dilators of the nostril and upper lip.

o The digastrick muscle of the lower jaw; the quadratus colli covers this part, and immediately under it the mylohyeideus lies.

p The inferior maxillary glands.

q Vena angularis, a branch of the external jugular vein.

In the Neck, Shoulders, and Trunk.

abc Levator humeri proprius; *a* the portion which arises, under the part *b*, from the transverse processes of the four uppermost vertebræ of the neck; *b* the part which arises from the processus mastoideus, tendinous, and by a tendinous membrane from the pole bone or ridge of the occiput: these two heads unite before they pass over the head of the humerus, and are inserted into that bone along with the transverse or superior part of the pectoralis, between the biceps and brachiæus internus: the first part hath the same origin as the angularis, called levator scapulæ proprius in the human body; the second has it's origin much like the anterior and superior part of the trapezius, which, in the human body is inserted into the clavicle, but the clavicle being wanting in a horse it is inserted into the humerus, and the angularis into it.

def The superior part of the trapezius, under which, at *d*, the splenius protuberates; at *e* the serratus major anticus; at *f* the rhomboides.—To this muscle the part, as above, called levator humeri, which arises from the bones of the head, belongs.

g The mane.

hikllmmnnopq Membrana carnosa; *h* the inferior part of the trapezius lying under the membranous part of this fleshy pannicle; *i* the superior fleshy part; *k* a membranous part; *llm* the posterior fleshy part, which begins at *ll*; *nnoq* the posterior membranous part lies over the obliquus descendens, linea alba abdominis and part of the serratus major posticus; *p* a large vein, which is spread in the fleshy part of this pannicle. It is attached to the upper edge of the superior part of the pectoralis, and the lower edge of the inferior part; so that they, together, surround the whole limb from the top of the shoulder to the bottom of the fore feet: it's lower part goes with the lower part of the pectoralis to be inserted into the humerus, and it's upper part with the upper part of the pectoralis down the fore limb: it may be called the most external part of the pectoralis, or fleshy membrane; and that part of the pectoralis, marked *ffgg* in table the seventh, may be called the external part of the pectoralis; the part marked *ddee* the middle; and the

part marked *h* the internal part: the internal part is inserted at the top of the humerus, the middle part as low as the bottom, and into the fascia of the coraco-radialis; and the external part runs, with part of this fleshy membrane, down the fore limb.

r The tail.

In the upper Extremities, or anterior Limbs.

abcdDefghiklmn The membranous continuation of the fleshy pannicle down the upper limbs, with the muscles, &c. protuberating under it; *a* extensor carpi radialis; *b* extensor digitorum communis; *cdD* flexor carpi ulnaris; *c* the external head, from the external protuberance of the os humeri posteriorly; *d* the internal head, arising from the internal protuberance of the os humeri; D the tendon; *e* the third described head, in table the third, of the profundus; *g* The middle part of the pectoralis, which sends a membranous expansion down this limb along with the expansion of the membrana carnosa; *i* a sort of spungy fatty substance, probably a production of the membrana adeposa, lying over the protuberating part of this joint to preserve the bending tendons from bruises when this part touches the ground, &c.

k The internal and external vena plantaris; *kl* the external branch from the basilica.

mn The tendons of the sublimis and profundus.

op Ligamentous fibres which come from the inside of the radius, and are inserted into the external metacarpal bone; they protuberate at *o* and join in with the carnous membrane about *p*.

qr The horny part of the hoof; *q* the superior part; *r* the sole or inferior part lying under the coffin bone.

In the lower or posterior Limbs.

ABabcdefghiklmnopqrstuvwxyz& The membranous continuation of the fleshy pannicle down the inferior, lower, or posterior limbs, with the musculus fasciæ latæ; the fasciæ latæ, and other expansions of the muscles, with the muscles, &c. protuberating under them: A the large adductor of the thigh; B gracilis; *a* the gluteus medius lying under the carnous membrane, and continuation of the tendon of the latissimus dorsi; *b* the origin of the musculus fasciæ latæ from the spine of the ilium; *c* the anterior fleshy part; *d* the posterior fleshy part; *e* the tendinous surface into which the carnous fibres of the fleshy bellies *c* and *d* are inserted internally; *f* the gluteus externus protuberating a little; *ghi* the biceps cruris, or biceps tibia; *g* the anterior part; *h* the middle part; *i* the posterior part; *k* the semitendinosus; K the patella; *l* the extensor longus digitorum pedis; *m* peroneus; *n* flexor digitorum pedis; *o* gemellus; *p* tendons formed by these fasciæ and expansions to join in with the extensors of the tarsus; about *p* and *q* there are seen branches of veins which terminate the saphæna minor in cutaneous ramifications; *q* nerves expanded upon these fasciæ, or sent off to the external parts (as the adipose membrane and cutis); they are branches of the sciatic nerve; *r* a sort of tendon formed by these fasciæ, which may probably assist the extensor digitorum when the tarsus is extended; *t* the tendons of the flexors; *u* the interosseus, &c. *ww* veins arising from under the hoof, which are branches of the vena tibialis posterior, from which the saphæna is derived; they are called venæ plantares; *x* a large nerve, called the external plantaris; *y* nervus plantaris internus; at *z* these fasciæ have an attachment to the tendons and ligaments as they pass over them; *&* a sort of spungy fatty substance, probably a production of the membrana adiposa, lying over the protuberating part of this joint to preserve the bending tendons from bruises, when it touches the ground, &c.

1 2 The horny part of the hoof; 1 the superior part; 2 the sole or inferior part lying under the coffin bone.

The Twelfth Anatomical TABLE of the Muscles, Fascias, Ligaments, Nerves, Arteries, Veins, Glands and Cartilages of a HORSE, viewed posteriorly, explained

In the Head.

a THE lateral dilator of the nostril.

bb Musculi canini.

cdde The orbicular muscle of the mouth.

fgh The depressor of the lower lip; it arises along with the buccinator, and is almost divided into two muscles, one superior the other inferior, for the passage of nerves and blood-vessels to the lower lip; *f* the superior part, which arises tendinous, and is inserted fleshy into the lower lip laterally; *gh* the inferior part, which arises fleshy, and is inserted tendinous into the lower lip near the middle; *g* the fleshy belly; *h* the tendon.

i Buccinator.

k The masseter.

l Mylohyoideus; it arises from the lower jaw near the sockets of the dentes molares, and something more anteriorly, and is inserted into the os hyoides.

mm The parotid gland.

n The inferior maxillary gland.

o Branches of the nervus maxillaris inferior: they are branches of the third branch of the fifth pair of nerves: and accompanied with an artery from the temporal artery, which communicates with the arteria angularis.

p Arteria angularis.

q Vena angularis.

r The salivary duct.

st Vena temporalis.

u The outer ear.

In the Neck.

abcd Coraco-hyoideus coming, at *a*, from it's origin at the upper and internal side of the humerus, betwixt the insertions of the sub-scapularis and teres major by a flat membranous tendon: it begins to be fleshy at *a* as it comes from under the serratus minor anticus; *c* it's insertion into the os hyoides: it has a strong attachment to the anterior part of the levator humeri or trapezius, near the whole length of it's fleshy part, and the upper part marked *d* in table the third is attached to the rectus anticus longus, or internus major capitis, or it arises from the os sphenoides, by a flat tendon, close to the insertion of that muscle.

e Sterno-hyoideus; it arises from the middle tendon of the sterno-thyroideus, and goes to be inserted into the os hyoides along with the coraco-hyoideus.

fg Sterno-mastoideus, or sterno-maxillaris; it arises from the top of the sternum, and is inserted, tendinous, into the lower jaw bone; at *f* it's tendon protuberates under the parotid gland; it is also inserted, by a continuation of the same flat tendon, into the root of the processus mastoideus.

hh Rectus internus major capitis.

ii Inter-transversales minores colli; they run from the transverse process of one vertebra to the transverse process of the next to it.

k The tendon of the trachelo-mastoideus.

lmnop Splenius; *l* the part coming from the origin of this muscle, which is from the expansion, common to it and the serratus minor posticus, &c. it arises tendinous from the ligamentum colli, under the rhomboides, and fleshy about the superior part of the neck; at *m* it is attached to the tendon of the trachelo-mastoideus, at *n* to the transversalis: it is likewise inserted into the fifth, fourth, and third transverse processes of the vertebræ of the neck by flat strong tendons, which run on the internal side of the muscle: *p* the part which goes to be inserted into the occiput.

qqrs Rhomboides; *qq* it's origin from the ligamentum colli; *qr* it's origin from the superior spines of the vertebræ of the back; *s* the part going to be inserted into the scapula.

t Ligamentum colli.

uwxyz Serratus major anticus; *uwxy* it's origination from the third, fourth, fifth, and sixth transverse processes of the vertebræ of the neck; *z* that part which is inserted into the external part of the scapula.

1 Vena jugularis communis.

2 Vena jugularis externa anterior.

3 Vena jugularis externa posterior, or superior.

4 Arteries coming out of the splenius to go to the trapezius and integuments.

5 Arteries accompanied with branches of the cervical nerves, which go to the levator humeri proprius and integuments.

In the Shoulder and Trunk.

abcd Infra-spinatus scapulæ; *b* it's origin from the dorsum scapulæ, and the cartilage on the border of that bone; *c* it's strong tendon, by which it is inserted into the protuberating part of the humerus, under the tendinous expansion which goes from the teres minor to the lesser anterior saw muscle; *d* a part of the carnous insertion of this muscle below that protuberating part of the os humeri.

effgh Teres minor; at *ff* it sends off a fascia, which connects it to the serratus minor anticus; from *f* to *h* it is inserted into the humerus, and at *g* into the fascia which runs over the extending muscles on the cubit.

ik Latissimus dorsi; *i* the part which lies upon the ribs; *k* the part which runs over the inferior angle of the scapula.

IK Triceps brachii; I the part called extensor longus; K extensor brevis.

L Part of the pectoralis, which sends an expansion down the inside of the cubit.

llmmnnopp Obliquus externus abdominis; *llmm* the part which arises from the ribs, and intercostals; *mmnn* the fleshy part which runs over the ribs and intercostals; *o* the fleshy part lying over the abdomen; *pp* the strong broad aponeurosis of this muscle.

q The elevating muscle of the tail, beginning it's origin from the inferior or posterior edge of the third spinal process of the os sacrum, which origin is continued from near the end of the spine about half way towards it's root, being fleshy from the sides, and edges, and internal ligaments of the spines of the sacrum, and below that from the whole length of the last of them. It is inserted into the first and second oblique processes of the os coccygis by two tendons; it then begins to arise from the spinal processes of the coccygis and after passing over one or two tendons, is inserted into the next or next but one below that, and so on to the end of the tail.

r The lateral muscle of the tail, or os coccygis; it arises tendinous from the spine of the last vertebra but one of the loins, which tendon is marked *eee* in table the fifth, and the fleshy part *f*; it is inserted tendinous into the oblique process of the third vertebra of the tail, and also into two, or three, below that, and then joins in with the elevating muscle of the tail.

s The inter-transverse muscles of the tail, arising from the transverse process of one bone of the tail, and inserted into that of the next, and so on through the whole length of the tail.—There are muscles which arise from the upper, or posterior part of the transverse processes, and are inserted into the oblique processes of the next but one or two below.

t The depressing muscle of the tail, beginning it's origin from under the transverse process of the third vertebra of the sacrum, and continuing it from the whole length of the transverse processes of the os sacrum below that, and from the inter-transverse ligaments, and so on down the tail: it is inserted into the bodies of the bones of the tail.

uu Sphincter externus ani.

w Acceleratores penis.

In the upper Limbs.

aa The extensor digitorum communis, protuberating under the fascia which covers the extending muscles on the cubit.

ABCDG*bcddeffg* An expansion which arises from the articular ligament A, and from the olecranon C: it receives an addition from the longus minor, and internal protuberance of the humerus and expansion of the biceps muscle, or coraco-radialis, then descends over the bending muscles of the cubit down to the ligaments on the carpus, to which it is attached as well as to the bones of the cubit on each side of the bounds of the bending muscles; *ff* it's attachment to the continuation of the ulna, or ligament from the ulna, which runs down towards the carpus, or to the radius near them; it has a strong attachment to the os pisiforme, or orbiculare betwixt *d* and *f*, and another betwixt the tendons of the flexor carpi ulnaris *de*; betwixt *f* and *f* it appears like a number of small tendons; there lies protuberating under it at D the tendon of the muscle, which is analogous to the extensor minimi digiti in the human body: at B*bcdde* the flexor carpi ulnaris; B*b* the external head arising by the tendon B from the external protuberance of the os humeri posteriorly; *c* the internal head arising from the internal protuberance of the os humeri; G*dde* the tendon which divides into two a little below G, and is inserted, by the part *dd*, into the splint bone; and by the part *e* into the os pisiforme or orbiculare; *g* the third described head in table the third of the profundus, of which *hh* is the tendon.

E The tendon of a muscle which is analogous to the extensor of the thumb in the human body.

hh The tendon of the profundus.

ikk The tendon of the sublimis going to be inserted, near *kk* (where it divides for the passage of the profundus,) into the great pastern, or bone of the first order of the finger.

ll Nervus plantaris externus and nervus plantaris internus.

L Vena cephalica; it falls into the jugular vein.

mm Vena plantaris externa and vena plantaris interna.

op The external articular ligament.

qr The internal articular ligament.

st A ligament which runs from the os orbiculare to the radius, and external articular ligament over the tendon *dd* of the flexor carpi ulnaris.

uw A ligament running from the orbicular bone of the carpus to the false metacarpal bone: it serves as a stay to that bone when the flexor carpi ulnaris is in action: there is a large vein protuberating under it which is a branch of the vena cephalica.

uxy A ligament which binds down the tendons of the sublimis and profundus running from the orbicular bone of the carpus to the articular ligament, &c. to the upper part of which the expansion of the bending muscles on the cubit makes a considerable addition: the part *ux* runs from the orbicular bone to the internal false metacarpal bone, and serves as a stay to it when the flexor carpi ulnaris is in action.

z A ligament which helps to bind down the tendon of the sublimis and profundus: it is fixed to the splint bones on each side: it is a continuation of the expansion which covers the bending muscles on the cubit.

1 A ligament inserted into the sesamoid bones, running over the tendons of the sublimis and profundus, which serves to prevent the tendons from starting from those bones when the joint is bent.

2 A ligament arising from the upper part of the great pastern on each side the tendons of the sublimis and profundus: it is attached to the tendon of the sublimis about 2, and serves, as well as the ligament 1, to confine the bending tendons to the bone when the joint is bent.

3 A ligament which binds the tendon of the profundus to the coronary bone when it is in action.

4 4 5 5 The interosseus: it is like a strong ligament arising from the bones of the carpus and upper part of the metacarpal bones: it is inserted into the sesamoid bones, and great pastern on each side, and sends off the ligaments 5 5 to the tendon of the extensor digitorum communis, which it keeps from starting when the joint is in motion.

6 A substance resembling the villous surface of a mushroom.

In the lower Limbs.

aaabcd Gluteus externus; *b* a fleshy origin from a ligament which runs betwixt the spinal, and transverse processes of the os sacrum; *bd* the place where the fascia lata is cut off from the production, which it sends under this muscle, or from it's attachment to the tendinous surface of the internal part of this muscle arising from the ligament which runs betwixt the os sacrum and ischium, and receives first the insertion of those fleshy fibres which arise betwixt it and the ends of the spinal processes of the os sacrum from the same ligament, and then the fibres *aaa*, which arise from the fascia lata, and descend obliquely inwards and downwards to be inserted into it: *c* the place where this muscle ceases to arise from the fascia lata, and goes to be inserted into the lateral protuberance of the thigh bone: it sends off a fascia over the posterior part of the thigh bone, which runs in a transverse direction, and into which the pyramidalis is inserted, or joined in with before it's insertion into the superior and posterior part of this protuberance.

efffg Gluteus medius; *e* the part which arises from the tendinous surface of the sacro-lumbalis, and does not adhere to the fascia lata; *fff* the part which receives fleshy fibres from the fascia lata; *g* it's origin from the ilium: it goes under the gluteus externus to be inserted into the great trochanter.

hikLlllmnnoop Musculus fascia lata; *h* it's origin from the ilium; *i* it's anterior fleshy belly; L the posterior fleshy belly, over which the fascia lata sends a strong membrane, as well as under; so that it is received or contained in a duplicature of the fascia lata; the fibres L*lllm* arising from the superior or external fascia and descending to be inserted into the inferior; the part *hik* arises from the spine of the os ilium internally tendinous: fleshy fibres arising from that flat internal tendon, and descending to be inserted chiefly into the inside of the fascia; *kloo* the fleshy part in the superior angle; *l* being thickest, it gradually diminishes till it is lost in the line *oo*; the dark colour of the fleshy fibres make some appearance through the fascia in this angle, though it is very thick, but not near so much as the part *hio*, because the covering of that is only (or little more than) a common membrane; the line *hm* marks the place where the fascia lata is cut off before it passes betwixt this muscle and the gluteus externus, to be inserted into the anterior costa of the os ilium; *lm* marks the place where the production of the fascia lata which is sent over this muscle, is cut off; and *lll* the place where it joins to the broad tendon of this muscle, in which place it is cut off; *nn* marks the place where the fascia lata ceases to adhere to the broad tendon of this muscle, in order to pass down over the leg and foot; at *p* the tendinous surface of the rectus cruris makes it's appearance through the tendon of this muscle.—This muscle is inserted by a strong tendon into the upper and anterior part of the tibia, adhereing to the tendon of the anterior, and middle part of the biceps muscle all the way from the patella to it's insertion into the tibia.

OPP The large adductor of the thigh; PP the place where the fascia lata is cut off, which confines this part of the muscle in it's place.

qrrsstuwxyz 1 2 3 4 4 5 6 7 8 9 10 11 12 13 Biceps cruris; *qrr* mark the superior, or anterior head where it arises by carnous fibres, from the fascia lata: it's principal origin is

from the ligaments which run from the spinal processes to the transverse processes of the os sacrum, and from thence to the tubercle of the ischium: *sstuw* mark the inferior or posterior head, where it arises by carnous fibres from the fascia lata: it's principal origin is from the tubercle of the ischium, beginning at the extremity of that tubercle from the inferior angle, and continuing it's origin, by a flat strong tendon, about six minutes along the inferior edge of that bone; this tendon is continued down from the tubercle towards *su* betwixt *t* and *w*, from which, a little above *t*, the fleshy fibres *sstz* 1 4 4 begin to arise; but the fleshy part *uwx* 2 4 5 begins it's origin from the tubercle, and continues it down the said tendon; *rry* the fleshy part of the anterior head where it does not arise from the fascia lata; *z* the tendon by which it is inserted into the patella, and superior and anterior part of the tibia; the part *nry* lies under a fascia sent from the anterior part of the posterior head to the tendon of the musculus fascia lata; *x* 1 2 4 4 5 the fleshy part of the posterior head, where it does not arise from the fascia lata; 7 3 4 4 5 6 8 9 10 11 12 13 the tendon of the posterior head, which joins the tendon of the anterior head near the patella, and is likewise inserted into the anterior part of the tibia all the way down to the ligament common to the extensor longus digitorum pedis, and tibialis anticus, and into part of the upper edge of that ligament; 5 6 is the strongest part of this tendon; it joins with a production of the fascia lata, and is inserted into the os calcis; there lie protuberating under this tendon, at 9, the extensor longus digitorum pedis, at 10 the peroneus, at 11 the flexor digitorum pedis, at 12 the soleus, and at 13 the gemellus.

14 15 15 16 17 Semi-tendinosus; 14 it's origin from the ligament running from the spinal to the transverse processes of the os sacrum, and from thence to the ischium; 14 15 15 mark the part where it receives carnous fibres from the fascia lata; 15 15 16 the fleshy part where it does not arise from the fascia lata; 17 the tendinous production which wraps over the gemellus to join in with the fascia lata, and tendon of the biceps cruris: it sends off an expansion which is attached to the tendinous ligament which lies over the gemellus, and covers some blood-vessels and nerves which pass over the gemellus and run down the leg, and are marked 14 in table the second at the heel: it is also inserted by a flat tendon, or expansion, into the plantaris near the bottom of the fleshy part; through which expansion there is an opening for the passage of a large nerve: it's principal insertion is by a flat tendon into the superior and anterior part of the tibia internally, marked *k* on the left lower limb in table the second.

18 19 19 20 The gracilis; 19 19 the part coming from it's origin, which is from the edge of the inferior branch of the os pubis near the symphysis by a broad and very short tendon, from thence the fleshy fibres run down to the internal condyle of the os femoris, where they terminate in a thin tendon, which afterwards degenerates into a kind of aponeurosis, and is inserted into the fore part of the inside of the head of the tibia; and from thence it is continued almost to the bottom of that bone, and the posterior part is attached to the tendinous surface of the flexor digitorum pedis.

21 7 8 A part of the fascia lata, &c. which is left remaining, the rest being cut away before it's attachment to the tendons of the biceps and semi-tendinosus: they cover the tendon of the gemellus, and are inserted into the inner side of the os calcis with a tendinous production of the plantaris: these fasciæ are inserted into the edges of the principal tendon of the plantaris, but most strongly into the external edge: the fasciæ, along with the tendinous production of the plantaris, being united, divide into two almost equal parts (or if they are continued into each other it is by what is membranous;) the external is inserted into the external edge of the plantaris as it passes over the calcaneum: the internal portion partly into the said tendon opposite

to the other, but chiefly into the internal side of the calcaneum close to the origin of the aponeurosis plantaris.

22 23 24 25 26 The tendon of the plantaris coming from under the tendons of the fasciæ and twisting over the tendon of the gemellus at 22; at 26 it divides for the passage of the tendon of the flexor digitorum pedis. The part 22 23 belongs to that part which is analogous to the plantaris in the human body, and inserted into the heel; and the part 23 24 25 26 is analogous to the short flexor of the toes arising from the heel or protuberance of the calcaneum, but in a horse they are continued one into the other.

27 The tendon of the flexor digitorum pedis of which 11 is the fleshy portion, lying partly under the broad tendon of the biceps cruris.

28 29 The tendon of the peroneus, of which 10 is the fleshy part lying under the broad tendon of the biceps cruris.

30 The tendon of the extensor longus digitorum pedis; of which 9 is the fleshy part lying under the broad tendon of the biceps cruris.

40 Extensor brevis digitorum pedis.

41 42 Tibialis posticus; 41 it's fleshy belly lying under the flat tendons of the sartorius and gracilis; 42 the tendon going to join in with the tendon of the flexor digitorum pedis.

43 Poplitæus, lying under the tendons of the sartorius and gracilis.

44 Some of the fleshy part of the flexor digitorum pedis, of which 27 is the tendon.

45 Nerves which make some appearance under the tendon of the biceps cruris, going to the tibialis anticus, &c. they are branches of the small sciatic ramus, or sciaticus externus, called likewise sciatico-peronæus.

46 The external nervus plantaris.

47 The internal nervus plantaris.

48 Arteria plantaris externa.

49 Vena plantaris externa.

50 Vena plantaris interna.

51 A ligament which runs from the tibia to the os calcis, it lies over the tendon of the peroneus.

52 52 The external articular ligament, which is inserted above into the tibia and below into the astragalus, and os calcis.

53 A ligament which binds together the bones of the tarsus and metatarsus inserted externally above into the os calcis, and below into the splint or external imperfect metatarsal bone.

54 A bursal ligament.

55 A strong ligament which binds the os calcis to the astragalus, os naviculare, ossa cuneiformia, and splint or imperfect metatarsal bone, marked 8 9 9 in table the second.

56 56 57 57 The interosseus, &c. it is like a strong ligament arising from the upper part of the metatarsal bones, and some of the tarsal bones, and is inserted into the sesamoid bones, and first bone of the toe; on each side it sends off the ligaments 57 57 to the tendon of the extensor digitorum pedis.

58 A ligament lying over the tendon of the plantaris: it is inserted into the sesamoid bones on each side of the tendon, to which bones it closely confines the tendon when this joint is bent, but is not attached to it.

59 A ligament arising from the first bone of the toe on each side, and inserted into the middle of the tendon of the plantaris, to which bone it confines the tendon, when this joint is bent.

60 A ligament which binds the tendon of the flexor digitorum pedis down to the second bone of the toe when this joint is bent.

61 A substance resembling the villous surface of a mushroom, arising from the coffin bone, received by the like substance arising from the hoof, which it mutually receives.

The Thirteenth Anatomical TABLE of the Muscles, Fascias, Ligaments, Nerves, Arteries, Veins, Clands and Cartilages of a HORSE, viewed posteriorly, explained

In the Head.

a GLANDULÆ labiales.

bb Musculus caninus.

cc Buccinator.

def The depressor of the lower lip: it arises along with the buccinator, and is almost divided into two muscles, one superior the other inferior, for the passage of nerves and blood-vessels to the lower lip; *d* the superior part which arises tendinous, and is inserted fleshy into the lower lip laterally; *ef* the inferior part which arises fleshy and is inserted tendinous into the lower lip near the middle: *e* the fleshy belly; *f* the tendon.—The part *d* is the depressor of the corner of the mouth, and the part *ef* the depressor of the lower lip, but the part *d* is covered by the blood-vessels and nerves which go to the chin.

gggh The orbicular muscle of the mouth.

ii The elevators of the chin.

k The eye-ball.

ll Musculus ciliaris.

m Masseter.

n Branches of the nervus maxillaris inferior: they are branches of the third branch of the fifth pair of nerves, and are accompanied with an artery from the temporal artery, which communicates with the arteria angularis.

oo Arteria angularis.

p Vena angularis.

q The salivary duct.

rs Vena temporalis.

t the outer ear.

In the Neck.

ab Coraco-hyoideus, coming at *a* from it's origin, at the upper and internal side of the humerus, betwixt the insertions of the sub-scapularis and teres major, by a flat membranous tendon: it begins to be fleshy as it comes from under the serratus minor anticus: *b* it's insertion into the os hyoides: it is attached to the anterior part of the trapezius near it's whole length, and above that attachment to the rectus major capitis anterior; or has an origin along with the insertion of that muscle from the os sphenoides by a flat tendon.

c Sterno-hyoideus: it arises from the middle tendon of the sterno-thyroideus, and is inserted into the os hyoides along with the caraco-hyoideus.

d 5 Genio-hyoideus; 5 it's origin from the lower jaw, tendinous.—It's insertion into the os hyoides is near *d*.

6 6 7 Diagastricus; 7 the middle tendon; 6 6 it's two insertions into the lower jaw.

ee Obliquus capitis inferior, covered by the fascia by which the complexus is attached to the transverse processes of the first and second vertebræ of the neck: it arises from all the length of the spine of the oblique process of the second vertebra of the neck, and from all the posterior part of that vertebra which the inter-vertebralis does not cover, and is inserted into all or most of the anterior part of the broad transverse process of the atlass, which the inter-vertebralis does not cover.

f Rectus internus major capitis, or rectus anticus longus: it arises from the transverse processes of the third and fourth vertebræ of the neck, and from a part of the longus colli: it is inserted into the os sphenoides.

ghiklmnooo Transversalis cervices; *gh* the superior part, which arises from the oblique processes of the third, fourth, fifth, sixth, and seventh vertebræ of the neck, and two of the uppermost of the back, viz. the beginning of the lower oblique process of the third, and uppermost of the fourth, and so of the rest: it is inserted into the transverse process of the first vertebra of the neck; *iklmn* the inferior part; it

arises from the transverse processes of eight of the superior vertebræ of the back, and from the fascia betwixt that and the broad tendon of the complexus, &c. by fleshy fibres: at *klmn* it is inserted into the transverse processes of the four inferior vertebræ of the neck, partly fleshy, but chiefly by broad thin tendons; at *ooo* the inter-transversalis makes some appearance.

pq Trachelo-mastoidæus, complexus minor, or mastoidæus lateralis; *p* the fleshy part: it arises from the oblique processes of the third, fourth, fifth, sixth, and seventh vertebræ of the neck; the uppermost of the back, and the transverse processes of the second and third vertebræ of the back; *q* the tendon going to be inserted into the root of the processus mastoidæus.

Rrssttuwx Complexus; it is attached by a fascia to the transverse processes of the first and second vertebræ of the neck. It arises from the oblique processes of the third vertebra of the neck, and from all those of the neck below that, and from the upper oblique process of the first vertebra of the back, and by a pretty strong, flat tendon from the second and third vertebræ of the back, from the last of which the tendon is reflected to the spinal process of the same vertebra, which makes a communication betwixt this part of the muscle and that arising from the spines of the third, fourth, fifth, sixth, and seventh vertebræ of the back: *r* fleshy fibres arising from the broad tendon; at R it arises tendinous from the ligamentum colli; *sstt* tendinous lines, by which the fleshy fibres are intersected, which advance towards the tendon *u*; *w* the part which is inserted, by a strong round tendon, into the occiput near it's fellow; at *x* are marked the directions of some tendinous threads which attach it to the ligamentum colli.

yz Ligamentum colli; *z* the place where the rhomboides and the trapezius are cut from their origins.

1 Part of the vena jugularis communis.

2 Vena jugularis externa anterior.

3 Vena jugularis externa posterior, or superior.

4 Branches of the cervical arteries and veins going to and coming from the splenius trapezius and integuments.

In the Trunk.

aa, &c. The serratus major posticus, inserted into the ribs.

bbbcccc, &c. *dd*, &c. The external inter-costals; *b* a part to which the external oblique muscle does not adhere; *cc*, &c. the part to which the external oblique muscle of the abdomen adheres, which is about as extensive as it's origin from the ribs; *d* the part over which the external oblique muscle of the abdomen runs without adhereing.

eee, &c. Fibres which arise partly, externally, tendinous, but chiefly fleshy; and run in a transverse direction from one rib to another.

ff, &c. Part of the internal inter-costals.

gg, &c. Fleshy fibres which run in the same direction as the external inter-costals from one cartilaginous ending of the ribs to another.

hiiklmm Obliquus internus or ascendens abdominis; it arises from the spine of the ilium, tendinous, and fleshy, which origin is continued to the ligamentum fallopii, from which it arises, and from the symphysis of the os pubis; it is inserted into the cartilage of the lowest rib, tendinous and fleshy, and into the cartilaginous endings of the ribs as far as the cartilago-ensiformis; *h* the fleshy part ending at *ii*; at *k* is an opening through which blood-vessels pass to and from the external oblique muscle; *l* the flat tendon; at *mm* that part of the tendon of this muscle which runs over the rectus is cut off.

no Rectus abdominis, arises from the os pubis and is in-

serted into the cartilago-ensiformis, and the cartilages of the tenth, ninth, eighth, seventh, sixth, fifth, fourth, and third ribs near the sternum; and into the sternum betwixt the roots of the cartilages of the third and fourth ribs.—There are fleshy fibres arising from the first rib which join it at it's origin from the sternum, betwixt the cartilages of the third and fourth ribs.—This is called a distinct muscle and named musculus in summo thorace situs.

p The elevating muscle of the tail.

q The lateral muscle of the tail.

r The inter-transverse muscle of the tail.

s The depressing muscle of the tail.

For a more full explanation of the muscles of the tail, see table the 12th.

t The external sphinctor ani.

u Acceleratores penis.

ww Glands.

—The blood-vessels and nerves which are marked on the thorax, are those which were distributed to the parts taken off, as the obliquus externus, latissimus dorsi, membrana carnosa, &c. and integuments: the nerves come from the nervi dorsales, or costales, and nervi lumbares; the arteries from the arteriæ inter-costales inferiores, and the arteriæ lumbares; the veins from the venæ inter-costales and venæ lumbares.

In the upper Limbs.

ABC Triceps brachii; A the part called extensor longus; B extensor brevis: the long head arises from the inferior costa of the scapula, and the short head from the humerus, they are inserted into the ancon at C.

abc Extensor digitorum communis; *a* the fleshy part which arises from the external condyle of the humerus, the upper and lateral part of the radius and fascia which covers the extending muscles on the cubit, but it's principal origin is by a strong flat tendon from the anterior part of the external condyle of the humerus, from which place it continues it's origin into the anterior fossula, or sinus, which receives the upper head of the radius when the cubit is bent: it lies under the extensor carpi radialis, to the tendon of which it adheres for about three minutes from it's beginning, as well as to the bursal ligament which lies under it; *bc* the tendon which is chiefly inserted into the coffin bone: it sends the slip *c* to the tendon of the extensor minimi digiti, to be along with it inserted into the anterior and superior part of the great pastern externally; and another slip which is inserted into the anterior and superior part of the great pastern internally: it likewise sends a flat tendinous slip or aponeurosis to the os orbiculare, and another to the superior part of the metacarpal bone or internal articular ligament near it's insertion into that bone: these are analogous to those aponeuroses in the human body, which bind the tendons of this muscle together.

dd The tendon of the muscle which is analogous to the extensor minimi digiti in the human body, joined by the slip *c* of the extensor digitorum communis: it arises from the superior part of the radius, from the external part of the ulna for a considerable way down that bone, and from the vagina or case which binds together the bending muscles of the cubit, and is inserted along with the slip *c* into the anterior and superior part of the great pastern externally: this slip, which it receives, is analogous to the aponeurosis in the human body, which binds the tendons of the extensor digitorum together: it sends a slip to the orbicular bone, to which, by that means, it is bound.

efghi Flexor carpi ulnaris: *e* the external head, arising, by the tendon *e*, from the external protuberance of the os humeri posteriorly: *f* the internal head, arising from the internal protuberance of the os humeri: *g* the tendon which divides into two a little below *g*, and is inserted, by the part *h*, into the external splint bone, and, by the part *i*, into the os pisiforme or orbiculare.—These heads are two distinct muscles, the one ulnaris externus, the other ulnaris internus; the tendon of the ulnaris externus only is divided, being inserted partly into the external splint bone, and partly into the orbiculare.

K*klm* The profundus: it arises by four distinct heads, the most considerable of which, marked K, arises from the internal protuberance of the os humeri posteriorly under and in common with the sublimis, with which it seems to be confounded, in some degree, all the way down the fleshy part till it comes to the tendon, where the four heads unite, and then the profundus and sublimis make two distinct tendons: the second head arises under the first, from the same protuberance, by a small flatish tendon, which soon swells into a round fleshy belly, then, gradually tapering, becomes a round tendon, and joins in with the first head a little above the orbicular bone of the carpus: the third head *k* arises fleshy from the ancon near it's extremity, and soon becoming a small long tendon joins in with the first and second heads about the same place where they unite: the fourth head arises fleshy from the flat posterior part of the radius about it's middle, and (first becoming tendinous) joins in with the heads about the same place where they join with each other; *lm* the common tendon, which is inserted below *m* into the coffin bone.—It receives, from the posterior part of the bones of the carpus, the insertion of what is analogous to the flexor brevis policis manus, and flexor parvus minimi digiti, in the human body.

N*no* The sublimis, which arises from the internal protuberance of the os humeri posteriorly, over and in common with the first head of the profundus, with which it seems to be confounded, in some degree, all the way down the fleshy part, till it comes near the orbicular bone of the carpus, where it makes a distinct tendon *no*, which divides, near *o*, for the passage of the profundus, and is inserted into the great pastern on each side of that tendon, and serves as a ligament to confine it to that bone when the joint is bent; N the fleshy part.—It receives, from the posterior and internal part of the radius, the insertion of what is analogous to the flexor longus pollicis manus in the human body.

pp Nervus plantaris.

q Arteria plantaris.

s Vena cephalica; it falls into the jugular vein.

tt Vena plantaris externa, and vena plantaris interna.

u The bursal ligament, at the juncture of the humerus with the scapula.

wx The external articular ligament of the carpus.

yz The internal articular ligament of the carpus.

1 2 A ligament running from the orbicular bone of the carpus to the splint bone: it serves as a stay to that bone when the flexor carpi ulnaris is in action: there is a large branch of the vena cephalica protuberating under it.

3 3 4 4 Interosseus, &c. it is like a strong ligament arising from the bones of the carpus, and upper part of the metacarpal bones: it is inserted into the sesamoid bones and great pastern on each side, and sends off the ligaments 4 4 to the tendon of the extensor digitorum, which it keeps from starting when the fetlock joint gives way.—It supplies the places of the interossei manus, and abductors of the fore finger, little finger, and short abductors of the thumb, with the adductors of the thumb and little finger.

In the lower Limbs.

ab Iliacus internus; *a* it's origin from the spine of the ilium: it arises from the whole or superior half of the inside of the os ilium, and has some origin from that part of the fascia lata which lies betwixt it and the glutei: it is joined in with the psoas magnus from it's origin, and with it inserted into the little trochanter of the thigh bone: they seem to be but one muscle.

cddddefgh Gluteus medius; *c* the part which arises from the tendinous surface of the sacro-lumbalis, and does not adhere to the fascia lata; *dddd* the part which receives fleshy fibres from the fascia lata; *e* it's origin from the ilium, which is continued from this place to the

posterior part of the spine, and all that space of the os ilium which lies betwixt the spine and the gluteus internus, partly tendinous, but chiefly fleshy; and from the ligament which goes between the ilium and the transverse processes of the os sacrum; *f* the part which lies under the gluteus externus and biceps cruris; *ggh* it's insertion into the great trochanter.

AAB Gluteus externus; AA the fleshy part; B a flat tendon.

C Gluteus medius.

D Pyramidalis.

E Musculus fascia lata.

F Sartorius.

*iklmn*GH Pyramidalis, arises from the os sacrum and the ligament betwixt that and the ischium: it is, for a considerable way, inseparably joined to the gluteus medius, and inserted at *k* into the back part of the great trochanter: it receives an expansion from the gluteus externus: G the insertion of it's flat tendon H.

o Triceps secundus; it arises from the ischium, and is inserted into the linea aspera of the thigh bone, and near it's insertion is attached to the large adductor.

qrst Triceps tertius, the large adductor of the thigh, or adductor magnus: it arises from the ligament running from the sacrum and coccyx to the ischium; which ligament is probably nothing more than the flat tendon of this muscle, to the posterior edge of which the fascia lata is joined, and to the anterior edge of the ligament running betwixt the os sacrum and the ischium: it's principal origin is from the tubercle of the ischium: it is inserted by a strong tendon into the internal condyle of the humerus, behind the origin of the articular ligament and a little below it, and by a flat tendon into the articular ligament and tendon of the semi-tendinosus: it joins in with the long adductor near it's insertion.

uuw Gracilis: it arises from the edge of the inferior branch of the os pubis, near the symphysis, by a broad and very short tendon; from thence the fleshy fibres run down to the internal condyle of the os femoris, where they terminate in a thin tendon, which afterwards degenerates into a kind of aponeurosis, and is inserted into the fore part of the inside of the head of the tibia.

xyyz The inferior part of the semi-tendinosus: the upper part is cut off at *x* the origin, by carnous fibres from the broad tendon of the adductor magnus, is shewn at *s:* the tendinous production which wraps over the gemellus to join in with the fascia lata and tendon of the biceps cruris is cut off at *yy:* it sends off an expansion which is attached to the tendinous ligament which lies over the gemellus and covers some nerves and bloodvessels which pass over the gemellus and run down the leg; they are marked 14 in table the second: it is also inserted by a flat tendon or expansion into the plantaris near the bottom of the fleshy part; through which expansion there is an opening for the passage of a large nerve marked 67 in table the third on the left lower limb; it's principal insertion is by a flat tendon into the superior and anterior part of the tibia internally.

1 2 3 Semi-membranosus; 2 it's origin from the tubercle of the ischium: at it's origin it is attached to the short head of the biceps cruris; about *z* it joins in with the semi-tendinosus, and is with it inserted into the tibia.

4 5 6 7 7 8 Vastus externus; 4 it's origin from the posterior part of the great trochanter; 5 the part which arises from the inside: they are both externally tendinous: it's origin is continued fleshy along the inside of the femoris for about two-thirds of it's length downwards; 6 the fleshy belly; 7 7 it's insertion into the patella; 7 8 it's insertion into the lateral ligament of the patella: it is likewise inserted into the tendon of the rectus.

9 Rectus cruris: it arises from the external or posterior part of the inferior spine of the ilium by one tendon, and by another from the anterior part of the same spine;

these tendons soon unite and form a large fleshy belly, which descends to be inserted into the patella.

10 11 12 12 13 14 15 16 The gemellus; 10 it's external head, which arises out of and from the borders of a large fossa or notch in the os femoris, a little above the external condyle, at 10 externally tendinous; 11 it's internal head, which arises from a roughness on the lower and posterior part of the os femoris a little above the internal condyle: 12 12 a sort of flat tendon, which may be easily separated from the muscle, only adhereing to it by it's external edge; it's internal edge joins the fascia of the semi-tendinosus, &c. it runs over the surface of the muscle, and joins in with the fascia sent from the semi-tendinosus, &c. which joins it both above and below, and by that means makes a case for the tendons of the gemellus and plantaris; 13 the external fleshy part; 14 the external fleshy part lying under the expansion of the semi-tendinosus, &c. 15 the tendon formed by part of the external head; 16 the tendon of the internal head, formed by the internal head and part of the external head: these tendons, 15 and 16, are both together inserted into the os calcis.

17 At 17 is marked the cutting off of the fascia from the semi-tendinosus.

18 19 The solæus, it arises from the external articular ligament of the knee, and is inserted into the fasciæ or tendinous parts of the gemellus 12 12 a little below 19, or attached to them and inserted with them into the os calcis: the fasciæ from the biceps, semi-tendinosus, gracilis, &c. with the tendinous part, marked 12 12 in this table, communicate with or are attached to each other, and are inserted partly into the os calcis on the inside of the principal tendon of the gemellus, with which, at their insertion, they are confounded, and are partly inserted on each edge of the tendon of the plantaris as it runs over the os calcis: their lateral parts are joined posteriorly by a ligamentous membrane, marked 22 23 24 in table the twelfth.

20 21 22 The tendon of the plantaris: this muscle arises under the external head of the gemellus (in which it is in a manner wraped up) out of the large fossa, or notch, in the os femoris: above the external condyle, on the external side of it's fleshy belly, the gemellus is attached to it by fleshy fibres; at 20 it runs over the end of the os calcis, where it is bound on each side by ligaments which prevent it's slipping to either side; at 21 it divides to be inserted on each side of the inferior part of the great pastern posteriorly, and to give passage to the tendon of the flexor digitorum pedis, to which tendon it serves as a ligament to confine it to the great pastern when the fetlock joint is bent, and by that means it receives assistance from that tendon in bending the fetlock joint.—This is analogous to the plantaris and short flexor of the toes in the human body, viz. the part above 20 to the plantaris, and the part below 20 to the short flexor of the toes.

23 25 25 25 26 Flexor digitorum pedis; 23 the fleshy belly, externally tendinous, which arises tendinous and fleshy from the fibula and articular ligament which runs from the external condyle of the os femoris to and down that bone, and from the posterior part of the tibia, tendinous and fleshy, which origination is continued near half the way down that bone from a considerable roughness, the protuberating parts of which give rise to the four or five tendinous parts of which this muscle is composed; 25 25 25 26 the tendon, inserted at 26 into the coffin bone.

27 27 28 29 Peronæus; it arises from the upper part of the fibula and articular ligament, which runs from the external condyle of the os femoris down the fibula: it has an origin from the tendinous surface of the flexor digitorum pedis, near all the length of the fleshy part of that muscle; 28 29 it's tendon, which is inserted into the tendon of the long extensor of the toes at 29, part of which is afterwards inserted into the great pastern on it's superior and anterior portions externally.

30 31 Extensor longus digitorum pedis; it arises along with the strong tendon of the tibialis anticus, to which it is inseparably joined near it's origin: it arises also from the tibia; 30 it's fleshy belly; 31 it's tendon, at 29 joined by the tendon of the peronæus, with part of which it sends off a slip to be inserted into the great pastern: on it's superior and anterior part externally it sends another slip, with the fasciæ which join it, to be inserted into the superior and anterior part of the great pastern internally, but it's principal insertion is into the anterior and superior part of the coffin bone.

32 Extensor brevis digitorum pedis.

33 34 Tibialis posticus; it arises from the external side of the posterior part of the head of the tibia, and from the tendinous surface of the flexor digitorum pedis; 33 it's fleshy belly; 34 it's tendon, inserted into the tendon of the flexor digitorum.

35 35 Poplitæus; it arises tendinous from the external condyle of the os femoris under the articular ligament, and is inserted into the tibia at 35 35 externally tendinous.

36 36 Nervus sciaticus.

37 Nervus sciatico-cruralis.

38 Nervus poplitæus.

39 Nervus plantaris externus and nervus plantaris internus, which are branches of the nervus sciatico-tibialis.

40 A branch sent from the nervus sciaticus, which divides, one branch to go with the blood-vessels to the gluteus, another to the biceps cruris, and another to the semi-tendinosus, &c.

41 Nervus sciatico-peronæus.

42 42 Rami of the sciatico-peronæus; they run in betwixt the peronæus and long extensor of the toe, and are distributed to those muscles with the tibialis anticus and the neighbouring parts.

43 A Branch of the nervus sciatico-cruralis.

44 45 46 Branches of the arteria pudica communis which is a branch of the internal iliaca or hypogastrica; 45 a branch cut off where it enters the biceps cruris; 46 branches cut off, which pass through the fascia lata to go to the semi-tendinosus.

47 Arteries which go to the biceps cruris.

48 A branch of the arteria poplitæa which goes to the biceps cruris.

49 Arteria tibialis anterior.

50 Arteria plantaris externa.

51 52 53 Branches of the vena hypogastrica; at 52 a branch which comes from the biceps cruris; at 53 branches are cut off which come from the semi-tendinosus.

54 A branch of the vena poplitæa which comes from the biceps.

55 A branch of the vena obturatrix.

56 Vena plantaris externa and vena plantaris interna.

57 57 Glandula poplitæa, commonly called the pope's eye.

58 58 59 59 60 60 A ligament running from the spines of the os sacrum to it's transverse processes, and from thence to the tubercle of the ischium, from which the upper head of the biceps receives a fleshy origin; 59 59 60 60 shew the place where the fascia lata is cut off which runs betwixt the fascia lata and biceps cruris.

61 62 The external articular ligament, which is inserted above into the tibia and below into the astragalus and os calcis.

63 63 A ligament which binds together the bones of the tarsus and metatarsus, inserted externally above into the os calcis, and below into the external splint bone, and internally into the os cuboides.

64 A bursal ligament.

65 A strong ligament which binds the os calcis to the astragalus, or naviculare, ossa cuniformia, and the internal splint bone.

66 66 67 67 Interosseus, &c. it is like a strong ligament, arising from some of the tarsal bones, and the upper part of the metatarsal bones, and is inserted into the sesamoid bones and great pastern on each side: it sends off the parts 67 67 on each side to bind down the tendon of the extensor digitorum pedis.—This is of a ligamentous nature, but supplies the places of the interosseus, the short flexor, adductor and abductor of the great toe, the abductor and short flexor proper to the little toe, and a ligament which arises from the calcaneum and belongs to the cuboid bone; but sends off an excursion which joins the origins of the short flexor and interosseus of the little toe, both those of the interossei of the third of the small toes and that of the adductor of the great toe in the human body. The ligamentous aponeurosis 67 is sent partly from the interosseus, &c. and partly from the capsular of the fetlock joint to be inserted into the tendon of the extensor digitorum pedis.

The Fourteenth Anatomical TABLE of the Muscles, Fascias, Ligaments, Nerves, Arteries, Veins, Glands and Cartilages of a HORSE, viewed posteriorly, explained

In the Head and Wind-pipe.

aaa THE orbicular muscle of the mouth.

bb Musculus caninus, or the elevators of the corner of the mouth and of the cheek: it arises from the upper jaw bone, and is inserted, at bb, into the orbicular muscle of the mouth and buccinator.

cd The buccinator: it arises in three different places: about d the superior fibres arise from the alveoli of the upper jaw: the middle fibres arise from the ligamentum intermaxillaris, and the inferior from the lower jaw: it is inserted into the glandulous membrane of the inside of the cheek and lips, and at c into the orbicularis oris.

e The glandulæ buccales, or glandulous membrane which lines the inside of the lips.

fg The elevator of the chin.

h The globe, or ball of the eye.

n Arteria temporalis.

oo Arteria angularis.

p Vena angularis.

qrs Vena temporalis.

i An artery which goes to the glandulæ sublinguales.

u Glandulæ sublinguales.

wx Genioglossus; w it's tendinous origin from the jaw bone; x it's insertion into the tongue: this insertion is continued from the os hyoides to near the tip of the tongue.

yz Hyothyreoideus; y it's origin from the thyroid cartilage; z it's insertion into the os hyoides.

1 1 2 The lower constrictor of the pharinx.

3 4 Hyoglossus; arising at 3 from the os hyoides, and inserted into the tongue near 4.

5 Part of the os hyoides.

6 The outer ear.

In the Neck.

abcdef Longus colli; a the part coming from it's inferior origin from the lateral parts of the bodies of the five uppermost vertebræ of the back, and the lowest of the neck; bcde it's originations from the transverse processes of the sixth, fifth, fourth, and third vertebræ of the neck: it is inserted at f into the anterior oblique process of the sixth vertebra of the neck: it is also inserted into the bodies of the fifth, fourth, third, and second laterally, near their trans-

verse processes, and into the anterior eminence or tubercle of the body of the atlas.

gg, &c. *hh,* &c. Inter-transversarii posteriores colli; *gg,* &c. their originations from the roots of the oblique processes, and betwixt them and the transverse processes where the inter-vertebralis does not cover; *hh,* &c. their insertions into the sixth, fifth, fourth, third and second transverse processes of the vertebræ of the neck.—To divide these into distinct muscles there seems to be, for each insertion into the transverse processes, two originations, viz. one from the inferior part of the vertebra below the insertion, and the other from the upper part of the next to that.—The lowest origin is from the first vertebra of the back, part of which is inserted into the transverse process of the seventh vertebra of the neck.

ikll Obliquus capitis inferior; *ik* it's origin from all the length of the spine of the second vertebra of the neck; at *k,* where it runs under the rectus capitis posticus longus, it is externally tendinous; it arises from all the posterior part of that vertebra which the inter-vertebralis does not cover, and is inserted, at *ll,* into all or most of the broad transverse process of the atlas, which is not covered by the inter-vertebralis.

mn Obliquus capitis superior; *m* it's fleshy origin, which is pretty deep from the broad transverse process of the atlas; *n* it's insertion into the occiput.

op Rectus capitis posticus major; *o* it's origin from the ridge or spine of the lower oblique process of the second vertebra of the neck; *p* it's insertion into the occiput.

q Rectus capitis posticus minor, or rather medius: it arises from the root of the spine of the oblique process of the second vertebra of the neck above the origin of the rectus major; and continues it's origin for about three minutes up the spine, or ridge of this vertebra: it is inserted by a short and broad tendon into the occiput, wrapping over the surface of the intervertebralis.

rstuwwx The multifidæ of the spine, arising at *rstu* from the descending oblique processes of the vertebræ of the neck, partly, externally, tendinous; *ww* the insertion of the parts arising at *stu,* from the descending oblique processes of the fifth, fourth, and third vertebræ of the neck, viz. all that part which arises from the third vertebra *u,* the external and middle parts of the origin from the fourth vertebra *t,* and the external part of the origin from the fifth vertebra *s.* The inner part of the origin from the fourth vertebra, and the middle part from the fifth vertebra, with the external part from the sixth vertebra *r,* are inserted into the spine of the third vertebra.—There are fibres inserted into the spine of the third vertebra, arising from three vertebræ below it; and in that manner it runs on down to the bottom of the spine.

yyy The inter-vertebralis appearing betwixt the originations of the inter-transversarii posteriores colli: they arise from the ascending oblique processes of the five inferior vertebræ of the neck, and from the space betwixt the oblique processes of the uppermost vertebra of the back; they are inserted each into the lateral parts of the bodies of the vertebræ above their origin respectively.

1 1 Branches of the cervical nerves.

2 Branches of the cervical arteries.

3 Branches of the cervical veins.

4 Part of the vena jugularis communis.

5 Vena jugularis externa anterior.

6 Vena jugularis externa posterior or superior.

7 8 9 10 Ligamentum colli; 8 the place where the trapezius and rhomboides are cut from their originations from this ligament; 9 the part which is inserted into the spines of the superior vertebræ; 10 the part which is inserted into the occiput.

In the Trunk.

a Semi-spinalis dorsi; it arises fleshy from the tendinous surface of the longissimus dorsi: and inserted into the spines of the ten superior vertebræ of the back: it communicates with the spinalis cervices as well as the fleshy fibres of the spinalis dorsi before it's insertion, the spinalis dorsi being inserted below it.

bbcc, &c. The external inter-costals; they arise, at *bb,* from the inferior edge, and a little of the outside of each rib, the last excepted: they are a little tendinous, and, descending obliquely downwards, are inserted at *cc* into the upper edge and a little of the outside of each rib, the first excepted.

ddee, &c. The internal inter-costals; they arise at *dd* from the superior edge of the bony part of each rib, except the first, (not covering any of the outside,) and from the edges of the cartilages of the ribs, and a considerable part of the outside of them; they are chiefly, externally, tendinous, but partly fleshy, and ascending obliquely upwards and forwards are inserted into the lower edge of the bony part of each rib, and into the edges and part of the outsides of their cartilages, the last rib excepted.

f The elevating muscle of the tail.

g The lateral muscle of the tail.

h The inter-transverse muscle of the tail.

i The depressing muscle of the tail.

The muscles of the tail are more fully explained in table the twelfth.

kklmm Transversalis abdominis; *kk* the part which arises from the inside of the ribs below the triangularis of the sternum and the diaphragm, by fleshy digitations; the part *l* arises from the three or four uppermost transverse processes of the vertebræ of the loins by an aponeurosis, and fleshy from the internal labium of the crista ossis ilii, and a great part of the ligamentum fallopii, or tendinous margin of the internal obliquus of the abdomen; and is inserted into the ensiform cartilage and linea alba, adhereing to the posterior plate of the aponeurosis of the internal oblique muscle of the abdomen: at it's first passing under the rectus the lower part of the aponeurosis of the transversalis is separated from the upper in a transverse direction from the edge of the rectus to the linea alba, about half way betwixt the navel and synchondrosis of the pubis, the upper part going behind the rectus and the lower before it and the pyramidalis.

oo, &c. Branches of the nervi costales, lying upon the transversalis, which go to the abdominal muscles and integuments.

p Branches of the nervi lumbares, which go to the abdominal muscles and integuments lying over the transversalis.

qq, &c. Arteries from the intercostalis inferior.

r The external branch of the outer iliac artery in two ramifications, accompanied by *s.*

s The external branch of the outer iliac vein in two ramifications.

t The external sphincter ani.

u Acceleratores penis.

In the upper Limbs.

abc Brachialis internus; *a* the part which arises from the neck of the humerus; *b* the part which arises from the internal lower part of the scapula; at *c* it is going to be inserted into the radius a little below the coraco-radialis and more internally.

defghi Profundus, or perforans; it arises by four distinct heads, the first, or most considerable, of which is that marked *de* in this table: it arises from the internal protuberance of the humerus, posteriorly, under, and in common with the sublimis, with which it seems to be confounded, in some degree, all the way down the fleshy part, till it comes to the tendon where the four heads unite, and then the profundus and sublimis make two distinct tendons: it is tendinous at *d:* the second head arises under the first, from the same protuberance, by a small flattish tendon, which soon

swells into a round fleshy belly, then tapering gradually becomes a round tendon, and joins in with the first head a little above the orbicular bone of the carpus: the third head *f* arises fleshy from the ancon near it's extremity, and soon becomes a small round tendon; *g* joins in with the first and second heads about *g*, where they unite; the fourth head arises fleshy from the flat posterior part of the radius, about it's middle (first becoming tendinous) and then joins in with the other heads about the same place where they join in with each other: they all together form the common tendon *hi*, which is inserted, at *i*, into the coffin bone.—It receives, from the posterior part of the bones of the carpus, the insertion of what is analogous to the flexor brevis pollicis manus, and flexor parvus minimi digiti in the human body.

klmnn The sublimis or perforatus; it arises from the internal protuberance of the os humeri, posteriorly, over, and in common with the first head of the profundus, with which it seems to be confounded, in some degree, all the way down the fleshy part, 'till it comes near the orbicular bone of the carpus, where it makes a distinct tendon *lmnn*, which divides at *m* for the profundus, and is inserted on each side of the great pastern, as at *n* and *n:* it serves as a ligament to confine the tendon of the profundus to that bone when the joint is bent.—This muscle receives from the posterior and internal part of the radius, the insertion of what is analogous to the flexor longus pollicis manus in the human body.

o A ligament which binds down the bending tendons, explained in table the twelfth.

pq Flexor carpi radialis; it arises from the internal protuberance of the os humeri, and is inserted at *q* into the splint bone.

rr Interosseus, &c. it arises from the bones of the carpus and metacarpus, and is inserted, at *rr*, into the ossa sesamoida.

s Nervus radialis.

t Vena cephalica: below the carpus it is called vena plantaris.

uu Ligaments which bind the orbicular bone to the radius, the bones of the carpus and metacarpal bone.

ww, &c. Articular ligaments.

xx The cartilages belonging to the coffin bone.

In the lower Limbs.

abbc Iliacus internus; *a* part of it's origin from the posterior part of the anterior spine, and some marks of it's origin from the fascia lata; *bb* it's origin from the anterior part of the anterior spine of the ilium, which is continued from all, or most part, of the inside of the ilium, which lies before the transverse processes of the vertebræ of the loins and sacrum: it joins in with the psoas magnus from it's origin, and is, with it, inserted into the little trochanter of the thigh bone: they seem to be but one muscle.

deeffgg Gluteus internus; *dee* it's origin from all that part of the outside of the ilium which is below the origin of the gluteus medius, running between the anterior inferior spine, and the great posterior sinus: it is likewise fixed in the edge of that sinus in the spine of the ischium, and in the orbicular ligament of the joint of the hip: it is inserted, at *ff*, into the anterior part of the upper edge of the great trochanter: it is externally tendinous at *d*, and there are tendinous fibres running through it at *gg*.

hi Obturator internus; it arises from the internal labium of all the anterior half of the foramen ovale a little distance from the neighbouring part of the obturator ligament, and also both above and below the foramen: it likewise arises from the upper half of the inside of the os ischium, from the upper oblique notch in the foramen ovale, to the superior part of the great posterior sinus of the os ilium; at *h* it comes out of the pelvis through the posterior notch of the ischium; and at *i* is inserted into the great trochanter.

kl Gemini; the upper part of which, *k*, arises from the acute process or spine of the ischium, near the sinus or notch through which the obturator internus bends itself, and is inserted, at *k*, into the great trochanter along with the obturator internus, and the other of the gemini, *l*, which arises from the posterior edge of the sinus, through which the obturator internus bends itself, and from the outer part of the tubercle near the lower part of that sinus, and is inserted along with the tendon of the obturator internus, at *l*, into the great trochanter.

m Obturator externus; it arises from the outer or anterior side of the os pubis, at the edge of that hole next the small ramus of the ischium, and a little to the neighbouring parts of the obturator ligament, and is inserted, at *m*, into the great trochanter.

n Quadratus; it arises from the outer edge, or the obtuse line which runs from under the acetabulum towards the lower part of the tuberosity of the ischium; and is inserted, at *n*, into the oblong eminence of the thigh bone, which stands out partly from the posterior side of the trochanter major, and partly below the same.

opqqrst Adductor magnus femoris, or triceps femoris; *o* the first part, or triceps primus; *pqq* the second part, or triceps secundus; *rst* the third part, or triceps tertius; it begins it's origin from the outer part of the anterior edge of the os pubis near it's syncondrosis, from whence it continues to arise as far as the tubercle of the ischium; from the tubercle of the ischium at *s* and fascia lata at *r*; and is inserted the first part at *o*, and the second at *qq*, into the linea aspera in some measure externally tendinous, and into the internal condyle of the femoris by a strong tendon behind the origin of the articular ligament, and a little below it.

uwx Gracilis; it arises from the edge of the inferior branch of the os pubis near the symphysis by a broad, and very short tendon; from thence the fleshy fibres run down to the internal condyle of the os femoris, where they terminate in a thin tendon, which afterwards degenerates into a kind of aponeurosis *x*, and is inserted into the fore part of the inside of the head of the tibia.

y The tendon of the musculus parvus, in articulatione femoris situs; it arises by a flat tendon over the posterior tendon of the rectus, from a little above the edge of the acetabulum, and soon becoming a round fleshy belly dwindles again into a small flat tendon, which is inserted into the thigh bone at *y*.

1 1 2 2 3 4 5 Cruralis, or cruræus; 1 1 it's origin, from the anterior and outer part of the thigh bone, externally tendinous, being by small flat tendons, which disappear at 2 2, but inwardly fleshy: it is inserted into the patella at 3 4, and into the external lateral ligament, at 4 5, by a flat tendon or fascia; at 3 it is partly divided for the reception of blood-vessels.

6 7 7 8 10 Vastus internus; 6 the part arising from the upper part of the thigh bone, which origin is continued almost down to the inner condyle, or from about half the length of the muscle, by fleshy fibres, from all that space between the origin of the cruræus and the insertion of the adductor magnus femoris: from all this extent the fibres run obliquely downwards and outwards, and are inserted, at 7 7, into the tendinous surface of the cruræus, and at 8 into the patella; 6 7 7 8 shew the impression made on this muscle by the rectus cruris; 10 shews the external surface of the internal side of this muscle on the left side.

11 Interosseus, &c.

A Sartorius.

B Triceps secundus.

C Transversus penis.

E One of the gemini.

F Obturator internus.

12 13 14 15 16 17 18 19 20 21 Plantaris; 12 it's origin out of the large fossa, or notch, of the os femoris; 13 14 it's belly; at 13 fleshy fibres are attached to the tendinous sur-

face of this muscle; 15 16 17 18 19 20 21 the tendon, which, about 15, begins to wrap over the tendon of the gemellus; at 16 and 17 it is attached to the os calcis by ligaments, which are inserted into it in those places; and at 18 to the great pastern by a ligament inserted into it there; at 19 it divides for the passage of the tendon of the flexor digitorum pedis; at 20 and 21 it is inserted into the great pastern.— The parts 16 and 17 may be called parts of the origin of the short flexors of the toes; the part above 16 and 17 being analogous to the plantaris, and the part below to the short flexors of the toes in the human body; one being inserted into the calcaneum, and the other arising from it; but, in a horse, one is like a continuation of the other, attached to the calcaneum on each side.

22 23 23 Poplitæus; at 22 it arises, tendinous, from the external condyle of the os femoris, under the articular ligament, and near 23 23 it is inserted externally tendinous into the tibia.

24 25 26 Tibialis posticus; 24 it's origin from the external side of the posterior part of the head of the tibia: it arises also from the tendinous surface of the flexor digitorum pedis; 25 it's fleshy belly; 26 it's tendon inserted into the tendon of the flexor digitorum pedis.

27 28 29 30 31 31 Flexor longus digitorum pedis; 27 it's origin from the fibula and the ligament which runs from the external condyle of the os femoris, to and down that bone, tendinous and fleshy, and from the posterior part of the tibia, tendinous and fleshy; which origination is con-

tinued near half the way down that bone from a considerable roughness, the protuberating parts giving rise to the tendinous parts of which this muscle is composed; 28 the fleshy belly, externally tendinous; 29 30 31 31 the tendon by which it ends, beginning at 29, coming from under the plantaris at 30, and inserted into the coffin bone at 31 31.— This muscle is analogous to both the flexor longus digitorum pedis, and flexor longus pollicis pedis in the human body: it receives an addition from the os calcis and ossa cuneiforma, which is analogous to a muscular head in the human body, which consists of two portions distinct from the beginning, both arising from the calcaneum, and inserted into the tendon of the long flexor of the toes before it divides; soon after which the lumbricales arise from the tendons into which it is divided.

32 32 Branches of the arteria glutæa, accompanied with veins and nerves.

33 The large sciatic nerve, which, on the thigh, is called sciatico-cruralis.

34 A branch of the arteria cruralis.

35 Arteria poplitæa.

36 Arteria obturatrix.

37 Nerves going to the tibialis anticus; they are rami of the small siatic branch.

38 Nervus sciatico-tibialis internus.

40 40, &c. Articular ligaments.

41 41 The cartilages belonging to the coffin bone.

The Fifteenth Anatomical TABLE of the Muscles, Fascias, Ligaments, Nerves, Arteries, Veins, Glands and Cartilages of a HORSE, viewed posteriorly, explained.

In the Head and Neck.

a STYLOGLOSSUS.

b Stylopharingæus.

c Stylohyoidæus.

d Hyoglossus; arises from the os hyoides, and is inserted into the tongue.

e Pterygoidæus internus.

f Pterygoidæus externus.

g The middle constrictor of the pharinx.

h The superior constrictor of the pharinx.

i Crico-arytænoideus.

k The posterior or inferior lateral cartilage.

l The elevator of the chin.

L The outer ear.

mn, &c. Inter-vertebrales; m, &c. their origins from the ascending oblique processes of the five inferior vertebræ of the neck: the lowest origin is from the space betwixt the oblique processes of the uppermost vertebra of the back; n, &c. their insertions into the lateral parts of the bodies of each vertebra above their origins.

opqqqqqr Ligamentum colli; the part p arises from the spines of the second and third vertebræ of the back, and the part o from most of the spines of the back below them; the part p is inserted, at qqqqq, into the spines of the five superior vertebræ of the neck, and the part o is inserted into the occiput at r.

In the Trunk.

aa Multifidi spinæ.

b The ligament which runs over the spines of the os sacrum.

c The elevating muscles of the tail.

d The lateral muscle of the tail.

ee The inter-transverse muscles of the tail.

f The depressing muscle of the tail.

The muscles of the tail are more fully explained in table the twelfth.

In the upper Limbs.

aabccdd Interosseus; arising at b from the os magnum or great round headed bone of the carpus, and, at cc, from the upper part of the metacarpal bone; it is fleshy at aa, and inserted, at dd, into the sesamoid bones.

e Vena cephalica; below the carpus it is called vena plantaris.

f Vena brachialis.

g Arteria brachialis.

h Nervus medianus.

iii Ligaments which bind the orbicular bone to the radius, the bones of the carpus, and metacarpal bone.

kk, &c. Articular ligaments.

lll Ligaments which bind the sesamoid bones to the great pasterns.

mm Cartilages belonging to the coffin bone.

n A cartilaginous ligament which ties the two sesamoid bones together.

In the lower Limbs.

ABBC Iliacus internus; A part of it's origin from the posterior part of the anterior spine, with some marks of it's origin from the fascia lata; BB it's origin from the anterior part of the anterior spine of the ilium, which is continued from all or most part of the inside of the ilium which lies before the transverse processes of the vertebræ of the loins and sacrum: it joins in with the psoas magnus from it's origin, and is with it inserted into the little trochanter of the thigh bone: they seem to be but one muscle.

aa Gemini.

bc Obturator internus.

dee Obturator externus; d the fleshy part; ee the tendon.

fg Quadratus; f it's origin; g it's insertion.

hi Pectineus; h part of it's origin; i it's insertion externally tendinous.

k Part of the sartorius.

K Triceps secundus.

lmmn Gracilis; *l* part of it's origin; *lmm* it's fleshy part; *n* it's flat tendon.

op Musculus parvus in articulatione femoris situs; *o* it's origin; *p* it's insertion.

qrs The origin of the rectus; *q* it's internal origin; *r* it's external origin; *s* the place where it is cut off.

t The external sphincter ani.

uw The internal sphincter ani, attached, at *u*, to the bodies of the second, third, and fourth bones of the tail.

xyz Levator ani, arising near *x* (where it is tendinous), from the acute process of the ischium; it is inserted, at *y*, into the transverse processes of the second, third, and fourth bones of the tail; and at *z* into the internal sphincter ani.

1 Transversus penis.
2 Acceleratores penis.
3 One of the erectores penis.
4 Arteria sacra.
5 Iliaca minor.
6 Arteria glutæa; of which 7 is a branch.
8 Arteria sciatica.
9 Pudica communis.
10 Arteria obturatrix.
11 Arteria cruralis, of which 12 is a branch.
13 Arteria poplitëa.
14 Vena poplitëa.
15 Arteria tibialis posterior.

16 Arteria peronæa posterior.

17 17 The large sciatic nerve, which on the thigh is called sciatico-cruralis.

18 Nervus sciatico-tibialis internus.

19 19 Nervus plantaris externus and nervus plantaris internus.—They are branches of the sciatico-cruralis internus.

20 A ligament which binds the fibula to the tibia.

21 A strong ligament, which binds the os calcis to the splint bone.

22 Ligaments which bind the bones of the tarsus together.

23 24 24 Interosseus, &c. 23 it's origin from the tarsal and metatarsal bones; 24 24 it's insertions into the sesamoid bones and upper part of the great pastern on each side. It sends off a small ligament on each side to the tendon of the extensor longus digitorum pedis.—This is of a ligamentous nature, but supplies the places of the interosseus, the short flexor, adductor and abductor of the great toe, the abductor and short flexor proper to the little toe, and a ligament which arises from the calcaneum.

25 A cartilaginous ligament, which ties the two sesamoid bones together.

26 27 27 27 Ligaments which bind the sesamoid bones to the great pastern.

28 28 Cartilages belonging to the coffin bone.

29 29, &c. Articular ligaments.

F I N I S .

THE
PLATES

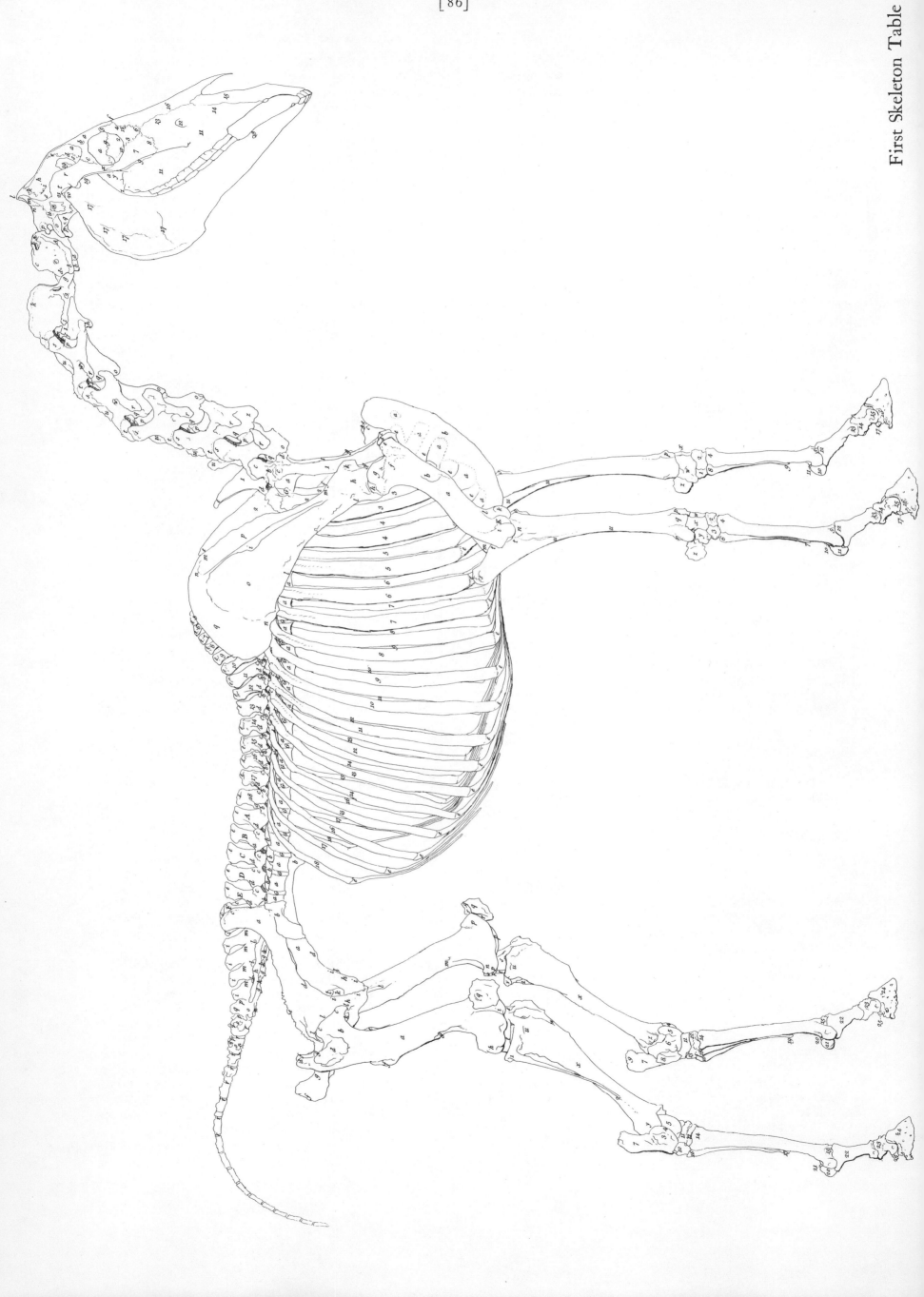

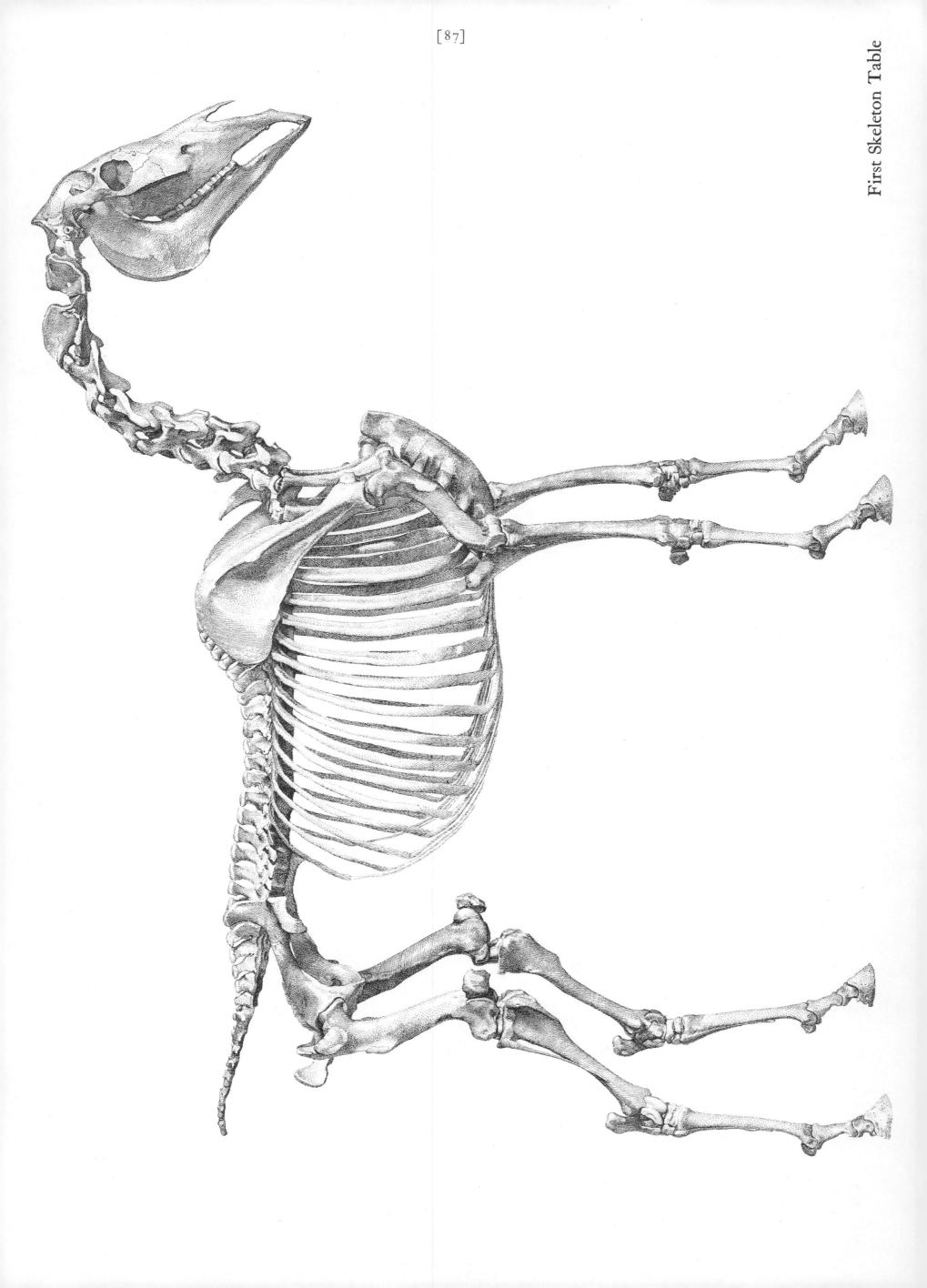

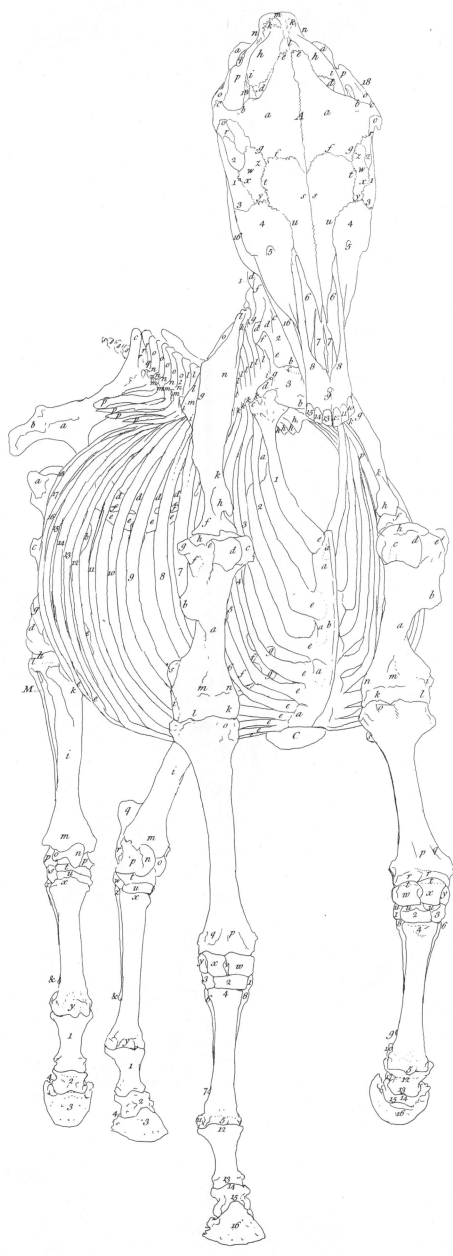

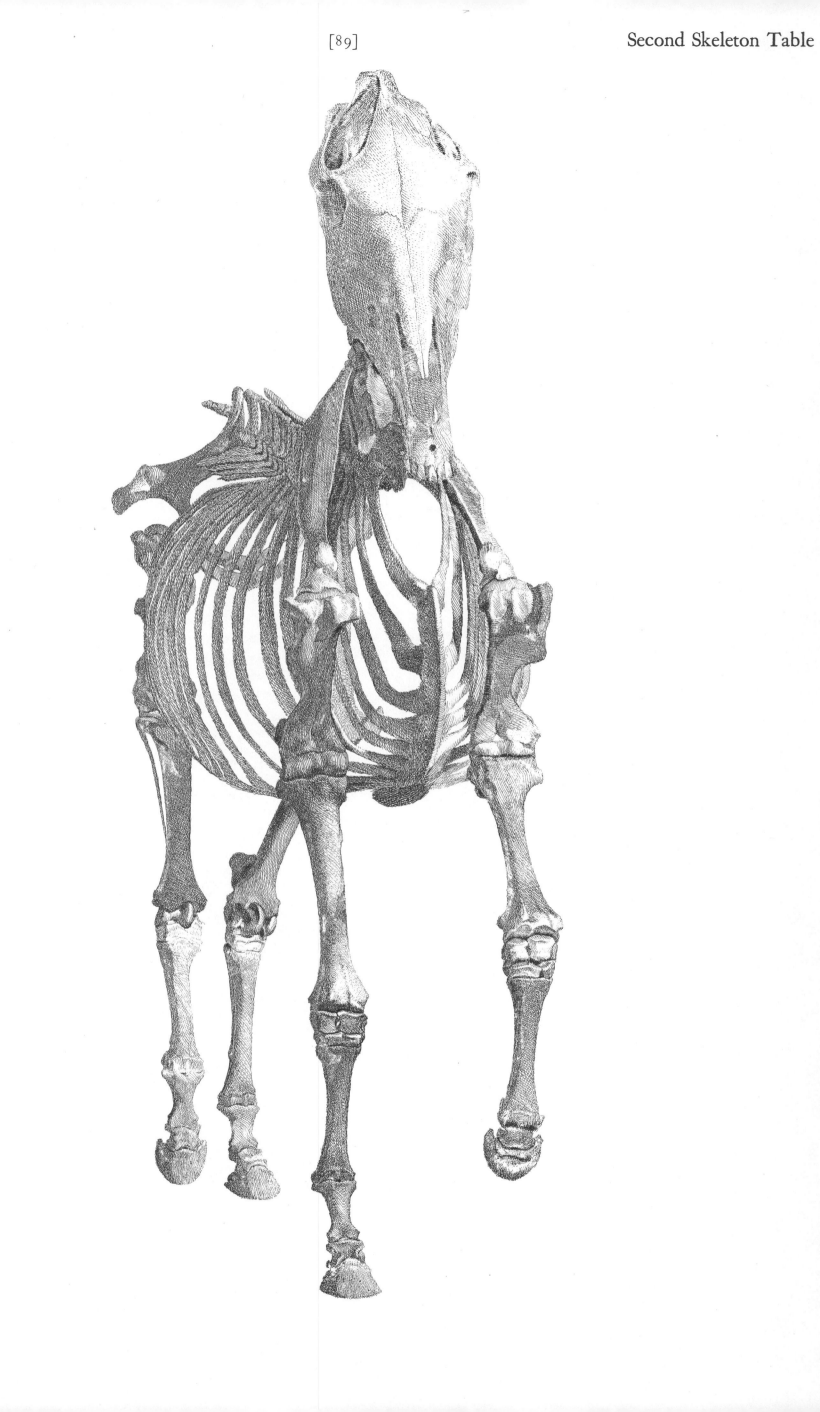

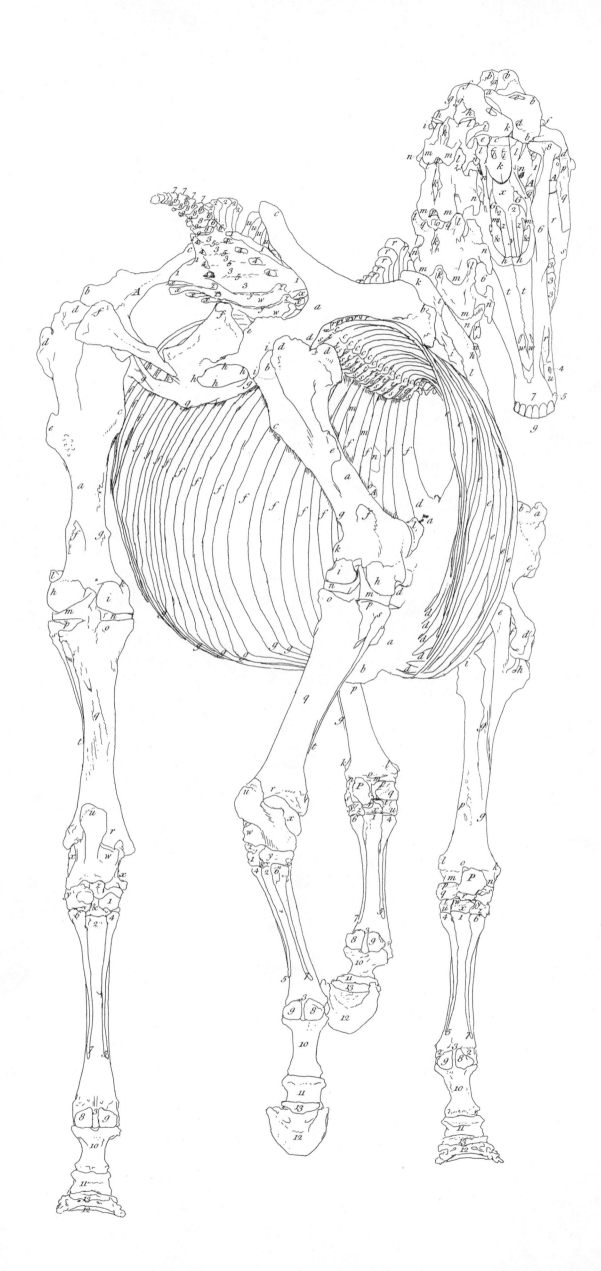

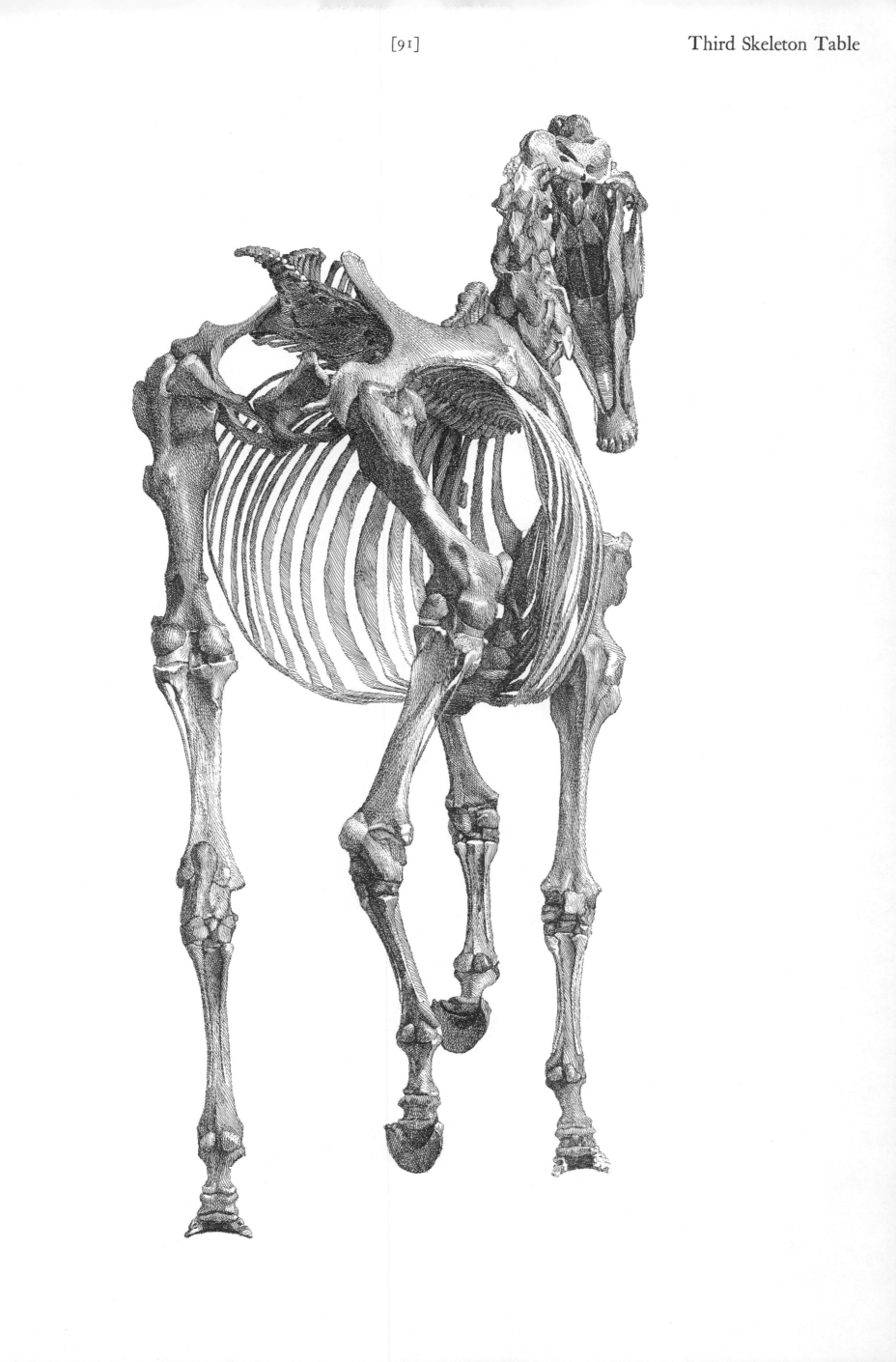

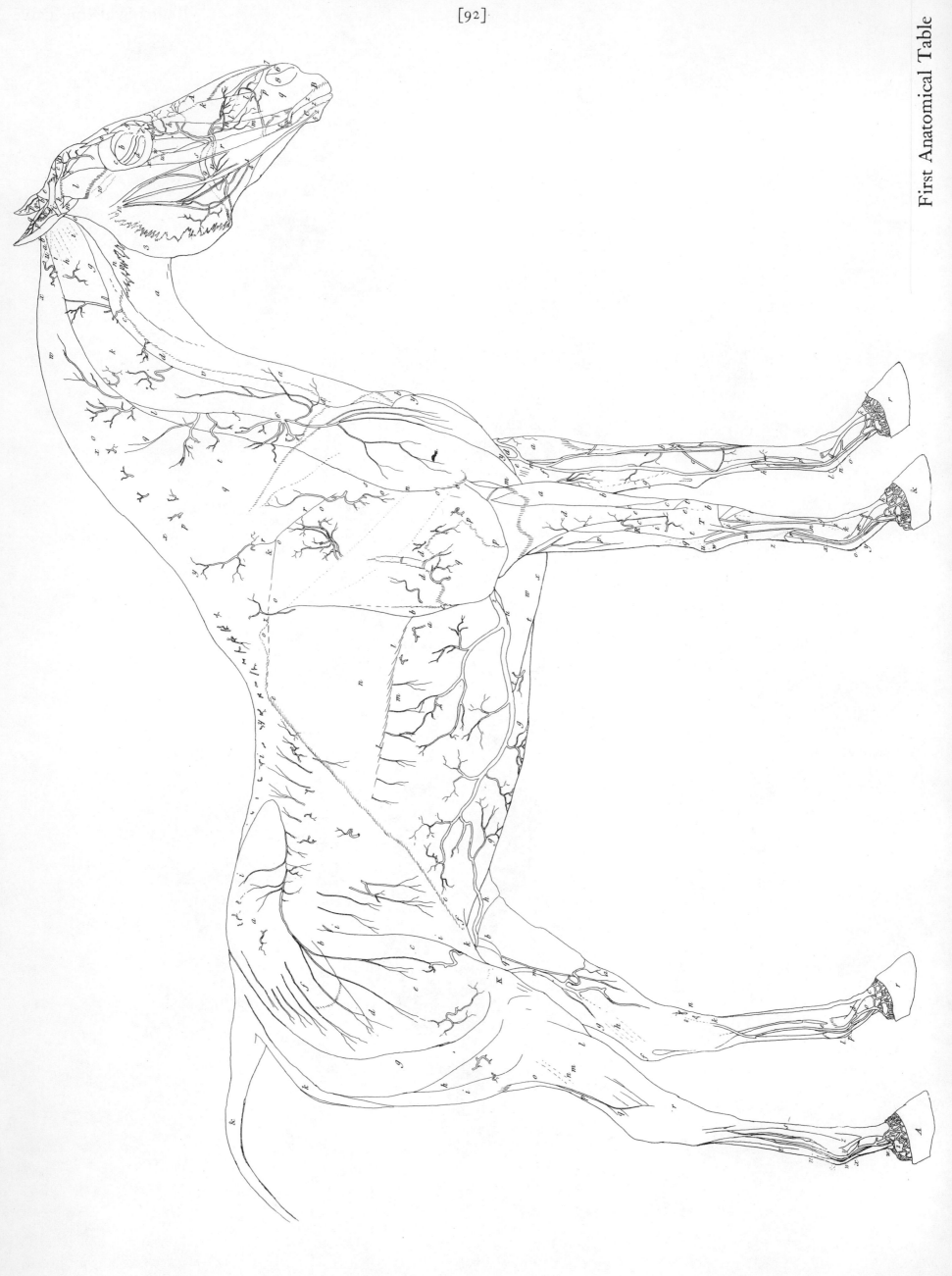

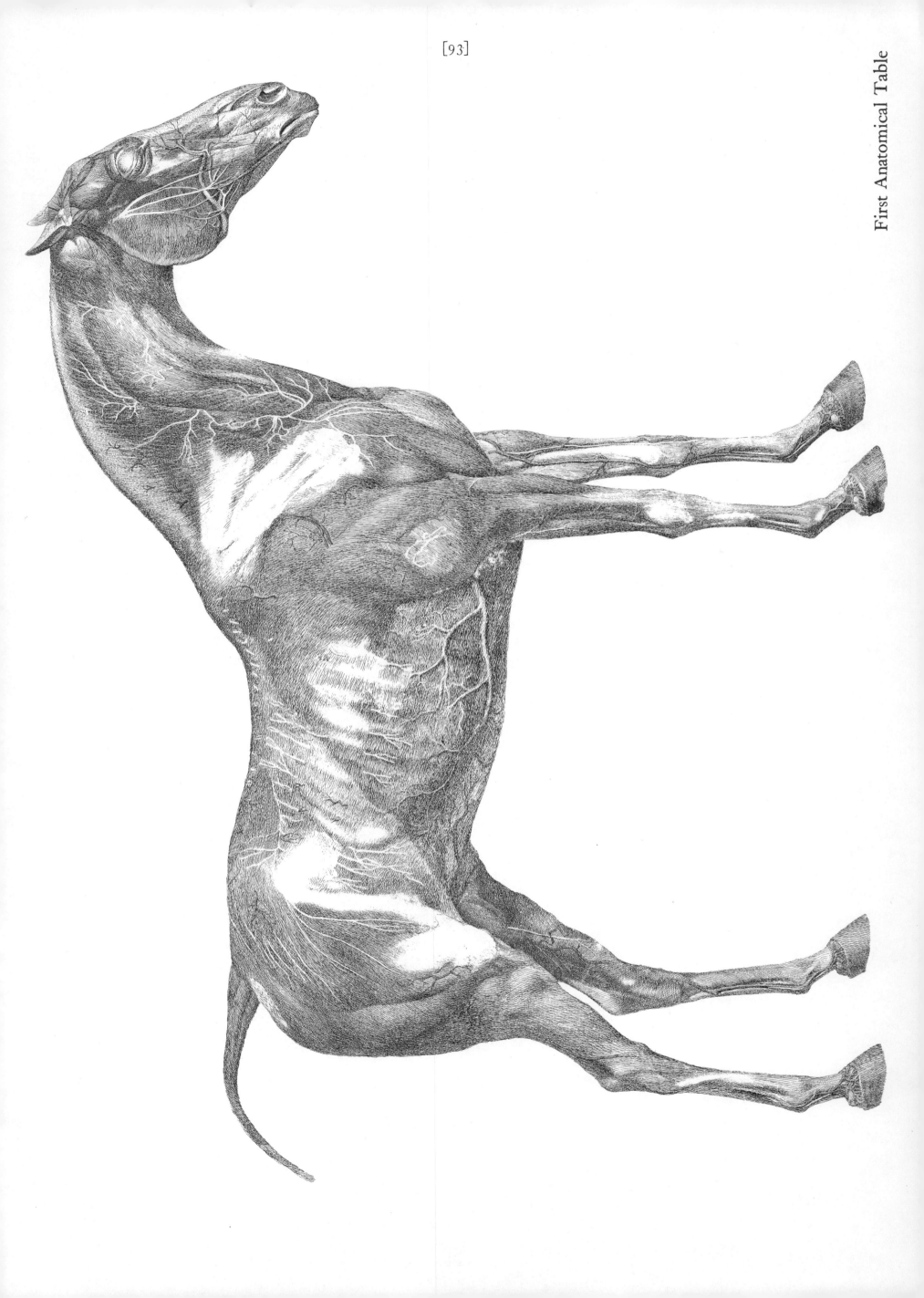

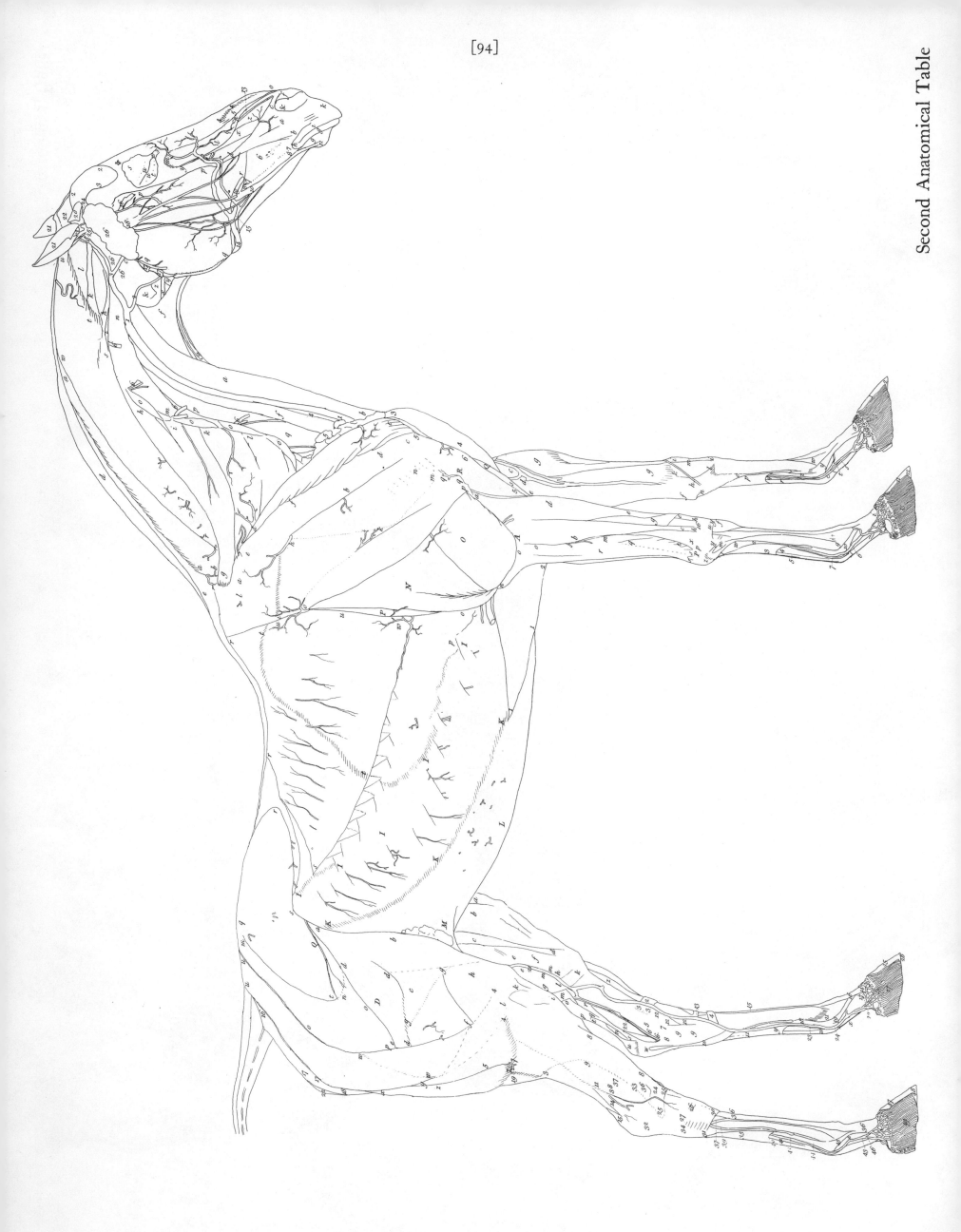

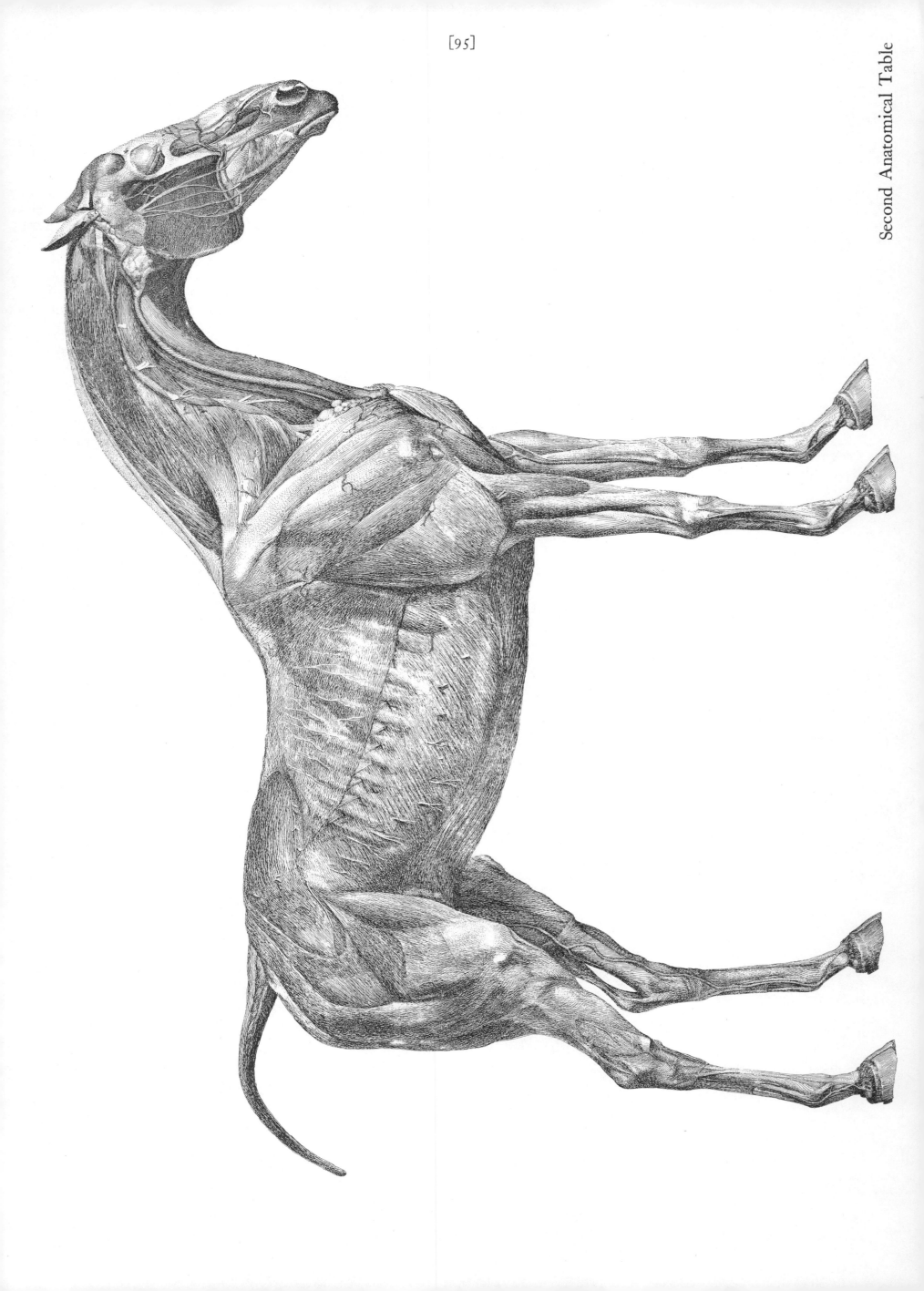

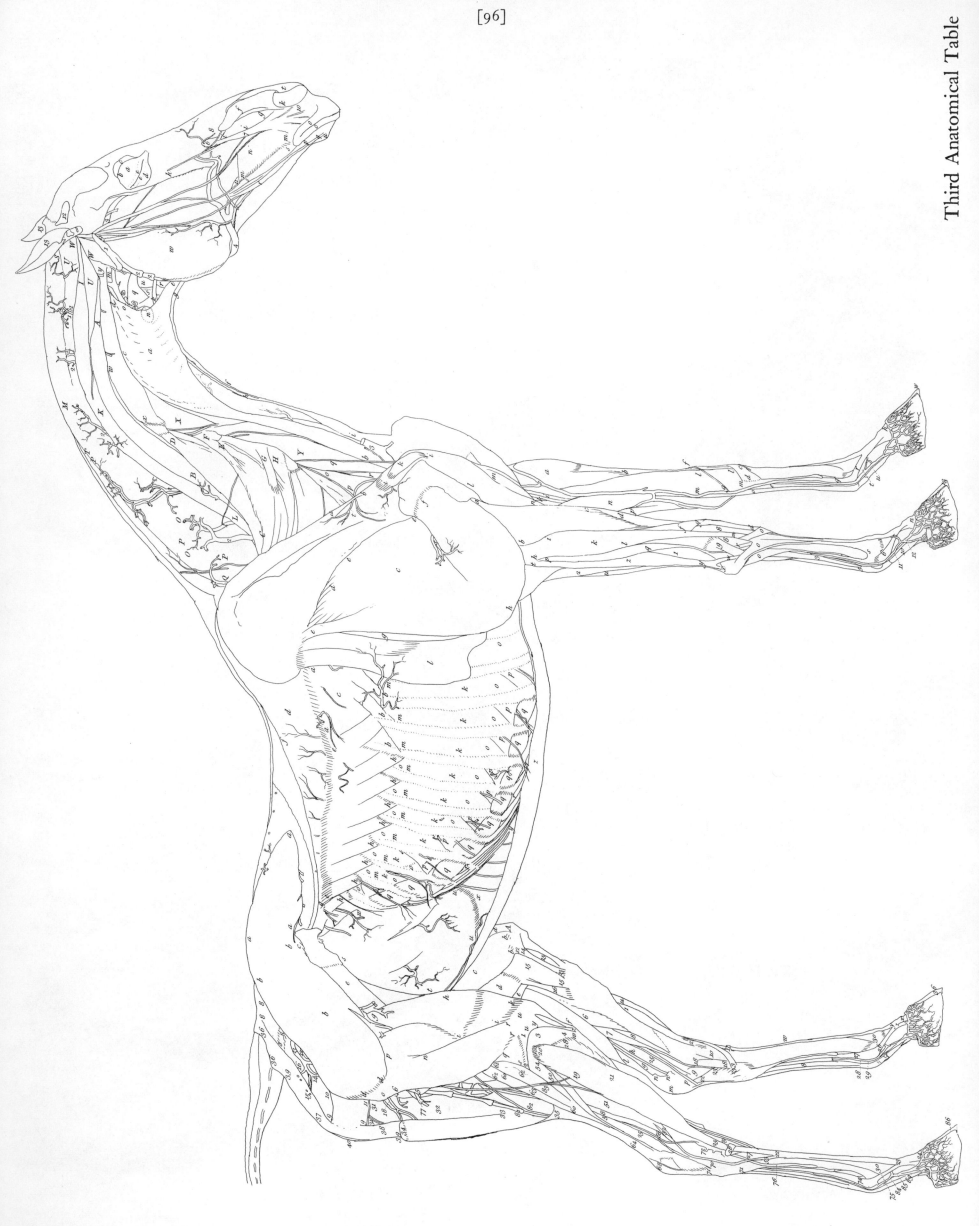

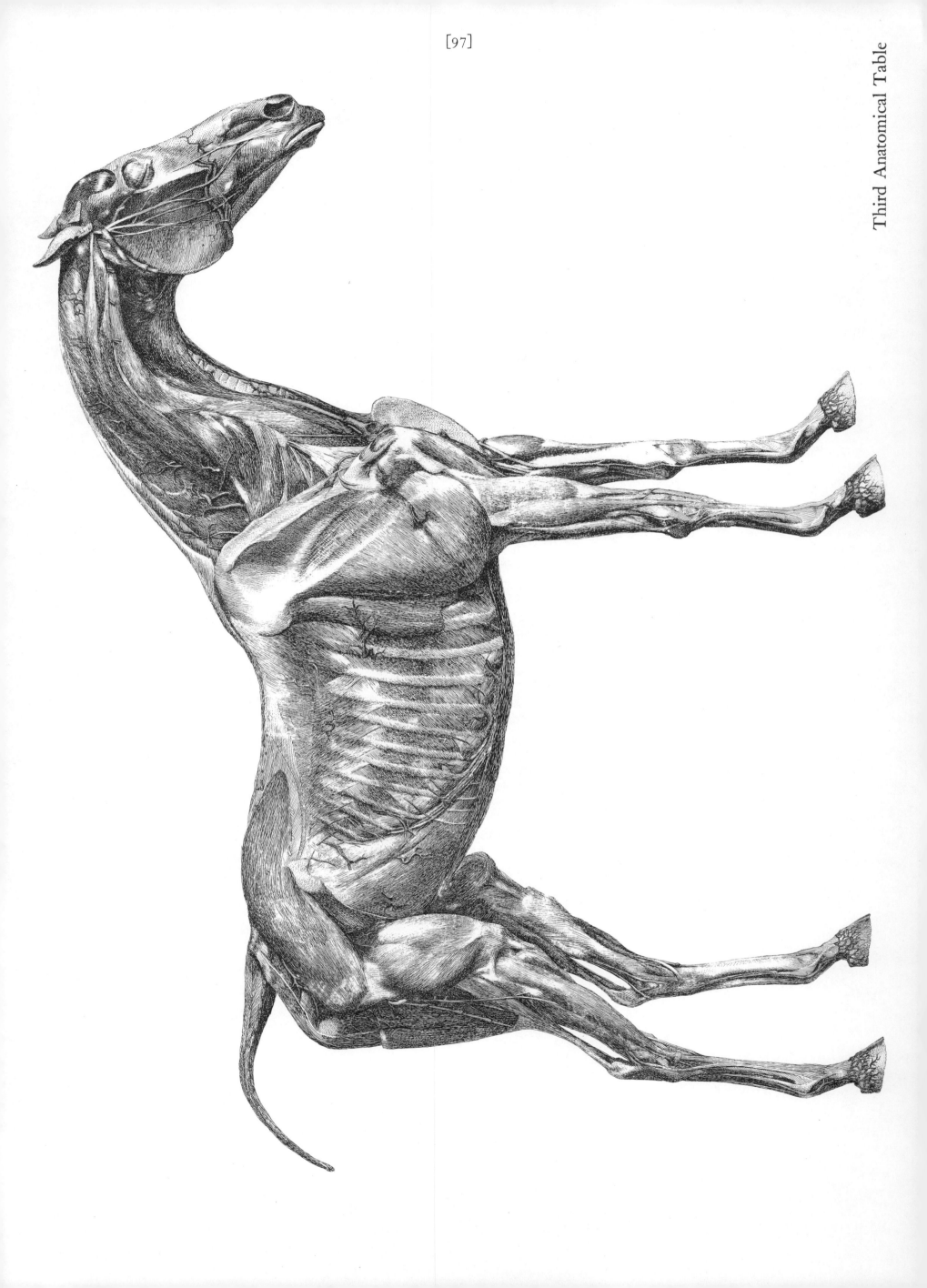

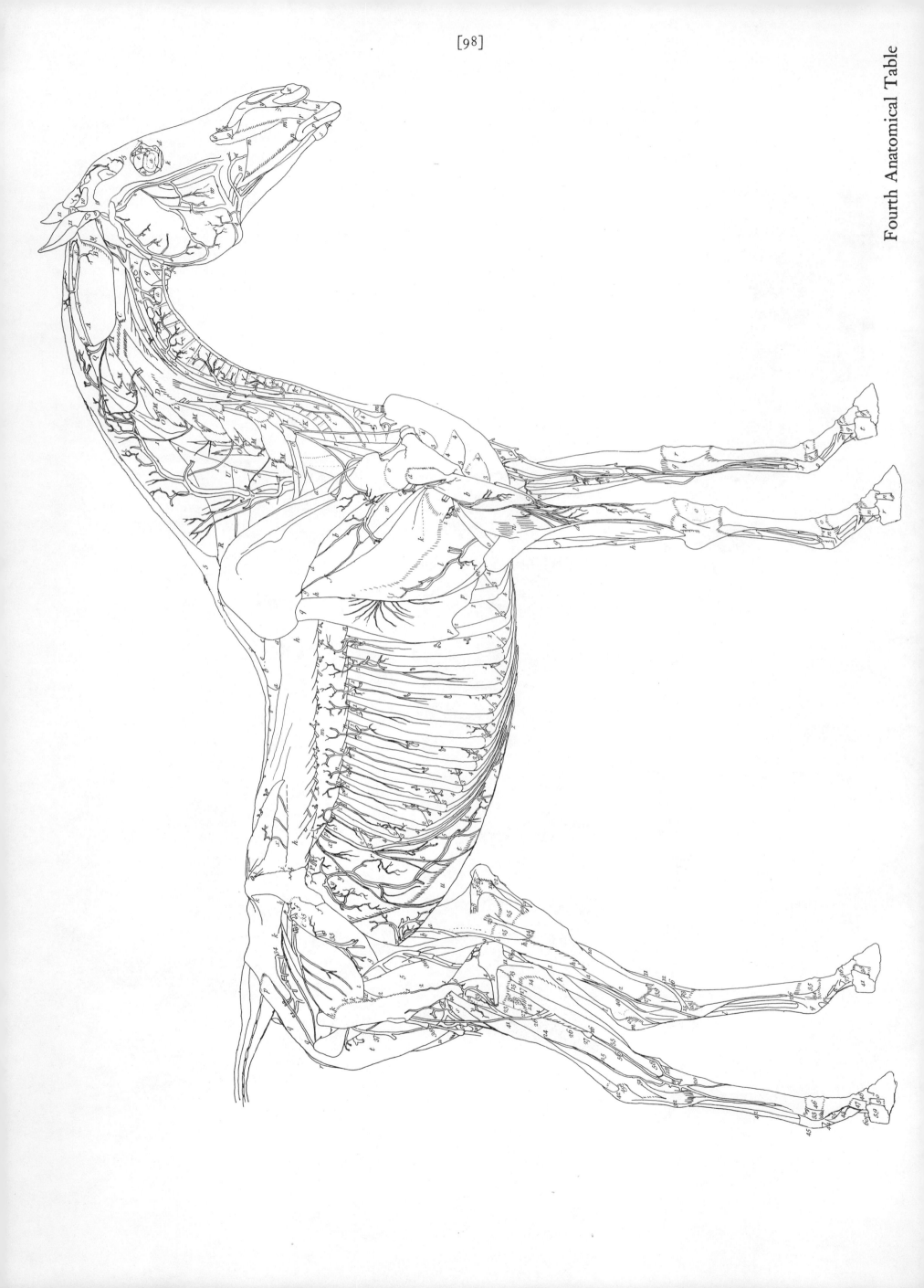

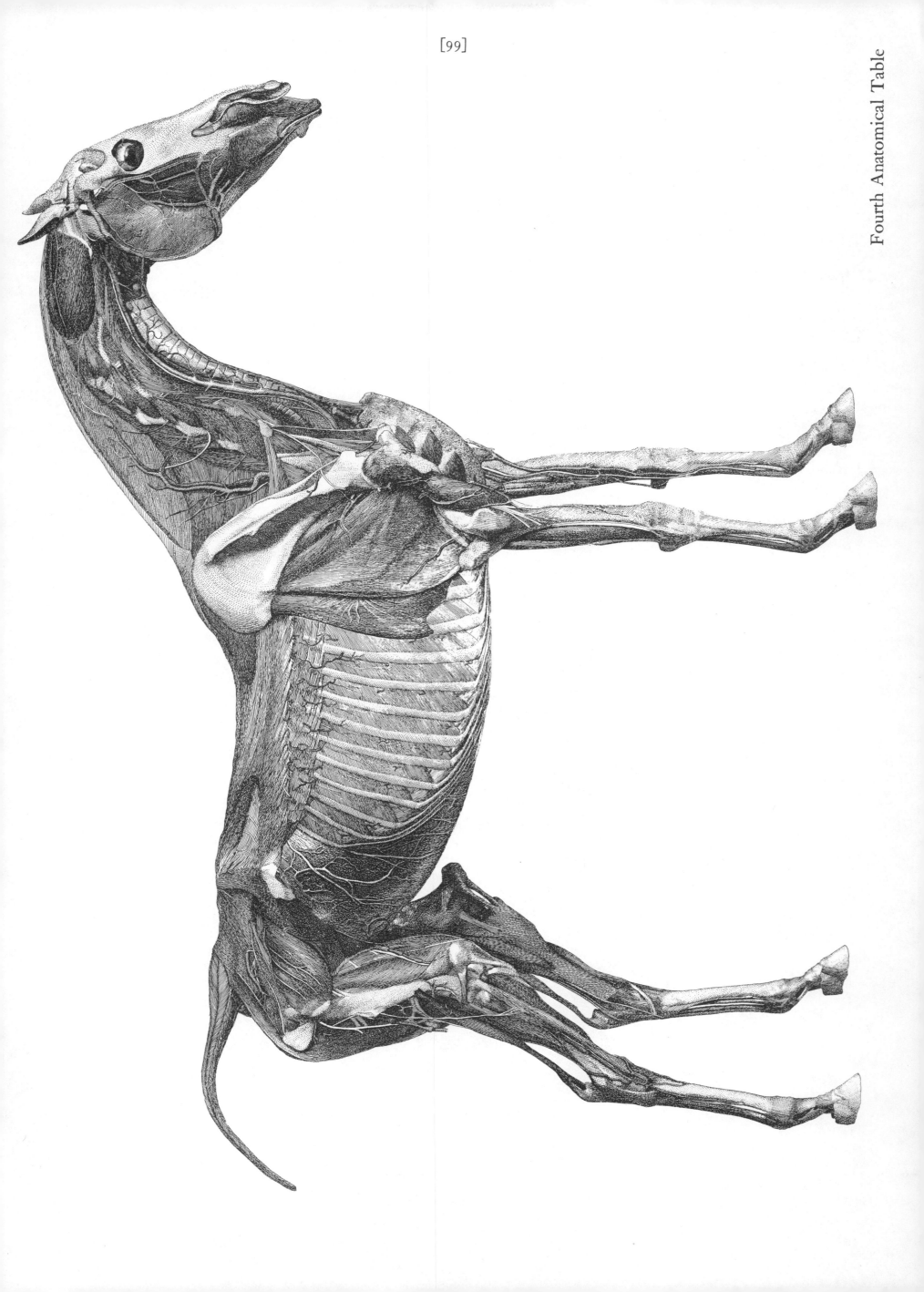

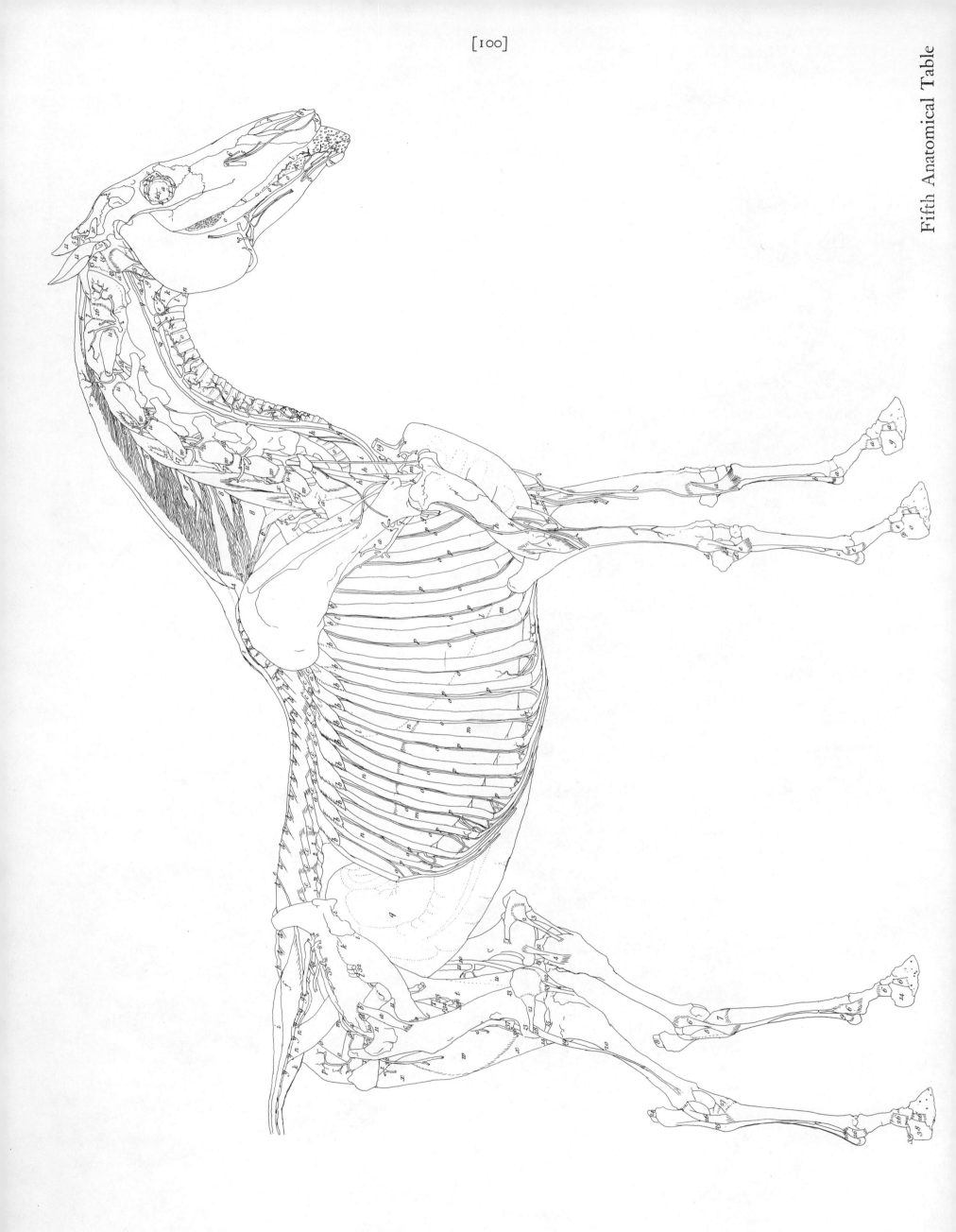

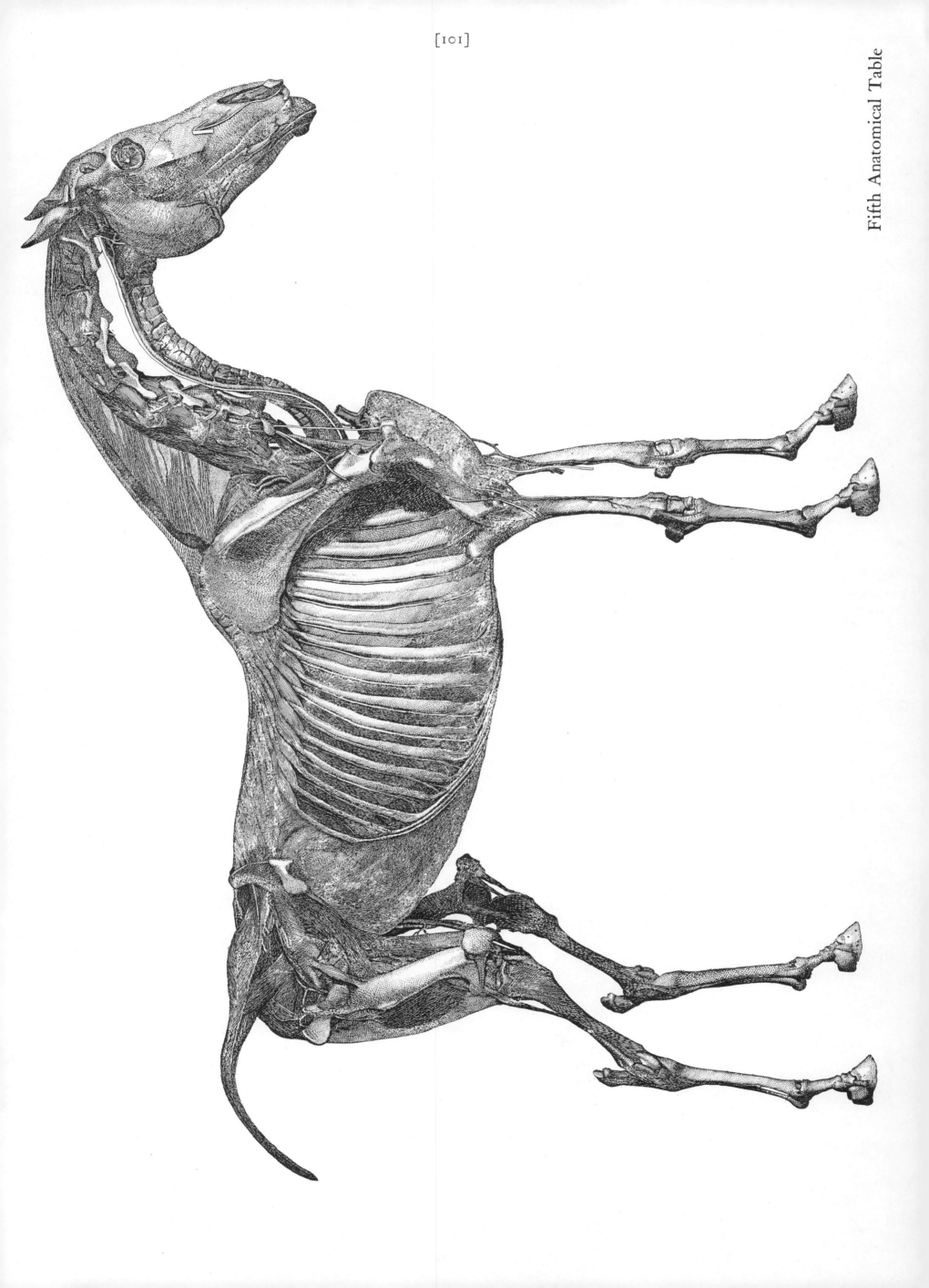

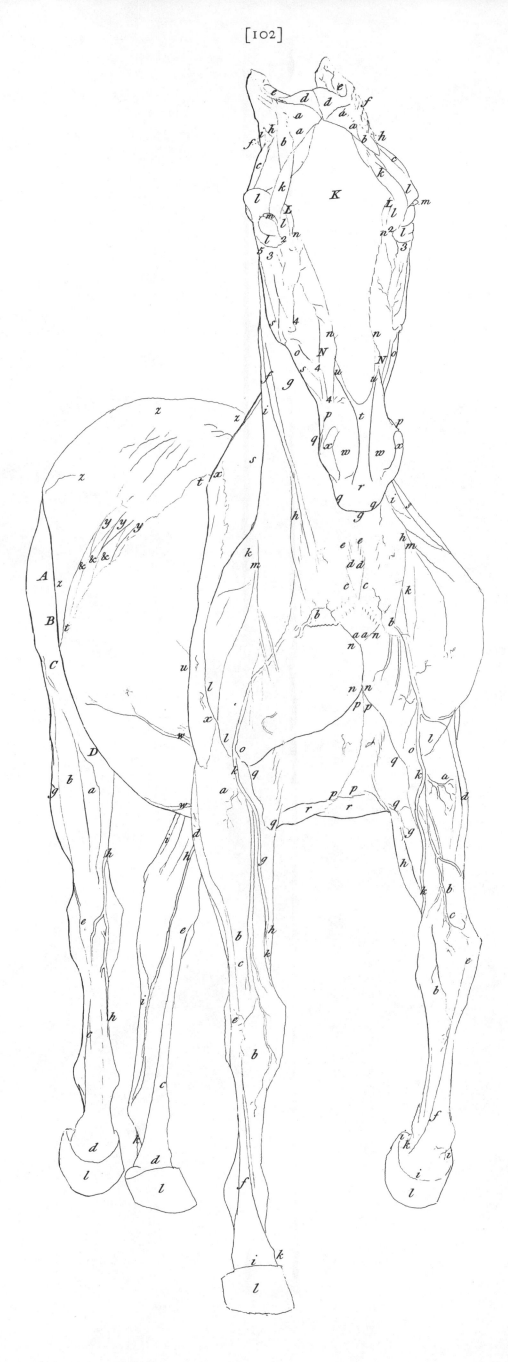

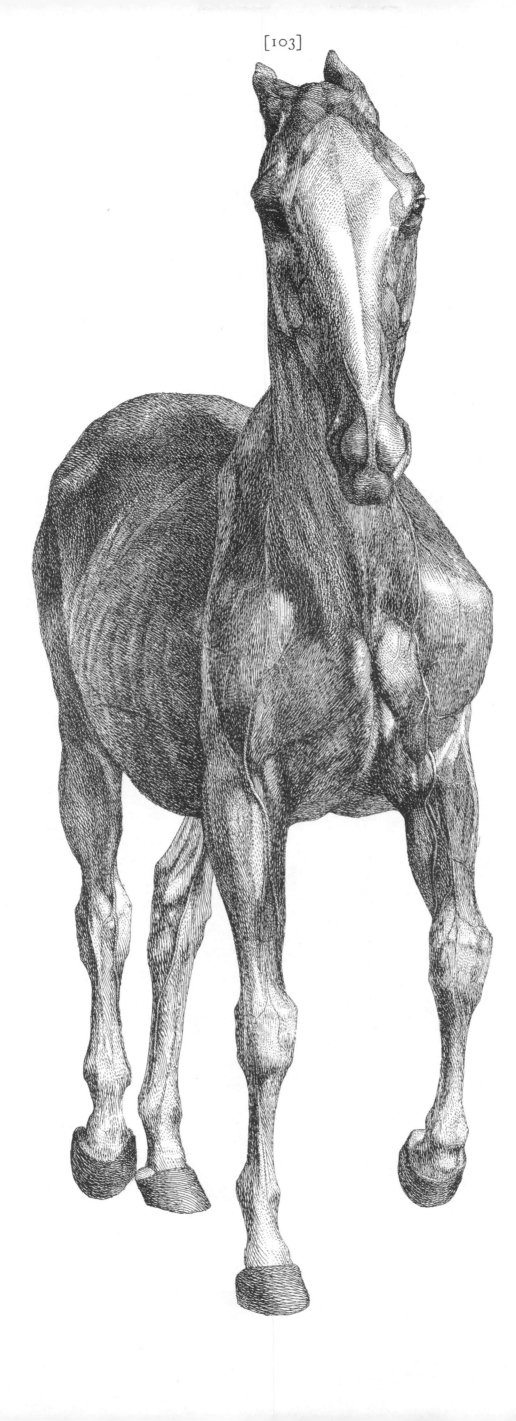

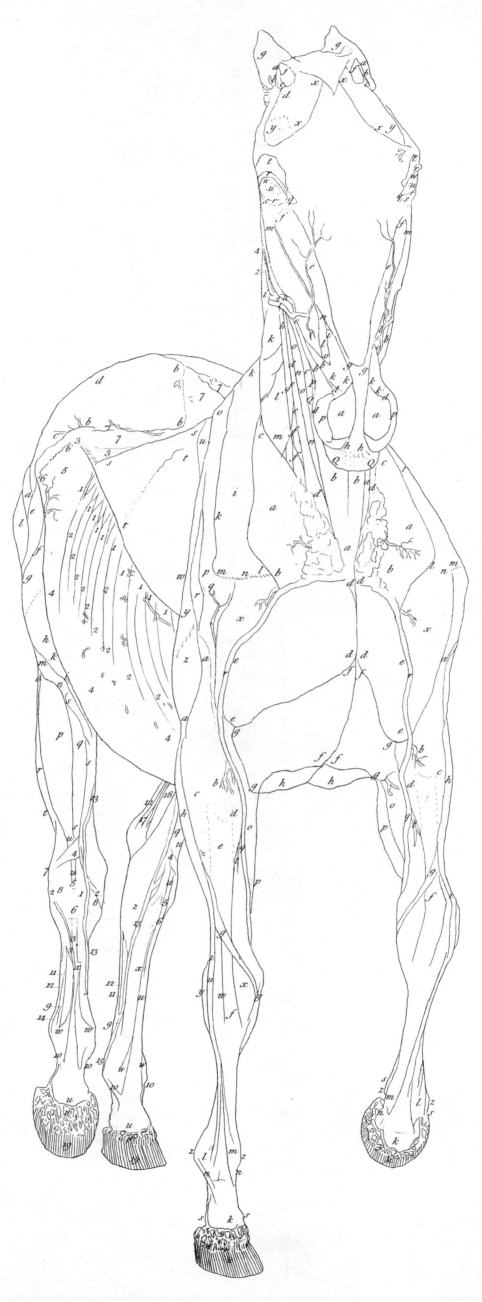

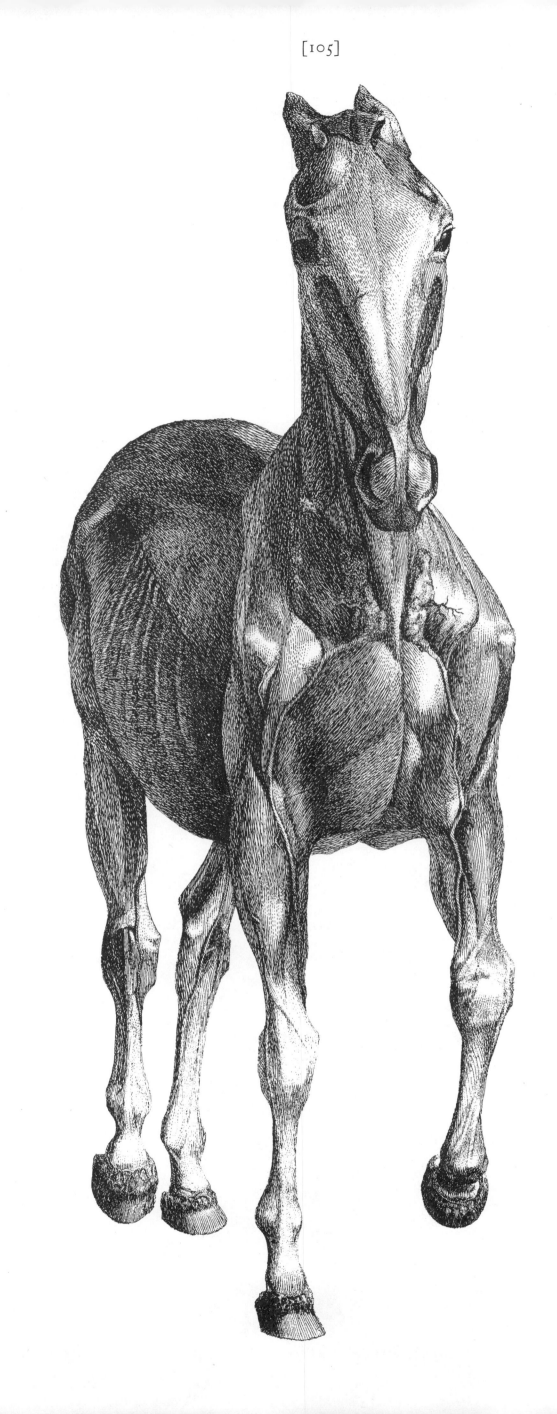

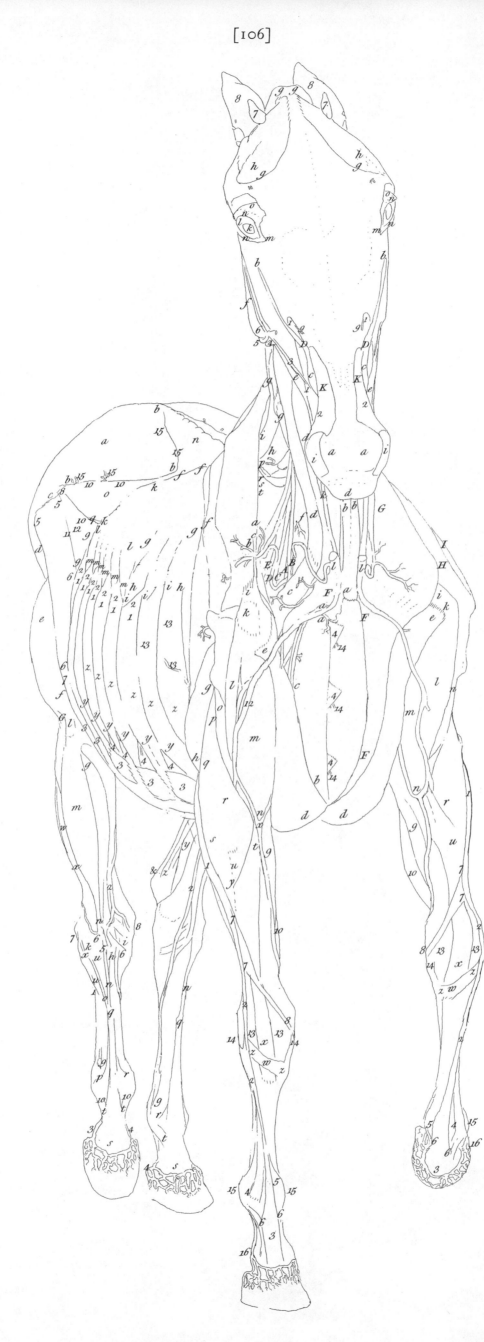

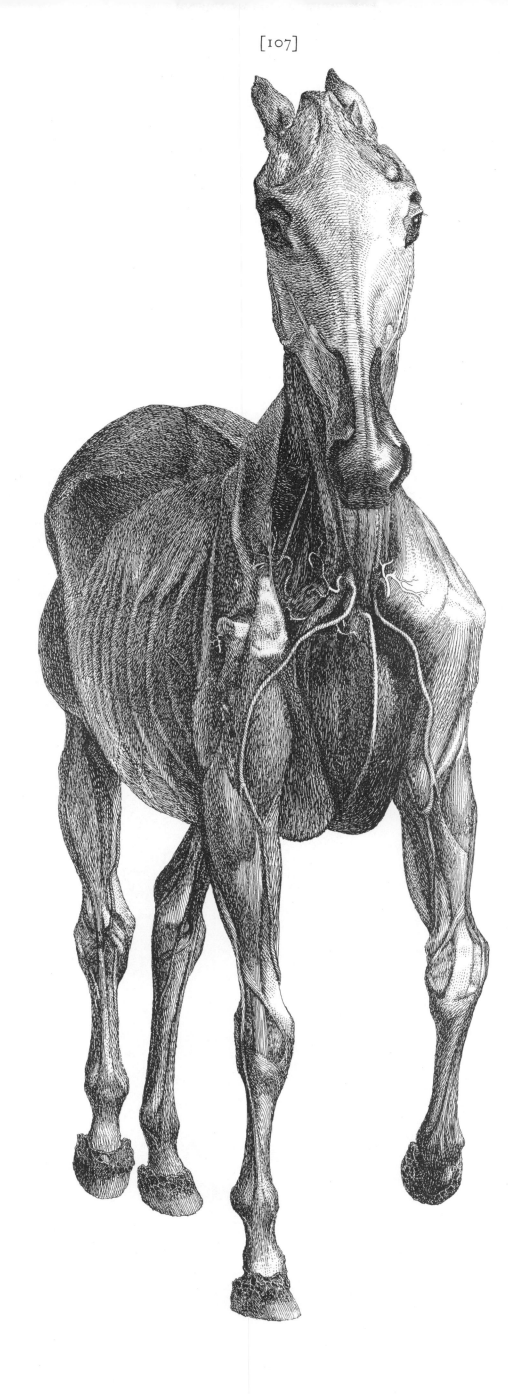

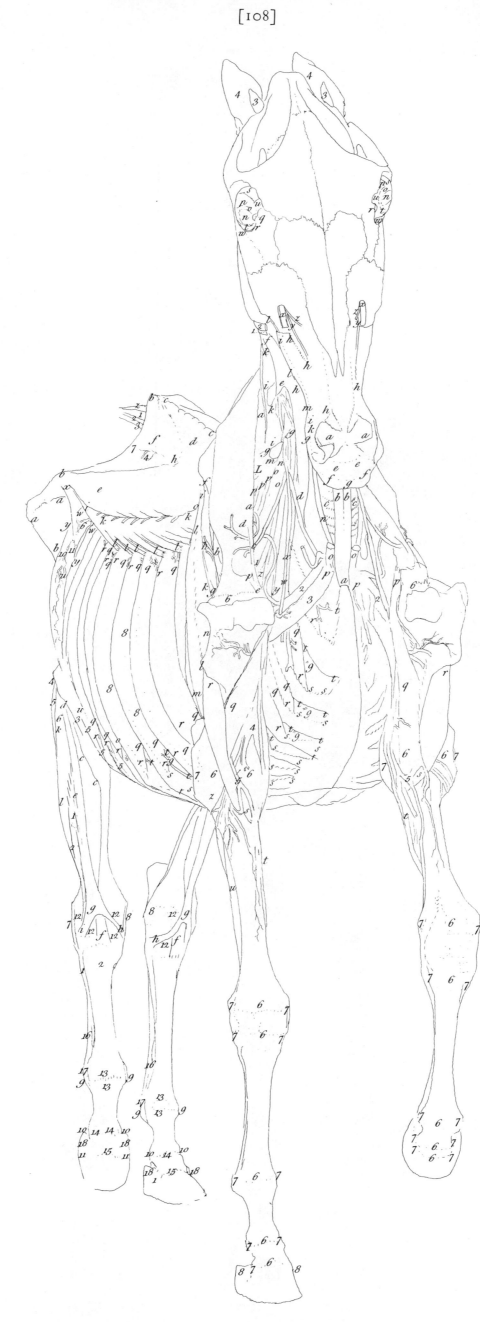

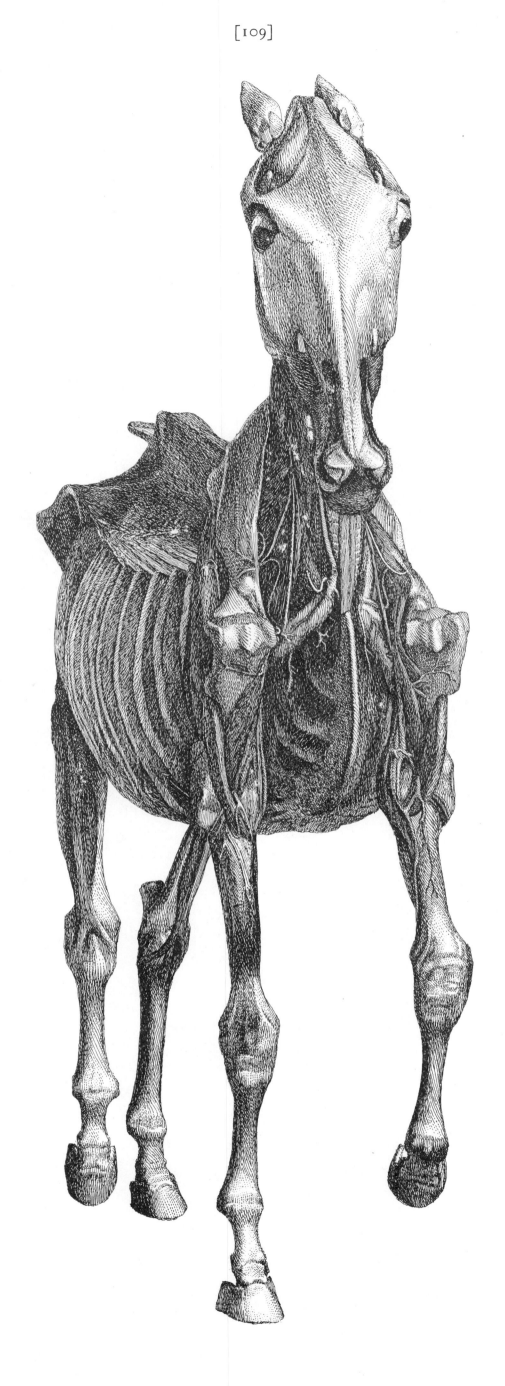

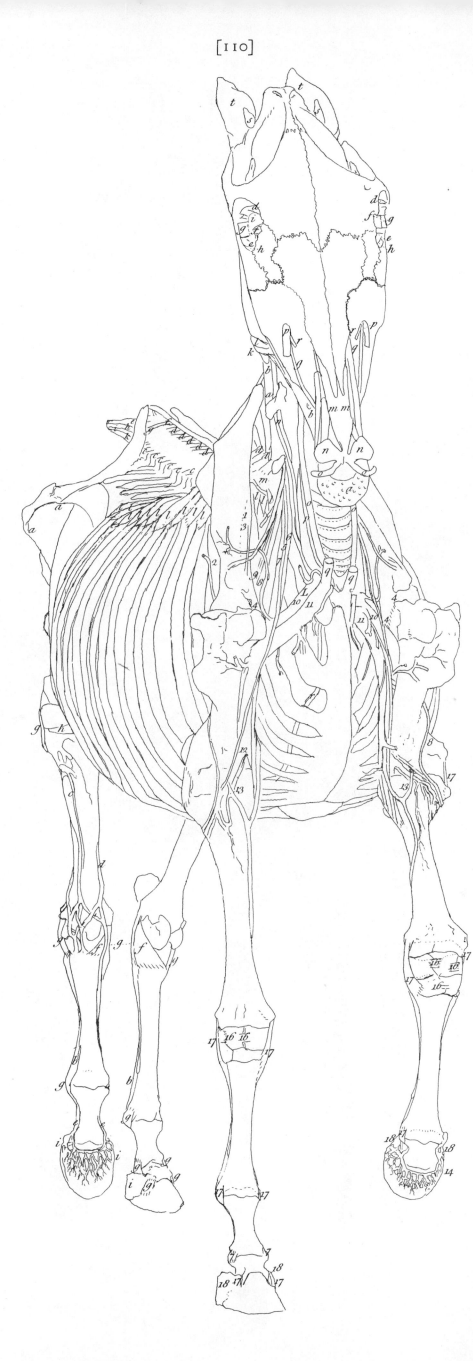

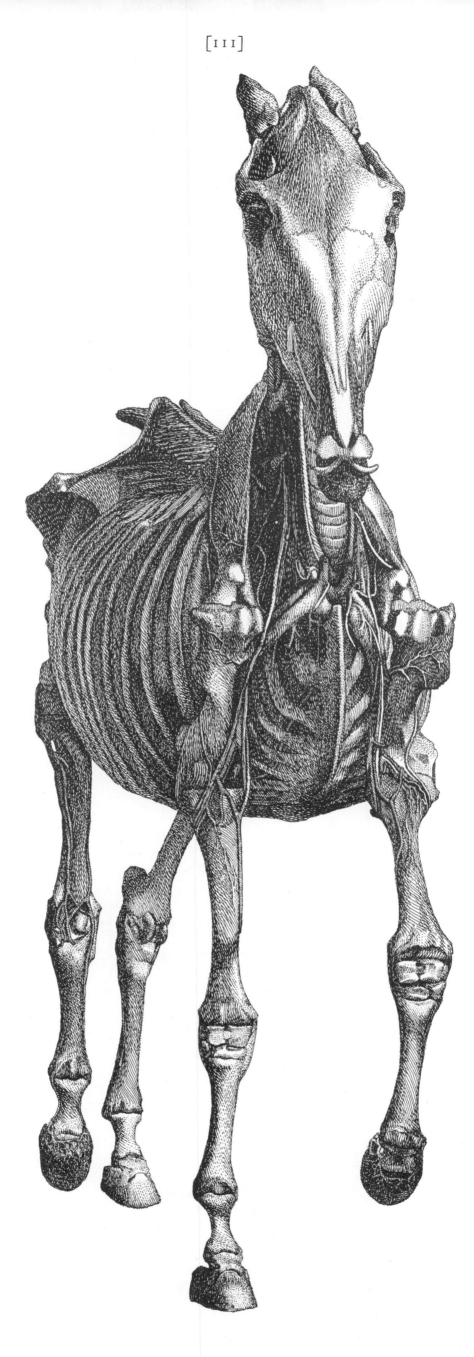

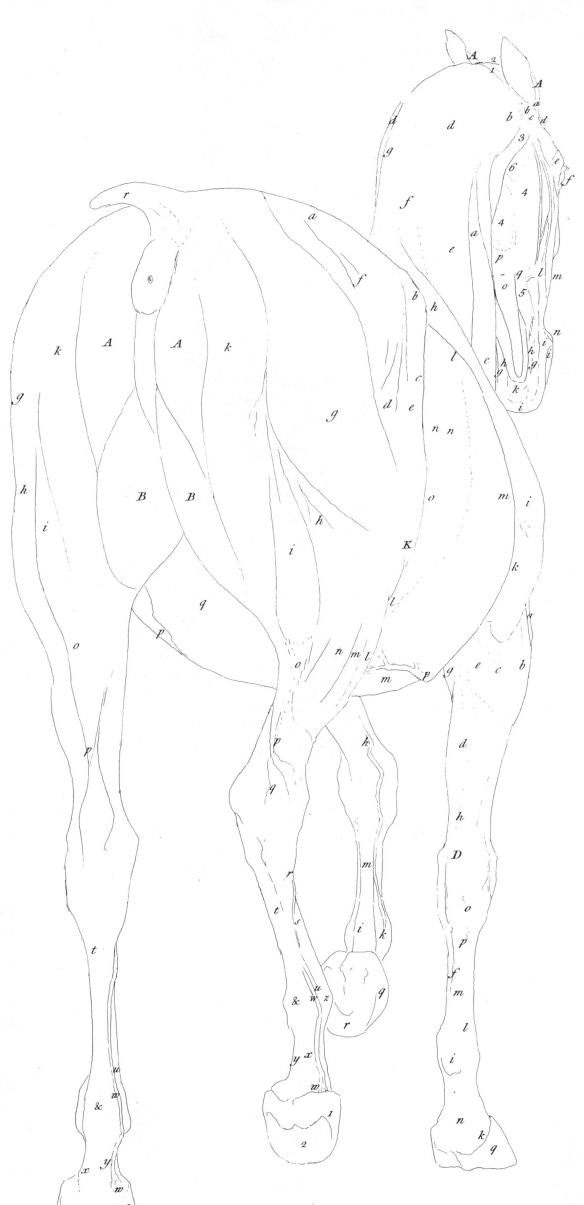

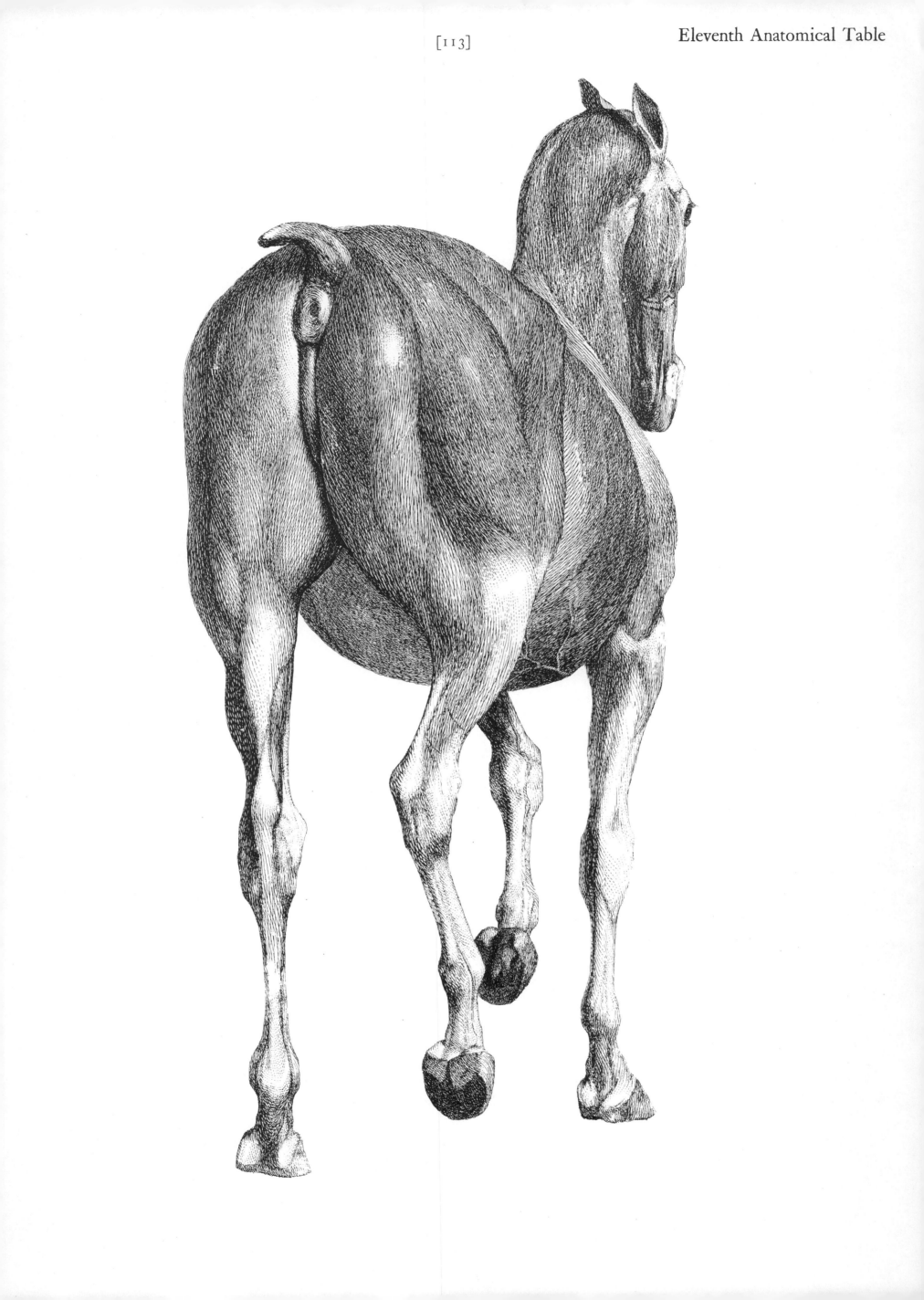

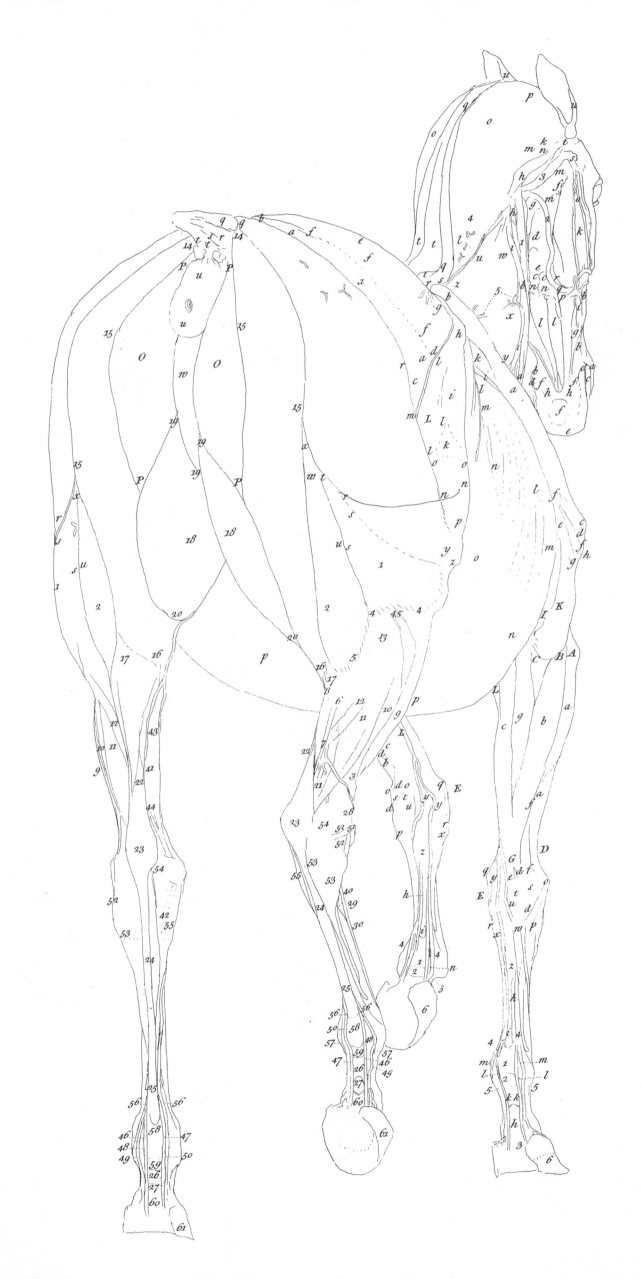

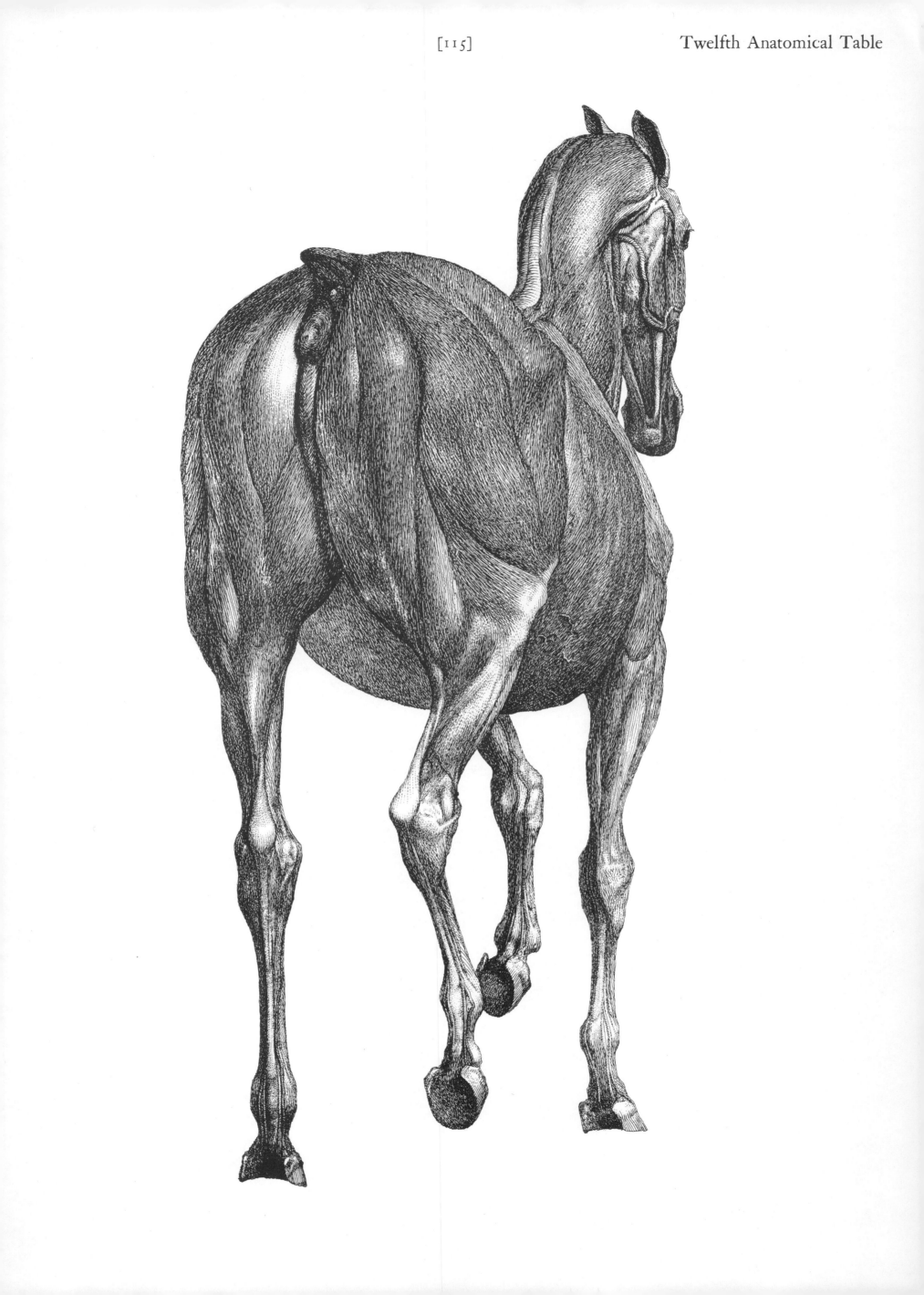

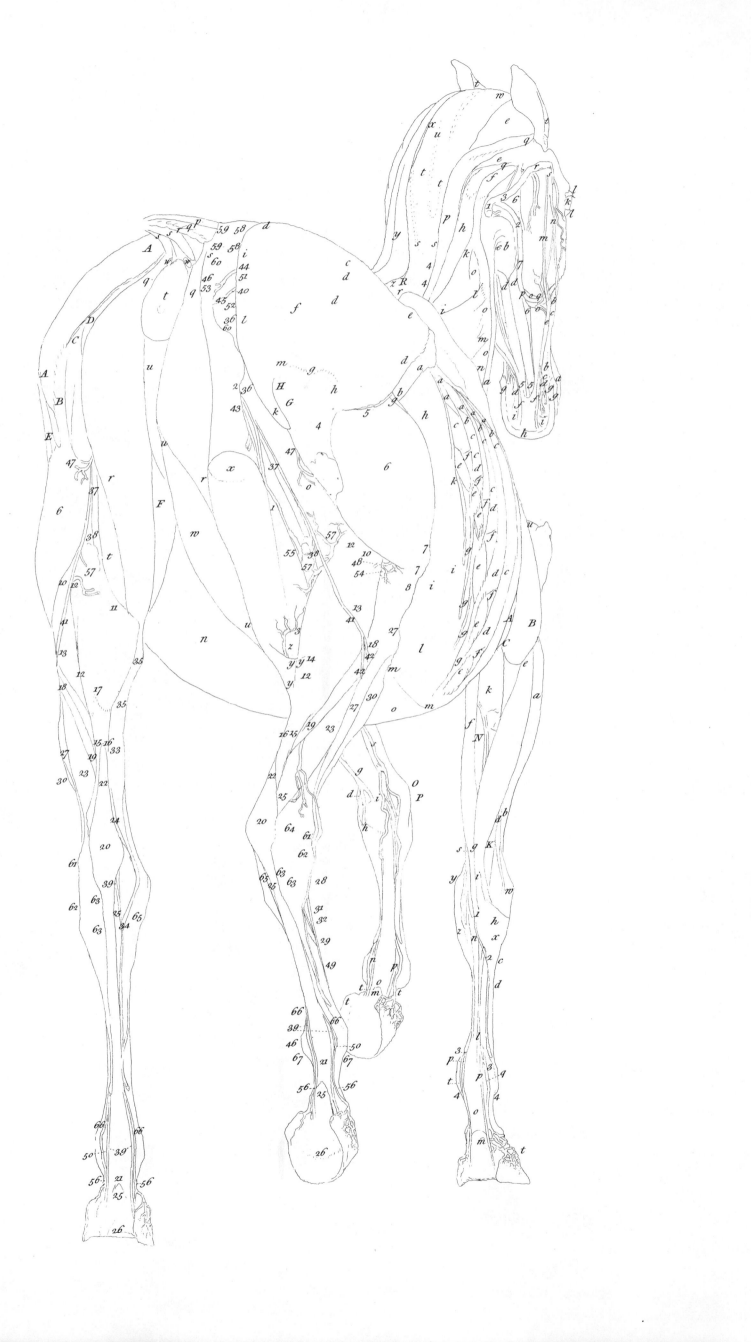

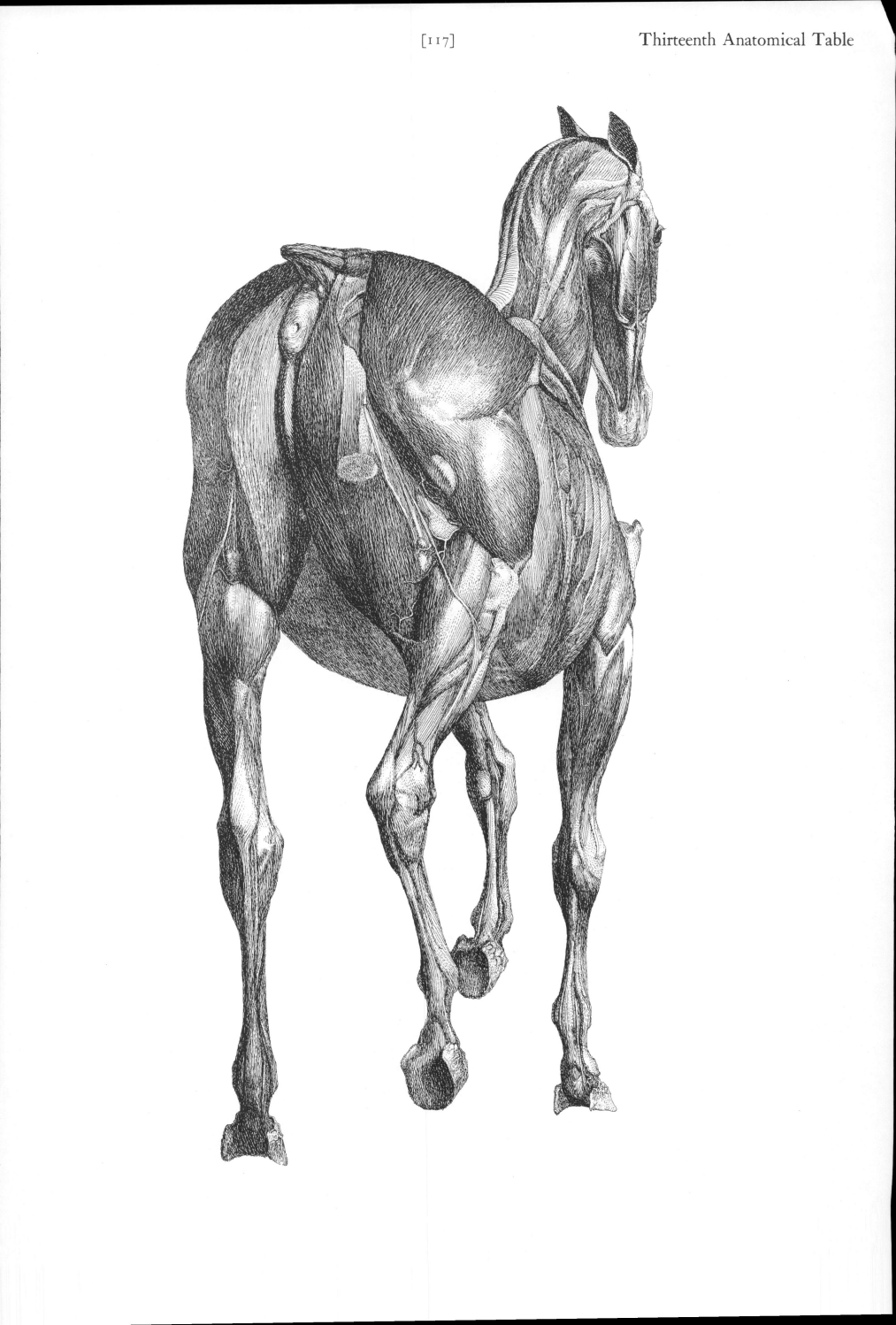

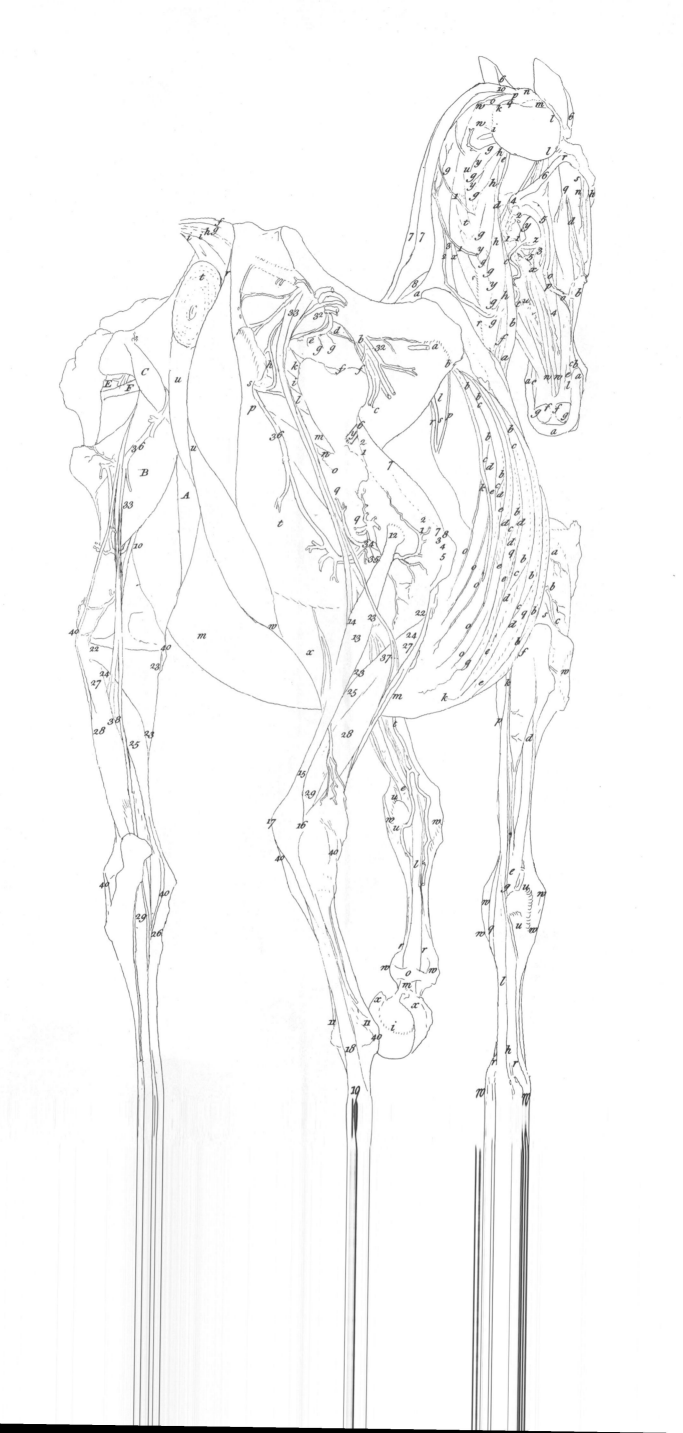

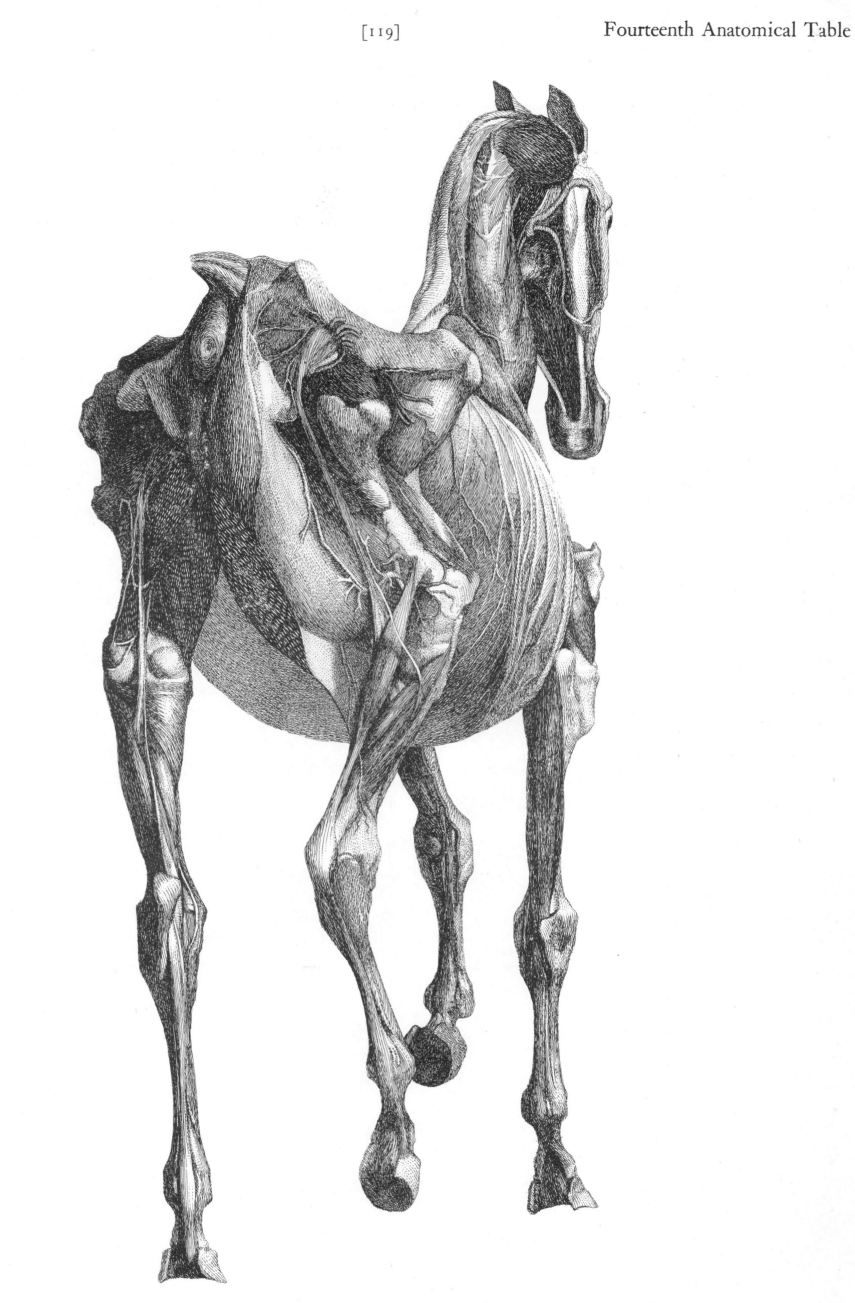

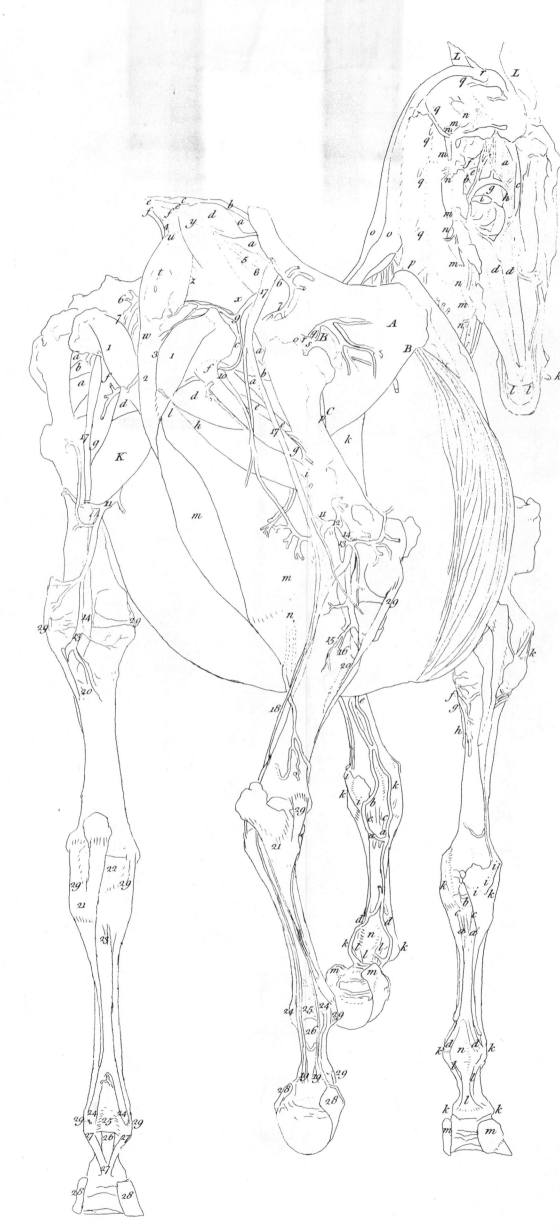

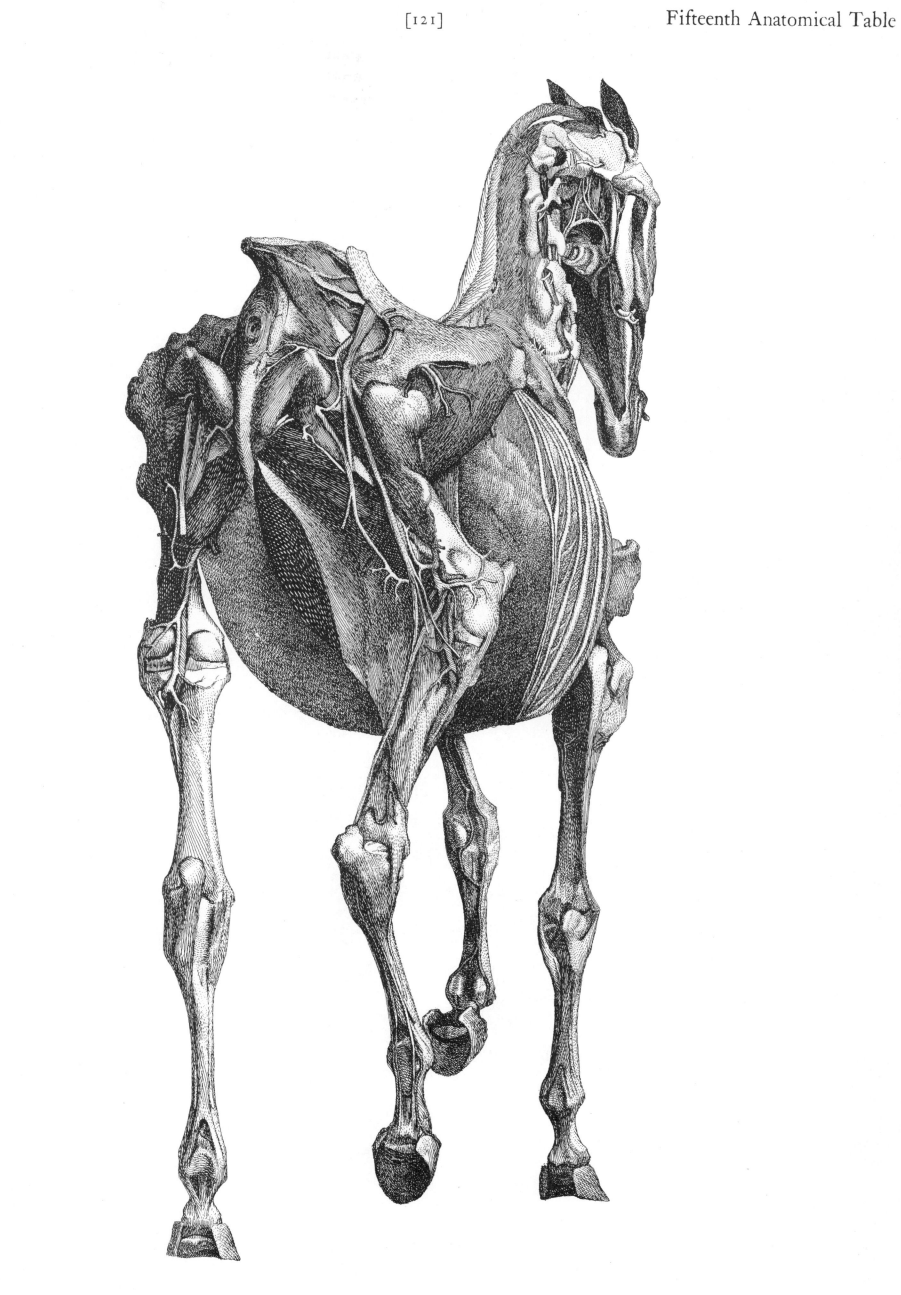